hyalyn
AMERICA'S FINEST PORCELAIN

S T E P H E N C . C O M P T O N

AMERICA
THROUGH TIME®
ADDING COLOR TO AMERICAN HISTORY

Dedicated to Barry Gurley Huffman

America Through Time is an imprint of Fonthill Media LLC
www.through-time.com
office@through-time.com

Published by Arcadia Publishing by arrangement with Fonthill Media LLC
For all general information, please contact Arcadia Publishing:
Telephone: 843-853-2070
Fax: 843-853-0044
E-mail: sales@arcadiapublishing.com
For customer service and orders:
Toll-Free 1-888-313-2665

www.arcadiapublishing.com

First published 2021

Copyright © Stephen C. Compton 2021

ISBN 978-1-63499-344-9

All rights reserved. No part of this publication may be reproduced, stored in
a retrieval system or transmitted in any form or by any means, electronic,
mechanical, photocopying, recording or otherwise, without prior permission
in writing from Fonthill Media LLC

Typeset in Mrs Eaves XL Serif Narrow 10pt on 14pt
Printed and bound in England

CONTENTS

Acknowledgments 1

Introduction: Live High on a Low Budget 5

1 The Moodys Before Hyalyn Porcelain, Inc. 7

2 Hyalyn Porcelain, Inc. (1945–1973) 20

3 First Products 34

4 Selling Hyalyn Porcelain 58

5 Post-Hyalyn Porcelain, Inc. (1973–1997) 67

6 Hyalyn's Products 79

Appendix I: Identifying Marks 166

Appendix II: Selected Catalogs 175

Endnotes 205

Bibliography 211

Index 214

ACKNOWLEDGMENTS

Many workers contributed to the manufacture of the quality porcelain ware seen in the following pages. Likewise, many people generously donated to the research, writing, and assembly of this book. In addition to my publisher, Fonthill Media, and the company's talented staff, I am grateful to the following people and organizations for their assistance. To anyone whose name I have inadvertently omitted, I sincerely apologize.

Kelly Aaron, Lynn Allen, Margaret Allen, Chrissy Bailey, Barbarella Home, Mark Bassett, James F. Brodey, Brent Brolin, Kara Campbell, City of Hickory Historic Preservation Commission, Herbert Cohen, Angelica Cruz DeSimeo, Patrick Daily, James DaMico, Jim Drobka, Kim Ellington, Judy Engel, Everything But The House, Leigh Sigmier Foster, J. R. Fralick, Brian Gallagher, Jane Gavin, Butch Harding, Emily Harnach, Hickory Landmarks Society, Mandy Pitts Hildebrand, Historical Association of Catawba County, Allen W. Huffman, Jr., Barry Gurley Huffman, Riley Humler, Michael Kaplan, Albert Keiser Jr., Leslie Keller, Nancy Kiplinger, Lindsey Lambert, Ken Lay, Vince Long, Halle Mares, North Carolina State University Libraries, Carol Moody Purcell, Mandy Reavis, Jean Richards, Meghan Shook, Ellen Show, Todd Sigmier, Pamela Smith, Michele Sommerlath, Stamford Modern, Clarissa Starnes, Bo Teague, Doris Teague, Stephanie Turner, Robert Warmuth, Lynne Warmuth Watson, Thomas Webb, Clara Wilson, Adam Zeisel, and Ross Zelenske.

Leslie and Frances Moody's daughters, Lynn Moody Igoe and Carol Moody Purcell, contributed indispensably to the research task. Hyalyn Porcelain, Inc. was the outcome of the Moodys' dream of operating a large-scale, high-quality ceramics manufacturing company. Before her death in 2006, Lynn spent countless hours studying and documenting Hyalyn Porcelain, Inc.'s history. In addition to Igoe's accumulated records, her sister, Carol, gathered up more Hyalyn Porcelain, Inc. archival resources, including catalogs, letters, and photographs. Along with Hyalyn Porcelain collector Barry Gurley Huffman's materials, these things are preserved for future research by the Historical Association of Catawba County (Newton, NC) and the Hickory Landmarks Society (Hickory, NC).

I especially wish to thank former Hyalyn Porcelain, Inc. designer Herb Cohen and Hyalyn Cosco, Inc. general manager and Hyalyn, Ltd. owner Robert Warmuth for their assistance. Their first-hand knowledge about the companies' histories and operations was immeasurably valuable.

A generous grant made for photography by the City of Hickory Historic Preservation Commission and unfettered access to archival collections preserved by the Historical Association of Catawba County and the Hickory Landmarks Society made an otherwise difficult, if not impossible task achievable. I extend my special thanks to Ross Zelenske, Bo Teague, and Patrick Daily for these opportunities, and photographer Stephanie Turner for her first-rate images.

I have the highest regard for Barry Huffman. Her persistent determination to see a Hyalyn Porcelain book written persuaded me to get involved in the project. Her passion for collecting and identifying things made by the company ensured that its products could be documented and photographed. Her unhesitant assistance along the way significantly lightened my load and enriched my writing. More than anyone, she merits credit for this book's publication. With great pleasure, I dedicate this book to Barry Gurley Huffman.

INTRODUCTION

LIVE HIGH ON A LOW BUDGET

When Hickory, North Carolina, resident and Hyalyn Porcelain collector Barry Huffman first approached me about writing a book about Hyalyn Porcelain, Inc., I declined. I am sure I did so another three or four times.

I have collected and written about traditional, hand-turned, mostly wood-fired North Carolina pottery for three decades. My focus includes eighteenth-to-twentieth century earthenware, stoneware, and art pottery made in countryside sheds and shops by folk potters. My books include *North Carolina Pottery: Earthenware, Stoneware, and Fancyware*; *Seagrove Potteries Through Time*; *It's Just Dirt! The Historic Art Potteries of North Carolina's Seagrove Region*; *A Handed Down Art: The Brown Family Potters*; *North Carolina Potteries Through Time*; *Jugtown Pottery: 1917–2017: A Century of Art and Craft in Clay*; and *North Carolina's Moravian Potters: The Art and Mystery of Pottery-Making in Wachovia*. Barry knew all of this about me. But, as this list demonstrates, I have not written about mass-produced ceramics like Hyalyn Porcelain.

I explained to Barry that I knew nothing about Hyalyn Porcelain. With my interest in folk pottery, I thought I would not like it if I saw it. Regardless, her resolve paid off. More encouragement led me to see some Hyalyn Porcelain kept at the Historical Association of Catawba County's Hickory History Center. To my surprise, I liked what I saw. She further piqued my curiosity when she explained that nationally known figures like Eva Zeisel, Michael Lax, Erwin Kalla, Georges Briard, and Herbert Cohen designed some of Hyalyn Porcelain, Inc.'s most successful lines of ware. When I spied boxes filled with sales catalogs, correspondence, photographs, and more, I knew that my answer to Barry's request to write about Hyalyn Porcelain was "Yes."

What struck me was that despite all of the knowledge I have about North Carolina's deep Native American, folk, and studio pottery-making traditions, I knew nothing about this significant ceramics-manufacturing enterprise. In part, that was because no one has written much about Hyalyn Porcelain, Inc. and its founders, Harvey Leslie "Less" Moody and Frances Johnson Moody. As I perceived it, a historical account of Hyalyn Porcelain, Inc. would add a "fourth leg to the table" comprising the state's ceramic arts story.

I admit to an addiction, of sorts, to pottery collecting (and research and writing about it). So, in writing this book, I, of course, purchased examples of Hyalyn Porcelain. I now have a collection of it. I have no interest in some of the company's products, but some are intriguing in design and beautiful in form and color. The designers' stories are as varied and as stimulating as Hyalyn Porcelain, Inc.'s products. The process for mass-producing cast porcelain is fascinating—especially when compared to the more straightforward wheel-turned process for pottery-making that is more familiar to me. Is it obvious? I have become a Hyalyn Porcelain fan.

Yet more than the things made or stories about the designers who imagined them, I find the underlying philosophy defining the kind of items made by Hyalyn Porcelain, Inc. most thought-provoking. A Hyalyn Porcelain, Inc. advertising slogan sums it up: "Live High on a Low Budget." In 1958, Hyalyn Porcelain, Inc. incorporated this slogan in a full-page advertisement printed in the June issue of *LIVING for Young Homemakers* magazine. The publication's "Live High on a Low Budget" feature showed more than fifty Hyalyn Porcelain pieces decorating a Cape Cod-styled home outfitted with furniture manufactured by Lenoir, North Carolina's Broyhill Furniture Company.

Calling Hyalyn Porcelain, Inc.'s ceramic ware "America's finest porcelain," and motivated by the slogan, "live high on a low budget," Less Moody meant to give customers pride of ownership at an affordable price. This aim came to Moody from his years as a student and assistant of Ohio State University's Arthur Baggs, who said:

> I, for one, refuse to believe that a thing must be cheap art to sell cheaply and in volume. I think it is a most interesting challenge to the artist to prove that fine, tasteful products can be made and sold with equal or greater success than that attained by wares of mediocre or bad artistic conception.

Baggs called his approach to industrial ceramic design "furnishing more artistic fuel for the large industrial furnaces." Hyalyn Porcelain, Inc. had some "duds" and things made there unflatteringly called "nifty gifties" add little to the company's reputation. Yet overall, this tactic worked and was essential to Hyalyn Porcelain, Inc.'s success.

While a 1960s North Carolina State University School of Design (now College of Design) student, I considered how many unsightly buildings (in my view) were constructed from quality materials. I believed that a capable designer could make more beautiful places using the same wood, brick, glass, metal, or stone. Today, I live in the Appalachian Mountains in a modest house constructed of good materials. I do not know who designed it, but it achieves my understanding of how good design and affordability are mutually attainable goals. Hyalyn Porcelain, Inc. applied this principle and successfully manufactured affordably-priced products that might pass as more expensive items. For many mid-twentieth century families of modest means, the opportunity to bring affordable ceramic art into their homes supplied beauty and enjoyment.

In the following pages, you will see what I learned from scratch about Hyalyn Porcelain. Looking through the hundreds of images, see what things you would select for your home or collection. Most of it is high-fired vitreous porcelain, much of it shaped by notable designers that buyers purchased for a few dollars apiece. That is "living high on a low budget," and it was Hyalyn Porcelain, Inc.'s main secret to success.

1

THE MOODYS BEFORE HYALYN PORCELAIN, INC.

Ideals expressed by the words "style" and "quality" pushed 1940s business newcomer Hyalyn Porcelain, Inc. toward achieving the company's notable goals. These two words are part of the company's first logotype, and they appear prominently in the company's first advertisements.

Yet why would anyone consider opening a new ceramics manufacturing plant amid World War II? Given that established pottery-making companies like McCoy, Haeger, Hull, Redwing, Roseville, and Stangl, to name a few, assured significant competition, why would North Carolina investors deposit substantial sums of money into a previously unknown Ohio couple's dream? Perhaps it had to do with a vision defined by those two words: style and quality. Indeed, that was part of it, but as time proved, there was much more to it than that.

Hyalyn Porcelain, Inc.'s success was generally due to the insight, training, skill, experience, and relentless drive of Harvey Leslie Moody and Frances Johnson Moody. Though they never owned the company outright, in many ways, it was their company. Their dreams shaped it and drove it forward to the satisfaction of an emerging, increasingly modern America. So who were these two people, and what prepared them to make Hyalyn Porcelain successful?

Fig. 1.1 Business card, *c.* 1945-1947. H. Leslie (Less) Moody. The words "style" and "quality," incorporated into the firm's original logotype, express Moody's ambitious goals for Hickory, North Carolina's Hyalyn Porcelain, Inc. (*Hickory Landmarks Society*)

HARVEY LESLIE MOODY

From an early age, Zanesville, Ohio's Harvey Leslie Moody gravitated toward a ceramics-related career. The son of James Harvey Moody and Della Irene Baughman, and the second of their four children, Less (the preferred spelling of his abbreviated name) Moody was born on January 26, 1908. Though they resided in Ohio's acclaimed "pottery capital," his parents did not work in the pottery industry.

Following public high school graduation in 1926, Less Moody worked between college sessions at Zanesville's Mosaic Tile Company. He worked summers (1927–1929) in Mosaic's Faience Design Office, where he made colored sketches and drawings for tile designs and decorations and estimated costs for production.[1] Established in 1894 by Karl Langerbeck and Herman Mueller, both of whom were formerly associated with the city's American Encaustic Tiling Company, Mosaic Tile Company expanded from floor tile manufacturing to the creation of hand-decorated tiles, many with Art Deco-styled designs.[2]

The first in his family to attend college, Moody initially studied architectural engineering at Pittsburgh's Carnegie Institute of Technology before attending Ohio State University.[3] With a year in architectural training completed, he possessed the skills to design Hyalyn Porcelain, Inc.'s first factory building in Hickory, North Carolina. Moody was a member of Ohio State University's Tau Sigma Delta fraternity, an honorary society in architecture and allied/fine arts for students demonstrating significant talent in these fields.[4] Despite his academic competence, his interest in architecture waned.

His Mosaic Tile Company work experience and the timely establishment of a new Ohio State University ceramics department lured Moody away from an architecture career to one in ceramics. In 1927, Moody moved from Carnegie Institute of Technology to Ohio State University's architectural engineering program. In 1928, the university recruited Arthur Eugene Baggs to teach ceramic arts and create its ceramics program. Baggs studied pottery-making with Alfred University's notable Charles Fergus Binns. With Dr. Herbert James Hall, Baggs established and operated Marblehead Pottery of Marblehead, Massachusetts, and served as a glaze chemist for Cleveland, Ohio's Cowan Pottery, before joining Ohio State University's faculty.[5] Writing in his "Proposal for a White Ware Industry in North Carolina," Moody says:

> During the [1927–1928] school year [I] learned that a new course in ceramic design was being planned and organized under the direction of Arthur E. Baggs, who still directs this work. Having become interested in the future in the ceramic industry, I transferred to this new course in the Spring of 1928 and was the first to be graduated by this department [1931].[6]

In the fall of 1928, Moody helped Arthur Baggs set up Ohio State University's new ceramics department. His job included assembling machinery, including a pug mill for preparing clay and a kiln and spray booths for glazing. While studying ceramics engineering and business courses, Moody worked as Arthur Baggs's undergraduate assistant.[7] In 1931, Ohio State University awarded Moody the Bachelor of Fine Arts (B.F.A.) degree in ceramic art. Following graduation and lacking any employment offers (amid the Great Depression), Moody remained at Ohio State University as a graduate assistant in the ceramic art department.

In the spring of 1932, perhaps anxious to gain further work experience, Moody accepted a jack-of-all-trades position at Love Field Pottery in Dallas, Texas. Leslie and Frances Johnson Moody were married at the latter's mother's home in Franklin County, Ohio, on September 6, 1932.[8] Afterward, they returned to Dallas. A skillful designer and sculptor, Frances Moody played an incalculable role in Less Moody's successful career in pottery management and manufacture.

Initially, Moody worked to resolve Love Field Pottery's production problems. He designed new items, made models and molds, developed new glazes, improved those in use upon his arrival, and added a new stoneware clay body. Lackluster sales of Love Field's crocks, jugs, and pitchers led the Moodys, in early 1933, to take to the road in south and west Texas, hoping to boost the flagging pottery's business. Provisions of the June 16, 1933, National Industrial Recovery Act, carried out by the National Recovery Administration, led to the Moodys' Texas sales venture's termination.[9] Then, they returned to Dallas, hoping to secure other employment. Frances tinted photographs for a city studio. Less taught a night class in ceramics for the Dallas Technical High School and tried his hand as a salesman during the day.[10] For the time being, the Moodys' dreams were dashed by the Great Depression's ongoing ill-effect on business and employment in the U.S.

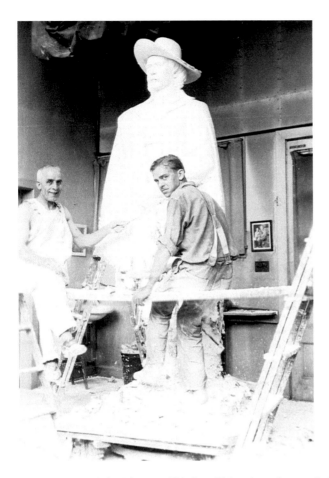

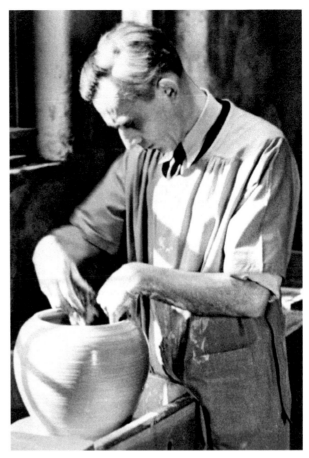

◄ **Fig. 1.2** Less Moody (right) assists Ohio State University sculptor and educator Erwin Frederick Frey (1892–1967) when creating Frey's George Armstrong Custer monument. The memorial stands in Custer's hometown—New Rumley, Ohio. (*Hickory Landmarks Society*)

► **Fig. 1.3** Arthur Eugene Baggs (1886–1947). A chemist, potter, and Ohio State University educator, Baggs studied under Alfred University's Charles Fergus Binns before operating Marblehead Pottery. Less Moody worked with Baggs at O.S.U. as a ceramics department assistant. (*Hickory Landmarks Society*)

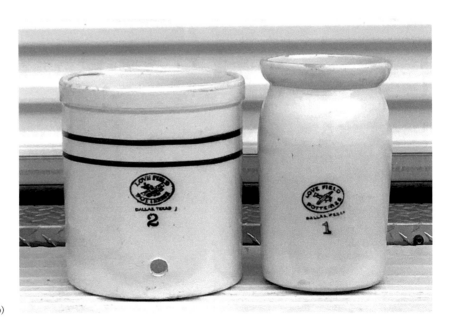

Fig. 1.4 A 2-gallon water cooler (left) and a 1-gallon storage jar from Love Field Pottery, Dallas, Texas. Stoneware with Bristol glaze and blue stenciling. For about a year (1932–1933), Less Moody tried boosting this shop's sales. The newly-wed Less and Frances Moody traveled Texas roads selling the flagging enterprise's products. (*Butch Harding photo*)

Seeing little hope for work in Texas's ceramics field, Less Moody again became an assistant in Ohio State University's ceramic art department. In 1934, Abingdon Sanitary Manufacturing Company's Vernon Beard Stockdale (chairman of Abingdon's artware division from 1934–1950) came to Ohio State University seeking a trained ceramist to manage the startup and operation of the company's proposed new artware division. Abingdon Sanitary Manufacturing Company employed Moody in March 1934.

Here is how Frances Moody described the couples' first visit to Abingdon, Illinois:

> My husband went to the pottery and had this interview with Mr. Raymond Bidwell. He came home and we had lunch and Mr. Bidwell asked that I come for an interview in the afternoon, because he was interested in the artistic side of it and wanted to know what I might add. I was asked to be a sort of non-commissioned participant in the program and whenever they wanted something done that was a thing of modeling, I was asked to do it unless someone else in the plant came up with an idea—or even when someone else from the outside presented an idea.[11]

Initially, Less Moody acted as a technician to develop the new artware line's glazes and colors. He then took charge of production before being named, after eight months on the job, to manage the artware division. Moody managed Abingdon Pottery from 1934–1941.

English-born Eric Hertslet designed most of Abingdon's first forms. Soon after the Moodys arrived in Abingdon, Hertslet died in a plane crash, and after that, Less and Frances Moody created most of the shop's designs. Like Abingdon's Fern Leaf line, Moody designed some things while overseeing proposed designs and glaze development. Frances Moody sculpted some figurines during her undergraduate term at Ohio State University.[12] She made some of Abingdon Pottery's sculptured forms, among other designs.

Moody describes the growth of Abingdon Pottery's business this way:

> For the first three years, sales of Abingdon were developed slowly but satisfactorily, and a great deal of experience was gained regarding the product, market, competition, etc. It was found that there was a market for quality ware, but that Abingdon prices were out of line. By developing more efficient production methods, setting up better control and developing a one firing process, costs were reduced as much as 35%, which enabled Abingdon to present a quality line in the proper price class. With these various developments and the consequent reduction in cost, Abingdon came to the front as one of the leading art ware lines in the country, and during the past three years the business in that department has increased more than 300%.[13]

In addition to the role that he played in establishing Abingdon's successful artware business, Less Moody led the company into the lucrative field of lamp base manufacture. While claiming responsibility for the development, sales, and contacts in this field of production, Moody pointed out that in 1941, the lamp base business alone contributed $100,000 to Abingdon Pottery's sales.

By the end of 1941, Moody believed he had contributed fully to Abingdon Pottery's success, and he was ready to move on. The Moodys had in mind establishing their own pottery business, and in January 1942, they left Abingdon, Illinois, for Greensboro, North Carolina, to search for investors.[14] As Abingdon's manager, Moody gained valuable hands-on experience and vast knowledge about setting up and operating a large-scale operation for quality mass-production of artware and lamp bases. These consequential lessons that he learned inevitably shaped Hyalyn Porcelain, Inc. product lines and processes and helped ensure the North Carolina company's success. Yet as is often the case, the road to success can be a bumpy ride.

On December 10, 1941 (three days following the bombing of Pearl Harbor), Less Moody wrote to the Patterson Foundry and Machine Co. of East Liverpool, Ohio. He inquired about the availability of pottery-making equipment for his factory. In response, the company's vice-president of sales, E. M. Underwood, explained that it would be difficult to get a full line of pottery equipment without some type of priority rating (in light of the nation's entry into World War II). He did say, though, that a company affiliate, the Economy Equipment Company, could supply reconditioned, used pottery equipment—almost everything needed to build a pottery.[15]

Fig. 1.5 Less Moody (seated, second from the right) meets with Abingdon Pottery's directors in February 1941. In 1934, Moody was named Abingdon Sanitary Manufacturing Company's new art division's general manager. (*Hickory Landmarks Society*)

Fig. 1.6 In addition to his duties as Abingdon Pottery's manager, Less Moody designed some early wares, including this Fern Leaf wall pocket planter (Abingdon No. 435), *c.* 1938. (*Compton photo*)

A letter from J. T. Robson of Ferro Enamel Corporation's Allied Engineering Division, written on December 12, 1941, answered Moody's queries regarding tunnel kilns. Robson indicated:

At the present time, we can obtain most of the materials for continuous kilns without priority, and practically all materials for small periodic kilns. The only material which we have difficulty in obtaining without a priority are the fans and pyrometric equipment.[16]

Robson recommended that Moody consider purchasing a small twenty-foot diameter continuous kiln owned by Haeger Potteries, Inc., of Dundee, Illinois. The circular muffle kiln was built for the Haeger Pottery Exhibit at the 1934 World's Fair. Moody, writing on December 16, 1941, expressed interest in the Haeger kiln. Explained Moody, "The need for a kiln is still in the planning stage but these plans should come to a head in the next 30 to 60 days. I wanted the information so I could determine whether or not to go ahead with my plans."[17] Soon after that, Moody was in North Carolina laying plans for a pottery manufacturing plant.

Moody did not go South empty-handed. His typewritten fourteen-page "Proposal [for a] White Ware Industry for North Carolina" gave potential investors a clear view of Moody's vision for the proposed business. His opening summary of the plan begins this way:

It is proposed to establish the whiteware industry in North Carolina for the production of quality china art ware, lamp bases, and kindred items. This industry, in the production of quality ware, will avail itself of the valuable resources of the mountain section of the state. These minerals—Feldspar, Kaolin and Flint, the basic materials needed, are found and mined in abundance. The only other basic material required for the production of fine china is Ball Clay, which comes from nearby Tennessee.[18]

The proposal describes equipment requirements, operational costs, facilities needed, organizational plans, market potential, and the anticipated financial return to investors.

On March 3, 1942, Moody met with Morganton, North Carolina, business leaders to propose locating his pottery factory there.[19] Despite Moody's well-laid plans and encouraging support from a Piedmont North Carolina town's business community, his dream for opening a pottery manufacturing plant failed to materialize. A newly imposed war-time regulation prohibiting new manufacturing's fuel oil use in its processes ruined his hopes.

Soon after that, a disheartened Less Moody received a call from New York inviting him to manage San Antonio, Texas's San José Potteries. At that time, Michaelian and Kohlberg Company of New York owned San José Potteries.[20] Lynn Moody Igoe describes the San José Potteries as her parents found it:

San Jose was a small operation, similar in size to Love Field Pottery in Dallas. The building was located near San Jose Mission, from which it derived its name. The ware made at San Jose was simple—plates, bowls, pitchers, small pots, jars, vases, and small figurines. Designs were traced on the pieces by hand and the spaces between the line drawings were spread with glaze colors from squeegee tubes, a different tube for each color of glaze. The body was a buff clay of poor quality and it was difficult to improve it to any degree. However, by the time Moody left San Jose, he had improved the ware to the point that the body would not pox the glaze with dent marks in the firing, as had been the case when he went to San Jose. Frances reworked the decorative designs on plates, bowls, and tiles for improved design and better production.[21]

After spending fifteen months in San Antonio, Moody received an invitation from Sperti, Inc.'s Ralph Lostro to manage Cincinnati's revered Rookwood Pottery.[22] Moody enthusiastically announced the news to his wife by telegram from Cincinnati on July 12, 1943.

START PACKING HAVE VERY GOOD DEAL TOUGH PROBLEM BUT BRIGHT FUTURE WITH WONDERFUL ORGANIZATION AM WRITING M AND K AT ONCE STAYING OVER UNTIL WEDNESDAY NIGHT TO GET PROGRAM STARTED WILL BE IN FRIDAY MORNING WILL WIRE TIME OF ARRIVAL THURSDAY LOVE TO ALL[23]

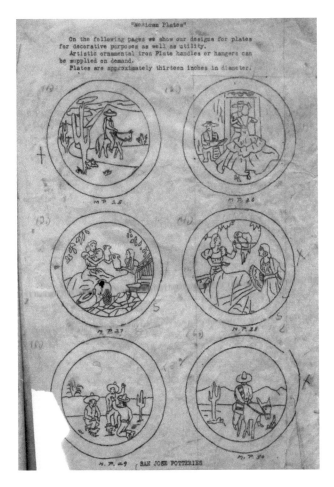

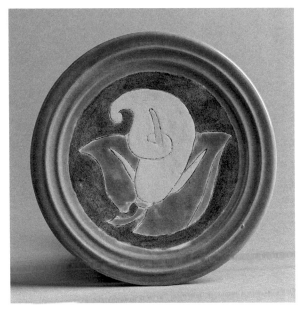

◄ **Fig. 1.7** Catalog page showing 13-inch plate designs for "decorative purposes" or "utility" from San José Potteries, San Antonio, Texas. For about fifteen months in 1942–1943, Less Moody managed the small pottery operation for the Michaelian and Kohlberg Company of New York. (*Hickory Landmarks Society*)

► **Fig. 1.8** Plate in the calla lily pattern from San José Potteries. Perhaps the company's most recognizable design, the calla lily pattern may have been created during Less Moody's term as the operation's manager. (*Stephanie Turner Photography*)

So, once again, the Moodys were off to a new home and a new challenge. Moody remained at Rookwood Pottery from 1943 to 1945.

Arthur E. Baggs, Moody's Ohio State University mentor and friend, recommended him for the Rookwood Pottery position. Rookwood technical advisor, Charles B. Hoffmann, was enthusiastic on July 3, 1943, when encouraging Moody to consider taking on the job as the shop's general manager:

> Dear Mr. Moody:
>
> I have just received a letter from Prof. Arthur E. Baggs of Ohio State University recommending you for a position that we have open at the Rookwood Pottery in Cincinnati.
>
> Sperti, Inc. has recently taken over Rookwood Pottery and is endeavoring to bring it back as an outstanding pottery, producing work of high artistic value along modern lines.
>
> We are expecting to employ some new artists and technicians, and will, at the same time, require the services of a first-class ceramic engineer. From Prof. Baggs' recommendation, we feel that you would be qualified to handle this work for us.
>
> Hoping to hear from you within the very near future, I am,
>
> Very truly yours,
>
> Chas. B. Hoffmann
>
> SPERTI, Inc.[24]

These were war years, and Rookwood's best production period had passed. In 1942, Dr. George Sperti purchased Rookwood Pottery from the *Institutum Divi Thomae*, a non-profit cancer research group co-founded by him and the Archdiocese of

Cincinnati.[25] When Sperti, Inc. hired Moody to revitalize the operation in 1943, the company made Rookwood Pottery in limited quantities.

David Rago, a specialist in twentieth-century decorative arts and furnishings, describes Rookwood's predicament this way:

Only after World War II, when the Rookwood Pottery—and factory-produced art pottery in general—seemed an anachronism, did production standards fall noticeably. By this time their diminishing band of artists were in their dotage and their innovative work was a thing of the past. Designs were often repeated, and old ideas were dredged up at the expense of creating new ones. The company trudged on until 1960 but, for all intents and purposes, Rookwood was finished by the time of World War II.[26]

Lynn Moody Igoe says that her father knew that his task was to rescue a declining pottery operation:

Unfortunately, too many things had already taken place at Rookwood, which sapped its vitality to the point where a return to former full production of creative artware was only a remote possibility. Part of the plant was being used as business offices by the Sperti Company, the parent company at that time, and other sections of the physical plant were in use as a research laboratory for Sperti products. Most of the artists' studios were still available and many of the artists were still producing one-of-a-kind creations, but at that time it was impossible to pay the artists what they were worth, and they could not be expected to stay on under those circumstances. The months spent at Rookwood were rewarding to a degree, but also frustrating. They were rewarding to Moody in the overseeing of the operations at Rookwood and the association with the skilled craftspeople and designers; frustrating in that the control of the operations was not put fully into his hands and, therefore, he was unable to implement plans for restoring Rookwood to full vitality of production.[27]

Another writer described the Rookwood situation this way:

It is known that [Moody] was frustrated in more than one attempt to introduce fresh ideas. Rookwood had experienced many shifts in ownership and management in a relatively short time. Still, it retained many longstanding employees, some in positions of authority. A natural resistance to change on the part of some of the "oldtimers" unquestionably contributed to the problems facing Rookwood in those very trying times.[28]

Rookwood Pottery expert Riley Humler says, "They needed a tunnel kiln and didn't have the money or desire to build one. Rookwood was a proud company with a history of making amazing one-of-a-kind ceramics and really didn't want to mass produce [pottery]."[29] Regardless, Moody had some success in Cincinnati. A salesman from the time said that orders outpaced Rookwood's ability to supply products.

Following his mid-year 1943 arrival, Moody quickly set out to find ways to improve Rookwood Pottery sales and profits. In November 1943, C. E. Waltman and Associates delivered a ceramic research report to Rookwood Pottery.[30] The information encompassed reviews of ceramic wares sold by various department stores, including Marshall Fields, Mandel Brothers, Carson's, and The Fair. The report presented observations, recommendations, and sketches of items that appeared in store displays in each instance. Rich with ideas, the report included suggestions like, make "simple shapes along Chinese and modern" lines, especially since modern styling "will be big with all the young people setting up homes after the war." Moreover, the study concludes that Early American designs, bright colors, and California crackleware are increasingly in demand. This report perhaps had little impact on Rookwood Pottery's output. The Waltman study undoubtedly filled Moody's head with vital information for product designs, which became apparent when he formulated his plan for Hyalyn Porcelain, Inc.

Before leaving Rookwood Pottery in 1945, Less Moody and Sperti's Ralph Lostro engaged Stockton West Burkhart, Inc., a Cincinnati advertising agency, to devise a 1945 promotional plan aimed at boosting Rookwood Pottery sales.[31] The plan called for two-week-long Rookwood Pottery exhibits to be shown in leading department stores. Rookwood Pottery items, ranging in retail value from $50 to $3,000, would be offered on consignment to select stores. As exhibited things sold,

they were replaced with others of comparable value before the exhibit was moved to another store. Store sales staff were to be paid a 5 percent commission on all Rookwood pottery they sold. These commissions were to be paid directly to sales staff to ensure that the store did not keep the money as an added discount. A vast range of advertising was recommended to entice buyers to visit the hosting department store while the Rookwood Pottery exhibit was displayed. Though brief, Moody's Rookwood Pottery employment and the benefits he gained from insightful studies and promotional schemes, like this one, paid for by Sperti, Inc., undoubtedly influenced how he approached product design decisions and advertising.

Moody took more than those things away from Rookwood Pottery when he engaged one of its artists to design some of Hyalyn Porcelain's first wares. In the fall of 1947, Wilhemine Rehm, "one of Cincinnati's foremost ceramists," accepted Hyalyn Porcelain, Inc.'s position as its designer. Rehm designed and decorated Rookwood Pottery, and Moody became acquainted with her while he was Rookwood's manager.[32]

At the end of World War II, Moody again hoped that he could start a North Carolina pottery. He failed to gain financial backing in Winston-Salem, North Carolina, where he sought support for his plan in the spring of 1945. Moody says that "I got the impression that Winston-Salem did not want a small $200,000 industry;

THE ENQUIRER, CINCINNATI,

New Crystal Glaze Described As Rookwood's Masterpiece

These vases are samples of the new type of glaze produced this year at Rookwood Pottery on Mount Adams. This art creation was presented to the public at the pottery's sixty-third birthday celebration last Saurday.

Fig. 1.9 In July 1943, company owners invited Less Moody to manage Cincinnati's famed Rookwood Pottery when the operation was in decline. A celebration of its sixty-third anniversary, the release of a touted "masterpiece glaze" and Moody's attempts to bring innovation to the shop's methods of production were not enough to stem the tide. In 1945, Moody left Cincinnati for North Carolina with plans to establish Hyalyn Porcelain, Inc. From *The Enquirer* (Cincinnati, Ohio), December 2, 1943. (*Newspapers.com*)

if I had been talking in terms of $500,000 and wanted one and a half million more—that would have been more attractive."[33] Moody soon found support in the city of Hickory. The community's chamber of commerce was keenly interested in his ideas, and the group's leaders promoted Moody's plan to local business leaders. This action led to Hyalyn Porcelain, Inc., a company whose stock was soon fully subscribed, almost entirely by local investors. Moody was named the firm's general manager. Nearly two decades after first working a summer job at Zanesville's Mosaic Tile Company, Moody's dream for operating his pottery was within reach.

No doubt, Moody's work before moving to North Carolina prepared him thoroughly for the task of organizing and operating Hyalyn Porcelain, Inc. From Mosaic Tile Company, Ohio State University's ceramics department, Love Field Pottery, Abingdon Pottery, San José Potteries, and Rookwood Pottery, he gained expertise in clay formulation, glaze chemistry, product design, plant operation, project planning, advertising, employee management, and so much more. Perhaps no one was better prepared than Moody to achieve the aims set out in his proposal for whiteware manufacture in North Carolina.

Prestigious organizations acknowledged Less Moody's lifetime contributions to the ceramic arts field. In 1961, he was elected chairman of the American Ceramic Society's Design Division after previously acting as the division's vice chairman.[34] In May 1963, the Society made Moody a Fellow for his involvement in ceramic design and technology.[35] His nomination for the honor was made by F. J. VonTury of Vontury, Inc., Perth Amboy, New Jersey, who in a letter to Moody said:

I am happy to take these steps to recommend that you become a Fellow in the Society. Your interest and activities in the Design Division have qualified you for this honor which in my opinion is already overdue.[36]

A relatively young man when his life ended at age sixty-five, Less Moody died in Hickory, North Carolina, on November 16, 1973.[37] Hamilton Cosco of Columbus, Indiana, purchased Hyalyn Porcelain, Inc. in October 1973, just weeks before Moody's death. Hamilton Cosco renamed the company Hyalyn Cosco, Inc.

FRANCES GOLDRICK JOHNSON MOODY

Like Less Moody, the young Frances Goldrick Johnson had a penchant for art and design. Her talents as an artist and sculptor contributed to the Moodys' success in the field of mass-produced pottery and porcelain manufacture.

Frances Johnson was born to Harry Mason Johnson and Lillian White Goldrick Johnson in Indianapolis, Indiana, on April 6, 1905. Harry Johnson died in 1926. In 1930, Lillian Johnson and four daughters, including Frances, resided in Bexley Village, near Columbus, Ohio. At the time, Frances worked as an art instructor at Ohio State University.[38]

Johnson spent her first college year (1922–1923) at Indiana University before attending Ohio State University. Ohio State University awarded her a Bachelor of Arts degree in 1926 and a Master of Arts degree in 1929.[39] She titled her thesis, "An Explanation of the Production of a Sculpture Group 'Diana' Together with a Brief Historical Survey of Sculpture."[40] Moody used some of her Ohio State University sculptures as prototypes for Abingdon Pottery forms.

Johnson studied sculpture at Ohio State University with Bruce Saville, who headed the school's sculpture department, and with Erwin F. Frey, who, after working for Rookwood Pottery, became an Ohio State University professor and sculptor-in-residence. Her studies included a year with Edward McCartan at New York's Art Students League and a European art studies tour. Johnson taught sculpture at Ohio State University as an assistant instructor before and after receiving the MA degree. During 1931 and 1932 summer sessions, she taught design, life drawing, and sculpture at New Jersey's Rutgers University.[41]

In the 1920s–1930s, Frances Johnson frequently entered juried exhibitions sponsored by the Columbus Art League. Her exhibited sculptures included *Garden Figure*, *Night*, *Diana*, *Javanese Dancer*, *Young African*, *Deer*, *Seated Nude*, *Slave Girl*, *Decorative Head*, and *Portrait*.[42] Figures called *Night* and *Seated Nude* were among Abingdon Pottery's earliest products.[43]

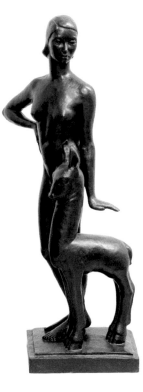

◀ **Fig. 1.10** Passport photo of Frances Goldrick Johnson Moody (1906–2000), *c*. 1926. (*Hickory Landmarks Society*)

▶ **Fig. 1.11** *Diana of the Chase*. Bronze by Frances Goldrick Johnson, 1929. Created for completion of the Master of Arts degree, Ohio State University, 1929. (*Collection of the Hickory Museum of Art, Hickory, North Carolina. Museum purchase, 1994.7. Hickory Museum of Art photo*)

Once married, the Moodys worked hand-in-hand as partners, ensuring that each of their ceramics ventures saw success. As stated earlier, Frances was helpful, "without commission," at Abingdon Pottery, where she modeled figures and objects for molding, and whenever management consulted her concerning others' ideas for new products. With designer Hertslet dead and Less Moody busied by all manner of things, Frances Moody contributed significantly to Abingdon's earliest ware lines. She designed at least four cookie jars for Abingdon, including *Hippo* and *Little Old Lady*, *Geisha* and *Coolie* tea tiles, upright and leaning goose figures, several sets of bookends, chess pieces (a carry-over from her Ohio State University days), and figurines, including *Scarf Dancer*, *Shepherdess and Fawn*, *Fruit Girl*, *Little Dutch Boy*, *Little Dutch Girl*, wall pockets, and in 1940, politically-inspired figures featuring elephants and donkeys.

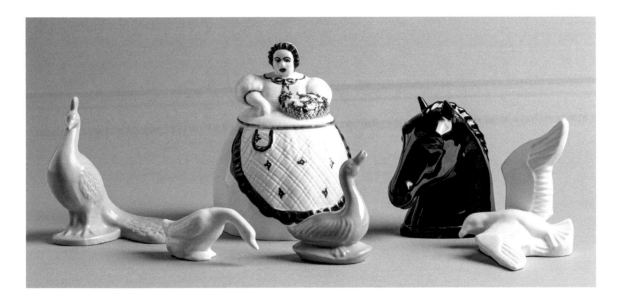

▲ **Fig. 1.12** Some things created by Frances Moody for Abingdon Pottery. (L–R) *Peacock* (No. 416; 1937); *Leaning Goose* (No. 99; *c*. 1942); *Little Ol' Lady* cookie jar (No. 471; 1939); *Upright Goose* (No. 571; 1942); *Horsehead* bookend (No. 441; 1938); and *Seagull* (No. 305; 1934). (*Stephanie Turner Photography*)

▼ **Fig. 1.13** Abingdon Pottery figures created by Frances Moody. (L–R) *Seated Nude* (No. 3903; 1935); *Nescia* (No. 3901; 1935); and *Scarf Dancer* (No. 3902; 1935). *Seated Nude*, along with many Frances Moody designs, were entered in Columbus Art League juried exhibitions. (*Hickory Landmarks Society*)

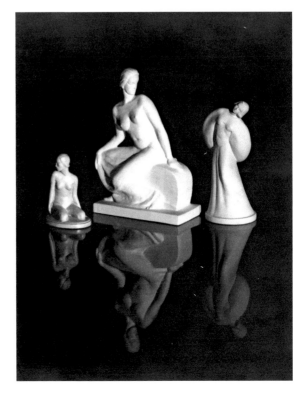

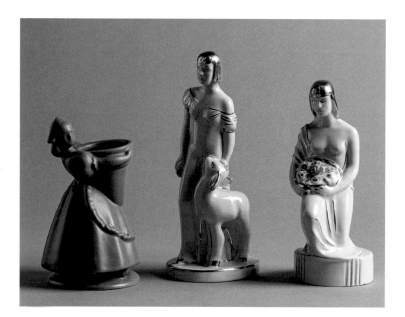
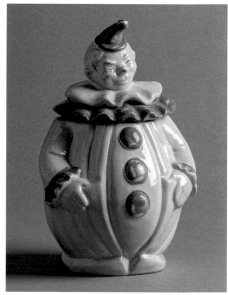

◄ **Fig. 1.14** Frances Moody derived Abingdon Pottery's *Shepherdess and Fawn* (center, No. 3906; 1937) from her *Diana of the Chase* (see Fig. 1.11). Other Abingdon figures by Moody include *Dutch Girl* (No. 470; 1939) and *Fruit Girl* (No. 3904; 1937). (*Stephanie Turner Photography*)

► **Fig. 1.15** While Less Moody managed San José Potteries, Frances Moody created two cookie jars for the company called *Cinderella* (or *Southern Belle*) and *Clown* (seen here). Both bear a copyright mark and the name Pan American Art. Colors are cold-painted over the glaze. (*Stephanie Turner Photography*)

Frances Moody improved some San José Potteries designs previously applied to the shop's plates, bowls, and tiles.[44] She gets credit for two cookie jars made for San José Potteries' Pan American Art division. One, referred to as *Cinderella* (or *Southern Belle*), was produced alongside one shaped like a rotund clown. Each one is identified by a base mark reading "© Pan American Art." If colored, cookie jar highlights, like aprons, hats, collars, and buttons, are cold painted, not glazed.[45]

If any, Frances Moody's hands-on role during the couple's brief stay at Rookwood Pottery is unknown. Her counsel and support were undoubtedly valued by her husband when he considered how to restore Rookwood Pottery to its prominent role as a national leader in art pottery production.

Both Less and Frances Moody designed some of Hyalyn Porcelain, Inc.'s first products. Through the years, Frances contributed vase designs and numerous sculptural pieces, including *Beauty Queen* (SP-42; No. 107), made in 1962 and given to each Miss America Pageant contestant. She created *Madonna and Child* (No. H10), *Angel* candlestick (No. H11), *Horsehead* (No. 100), *Egyptian Princess* (No. 101), *Owl* (No. 102), *African Head* (No. 103), *Peasant Girl* (No. 104), *Seagull* (No. 105), *Polynesian* (No. 106), *Haru* (No. 108), *Kiku* (No. 109), and *Yako* (No. 110). Some pieces, when paired and weighted, functioned as bookends. The three sculpted Japanese geishas (*Haru*, *Kiku*, and *Yako*) were promoted as "perfect alone or charming with floral arrangements."

The full extent of Frances Moody's role in lamp base design is unknown, but it may have been considerable. Writing to lamp base customer Morris Greenspan in 1972, Less Moody describes how Frances Moody sculpted lamp bases at home:

We have pulled out the model of the HL62 as well as the model on the MG23. We have drawn on the cross hatched pattern and now I must [ask] my wife to do the modelling. She says she can give it more time if I take the model home. [I'll] take it to the house so she can work on it in her studio an hour or so at a time.

I won't make any promises but I do hope that she can finish up the modeling in the next couple of weeks by working at odd times. I assure you that we'll get it blocked as soon as the modeling is completed.[46]

A Lasting Legacy

Dying in Chapel Hill, North Carolina, on January 16, 2000, at age ninety-five, Frances long outlived Less. To honor his life, she contributed a collection of American art pottery assembled by them to the Hickory Museum of Art. The collection includes examples from Rookwood Pottery (including examples by Kataro Shirayamadani and E. T. Hurley), Catalina Pottery, Van Briggle Pottery, Tiffany Pottery, Weller Pottery, and Roseville Pottery.[47]

The make-up of this collection shows that the Moodys understood and admired the work of great American ceramic artists. Less Moody knew the importance of Rookwood Pottery when he went there to bring life back to it—what a daunting responsibility. Yet he excitedly accepted the challenge. The Moodys' teachers and mentors, including Arthur Baggs, Erwin Frey, Bruce Saville, and Edward McCartan (to name a few) prepared them for success. Just a young couple when they moved to Cincinnati, their futures as artists and ceramists held many possibilities.

Yet when Less and Frances Moody finally got their chance to give shape and purpose to their own pottery, they did not set out to make it the next Rookwood, Marblehead, Teco, or Grueby pottery. Their dream for Hyalyn Porcelain was clear—to mass-produce quality artware, beautifully designed and manufactured, at an affordable price. Over time, Hyalyn Porcelain associated with some of the finest mid-twentieth-century designers, including Eva Zeisel, Michael Lax, Herbert Cohen, Georges Briard, Erwin Kalla, and Charles Leslie Fordyce. The Moodys' wished-for dream, shaped by the words "style" and "quality," came true when they saw ware designed by these all-stars and manufactured by Hyalyn Porcelain in shops and homes across America.

2

HYALYN PORCELAIN, INC.
(1945–1973)

Less Moody demonstrated how determined he was to open a pottery factory when, in December 1941, at the beginning of U.S. involvement in World War II, he penned letters to Ohio-based machinery suppliers from Abingdon, Illinois. The equipment he sought made it clear that he had in mind a factory, like Abingdon Pottery, capable of mass-production. Frances Moody was clear about it when she said, "We did not want a two-man shop but a large pottery with large production capacity."[1] Although he considered purchasing Haeger Pottery's small circular muffle kiln for his startup, Moody stated that he intended to employ much larger tunnel kilns like those he used at Abingdon Pottery.

Moody's Abingdon Pottery experience unquestionably helped shape his ideas about the market for quality, affordable artware. His 1942 proposal defined the market, as Moody perceived it then:

The plan is to start manufacturing art ware, which consists of vases, bowls, bookends, console sets, and like items, and lamp bases. These items are to be produced in vitreous china body in plain colors.

The line should be developed for the middle price market, for there are few manufacturers in this field, and they are all relatively small operators. The market for quality ware is growing due to increased incomes and increased standard of living, plus the fact that china imports from Germany, Czechoslovakia, France, and Japan have been eliminated for some time to come. [Up to 3 years ago 60% of china art ware and lamp bases sold in this country were imported from the above countries].

At the present time, manufacturers in this field are unable to supply the demand for quality ware.

The lamp base market is greatly improved since metal used for lamps has been reduced by government order. This will call for more table lamps and in order to keep up their dollar volume, the lamp manufacturers are developing the better quality field. This definitely promotes the demand for china lamp bases.

Florists are always a good outlet for vases and flower containers and the trend among florists is for better quality merchandise. Florist lines will be sold through florist jobbers.

The plan of production is for the start to be made with the lamp manufacturers for this is a ready and open market and the writer has some excellent contacts in this connection. At the same time a small line of art ware will be developed for the "importer" and decorator trade.

As the business expands and the workmen become better trained for their jobs, the lines will be expanded into other markets mentioned above.[2]

With essential questions answered, and a prospectus describing his proposed enterprise in hand, Moody headed to North Carolina in early 1942 to pitch his plan to potential investors. A previous visit to the state convinced him that it was an ideal location for a manufacturing plant. Raw materials like kaolin, flint (quartz), and feldspar were abundant in western North Carolina's Spruce Pine mineral district, and ball clay was mined in eastern Tennessee. The area's mild climate and plentiful

workforce added to the region's appeal. Known as the "Good Roads State," North Carolina was adequately prepared for transporting goods to all parts of the nation.

Moody's proposal first gained interest among Morganton, North Carolina business leaders. Located near the Appalachian Mountains in the westernmost part of the state's Piedmont Region, Morganton was well-suited for the factory. When World War II put an end to his plans to build his factory, Moody refused to give up. When the war ended, he again traveled to North Carolina in 1945 with Ohio State University's Arthur Baggs to find the right place and willing investors for his venture.[3] Morganton leaders' interests waned during the war. Then, after being rebuffed by Winston-Salem, North Carolina leaders, he was encouraged by Duke Power Company's John W. Fox to present his ideas to Hickory, North Carolina's chamber of commerce.[4] There, Moody's proposal received an enthusiastic response.

Hyalyn Porcelain, Inc. was chartered by the state of North Carolina on July 23, 1945, with Hickory's Lester Clark Gifford, Walker Lyerly, Sr., and Kenneth Campbell Menzies as incorporators. Stockholders first met on September 12, 1945. Lee P. Frans was made president, Walker Lyerly, Sr., became vice-president, and Less Moody was named secretary-treasurer and general manager for the business. To raise $500,000, the corporation issued 4,000 shares of $100 par value common stock and 1,000 shares of par value preferred stock.[5] Catawba County, North Carolina, residents purchased ninety-percent of the stock.

Hyalyn's name came from "hyaline," meaning "having a glassy or translucent appearance." True to the company's name, some of Hyalyn Porcelain, Inc.'s earliest ware bears a lustrous, translucent glaze, including examples with hand-painted underglaze decoration. The Moodys may have come up with the name while Less Moody worked for Cincinnati's Rookwood Pottery.[6] According to Frances Moody, the spelling change from "hyaline" to "hyalyn" made the word look more artistic.[7] Walker Lyerly, the company's first vice-president, owned Hickory's Hy-lan Furniture Co., a bedroom and dining room furniture maker.[8] This fact, too, may have influenced the spelling.

◄ Fig. 2.1 Less Moody's sketched concept for a Hyalyn Porcelain logotype, c. 1945–1946. Typically, when spelled-out in advertising and when used for marking the company's products, the word "hyalyn" begins with a lowercase letter "h." (*Hickory Landmarks Society*)

► Fig. 2.2 Hyalyn Porcelain, Inc., used this shield mark in early advertising and to mark some of the company's first products produced in 1946–1947. Original proof, c. 1946. (*Hickory Landmarks Society*)

With investors on board and capital raised, the company purchased a seven-acre site in Hickory. The property was located on the Carolina and North Western Railway, midway between the Piedmont Gas Company plant and the railroad's shops.[9] Less Moody designed a 28,000-sq. foot factory building that included a partial basement. In November 1945, Hyalyn Porcelain, Inc. contracted with Elliott Building Company to construct the facility.[10] Once built, Moody set about equipping it for porcelain artware and lamp base production. An account in the June 6, 1950, edition of *Retailing Daily* describes an addition to the factory building and the assembly of a second tunnel kiln that allowed the company to double the amount of porcelain produced. By 1961, multiple additions were made to Moody's original plan, bringing the plant's total area up to about 60,000 square feet.[11]

Hyalyn Porcelain, Inc.'s tunnel kiln burned propane gas stored in a large on-site tank. The first propane purchase occurred on September 18, 1946, followed by a second on November 25. Since natural gas was not available, propane was Hyalyn's required fuel. Workers started the plant's tunnel kiln on November 1, 1946, and limited porcelain production began on January 1, 1947. According to a December 30, 1946, news article, Hyalyn Porcelain, Inc. first produced "a fine porcelain lamp base" while its line of art ware was in development.[12] By May 1, 1947, Hyalyn Porcelain, Inc.'s first line of ware went on the market.[13]

Hyalyn Porcelain, Inc.'s first tunnel kiln probably came from Columbus, Ohio's Harrop Ceramic Service Company. Harrop engineer Joe Caughlin and George D. Brush, a civil engineer who became Harrop's president following Carl B. Harrop's death in 1934, are named in kiln startup records.[14] Carl Harrop taught ceramic engineering at Ohio State University. He patented a new type of continuous car tunnel kiln in 1918. Moody employed a 400-foot-long oil-fired Harrop kiln at Abingdon when the company's artware division opened in 1934. In 1939, Abingdon Pottery added a 135-foot-long Swindell-Dressler indirect-fired muffle kiln.[15] Hyalyn Porcelain, Inc. installed a second tunnel kiln in 1950.[16]

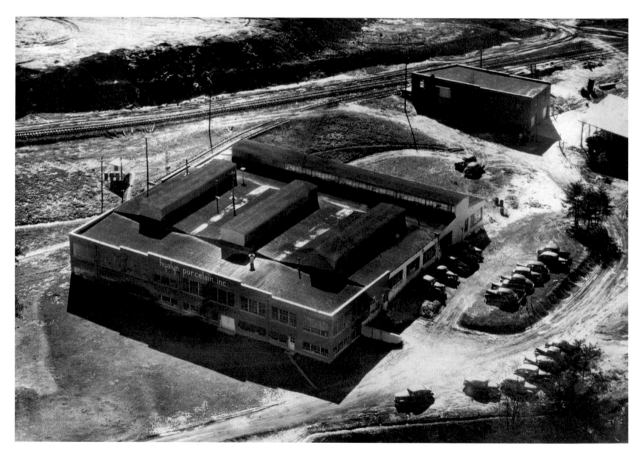

Fig. 2.3 Less Moody's architectural training aided in the design of Hyalyn Porcelain, Inc.'s first facility. The modern clerestory-lighted and ventilated space consisted of 28,000 square feet of floor space and a partial basement below. Image by Air Photos Associates, Inc., Plainville, Connecticut. (*Hickory Landmarks Society*)

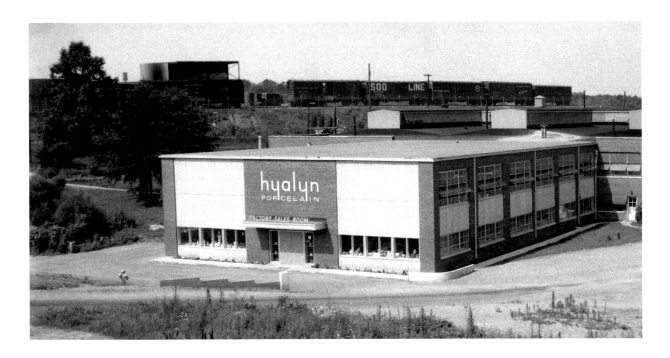

▲ **Fig. 2.4** Hyalyn Porcelain Inc.'s early success, including lamp base and artware production, led to the expansion of its first facility. The *c.* 1950 addition seen above included a second tunnel kiln and a factory salesroom. (*Hickory Landmarks Society*)

▼ **Fig. 2.5** On November 1, 1946, Less Moody and Edgar Littlefield started up Hyalyn's tunnel kiln for the first time. Their notes show that initial challenges included smoky and underfired ware, broken muffle plates, and the effects of changes in the weather. Soon, however, quality ware regularly emerged from the kiln. (*Historical Association of Catawba County*)

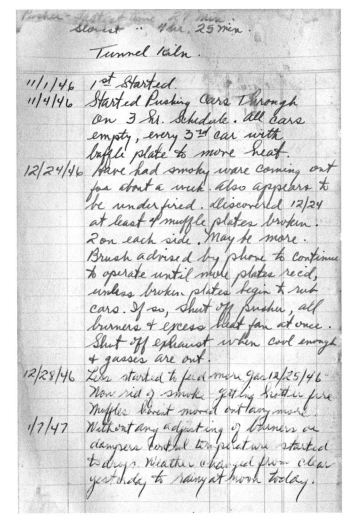

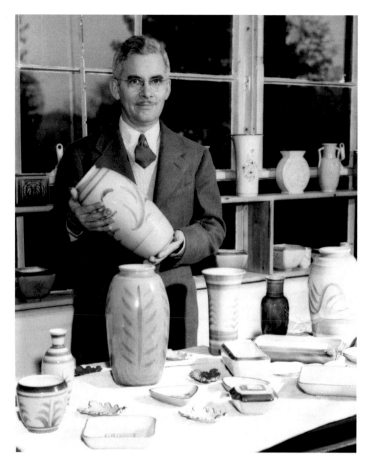

Fig. 2.6 By early 1948, Hyalyn Porcelain, Inc., produced dozens of quality artware items, including examples like the ones seen here proudly displayed by Less Moody. Rookwood's Wilhelmine Rehm and Ohio State University's Edgar Littlefield likely designed the objects seen here. Image originally published by the *Journal and Sentinel* (Winston-Salem, NC), January 4, 1948, p. 1D. Frank Jones photo. (*Hickory Landmarks Society*)

For a time, broken muffle plates, smoky and underfired ware, and combustion chamber cracks plagued the kiln's operation. Just when all seemed ready for production, records show that on August 17, 1947, there was a "Wreck in kiln—4 cars torn up. Fires out." Fortunately, the event did not damage the kiln, and test runs continued.

On August 22, 1947, workers raised the kiln temperature to 2,020˚F with no concerns about the kiln's performance.[17] On January 14, 1948, Less Moody reported to Hyalyn Porcelain, Inc.'s stockholders and directors about the mechanical problems encountered in 1947. Speaking optimistically about the plant's future, he stated his belief that the costly delays and handicaps experienced in 1947 had been overcome, with the way cleared for "a period of uninterrupted progress toward profitable operation."[18]

Hyalyn president, Lee Frans, shared Moody's optimism, saying:

During the past three months I have had an opportunity to meet and visit with some of the lamp manufacturers who are using Hyalyn lamp bases. They have been most enthusiastic about Hyalyn quality and the future for Hyalyn as their supplier.

I have also had an opportunity to visit with Chicago and New York representatives who handle the sale of the art-ware line in those respective territories. They are highly enthusiastic about sales and feel certain that many new accounts will be opened.[19]

According to Frans, Hyalyn Porcelain, Inc. maintained permanent displays in New York, Chicago, Los Angeles, and Dallas buying centers. As many as twenty manufacturers' agents were deployed as "road salesmen."[20]

Frans went on to say to stockholders:

I have followed the development of this company very closely and realize that the record for the past year with the great loss incurred is everything but good, but I'm sure that all of you realize that any new company starting from scratch, where you have no experienced labor, is bound to be confronted with problems to be worked out, and it takes time for it to get on its feet. I don't want to seem too optimistic, but I assure you that if you just bear with us we will work out of our difficulty satisfactorily and develop an industry in Hickory that we will not only be proud of, but find to be profitable.[21]

The project's leaders' enthusiasm was warranted since, by early 1948, the plant was fully functional with equipment valued at nearly $62,000. Items inventoried at the time included the following:

List of Major Items of Equipment & Machinery[22]

(1) No. 4 Jar Mill
(3) No. 7 Pebble Mills
(1) Type #20 Rotoclone
(1) Jar Roller Mill
(2) Ceiling Agitators
(1) Mould Maker's Jolly
(7) Toledo Scales
(1) Rotospray
(1) Ferro Filter
(1) Muffle Tunnel Kiln [valued at $19,433]
(1) Propane Storage Tank
(1) Gas Compressor
(1) Gas Fired Test Kiln
(32) Bench Whirlers
(2) Portable Agitators
(1) Large Slip Pump
(1) Glaze Pump
(1) Gardner Grinder
(1) Elevator

(1) Spraying Equipment
(2) Slip agitators
(2) Slip tanks
(1) Air Compressor, Complete Unit
(1) Large Rotospray
(1) Ferro Filter, small
(1) Steel Shelving
(1) Ball Clay Washer
(1 lot) Desks, Tables, Chairs
(4) File Cabinets
(3) Ediphone Dictating Machines
(1) Adding Machine—Victor
(1) Adding Machine—Clary
(1) Typewriter—Electromatic
(1) Typewriter—Royal
(1) Decorating Kiln
(1) Paper Shredder [for making packing material]
(40) Ware trucks

When they moved to North Carolina, both Moodys were seasoned designers, which was a profitable advantage to the development of product lines. Of Hyalyn Porcelain, Inc., Moody once said that "this business is primarily design."[23] One of the first Hyalyn Porcelain, Inc. employees added was the skilled ceramic artist and ceramic engineer Edgar Littlefield. In May 1947, Charlotte, North Carolina's Mint Museum displayed some of Hyalyn's first porcelain ware. Edgar Littlefield designed most of the exhibited pieces. The museum's director, Joseph S. Hutchinson, said that Hyalyn's objective was "to adapt the ideal of the studio potter to mass production methods, not with the idea of faking hand-made ware, but rather in the belief that fine pottery can be made by commercial processes."[24]

Hyalyn Porcelain, Inc. needed mold makers, kiln operators, and other skilled laborers to manufacture well-designed, mass-produced ware. In August 1946, Moody advertised in Zanesville, Ohio's *Times Recorder* newspaper seeking an "experienced pottery mould maker-modeler."[25] With the plant in full production in 1948, Moody advertised in Zanesville and East Liverpool, Ohio, newspapers for experienced casters "for quality line of artware and lamps." His appeal to workers was enticing: "New plant, good working conditions, good wages. Ideal climate in western North Carolina."[26]

Moody assembled an initial team of six skilled pottery workers. By late 1947, Hyalyn Porcelain, Inc. employed nearly forty people.[27] Some former Abingdon Pottery employees joined Hyalyn's early workforce, including Marvin L. "Bud" Crumbaker, who came from there and became the plant's first superintendent. A skilled Ohio pottery worker named Benjamin Crews, Jr., managed Hyalyn Porcelain, Inc.'s decorating department. Other early Hyalyn Porcelain, Inc. employees

were Clyde Fox (supervisor, mold shop), Grady Hodges (glazer), Fred Mingus (glazer), Everette Fulbright (mold maker), Lentferd W. Brittain (foreman, shipping), Emma Louise Cilley (decorator), Fred Huffman (foreman), James Hal Wilson (accountant), Zana Wilson (stenographer), Dale Hedrick, Sr., (glazer), Gwen Crews (decorator), and Maurice Todd.

Within two years from its 1945 incorporation to the release of its first line of porcelain ware in 1947, Less Moody sufficiently prepared Hyalyn Porcelain, Inc. to compete with established pottery manufacturers. The capital was raised; the land was purchased; a factory building was constructed and equipped; employees were hired; products were designed and manufactured, and sales began. Yet essential questions remained for Moody and Hyalyn Porcelain, Inc.'s investors. Would Hyalyn Porcelain, Inc.'s first products sell, and was there a profit to be made?

CAROLINA CHINA

Less Moody may have been more concerned about whether or not he would remain Hyalyn Porcelain, Inc.'s general manager. Disagreements with new managers led to his departure from Abingdon Pottery. Could similar unhappiness lead to his exodus from Hyalyn Porcelain, Inc.?

Moody's surviving Hyalyn-related papers include references to a puzzling plan for a business called Carolina China. Moody's notes include sketched ideas for a Carolina China logotype, as well as drawings for a relatively small, fully-functioning porcelain-manufacturing facility bearing the same name. The shop was designed to be situated by a rail siding and included defined spaces for clay working and storage, plaster and mold storage, casting, glaze preparation and spraying, and a kiln. The logotype sketches are drawn on Hyalyn Porcelain, Inc. letterhead, suggesting that the plan was on Moody's mind following Hyalyn Porcelain, Inc.'s start-up. The purpose of Moody's Carolina China scheme remains unclear. So far as is known, he never executed the plan. And history records that Moody remained in charge of Hyalyn Porcelain, Inc. from its incorporation in 1945 until its sale in 1973.

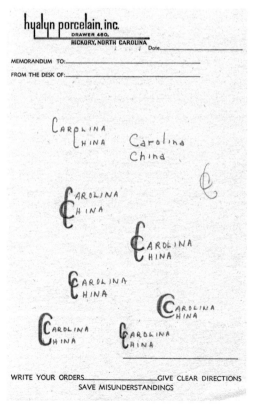

Fig. 2.7 Less Moody's surviving records hold unexplained plans for an enterprise called Carolina China Company. Since Moody sketched his logotype ideas on c. 1940s Hyalyn Porcelain, Inc., letterhead, he may have been hedging his bets against Hyalyn Porcelain's success or his role as its manager. (*Hickory Landmarks Society*)

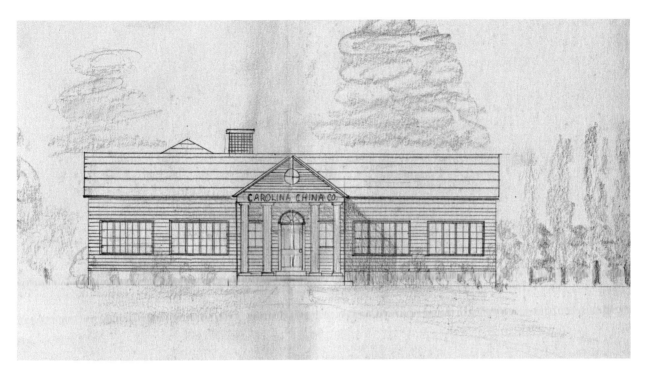

Fig. 2.8 Less Moody's scheme for the Carolina China Company included roughly drawn floor plans and elevations for a building and projections for the company's income and his salary. Moody never initiated the project. He worked as Hyalyn Porcelain, Inc.'s general manager until 1973, the year of the company's sale to Hamilton Cosco and his death. (*Hickory Landmarks Society*)

THE PROCESS AND THE PRODUCTS

Moody eagerly promoted the superiority of Hyalyn's porcelain over pottery. He encouraged his sales team to do the same to convince wholesale buyers of its benefits. "All Porcelain is Pottery," explained Moody in an early Hyalyn Porcelain catalog, "but Pottery is not Porcelain. The major difference lies in the strength and durability of the ware, itself; it is in the hardness and depth of reflection in its glaze. Too, Porcelain is vitreous [hard-fired] so that it is not porous like pottery."[28]

Moody included a detailed description of Hyalyn Porcelain, Inc.'s process for manufacturing quality porcelain ware in an early 1950s catalog.[29] His informative explanation is shared here in its entirety:

Hyalyn Porcelain is produced from SIX choice clays, and the carefully selected and process materials come from SIX different sections of the United States and Canada. The secret formula is jealously guarded.

Each material or ingredient is carefully analyzed and tested in carload lots. In preparing the batch, each material is carefully weighed and proportioned accurately before being placed in the large ball mills, to be ground to proper fineness. Water is added to the batch in the mill, so that the final result is the correctly blended "slip." Before removing the batch from the mill, it must be again tested and balanced, to meet the rigid specifications for quality production. This is one of the basic secrets of fine quality ware. All Hyalyn ware is made from this fine grain liquid clay, or "slip." And until it reaches its final form—days, or even weeks later, it is constantly in agitation.

The slip is pumped from the mill, over powerful electromagnets, which draw out any ferrous content, which would show as a blemish on the ware when fired. The slip is further refined; strained through a series of screens, each one finer than the preceding one, to eliminate any coarse, unground particles. This liquid clay then is stored in large sealed vats, where great paddles constantly revolve, keeping all particles of clay in suspension. Storage of large quantities of prepared slip is necessary, for in this condition, the clay ages for better working qualities.

From the storage tank, the slip is pumped through large pipes, into the casting shop, where the ware is produced. Here it is stored in small agitators, to serve the potters. They pour the slip into hollow plaster-of-Paris moulds. The moulds are filled to the brim, and the porous plaster absorbs sufficient water from the slip, so that a layer of clay is formed on the sides of the mould. When the required thickness has been reached, the excess slip is poured off, leaving the hollow piece. As the cast piece dries in the mould, it shrinks, so that the mould can be opened, and the piece removed. There is still considerable moisture in the clay piece, so it must remain in a very hot, dry room, until this moisture is driven off. When the clay piece is dry, the seams formed by the mould joints must be fettled off, and the piece washed, so that it will be perfectly smooth, with no blemishes. At this point, each clay piece is carefully inspected, and must be passed before moving to the next process, which is glazing. Hyalyn glaze is a glass-like film that covers the clay, giving it its final texture and color. There are many types of glazes, but all of them are blends of various sodium silicate combinations, that will melt into a glass that will fit the clay body at the firing temperature. Colors of all glazes are derived from metallic oxides. The glazes are applied to the ware by atomizing with spray guns.

Hyalyn, being a true porcelain, has the glaze applied on the clay, so that the glaze and body reach maturity together, at a high temperature for better quality and an inseparable bond. This is another of the major differences between the processes used in production of porcelain and ordinary pottery.

After the glaze has been applied oddly enough, and regardless of its final color, it has the appearance of a fine pastel colored talc, when dry on the ware, and prior to the firing. The true development of the color takes place in the firing process. Ceramic chemistry is the chemistry of combustion, for the chemical action or change takes place at the high fired temperature.

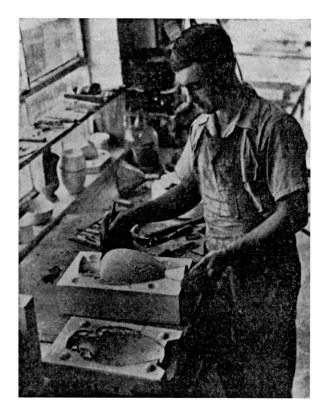 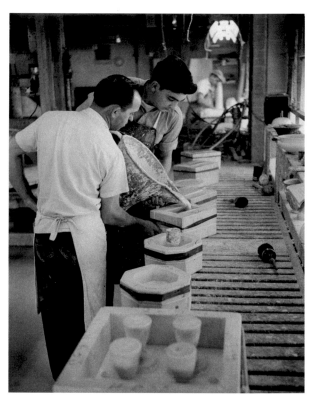

◄ **Fig. 2.9** Mold-maker, Everette Fulbright. Hyalyn Porcelain, Inc., January 1948. From the *Journal and Sentinel* (Winston-Salem, NC), January 4, 1948, p. 1D. Used by permission. (*Historical Association of Catawba County*)

▶ **Fig. 2.10** Hyalyn Porcelain, Inc., workers fill plaster molds with porcelain slip. (*MaDan Studios photo, 1957. Photographs of Hyalyn Porcelain Company, MC 00337, Special Collections Research Center, North Carolina State University Libraries, Raleigh, NC*)

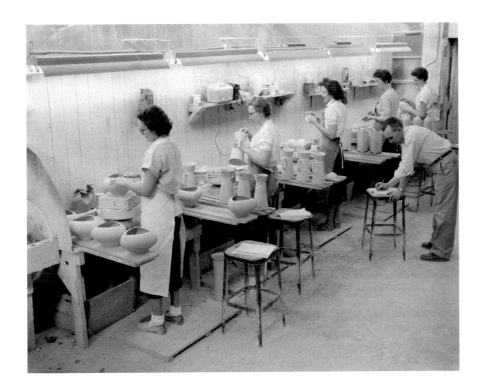

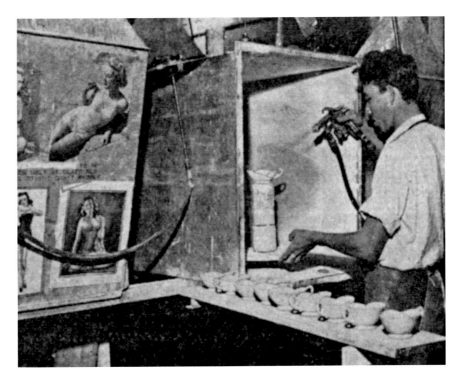

▲ **Fig. 2.11** Hyalyn Porcelain, Inc.'s finishing department workers fettle and sand unfired items. Some of the things seen here, including hanging planters, were designed by in-house designer Herbert Cohen. (*MaDan Studios photo, 1957. Photographs of Hyalyn Porcelain Company, MC 00337, Special Collections Research Center, North Carolina State University Libraries, Raleigh, NC*)

▼ **Fig. 2.12** With nearby pinups keeping him company, Fred Mingus sprays glaze onto unfired porcelain items. This newspaper photograph's seemingly tongue-in-cheek caption reads, "A study of form and line is helpful in the manufacturing of pottery." From the *Journal and Sentinel* (Winston-Salem, NC), January 4, 1948, p. 1D. Used by permission. (*Historical Association of Catawba County*)

The glaze sprayed piece is now ready for the firing treatment, which develops the hardness and color. At Hyalyn, the ware is carefully placed on cars, which roll through long muffled tunnel kilns. These cars run on a track, entering the kiln cold. They progress slowly through these long tunnels, reaching their peak temperature of 2200˚F. Rolling forward through this white hot heat, they proceed very slowly into lower temperatures; at last emerging as finished pieces, cool enough to be handled. This is a continuous process—twenty-four hours a day, seven days a week.

The fired ware as it comes from the kiln, has its hardness and color, and is again inspected. The Hyalyn "Garden Club Line" and "Pebble Grain Line" are inspected and ground —(here any small imperfections are removed thus giving each piece a perfect base)—and are then ready for shipment. Items in the "Decorative Accessory" group are sent into the Decorating department for further processing.

In the Decorating department, the picture decorations are applied by decalcomania process. Pictures are printed in ceramic colors as decals, and then are applied to the ware so that, when fired, the colors melt into the glazed surface. The bands and other decorative treatments are applied by hand, and then the completed decorated piece is again fired at 1350˚F, in electric kilns. This is also the maturing temperature for the 22-k gold used in Hyalyn decorations.

The finished decorated ware when drawn from the kiln, is again inspected, and only the best selections go to the shipping department. This fine product is now ready to provide a gracious home with a lovely accent.

By slip-casting porcelain, Moody economically created finely designed and finished products in his new Hyalyn Porcelain, Inc. plant. Moody's mentor, Arthur Baggs, instilled in him the belief that large scale, industrially manufactured products should exhibit good design. When asked what influence Charles Fergus Binns had on his work, Baggs answered:

I think he gave to all his students a deep respect for ceramics as a profession and for honest, thorough craftsmanship. Dinnerware or brick or sewer pipe or unique individual pots: all were things to be made with pride in the fine quality of the product.[30]

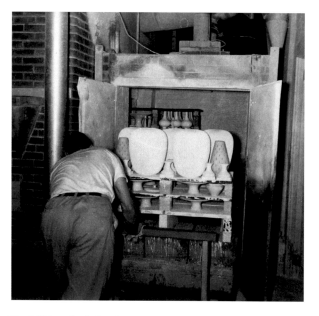 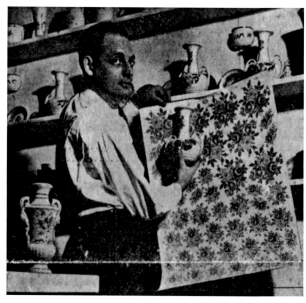

◀ **Fig. 2.13** A car loaded with glazed but yet-to-be-fired ware rolls into Hyalyn's tunnel kiln. Some of the things seen here were designed by Michael Lax for the Raymor Capri line, *c.* 1953. (*Hickory Landmarks Society*)

▶ **Fig. 2.14** Ben Crews, Hyalyn Porcelain, Inc.'s decorating department manager, exhibits a sheet of decalcomania designs that will be cut apart and added to items before subjecting them to a second, lower temperature firing in an electric kiln. From the *Journal and Sentinel* (Winston-Salem, NC), January 4, 1948, p. 1D. Used by permission. (*Historical Association of Catawba County*)

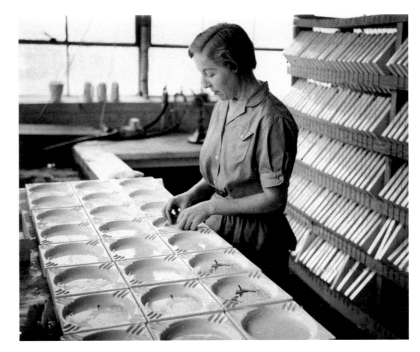

Fig. 2.15 In Hyalyn Porcelain, Inc.'s decorating department, scores of items, like these No. 615 ashtrays, have decalcomania applied to them. (*MaDan Studios photo, 1957. Photographs of Hyalyn Porcelain Company, MC 00337, Special Collections Research Center, North Carolina State University Libraries, Raleigh, NC*)

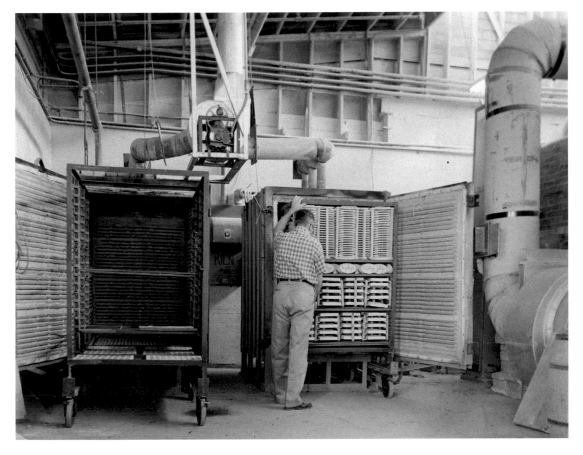

Fig. 2.16 Following the application of decalcomania, decorated ware is loaded into large electric kilns like these for finishing. (*MaDan Studios photo, 1957. Photographs of Hyalyn Porcelain Company, MC 00337, Special Collections Research Center, North Carolina State University Libraries, Raleigh, NC*)

Fig. 2.17 Local Catawba County artist, Louise Cilley, applies hand-painted underglaze designs to various shapes. These shapes, and their decorative motifs, are attributed to ceramics engineer, educator, and artist Edgar Littlefield. From the *Journal and Sentinel* (Winston-Salem, NC), January 4, 1948, p. 1D. Used by permission. (*Historical Association of Catawba County*)

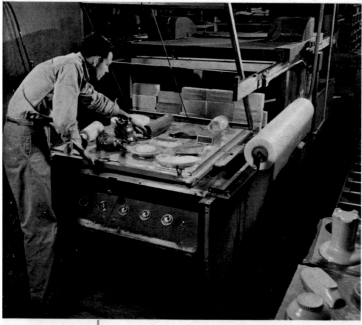

Fig. 2.18 In 1958, Hyalyn Porcelain, Inc., touted its innovative "skin packing" shipping process. Claiming its place as a pioneer in utilizing the method, the company promised its customers many advantages to other practices, including lower shipping charges, decreased breakage, and less mess created by discarded packaging materials. A 1961 *Ceramic Industry* cover image shows how transparent film seals items against a backboard. (*Historical Association of Catawba County*)

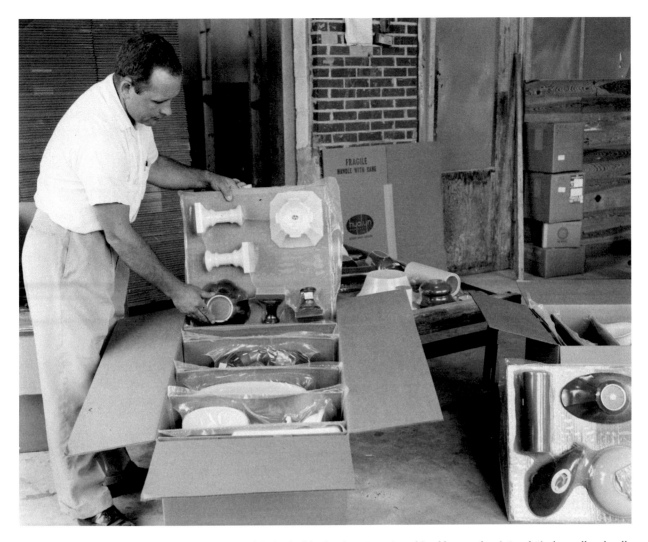

Fig. 2.19 Requiring no loose materials, Hyalyn Porcelain Inc.'s shipping department combined large orders into relatively small and well-protected packages. (*MaDan Studios photo, 1957. Photographs of Hyalyn Porcelain Company, MC 00337, Special Collections Research Center, North Carolina State University Libraries, Raleigh, NC*)

Binns, an English-born studio potter, was the first director of what became Alfred University's New York State College of Ceramics. Moody held this vision for the value of artistry and design when choosing his product lines. Roberta Stokes Persick, writing about Arthur Baggs's influence on modern ceramic production, said:

> The artist must allow the possibilities and limitations of his materials and processes and be able to visualize and carry out designs of form and decoration adjustable to the factory production system. He must be alert to market demands, and be equipped with the desire to provide the very best in artistic taste and quality.[31]

This line of thinking shaped Moody's vision for the products Hyalyn Porcelain, Inc. produced. Moody knew that an efficiently run factory was no assurance of Hyalyn's success. Hyalyn Porcelain, Inc.'s products had to be affordable and well-designed. He promoted it as finest in style, quality, craftsmanship, and beauty of color.

3

FIRST PRODUCTS

Less Moody realized his long-anticipated dream of operating his own pottery company when Hyalyn Porcelain, Inc. began limited production in January 1947. After starting up the plant's tunnel kiln for the first time on November 1, 1946, Hyalyn Porcelain, Inc. sold a mere $48.61 worth of ware in December.[1] Regardless of the firm's unexceptional beginning, a wealth of knowledge and experience prepared Moody for future success. However, success was far from assured. What if Hyalyn Porcelain's products proved to be of little interest to customers? What if Hyalyn could not employ skilled workers? What if production problems delayed or prevented timely production?

Certainly, Moody felt the weight of investors' hopes for a profit since the $500,000 they devoted to his plan in 1945 has the equivalent purchasing power in 2021 of more than $7,235,000. Fortunately, post-war customers liked Hyalyn Porcelain's products well enough to make the company profitable. Annual sales grew from about $47,000 in 1947 to $378,774 in 1950. In the 1949–1950 period, pre-tax net income averaged about 20 percent annually. Although the pre-tax net income percentage lowered to somewhat less than 10 percent annually in most of the 1950s, the plant was profitable every year but 1954, when it incurred a small loss.[2]

Less Moody's Abingdon Pottery experience equipped him to set up a factory suited to the large-scale manufacture of mass-produced ceramic ware. By bringing aboard seasoned workers like Ohio State University's Edgar Littlefield as a designer and ceramic engineer, and Bud Crumbaker as the plant's superintendent, he boosted his chance for success. On his own, Moody was a capable designer, glaze expert, and manager.

The creation of high-quality products was necessary, but nothing was more critical to Hyalyn Porcelain, Inc.'s early success than good design. At first, product design fell to Less and Frances Moody, Ohio State University's Edgar Littlefield, Rookwood Pottery's Wilhelmine Rehm, and decorators like Emma Louise Cilley.

In addition to lamp bases, which were a mainstay of the business, Hyalyn Porcelain, Inc. fashioned china specialties, artware, and decorative accessories. Lamp companies, like Lightolier and Rembrandt, provided many lamp base designs. Moody likely invited some of these company's lamp base designers to create Hyalyn Porcelain artware shapes.

Top of the next page:

◄ **Fig. 3.1** A large inverted bell-shaped vessel with footed base, everted rim, and subtle underglaze decoration by Edgar Littlefield. Ohio State University, 1933. In addition to aiding in Hyalyn Porcelain, Inc.'s first kiln setup, Littlefield designed some of the company's first shapes and decorations. (*Stephanie Turner Photography*)

► **Fig. 3.2** Two early Hyalyn Porcelain, Inc., examples whose designs and decorations are attributed to Edgar Littlefield. (L–R) No. 204 and No. 206. (*Compton photo*)

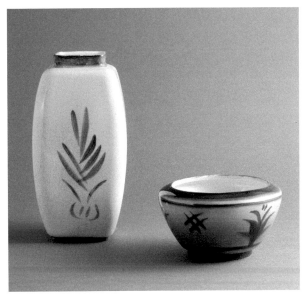

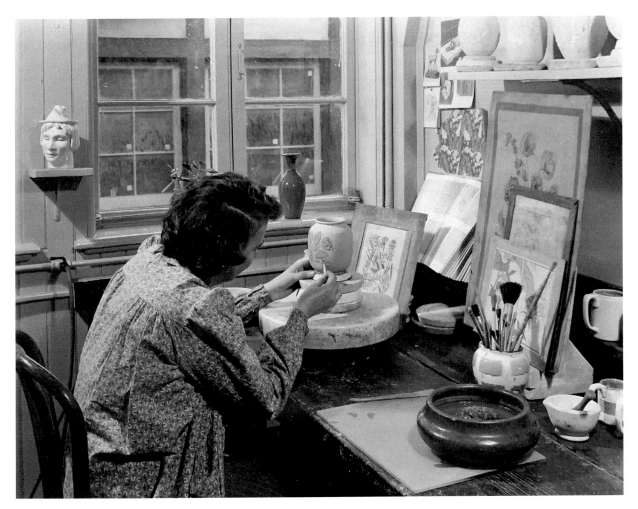

Fig. 3.3 Working in her Rookwood Pottery studio, Wilhelmine Rehm carves the surface of a vase. In 1947, Less Moody chose Rehm to be Hyalyn Porcelain, Inc.'s designer. Moody met her while serving as Rookwood's manager. Rehm is credited with the design of some of Hyalyn's earliest shapes. (*Image courtesy of Riley Humler*)

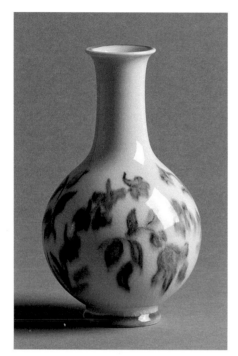

From top to bottom:

Fig. 3.4 Footed vase with underglaze decoration by Wilhelmine Rehm from Rookwood Pottery, Cincinnati, Ohio, 1945. Shape No. 6916 (marked XLV). (*Stephanie Turner Photography*)

Fig. 3.5 Four carved Hyalyn Porcelain, Inc., shapes attributed to Wilhelmine Rehm. Two Hyalyn Porcelain-manufactured lamp bases made for Rembrandt Lamp Company exhibit similar designs (see Figs. LL.2 and LL.3). (L–R) No. 208; No. 207; No. 202; and No. 203. (*Stephanie Turner Photography*)

Fig. 3.6 and Fig. 3.7 Hyalyn's No. 207 and No. 202 pillow vases share traits with Rookwood Pottery production forms whose shapes and glazes were likely known to both Wilhelmine Rehm and Less Moody. The shape of the Rookwood Pottery vase seen in Fig. 3.6 (No. 6706) was designed in 1938 by John Delaney Wareham. Kataro Shirayamadani and Ruben Earl Menzel created its carved panel. For comparison, see Hyalyn's No. 207 vase in Fig. 3.7 (left). Rookwood's vase No. 6474, seen on the far right in Fig. 3.7, was designed in 1934 by Arthur P. Conant. Compare it to Hyalyn's No. 202 vase seen in Fig. 3.7 (center). (Fig. 3.6: *Everything But the House, EBTH.com. Used by permission*; Fig. 3.7: *Stephanie Turner Photography*)

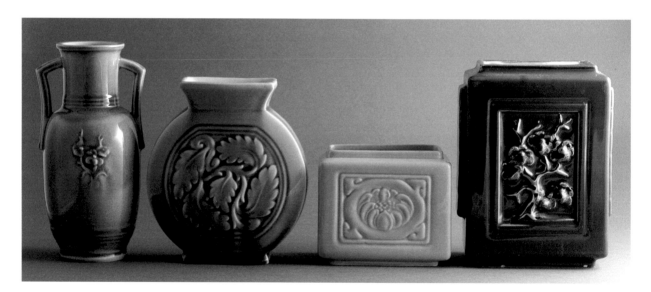

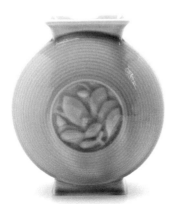

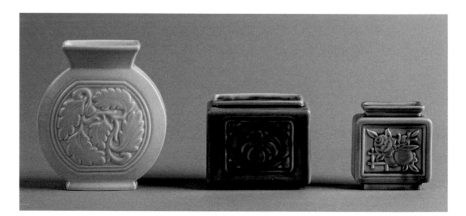

FINE CHINA

Considering that Less Moody's career as a ceramicist began at Zanesville's Mosaic Tile Company, tiles were predictably among Hyalyn Porcelain, Inc.'s first products. The tiles seen in Fig. 3.8 may be examples of Hyalyn Porcelain, Inc.'s china specialties. One tile's box lid displays a foil label like its early hyalyn porcelain shield mark reading "hyalyn fine china." The tiles are felt-backed. Black glaze coats their edges. The outline of each one's floral design is slightly embossed into the clay. Matching details on each tile's decoration suggest that the pattern was transfer-printed or pressed onto the tiles before firing.

In a letter written to Lawrence H. Brown, of Inverness, Florida, in 1969, Moody describes an experimental tile-making process. He tells about working at Ohio State University with Byron Ford in the 1930s:

> Byron was able to build up a deposit using the photographic negative so that he could get the modeled effect of high for the light and low for the heavy and use a flowing glaze to get the color break. He was very successful in this development and did many things but never did follow up on it.[3]

Regardless of how he created the tiles seen in Fig. 3.8, their appearance differs from Hyalyn Porcelain, Inc.'s decalcomania-decorated tiles made later on.

A 1948 Ithaca, New York newspaper advertisement describes a decorated Hyalyn salad plate as "Glossy, translucent china with lovely fruit design." Although it is impossible to say what its creator had in mind when making it, its similarity in style to some fine china dishes is apparent.

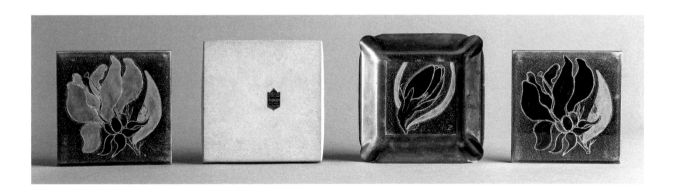

▲ **Fig. 3.8** Square tiles, *c.* 1946–1950. Hyalyn packaged the tile on the left in the box to its right that bears a "hyalyn fine china" foil sticker. In Hyalyn Porcelain, Inc.'s early years, Less Moody aimed to create some items fitting the definition of "fine china." (*Stephanie Turner Photography*)

▼ **Fig. 3.9** Though missing from Hyalyn's 1948–1949 catalog, this salad plate, advertised for sale as "glossy, translucent china" in New York's *Ithaca Journal* on December 8, 1948, further demonstrates Moody's early desire to create "fine china" in the likeness of popular English, European, and Asian ware. (*Newspapers.com*)

Salad Plates

Beautiful Hyalyn salad plate. Glossy, translucent china with lovely fruit design.

1.98 ea.

Fig. 3.10 Hyalyn's salad plate, seen in Fig. 3.9, is similar in design to these English examples, including a Coalport Bone China, Indian Tree design plate (left), and a Mason's Patent Ironstone china plate (right). The inclusion of traditionally-styled shapes and decorations among the company's first items suggests that some customers' pre-World War II tastes had not yet given way to emerging post-war modern trends. (*Stephanie Turner Photography*)

Fig. 3.11 and Fig. 3.12 Before leaving Abingdon Pottery in 1942, Less Moody introduced a line of highly decorated shapes like the No. 522 Barre vase (left) and No. 520 Baden vase (right) seen in Fig. 3.11. Abingdon released each one for sale in 1940. Their style and decoration are reminiscent of porcelain made in Limoges, France, like the example seen in Fig. 3.12. (*Stephanie Turner Photography*)

Fig. 3.13 Hyalyn Porcelain, Inc.'s first products included some like these (L–R: No. 600 and No. 608) called "hand-decorated traditional porcelains." Base colors included Brilliant White and Sea Island Coral. In addition to decalcomania, hand-painted highlights were applied to them using 22-k coin gold. The No. 600 shape may have been offered only in 1947. (*Stephanie Turner Photography*)

Less Moody added some decorated ware to Abingdon Pottery's product line before leaving the company in 1941. According to Joe Paradis, outside sources added decalcomania and gold highlights to these pieces.[4] Abingdon shapes decorated in this fashion include cornucopias and vases, like the firm's *Classic, Acanthus, Baden, Abbey, Boyne,* and *Berne* shapes (introduced between the years 1939–1941) and others.[5] Like these Abingdon examples, some early Hyalyn Porcelain, Inc. items are highly decorated, with fluted surfaces, fancy handles, decalcomania, and other add-ons.

Calling some of Hyalyn Porcelain, Inc.'s early products "fine china" may indeed harken back to Moody's days at Abingdon Pottery, where catalog promotions decreed that its wares had "The clear ring of fine china."[6] Scarce evidence for Hyalyn Porcelain, Inc.'s production of anything qualifying as fine china suggests that its manufacture, if commercially pursued at all, was short-lived.

EARLY PRODUCTS

Among Hyalyn Porcelain, Inc.'s first products are some designs that might be mistaken for Rookwood Pottery's production wares and, as indicated above, some by Abingdon Pottery. Perhaps this is understandable since Less Moody managed both operations, and Hyalyn Porcelain, Inc. employed former Rookwood and Abingdon employees.

Hyalyn Porcelain, Inc.'s pillow vases, numbered 202, 203, and 207, are somewhat like Rookwood Pottery shapes numbered respectively, 6474, 6468, and 6706. Rookwood's shapes 6474 and 6468 were designed in the 1930s by Arthur P. Conant.[7] Like Hyalyn Porcelain, Inc.'s vases, each has a framed, carved panel on its front and back sides, a footed base, and a slightly extended rim surrounding its opening.

Hyalyn Porcelain, Inc.'s shape No. 207 is similar to Rookwood Pottery's No. 6706. This Rookwood shape was created in 1938 by John Delaney Wareham. Kataro Shirayamadani and Ruben Earl Menzel designed the decorated panel.[8]

Although it is unlikely that anyone involved in creating Rookwood Pottery's shapes 6474, 6468, and 6706 had a direct hand in designing Hyalyn Porcelain, Inc.'s similar forms, Shirayamadani, Wareham, and Menzel were employed there when Less Moody was the shop's manager. Before Moody's arrival, Conant departed Rookwood Pottery in 1939 to decorate ware at Kentucky's Kenton Hills Pottery.[9] Some of Conant's shapes, including No. 6474, were made by Rookwood Pottery

during Moody's term. As Rookwood Pottery's manager, Moody had the opportunity to study the company's shapes and glazes. Rookwood's Wilhelmine Rehm was named Hyalyn Porcelain, Inc.'s designer in the fall of 1947. Beforehand, Rehm may have worked for Hyalyn Porcelain, Inc. as a freelance designer. Perhaps in addition to others, Hyalyn Porcelain, Inc.'s Nos. 202, 203, 207, and 208 were probably created by Rehm, collaborating with Less Moody.

Some Hyalyn Porcelain, Inc. 500 and 600 line shapes bear ornate handles, floral decalcomania, and gold lines. If placed in an Abingdon Pottery lineup, most of these shapes would be indistinguishable from the Illinois firm's products. Four wall pockets (teapot, rolling pin, jar, saucepan), three cachepots (an ornamental floral container), several ashtrays, and an array of vases make up these lines. They came decorated or in plain colors. The appeal of Hyalyn Porcelain, Inc.'s 500 and 600 lines seems geared toward older buyers than toward an emerging band of younger, post-war consumers.

A January–June 1948 Hyalyn Porcelain, Inc. sales record and the 1948–1949 sales year catalog show that the plant first made artware and decorative accessories in four numbered lines (200s; 500s; 600s; and 801). Initially, these lines included at least forty-three shapes (Nos. 201-223; 501-503; 510-513; 600; 602-610; 613; and 801).[10]

Hyalyn Porcelain, Inc. offered its first forms in one of three ways. Some were plain-glazed in colors, without further decoration, and some 200 line wares bore hand-painted underglaze designs. Items from the 500 and 600 lines often came with applied decalcomania and hand-painted 22-k gold edging and accents.

Hyalyn Porcelain, Inc.'s No. 801 is a coupe-shaped 8-inch plate. Each No. 801 plate carried a central decalcomania image. A wide, colored band, encircled by edging lines hand-painted with 22-k gold, surrounded each image. In 1948, the company's first full production year, four picture plate designs showed three fruit displays and one Jean-Antoine Watteau scene. Hyalyn Porcelain, Inc. also offered a group of No. 801 coupe plates showing coaches and carriages, called "last season's sales sensation." In 1949, Hyalyn Porcelain, Inc. promoted six coach and carriage designs. Unfortunately, since Hyalyn Porcelain, Inc. lacked the exclusive right to use the decalcomania, other companies sold similar plates.

On February 14, 1949, Barney Parsons, a representative of Walter Crowell, a wholesaler located at 225 Fifth Avenue, in New York's Gift and Art Center, expressed his concern to Less Moody about Hyalyn Porcelain, Inc.'s competitors. He wrote:

> You beat the gun on the Carriage Plates, Les [sic.], and we tried to follow through. However, there are about 15 different kinds, types and prices on the market, so I suggest that you don't go haywire—in fact, be very careful.[11]

Along with his note, Parsons enclosed a clipped advertisement showing Atlas China Company's carriage plates, offered for $7.50 per dozen. The carriage images were identical to Hyalyn's, and Hyalyn Porcelain, Inc.'s plate price was considerably higher at $12 per dozen.

Initially, Hyalyn Porcelain, Inc. dedicated much of its advertising to promoting its No. 801 coupe plates. In addition to its coach and carriage plates, offered in 1948 and 1949, Hyalyn Porcelain, Inc.'s 1949 offerings included three fruit-design plates, four floral-design plates, two Watteau patterns, and four plates featuring "horseless carriages." An unnamed artist made Hyalyn Porcelain, Inc.'s Ford, Buick, Oldsmobile, and Cadillac patterns. Hyalyn Porcelain, Inc. promoted them as "A 'Hot' item without competition."

Most items from the 200 line, if decorated, featured simple, stylized, hand-painted underglaze designs. For the 1949 season, Moody introduced a new decoration for the 200 series.[12] He considered calling it "Mottled Black Matt Modern," but he changed its description to "Two-color Black Matt Modern." Moody described this decoration as "an interpretation of freedom in modern ceramic art."

In 1949, only five 200 line shapes featured hand-painted underglaze decoration. Ten forms came in "Two-color Matt Black Modern." Decalcomania decoration applied to the 500 and 600 lines consisted of clusters of fruit or flowers, single flowers, birds, and Watteau scenes.

Moody explored many avenues to find shapes and glazes that would appeal to post-war customers. Like the advice he received from Walter Crowell's Barney Parsons, feedback helped shape and modify Hyalyn Porcelain, Inc.'s offerings. A note written to Moody in June 1948 from experienced Chicago wholesaler Harry A. Neville offered guidance about some of Hyalyn Porcelain, Inc.'s first products:

Dear Les [*sic.*],

Just a short note commenting on your remarks in your recent letter. In planning for Fall [1948], I hope it is not your intention to eliminate entirely the decorated group [presumably, the hand-painted, underglaze-decorated 200s]. On the basis of our experience I would like to suggest that you drop the overglaze decoration in the 500 and 600 series [decalcomania and gold accents]. I believe we can do something with the Cashe Pots [*sic.*] 511-2-3, and would like to have samples of these come through (except white) in plain colors. The decal ware is highly competitive and as far as I am concerned we can live without it.[13]

Sound advice and market experience led Moody to change many things about Hyalyn Porcelain, Inc.'s product lines during the first production years. The 1951–1952 catalog offered two entirely new lines designed by Charles Leslie Fordyce—noticeably modern in appearance—called Golden Bar and Free Form.[14] Gone altogether was anything hand-decorated, or the finish called Two-color Matt Black Mottled. In addition to some new ones, a few original 200 line forms remained in production. All shapes were available in solid colors only: Dawn Mist Gray, Lime Chartreuse, Spruce Green, New Sandalwood, Mink Brown, Ivory, and Speckled Yellow. Decorators added decalcomania to No. 801 picture plates (twenty-four patterns), ashtrays, cigarette cups, mugs, coasters, and hot plates (tiles). A Frances Moody-sculpted *Madonna and Child* and *Angel Candlestick* were offered "for early holiday season sales."

In 1953, Hyalyn Porcelain, Inc. introduced its new Pebble Grain Finish and a floral ware line called the Etruscan Group. The year 1953 was a breakthrough for Hyalyn Porcelain, Inc. when Raymor/Richards Morgenthau, Inc. turned to it to produce Michael Lax's soon-to-be-acclaimed Raymor Capri line of ware.

Raymor/Richards Morgenthau Co.

Hyalyn Porcelain, Inc. manufactured groups of ceramic items for Raymor/Richards Morgenthau Co., including Raymor Capri (Michael Lax), Hi-Line (Michael and Rosemary Lax), Basketry (Esta Brodey/Peerless Art Co.), Casual Craft (Erwin Kalla), High Fashion (Eva Zeisel), and groups of smoking and floral arrangement accessories, including large planters.

Russel Wright and Irving Richards (born Rappaport) formed Russel Wright, Inc. in 1936. The two met at a dinner hosted by Richards's acquaintance and Stern Brothers buyer, Andrew "Andy" Ruge. Russel Wright, Inc. became Wright Accessories, Inc. in 1937, before Wright sold his stake in the company to Richards in 1941. Following its acquisition, Richards gave the enterprise the name Raymor Mfg. Division, Inc.[15] In the meantime, Richards established Richards Morgenthau, Inc. with Eugene Morgenthau; he commented:

Russel no longer wanted to be involved in business of any type—it was getting too big for him and he asked me to buy him out, which I did. And that's when it became Raymor and Richards-Morgenthau. I took Eugene Morgenthau in—he had worked for the Lightolier company. I took him in because he was a good factory man. And that was the episode.[16]

Before Wright and Richards incorporated Russel Wright, Inc., Irving Richards sold his New York City bookstore where he sold rare books and joined Lightolier as an employee. In Europe, Richards sought out new concepts for Lightolier lamp designs. The designs he saw there—for lamps and many more things—opened his eyes to creative ideas that forged a new path for his career and life, giving shape to the company he called Raymor.[17]

Raymor imported European items and manufactured modern American furniture, lamps, ceramic items, and home accessories under the banner of "Modern in the Tradition of Good Taste." Raymor attracted many notable designers, including George Nelson, Ray and Charles Eames, Ben Seibel, Michael Lax, Eva Zeisel, and Peter Max. Michael Kaplan noted:

An innovative formula, devised by Irving Richards, integrated design, production and merchandising in a way that insured [*sic.*] a strong market for "modern" design. Raymor launched careers of outstanding designers and introduced established Europeans to the United States market.[18]

Michael Lax, whose Hyalyn-manufactured Raymor Capri line remains popular with mid-century-modern collectors today, benefited from his association with Richards and Raymor. His story is like many others. Richards describes how Raymor and designers, like Lax, connected:

> Well, you've got to realize that, over a rather protracted period of time, the reputation of our company had been built up and much that you do results from the reputation; designers coming to you with their product, manufacturers knowing Richards-Morgenthau as an entity coming to you. And things become easier. You don't have to go into the trenches to get designers; they come to you. And this happened constantly with us: designers calling me up from here and there, would I look at their work. Michael Lax was one in particular. He came to me and the very first thing that he ever designed was a combination white porcelain and walnut candlestick. I redesigned the entire thing—from the point of view of proportions—and we had it made.[19]

This description suggests that Lax's candlestick was the Capri line's first item. As Hyalyn Porcelain, Inc. manufactured the Raymor Capri line, it seems likely that the candlestick was made there.

Generally, Raymor-Hyalyn partnerships for manufacturing and distribution were fruitful, though some were more successful than others, as Richards noted:

> We had our flops, too, let me remind you ... One of ours was Eva Zeisel. She was a great designer—there's no doubt about it ... But Eva Zeisel was a character. She designed a line of decorative ceramics for us made by Hyalin [sic.] in North Carolina. It was not a success.[20]

Irving Richards and Less Moody held similar philosophies about design and merchandising. Hyalyn's adopted slogan, "live high on a low budget," complemented Richards's sensibilities, like good design and affordability. Kaplan says of Raymor:

> An important principle of the company's sales philosophy was accessibility. Born of the Great Depression, Raymor enabled anyone with a modest income to buy good design at affordable prices. Products were sold nationwide in department stores, and the advertising—featuring the slogan "modern in the tradition of good taste"—was clearly populist, aimed to overcome any unfamiliarity or discomfort with modern design.[21]

Richards commented on the matter:

> My entire motivation in business was to provide good design at an affordable price ... And I never did anything or permitted the company to do anything in design or merchandising that was elitism.[22]

Richards and Raymor contributed to Hyalyn Porcelain, Inc.'s success by allying its manufacturing output to the names of seasoned and rising stars in modern design. For a 1950s company that desperately needed new ideas that were more modern than traditional in scope, Raymor was a timely and beneficial partner.

THE GARDEN CLUB CONNECTION

Except for the shop's No. 801 coupe plates, mainly intended for display, not table use, dinnerware is noticeably absent from Hyalyn Porcelain, Inc.'s early lineup. Products geared toward floral arrangement made up most other items.

Early in the twentieth century, in an age when men were usually families' primary wage earners and women were typically homemakers, a national garden club movement flourished. The country's first garden club was started in 1891 in the Athens, Georgia, home of Mrs. E. K. Lumpkin. At first open by invitation only, members soon opened up this club's membership. Today, according to the not-for-profit National Garden Clubs, Inc., the United States hosts about 5,000

garden clubs and 165,000 members.[23] The formation of garden clubs fit in with the nation's women's club movement, whose constituent groups were often led by smart, influential, progressive women. Garden clubs' aims include landscape preservation and restoration, gardening, and floral design. Hyalyn Porcelain, Inc. made many of its first shapes for floral design—a trend that continued throughout its history.

Hyalyn Porcelain, Inc.'s floral arrangement shapes included vases, bowls of various heights, cachepots, and wall pockets. Some things, like bowls, could be used for serving food, as well. Yet Less Moody saw a market for well-designed and durable porcelain goods that could meet the needs of garden club and non-garden club members alike. In fact, among all of the Hyalyn Porcelain, Inc. lines created during Moody's years as general manager, the Garden Club Line was the most enduring one.

Initially called the Floral Arrangement Line, the group included "simple basic forms in seven proven colors to accent nature's colorful floral displays." Some of the shapes offered in 1951 were among the first produced by Hyalyn Porcelain, Inc. in 1947–1948 (including Nos. 204, 205, 210, 213, 214, and 220). In ensuing years, Hyalyn regularly added new floral design shapes to its list of products. Hyalyn Porcelain, Inc.'s 1953 catalog featured various vases finished with a new pebble grain finish, with one example shown filled with daffodils, pussy willows, and other cut flowers. The Etruscan Group was introduced that year in five colors "at the request of the Garden Clubs." The company's fall 1953 catalog additions included new Garden Club Line shapes "to fill the demands of the Garden Clubs for a more extensive line of flower containers." At the same time, the Contour Group was released in five shapes, "excellent for flower arrangements, fruit, and nut bowls."

Except for pillow vases Nos. 202, 203, and 207, and vase No. 208, which have carved, low relief add-ons, all other 200 line shapes from Hyalyn Porcelain, Inc.'s first production generally have sleek glazed surfaces, footed bases, and rounded corners and edges. This feature made them ideal for floral arrangement and easy to clean.

DECORATIVE ACCESSORIES

Hyalyn Porcelain, Inc.'s decorative accessories line grew through the years to include many items like wall plaques and hot plate tiles. Initially, coasters and ashtrays best fit the description. Said to have "eye-and-buy charm" and be "fresh and appealing in design," the No. 602 and No. 603 ashtrays were promoted as a "quality product destined for fame." In truth, each one was a simple coupe-shaped disc, set upon a slight foot. Decoration included decalcomania and gold (or more rarely glaze-colored) edging. The No. 602 ashtray measures 4.25 inches in diameter, whereas the No. 603 ashtray measures 5.25 inches. In 1948, No. 602 ashtrays came in six patterns: Natural Rose, two Floral Bouquet designs, Bird of Paradise, and two Colonial designs. No. 603 ashtrays came in four decorations: Two Colonial designs, Chintz Floral, and Natural Rose. Remarkably, the 1947 lineup included twenty-four No. 602 patterns and twelve No. 603 patterns. In the earliest line, the company also offered a triangular ashtray (No. 223) and an oak leaf-shaped ashtray (No. 604).

CHANGING TRENDS IN DESIGN

As the nation moved beyond World War II into the 1950s, Less Moody was attentive to changing design trends. Charles Leslie Fordyce's 1951 Golden Bar and Free Form lines were noticeable departures in style from Hyalyn Porcelain, Inc.'s somewhat anachronistic first-offerings. Michael Lax's Capri shapes, made in 1953 for Raymor, appealed to an emerging pool of American buyers who desired things with a more modern look. In 1956, Herb Cohen's employment as Hyalyn Porcelain, Inc.'s in-house designer led to many new shapes that were useful for floral arrangement, party serving, and smoking. Observers described Cohen's sleek, smooth-sided, and unadorned spherical, triangular, and linear forms as graceful and tasteful in their simplicity.[24]

Cohen's two-tone colored Portfolio Collection, a series highlighted by abstractly carved patterns cut into its pieces' broad, horizontal rims, was thoroughly modern in appearance. Later on, Hyalyn Porcelain, Inc.'s Decorators Collection fit the bill for mid-century-modern design. The late 1950s–early 1960s production of Raymor's Casual Craft line by Erwin Kalla, its

Basketry line by Esta Brodey's Peerless Art Co., and its High Fashion line by Eva Zeisel cinched Hyalyn's place in modern design and production.

In 1958, Moody expressed his thoughts about design with members of the American Ceramic Society in a talk he called "Designs for Progress." Citing Frank Lloyd Wright's notion that form follows function, Moody explained:

> Yes, first we work from the function or purpose and then develop the idea into good, pleasing form ... The difficult question to answer is: What is pleasing form? Is it new and different from everything else or should it be classic, adaptation or a combination of the two?[25]

Arthur Baggs taught Moody to be realistic about design decisions. Baggs told Moody's graduating class, "We have taught you what is good in design, but now you will go out in the field and design what the public wants to buy." Accepting the relevance of both Wright's and Baggs's declarations, Moody concluded that, "It is so true, for we cannot always sell the perfect design, we must keep our eyes open to what the public, the buyer with money, wants."[26]

"Design for progress," proposed Moody, "is a gradual evolution. We couldn't sell the design today of the 30's nor are we capable of selling designs now that will be salable in 1975. You can design beyond today and be a failure."[27] This was Moody's constant challenge—to match consumers' tastes with good design. Hyalyn Porcelain, Inc. met this challenge. Despite his belief in sound design, a trait evident from the beginning of the company's production, Moody acknowledged that "Too often we get too gimmicky but sometimes it sells, unfortunately."[28]

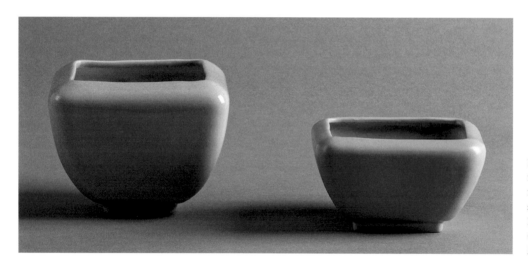

Fig. 3.14 Square bowls for use as planters, floral displays, and serving pieces. (L–R) No. 201 and No. 205. (*Stephanie Turner Photography*)

On the next page:

Top row:

◄ **Fig. 3.15** A colored design drawing on paper for Hyalyn Porcelain, Inc.'s No. 202 pillow vase. Design attributed to Wilhelmine Rehm. (*Historical Association of Catawba County*)

► **Fig. 3.16** Two examples of Hyalyn Porcelain, Inc.'s No. 202 pillow vase. Design attributed to Wilhelmine Rehm. (*Stephanie Turner Photography*)

Middle row:

◄ **Fig. 3.17** A colored design drawing on paper for Hyalyn Porcelain, Inc.'s No. 203 pillow vase. Design attributed to Wilhelmine Rehm. (*Historical Association of Catawba County*)

► **Fig. 3.18** Hyalyn's No. 203 pillow vase. Moody's use of a translucent glaze and blue highlights add to this example's appearance and appeal. Design attributed to Wilhelmine Rehm. (*Stephanie Turner Photography*)

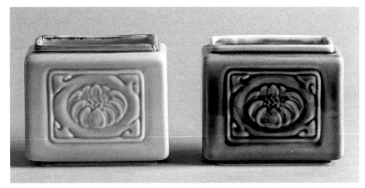

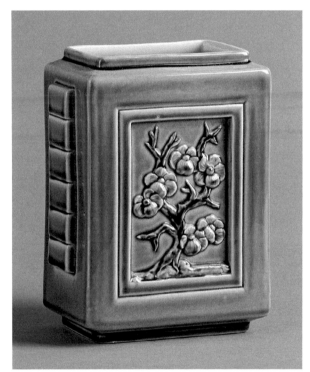

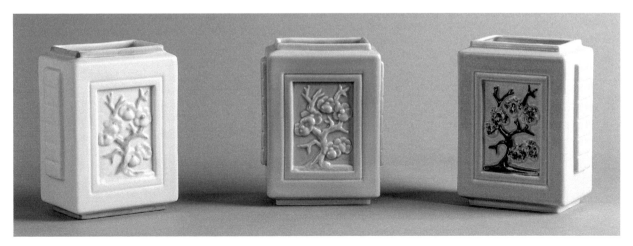

Fig. 3.19 One of Hyalyn Porcelain, Inc.'s most popular forms, the No. 203 pillow vase came with gloss or matte glazes of various colors and a variety of hand-painted highlight colors. Design attributed to Wilhelmine Rehm. (*Stephanie Turner Photography*)

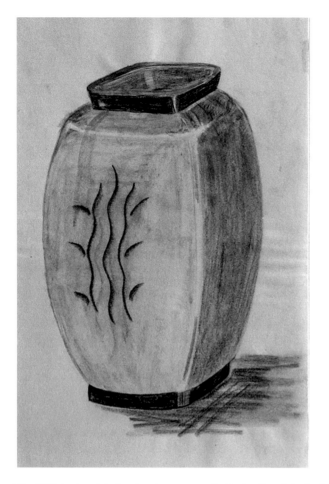
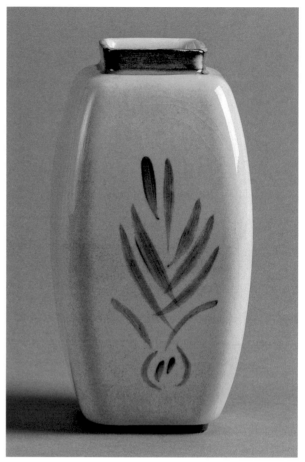

◄ **Fig. 3.20** A colored design drawing on paper for Hyalyn Porcelain, Inc.'s No. 204 square vase. This shape and decorative design are attributed to Edgar Littlefield. (*Historical Association of Catawba County*)

► **Fig. 3.21** Hyalyn Porcelain, Inc.'s No. 204 square vase with underglaze decoration. Design attributed to Edgar Littlefield. (*Stephanie Turner Photography*)

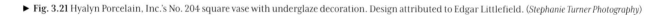

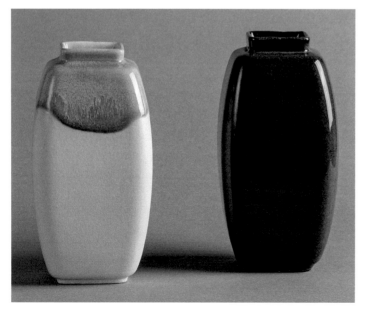

Fig. 3.22 The No. 204 square vase on the right bears a glossy monochromatic brown glaze, whereas the example on the left features a colored glaze above the piece's pure white porcelain body. This compound glazing technique is a variation on what Less Moody called "Two-color Black Matt Modern" (Moody variously spelled the word "matt" and "matte"). In this case, Matt White replaces the Black Matt glaze. (*Stephanie Turner Photography*)

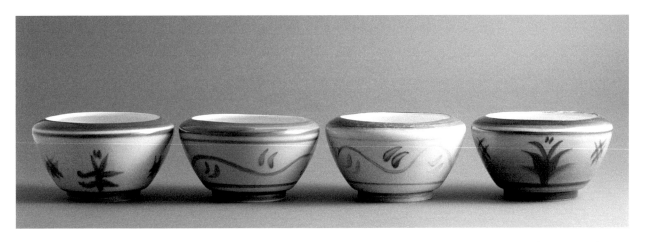

Fig. 3.23 Four No. 206 bowls with translucent glazes and underglaze decoration. Designs attributed to Edgar Littlefield. (*Compton photo*)

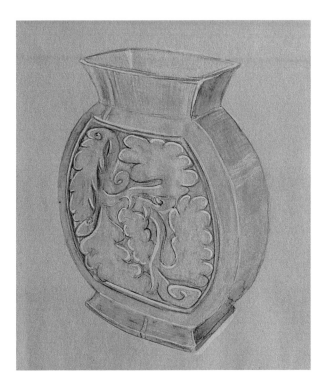

◀ **Fig. 3.24** A colored design drawing on paper for Hyalyn's No. 207 pillow vase. Design attributed to Wilhelmine Rehm. (*Historical Association of Catawba County*)

▶ **Fig. 3.25** Hyalyn Porcelain, Inc.'s No. 207 pillow vase with a beautifully rendered carved design and translucent glaze. Design attributed to Wilhelmine Rehm. (*Stephanie Turner Photography*)

◄ **Fig. 3.26** Hyalyn Porcelain, Inc.'s No. 308 handled vase. Carved design and translucent glaze. Hyalyn made a version of this form without handles. Design attributed to Wilhelmine Rehm. (*Stephanie Turner Photography*)

► **Fig. 3.27** Hyalyn Porcelain, Inc.'s No. 212 vase (left) and No. 210 window bowl (right), both with underglaze decoration. Early underglaze decorations were hand-painted by Louise Cilley. Form No. 212 was discontinued early on and does not appear in the 1948-1949 catalog. Designs attributed to Edgar Littlefield. (*Stephanie Turner Photography*)

 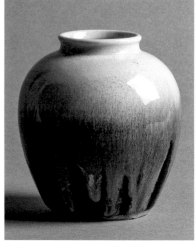

◄ **Fig. 3.28** Hyalyn Porcelain, Inc., ball vases, No. 211, with underglaze decoration. Designs attributed to Edgar Littlefield. (*Stephanie Turner Photography*)

► **Fig. 3.29** Hyalyn Porcelain, Inc.'s No. 211 ball vase with "Two-color Black Matt Modern" glazing. Less Moody introduced this glaze combination in the company's 1948–1949 sales catalog. When planning the new season's catalog, he initially referred to it as "Mottled Black Matte Modern." Glaze color combinations were Gray on Black, Green on Black, and Tan on Black. (*Stephanie Turner Photography*)

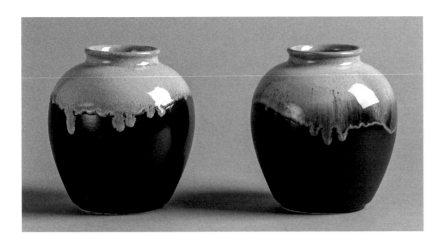

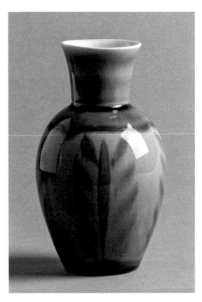

◄ **Fig. 3.30** A pair of Hyalyn Porcelain, Inc.'s No. 211 ball vases, each one with "Two-color Black Matt Modern" glazing. (*Stephanie Turner Photography*)

► **Fig. 3.31** Hyalyn Porcelain, Inc.'s No. 212 vase with underglaze decoration. Design attributed to Edgar Littlefield. (*Stephanie Turner Photography*)

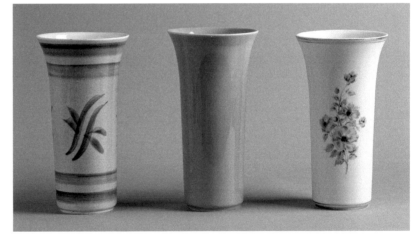

Fig. 3.32 A trio of Hyalyn Porcelain, Inc.'s No. 213 vases. Many of Hyalyn Porcelain, Inc.'s first products appear with hand-painted and decalcomania decorations. The company offered undecorated (called plain) wares with glaze colors named Dawn Mist Gray, Lime Chartreuse, New Aqua Green, Jasmine Yellow, Matt White, Brilliant White, and Sea-Island Coral. (*Stephanie Turner Photography*)

Fig. 3.33 Hyalyn Porcelain, Inc.'s No. 214 square bowls shown (L–R) with "Two-color Black Matt Modern" glazing, underglaze decoration, and undecorated (plain). (*Stephanie Turner Photography*)

Fig. 3.34 Hyalyn Porcelain, Inc.'s No. 215 bud vases with underglaze decoration showing through translucent green and brown glazes. Design attributed to Edgar Littlefield. (*Stephanie Turner Photography*)

Fig. 3.35 and Fig. 3.36 Hyalyn Porcelain, Inc.'s No. 216 vase with underglaze decoration. This form was discontinued early on and does not appear in the 1948–1949 catalog. Design attributed to Edgar Littlefield. (*Stephanie Turner Photography*)

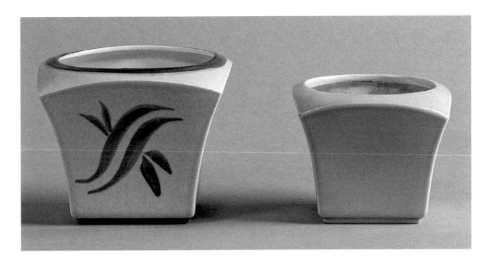

Fig. 3.37 Hyalyn Porcelain, Inc.'s No. 219 and No. 217 square pots. Designs attributed to Edgar Littlefield. (*Stephanie Turner Photography*)

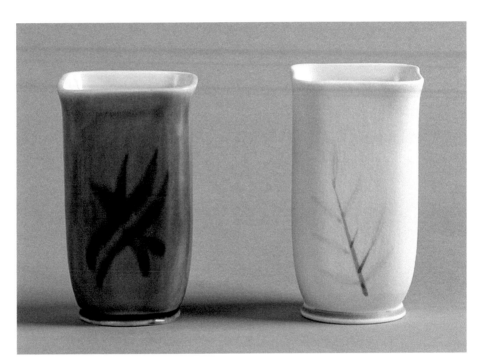

Fig. 3.38 Hyalyn Porcelain, Inc.'s No. 218 square vases. Design attributed to Edgar Littlefield. (*Stephanie Turner Photography*)

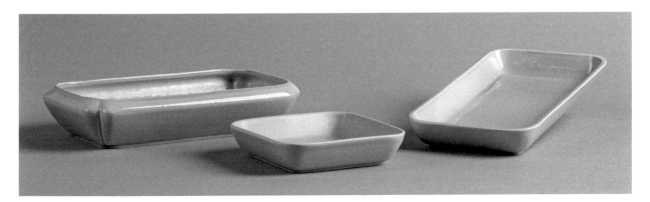

Fig. 3.39 Called long bowls and trays, Hyalyn Porcelain, Inc.'s (L–R) Nos. 220, 222, and 226, were useful for floral arrangement or serving. (*Stephanie Turner Photography*)

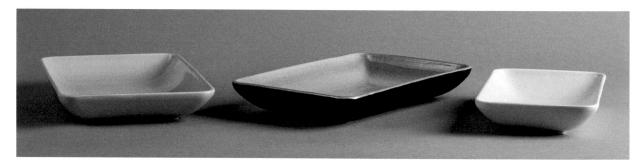

Fig. 3.40 A trio of Hyalyn Porcelain, Inc. trays, Nos. 224 (left and center) and No. 225. Plain-glazed and "Two-color Black Matt Modern" glazing. (*Stephanie Turner Photography*)

Fig. 3.41 Hyalyn Porcelain, Inc.'s (L–R) No. 229, 228, and 231 plain-glazed pillow vases. (*Stephanie Turner Photography*)

Fig. 3.42 A pair of Hyalyn Porcelain, Inc.'s No. 501 Sauce Pan wall pockets. The company's other early wall pockets include a Rolling Pin (No. 510), Jar (No.502), and Teapot (No. 500). Teapot wall pockets came with spouts oriented either right or left. (*Stephanie Turner Photography*)

Fig. 3.43 Hyalyn Porcelain, Inc.'s No. 513 (left) and No. 512 cachepots. (*Stephanie Turner Photography*)

Fig. 3.44 Hyalyn Porcelain, Inc.'s 4.25-inch No. 602 ashtrays bearing some of the company's many decalcomania patterns. (*Compton photo*)

Fig. 3.45 Hyalyn Porcelain, Inc.'s 5.25-inch No. 603 ashtrays. (*Compton photo*)

Fig. 3.46 Hyalyn Porcelain, Inc.'s No. 605 vase (left) and No. 604 oak leaf ashtray. The vase came in two glaze colors, White and Coral, and could have decalcomania and 22-k gold highlights added. The back of the oak leaf ashtray is signed "Christian." Members of the Christian family resided in Hickory, suggesting that the signature represents the artist's surname. (*Compton photo*)

On the next page, from top to bottom:

Fig. 3.47 Two of Hyalyn Porcelain, Inc.'s No. 608 flare vases (left and right) and a No. 606 urn vase (center). (*Stephanie Turner Photography*)

Fig. 3.48 A pair of Hyalyn Porcelain, Inc.'s No. 607 cornucopia vases. (*Stephanie Turner Photography*)

Fig. 3.49 Hyalyn Porcelain, Inc.'s No. 609 console bowl and two candleholders (possibly No. 610). Hyalyn Porcelain, Inc. discontinued these early products before the publication of Hyalyn's 1948–1949 catalog. (*Stephanie Turner Photography*)

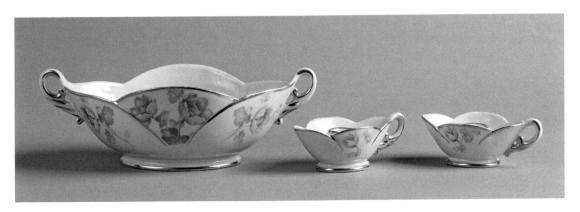

PICTURE PLATES

BY

*I*nstantaneous hit! For accent in the fine home . . . for that touch of smartness in the small home. A note of distinction in any home . . . for wall decor . . . for cupboard charm . . . for the tea party. Of finest translucent porcelain. Hand decorated in 22 karat gold in four patterns . . . three distinctive fruit patterns, one ancestors' colonial. Green, maroon, and yellow. Already market tested and sales proven. The hit of the shows.

$12.00 per Dozen
Minimum order one dozen.

hyalyn porcelain, inc.
DRAWER 460,
HICKORY, NORTH CAROLINA

Permanent displays

Chicago	New York
Harry Neville	Walter Crowell
15-111 Merchandise Mart	225 Fifth Ave.

Write for Catalog

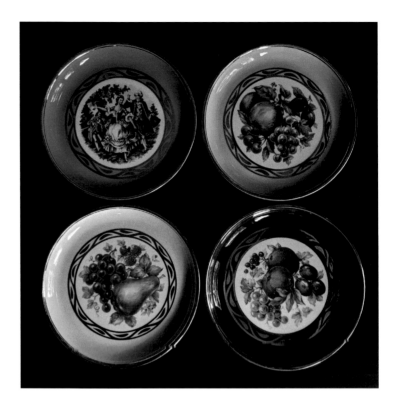

◀ **Fig. 3.50** Hyalyn Porcelain Inc.'s No. 801 picture plates were suited for wall decoration, and "Smart too, for dessert or luncheon service." The coupe-shaped plates (sides curving upward from the base and no rim) were among its most heavily promoted items. From the *Crockery & Glass Journal,* August 1948. (*Historical Association of Catawba County, Newton, NC*)

▶ **Fig. 3.51** Hyalyn Porcelain, Inc.'s 1948–1948 catalog featured No. 801 picture plates in these four patterns (Apple, Orange, Pear, and Colonial), with three border colors (maroon, green, and yellow). On the earliest plates, Hyalyn Porcelain, Inc.'s decorators applied a crisscrossed band of gold around the picture. Each plate measures 8 inches in diameter. (*Compton photo*)

Fig. 3.52 Popular Hyalyn Porcelain, Inc. picture plate designs included antique carriages and cars. The carriage patterns were used by other manufacturers, as well, whereas the car designs were made exclusively for Hyalyn Porcelain, Inc. (*Compton photo*)

Fig. 3.53 Using the same No. 801 plate molds, Hyalyn Porcelain, Inc., offered dozens of decorative options and colors like the examples seen here. (*Compton photo*)

4

SELLING HYALYN PORCELAIN

Though touted as "America's Finest Porcelain," Hyalyn Porcelain, Inc.'s ware did not sell itself. No grand design or fine quality measure alone was enough to move a vase, bowl, or dish from Hyalyn's kilns to a customer's home. After setting up the factory, this was, without a doubt, Less Moody's greatest challenge.

The post-World War II, new-kid-on-the-block, Hyalyn Porcelain, Inc. was not without competition. Having worked in the industry for years, Moody knew the competitors, perhaps better than most. Moody thought of longstanding companies, like Haeger Potteries, Inc., as leading challengers. In 1962, Moody described to Joe VonTury how a Cleveland importer copied almost all of Hyalyn's line.[1] In the 1970s, Hyalyn Porcelain, Inc. competed with Japanese manufacturers whose "modern equipment, good controls, and good engineering," according to Moody, produced excellent quality lines.[2] From the company's start, Moody understood the need for promotion, advertising, and a band of promoters and sellers who would generate a national market for Hyalyn Porcelain, Inc.'s products.

BRAND RECOGNITION

A functioning Hyalyn Porcelain, Inc. factory in 1947 led to contracts for lamp base production. Over time, this included companies like Westwood, Heifetz, Morris Greenspan Lamp Manufacturing, and Lightolier. Before Hyalyn Porcelain, Inc. made much artware, shipments of lamp bases traveled from Hickory for assembly into finished lamps elsewhere. Hyalyn Porcelain, Inc.'s lamp bases' quality did not go unnoticed, raising its reputation for excellence. Sometimes, Hyalyn-manufactured lamp bases bore the company's label. Yet for the most part, no one buying a Hyalyn-made lamp knew it. With artware, it was different. Every piece could show the name hyalyn, and Moody took full advantage of the opportunity.

Marking Hyalyn Porcelain took many forms (for Hyalyn Porcelain, Inc.'s marks, see the Appendix). At first, most molded bases included the word "hyalyn" and a shape number. Hyalyn Porcelain, Inc.'s No. 801 coupe "picture plates," No. 601 coasters, and No. 602 ashtrays were exceptions to this practice. Most No. 801 dish backs had a stamped, shield-shaped mark containing the words "hyalyn PORCELAIN" (in black or gold). Only the name "hyalyn" marked some coupe plate backs, often in gold. No. 602 ashtrays seem to have lacked molded marks, but most have the name "hyalyn" as it appears on some coupe plates, and the number 602 stamped on their base. Some No. 602 ashtrays bear a letter specifying the front's decalcomania pattern. Hyalyn Porcelain, Inc. marked some items—even some with embossed base marks—with shield-shaped, embossed foil-coated paper labels. These shield-shaped labels read "hyalyn PORCELAIN" or "hyalyn fine china." Hyalyn marked some No. 601 coasters with a stamped shield, though most bear no mark.

In 1953, Hyalyn Porcelain, Inc. introduced a logotype with "hyalyn" bound inside a circle. Wares made in the 1953–1954 (some to 1956) period bear this mark. Its short-term use, combined with low sales in 1954, may contribute to this mark's scarcity. Following his arrival in 1956, Hyalyn Porcelain, Inc. designer Herb Cohen created a new oval-shaped Hyalyn

Porcelain, Inc. logotype. Cohen inserted "hyalyn PORCELAIN" inside the oval. Workers applied a similar foil-coated paper label to finished artware. Versions of Cohen's oval mark appear on Hyalyn Porcelain, Inc. wares made from around 1956 until about 1962. Cork bases have a variety of Cohen's mark with "hyalyn PORCELAIN" inside the oval and USA below the oval. The oval mark's replacement is one made up by superimposing the word "hyalyn" over a line-drawing of Hyalyn's No. 299 bowl with an A-type pedestal—a design that may be Less Moody's own. Below the pedestal are the letters "U.S.A." and the words "AMERICA'S FINEST PORCELAIN." A trademark registration symbol appears nearby. Following Hyalyn Porcelain, Inc.'s sale in 1973 to Hamilton Cosco, the new company (Hyalyn Cosco) reintroduced an oval logotype. The molded mark has "hyalyn" inside, "U.S.A." below the oval, and a shape number above the oval.

Advertisements, promotional flyers, catalogs, company letterheads, and shipping containers displayed logotypes similar in design to the marks described above. Moody created the streamlined letter font used to spell out the words "hyalyn" and "porcelain" with exaggerated "h," "y," and "l" letters. This lettering style persisted from Hyalyn Porcelain, Inc.'s beginning to its end. The word hyalyn, spelled in this form with its lower-case letter "h," is incorporated into every company symbol and label.

Hyalyn Porcelain, Inc.'s early shield mark is bordered near its base by the words "style" and "quality" when printed. The company's succeeding circular mark is found in period advertisements and on nearly every page of Hyalyn Porcelain, Inc.'s 1953 catalog. Once made, Cohen's oval mark appears in its original form and its variations in newspaper and magazine ads, in catalogs, and on nearly anything printed. In the 1960s, Hyalyn Porcelain, Inc. used its trademarked logotype featuring a No. 299A floral arrangement bowl. In 1968, when porcelain production ended and semi-porcelain production began, Hyalyn Porcelain, Inc. dropped "porcelain" from its trademark.

ADVERTISING

With production successfully underway, Moody boosted Hyalyn Porcelain in trade journals. The promotions included articles and advertisements. A June–July 1957 issue of *The Counselor* (an advertising specialty industry magazine) contained a twelve-page illustrated article penned by Moody and Goodwill Ambassador division manager James Pugh. The piece described how Hyalyn Porcelain, Inc. made advertising specialty items.[3]

Ads highlighting some of the company's first products, including examples from the 200 line and 600 line, were placed in January 1948's *Giftwares and Housewares*, and *Crockery and Glass Journal* issues. Hyalyn Porcelain, Inc. offered catalogs, counter cards, and folders to wholesale buyers. In August 1948, *Crockery and Glass Journal* advertised No. 801 picture plates. In September, *The Gift and Art Buyer* included a sales pitch for Hyalyn Porcelain, Inc.'s No. 602 and No. 603 ashtrays—two sizes in six decorative patterns. *The Gift and Art Buyer* and *Crockery and Glass Journal* continued to be popular venues for Hyalyn-initiated advertisement. A January 1952 ad in *The Gift and Art Buyer* promoted ashtrays, cigarette cups, vases, planters, trays, candleholders, and "famous picture plates." *Crockery and Glass Journal's* March 1953 ad offered the company's recently released Pagoda Square Plates in a choice of thirty decorative patterns.

The cover layout for Hyalyn Porcelain, Inc.'s 1958 *Fall Additions* catalog was the same as a full-page ad placed in the June 1958 issue of *Living for Young Homemakers*. Lenoir, North Carolina's Broyhill Furniture Company purchased fourteen pages of the magazine's "Live High on a Low Budget" section to highlight a newly-constructed Cape Cod-styled house. Fully outfitted with the company's furniture, decorators extensively accessorized the residence with fifty Hyalyn Porcelain pieces.

In 1958, Hyalyn Porcelain, Inc. embarked on an ambitious television advertising campaign when the company offered ware as merchandise awards on the popular Art Linkletter's *House Party* show. CBS television and radio stations broadcast the show on 118 television and 210 radio stations nationwide.

In the 1950s and 1960s, Hyalyn Porcelain, Inc. conducted national print advertising campaigns. In 1959, an ambitious advertising drive placed ads in several shelter magazines. So-called shelter magazines focused on interior design and home design, furnishings, and landscape gardening. Hyalyn Porcelain, Inc.'s sales pitch to buyers was "Through the vigorous use of editorial and consumer magazine advertising in the leading shelter magazines, hyalyn is pre-selling for you 'AMERICA'S FINEST PORCELAIN.'" Display ads were placed in *House Beautiful*, *House & Garden*, *Living for Young Homemakers*,

◀ **Fig. 4.1** Hyalyn Porcelain, Inc.'s 1951 introduction of two new lines created by Charles Leslie Fordyce signaled a departure from traditional forms to more modern designs. Each of the lines, called Golden Bar (glazed in Oatmeal, Mossy Chartreuse, and Sahara Sand) and Free Form (glazed in Birch Gray, Forest Green, and Mink Brown), offered eight shapes. From *The Gift and Art Buyer*, August 1951. (*Courtesy of Mark Bassett*)

▶ **Fig. 4.2** Hyalyn Porcelain, Inc.'s 1958 *Fall Additions* catalog featured this promotion about C.B.S. T.V.'s popular *House Party* show host Art Linkletter. *House Party* participants received Hyalyn Porcelain as merchandise awards. That same year, the June issue of *Living for Young Homemakers* included a full-page reproduction of the 1958 *Fall Additions* catalog cover. The magazine's "Live High on a Low Budget" feature section incorporated more than fifty Hyalyn Porcelain, Inc., pieces. (*Historical Association of Catawba County*)

and *House & Garden's* 1960 *Book of Decorating and Entertaining*. At the time, *House Beautiful* claimed 700,000 readers. *Living for Young Homemakers'* 3,000,000 readers were called "prime prospects for hyalyn."

National campaigns continued in the 1960s, including ads featuring Hyalyn Porcelain, Inc.'s Portfolio Collection and Decorators Collection items. Readers were encouraged to order color brochures for a dime, and the fact that Hyalyn Porcelain was from Hickory, North Carolina, was highlighted in each ad.

In 1962, Hyalyn Porcelain, Inc.'s "One look and you'll know it's hyalyn" campaign placed ads in *Better Homes & Gardens Home Furnishings Ideas*, *House & Garden*, and *House & Garden's Book of Decorating*.

With much of Hyalyn Porcelain, Inc.'s advertising aimed toward wholesale buyers, retail Hyalyn Porcelain sellers reached out to their customers in places like *House Beautiful* and *The New York Times*. Honolulu's Liberty House department store was an early Hyalyn Porcelain, Inc. retailer whose ads frequently featured its products. Gift shops, florists, furniture, department, and hardware stores enthusiastically advertised Hyalyn Porcelain.

Product placement in others' ads was another plus for Hyalyn Porcelain, Inc. Following its release in 1953, examples of Michael Lax's Raymor Capri tableware found their way into illustrations and photographs accompanying food-related and modern-living magazine articles. In 1961, Ever-thine Flowers, of Los Angeles, promoted its colorful artificial flower arrangements as "exquisite duplicates of nature's own creation." A large, $20 wholesale-priced floral arrangement flows

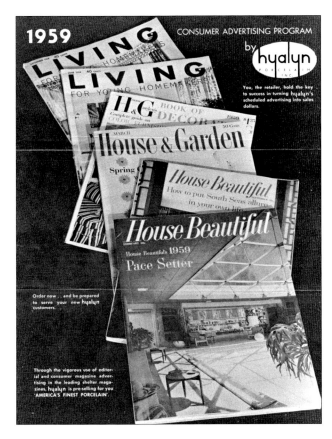

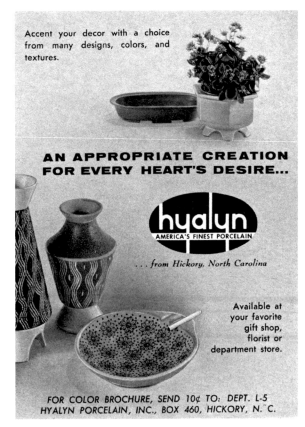

◀ **Fig. 4.3** In 1959, Hyalyn Porcelain, Inc., embarked on an ambitious national advertising campaign. The company placed ads in the country's leading shelter magazines like *Living for Young Homemakers*, *House & Garden*, and *House Beautiful*. (*Historical Association of Catawba County*)

▶ **Fig. 4.4** Illustrated, descriptive ads like this one for Hyalyn Porcelain, Inc.'s Decorators Collection appeared in shelter magazines. These promotions aimed to increase retail buyers' interest in the company's products while encouraging gift shop, florist, and department store buyers to add them to their inventories. (*Historical Association of Catawba County*)

Fig. 4.5 Hyalyn Porcelain, Inc. collaborated with retailers when placing newspaper advertisements like this one for Honolulu, Hawaii's Liberty House department store. The items shown include some of the company's first products described as "modern interpretations of ageless Chinese art." From the *Honolulu Star Bulletin* (Honolulu, HI), June 14, 1948. (*Newspapers.com*)

out from a pedestaled Hyalyn bowl in Ever-thine's advertisement. Sometimes, ads named Hyalyn Porcelain, Inc. alongside the seller's product. Breck's of Boston, in a 1963 ad, promoted its April artificial flower show with the claim that it "has the largest selection of artificial flowers in New England and the largest selection of Hyalyn Porcelain." "At Breck's," goes the ad, "artificial flowers and flower containers are a specialty, not a sideline."

CATALOGS

Less Moody wasted no time before putting out Hyalyn Porcelain, Inc. catalogs. The first may have been published in 1947. Hyalyn Porcelain, Inc. produced catalogs every year after that. As was his custom as Abingdon Pottery's manager, Moody used catalogs to promote wholesale sales. Hyalyn Porcelain, Inc. dated a few catalogs for a single year. But it was usual for Hyalyn Porcelain, Inc. to issue an annual catalog that bridged from spring of one year to spring of the next year (e.g., 1951–1952). A smaller supplement usually introduced new "fall additions." By the early 1950s, most catalogs used four-color printing to create full-color displays on front and back covers. Inside pages, though mostly printed in black and white, were sometimes printed in color. Each catalog included an order form making it easy for buyers to place orders.

Hyalyn Porcelain, Inc. made up specialty catalogs in collaboration with Raymor/Richards Morgenthau Co. and M. Wille Inc./Georges Briard Designs. One, made around 1958 for Raymor/Richards Morgenthau Co., featured Erwin Kalla's Casual Craft line, Michael Lax's Raymor Capri line, and Peerless Art Company's Basketry line. Its front cover shows a selection of Casual Craft items, whereas the back cover displays Raymor Capri in three colors: White, Blue Matt(e), and Mustard Yellow. Except for the Basketry line's catalog section's opening page, all other inside pages are black and white. Hyalyn Porcelain, Inc., with M. Wille, Inc., and Georges Briard Designs, issued a catalog for Briard's 1961 Midas line. Its full-color covers, front and back, enclosed ten black and white pages inside. In 1964, Hyalyn Porcelain, Inc. again teamed up with Raymor/Richards Morgenthau Co. when creating a catalog for Eva Zeisel's High Fashion line.

Single and multi-page flyers and brochures supplemented some specialty catalogs. Raymor/Richards Morgenthau Co., with Hyalyn Porcelain, Inc., produced one for Michael Lax's Raymor Capri and another for his and Rosemary Lax's Hi-Line items, one for large planter pots, and one for smoking accessories for the Casual Craft, Raymor Capri, and Basketry lines. M. Wille/Georges Briard Designs and Hyalyn Porcelain, Inc. released a bifold brochure featuring the Midas line in gold and silver. On its own, Hyalyn Porcelain, Inc. created supplements to promote its Fruit Creations and Flower Creations products and its Paisley line, designed by Lee Bernay.

Fig. 4.6 Catalogs and sales flyers provided Hyalyn Porcelain, Inc.'s wholesale buyers opportunities to choose from the company's best sellers and new offerings. Hyalyn Porcelain, Inc., produced a complete catalog annually, which usually was followed by a fall catalog promoting new items. (*Historical Association of Catawba County*)

TRADE SHOWS

Participation in trade shows contributed to Hyalyn Porcelain, Inc.'s success. Less Moody ensured that the company, from its earliest years of operation, was represented at most, if not all, national gift and floral trade shows. He often staffed Hyalyn Porcelain, Inc.'s exhibits himself.

These trade shows introduced new customers to Hyalyn Porcelain, Inc. and showcased its new lines and new items recently added to existing lines. Since many competing companies were present, the shows were occasions to review others' products and prices. They provided Moody, or anyone representing Hyalyn Porcelain, Inc., the chance to network with other industry leaders and representatives.

SHOWROOMS AND SALES REPRESENTATIVES

When Hyalyn Porcelain, Inc.'s first line of ware was market-ready in 1947, Moody displayed its items in important wholesale market showrooms. His marketing strategy is outlined in a May 29, 1947 letter written to Chester Heppberger of Naperville, Illinois:

> When I was in Chicago the last time, I succeeded in getting that territory pretty well lined up, so have been devoting my time in arranging representatives in other parts of the country. Now, I am happy to say that that job is pretty well set and we will be going into the fall season with our line in show rooms in New York, Chicago, Dallas and Los Angeles and will have traveling salesmen in every state in the Union. It isn't at all easy to introduce a new line, a new name and new merchandise in the present market. Present day business means a great number of small orders, so it requires pretty thorough coverage of all territories.
>
> Everything seems to be shaping up fine. The line has been well received and we are anticipating a good fall business on our new merchandise. If I don't get to Chicago sooner, I most certainly will be there during the first week of August which is the time of the Chicago Gift Show. The results of that show will greatly determine the prospects for increased business this fall.[4]

Throughout Hyalyn Porcelain, Inc.'s years of operation, permanent displays were maintained in various cities nationwide, including Atlanta, Boston, Burlington (MA), Chicago, Dallas, Detroit, Kansas City, Los Angeles, Miami, Minneapolis, New York, San Francisco, and Seattle.

Distributors representing Hyalyn Porcelain, Inc. in these cities included Walter Crowell Company, Harry A. Neville, G. L. Wennerstrom and Associates, Thomas & Moore, Pryor & Co., Linn Myers, Inc., K. R. Cahill Company, Ira A. Jones Company, Eddie Parker Sales, Hixson Enterprises, Inc., Hixon-Williams Company, The Halperin Company, Nettie L. Reife Rucka, Johnson Associates, The Buchel Company, Rubel and Company, Van Dow-Fenton, Clayson Carlson, H.P. and H.F. Hunt Co., F. J. Tiedeken Co., Sterling Bell Associates, The Weikels, Anderson and Romaine, Robann of California, Marshall-Kaye Inc., C. A. McMinn, Howard Gardiner, Inc., and M. L. "Mike" Alpert.

Manufacturers representatives' territories encompassed the lower forty-eight states, Hawaii, Puerto Rico, and Canada. Among those representing Hyalyn Porcelain, Inc. were Hal M. O'Brian, Robert G. Vinz, George E. Marston Co., Church Bros., Pauline Paul, D. Jessup King, Leo Neuburger, W. C. Wentz Co., Nettie L. Reife Rucka, Lynn V. Jones, Columbine Company, Johnson Associates, Robert Snoddy, Sue Simonsen, Kilani Sales, Stratford Sales, Ltd., Ascencio Trading, Dave Latz, Paul Stoker, Clinton A. Johnson, Robert Erbe, Allyn Nelson, Frank R. Coonan, Co., Douglas C. Cofeill, George Hager, and Robert and Cynthia Penn.

Less Moody conducted annual sales meetings in North Carolina and at other times in other U.S. locations. Moody and staff introduced new designs, ware lines, and promotional and advertising plans. Sales representatives offered ideas for new products. Moody offered ways to incentivize buyers. For example, Moody proposed a "Baker's Dozen" plan as a "sales pitch for bigger orders." The Baker's Dozen program encouraged buying in dozen lots. For every dozen of any Hyalyn Porcelain items sold to regular accounts, the customer received a free thirteenth item. Hyalyn Porcelain, Inc. offered special prices on products to help sales representatives "land that new customer, offer a favor to an established customer, or to get your foot in the door for a re-order."

An undated poem, presumably written by Moody, sums up what he expected from persons selling Hyalyn Porcelain.

HOW TO BE A SUCCESSFUL HYALYN SALESMAN
I wish that I could give you some magic word or phrase
To guarantee you each success on all your working days.
Alas, I've no such knowledge. What I've gleaned of selling lore,
You too have read and heard it and practiced it before.
But the longer I'm in business, the more I realize
There's one basic fact in selling which you cannot compromise.
And around each word of counsel this simple truth will lurk:
In all the salesman's know how, there's no substitute for work.
You may have the finest product to be had throughout the land,
You may have the smoothest sales talk that a salesman ever planned,
But this truth is there to haunt you, to chide you, and to gall,
You'll never make a sale until you make the call!
And when your score is tallied to see how well you played,
Your sales are in proportion to the contacts that you made.
There is no magic formula to regulate our days,
It's a job in which persistence is the quality that pays.
So when you're tired, discouraged, somewhat inclined to shirk,
Remember that the experts have found no substitute for work.[5]

Aimcee Wholesale Corporation and Frederick Wholesale Corporation represented about 130 retail stores, including Bloomingdale's, Bullock's, Thalhimer Brothers, Liberty House, City of Paris, R. H. Stearns, and others. Stores placed orders for Hyalyn Porcelain, Inc. products through these wholesalers, who collected payment and paid Hyalyn Porcelain, Inc. for the sales. Sales representatives were responsible for calling on store employees whose jobs included placing orders for Hyalyn Porcelain, Inc. products.

Moody believed that useful information shared with customers resulted in sales. For example, he often promoted Hyalyn Porcelain, Inc.'s porcelain-making process, and he encouraged his sales team members to explain it to customers. One early catalog described the procedure from start to finish. Hyalyn Porcelain, Inc. loaned a photographic slide show to garden clubs. It sold a booklet about flower arranging written by Mary Jo Napier when the company released the Rachel Carr Collection of bowls and vases for flower arrangement. Moody explained the booklet's value to his sales team when he wrote:

> Your best market will be the gift shop and department store that has a strong connection with Garden Clubs and floral designers. Any housewife who is interested in flower designing, should be interested in this booklet, which is the first of its kind to really cover basic floral designing in simple step by step form. Acquaint yourself with this book and tell all of your customers about it. Be sure that this booklet is on display in all salesrooms for it attracts attention, promotes Hyalyn and creates additional sales.[6]

In 1964, Moody did a remarkable job creating an analysis for sales potential throughout U.S. regions. The information included projections for how many sales might be realized, given proper attention, in towns, cities, and counties on a state-by-state basis. The report rated each area on sales activity and a quality index. Moody measured a location's sales activity against 100 percent, so it was lower in some places, and in others higher, to show the best sites for sales. The quality index was Moody's assessment of whether an area's residents were more likely to buy better or lower quality merchandise. Moody's detailed reports made it possible for representatives to focus on locations where higher sales were more likely.

CONTRACT SALES

In addition to contract lamp base sales, which were always a reliable source of income, Hyalyn Porcelain, Inc. also accepted contract orders for specialty items. Often made for businesses and civic organizations, these items (often ashtrays) usually carried the entity's logo or trademark and sometimes other information pertinent to the event or promoted product. For example, Hyalyn Porcelain, Inc. made ashtrays (or trinket dishes) in the shape of U.S. states marked on their bases Emrich's and State of the Union. A small figurine, called a *Kay Award*, was designed by Frances Moody for annual presentation to Hickory Community Theatre's outstanding volunteers and actors. After Hyalyn Porcelain, Inc. made them, these awards were produced by World of Ceramics until about 2001–2002.[7] Frances Moody's *Beauty Queen* figure, completed in 1962 to be presented to Miss America pageant contestants, is a significant example of her contribution to Hyalyn Porcelain, Inc.'s success.

FACTORY RETAIL SALES

On Friday, September 7, 1956, Hyalyn Porcelain, Inc. opened a factory salesroom on the Lenoir Highway in Hickory, North Carolina. A three-day grand opening event offered lamp bases, art ware, vases, bowls, planters, and decorative accessories. Hyalyn Porcelain, Inc. designer Herb Cohen drew up a clever bifold pamphlet promoting the store that included a directional map inside. Hyalyn Porcelain, Inc. wisely operated its outlet store near U.S. highways 70, 64, and 321 on routes used to reach the Blue Ridge Mountains, making it an ideal site for retail sales to travelers and residents alike.

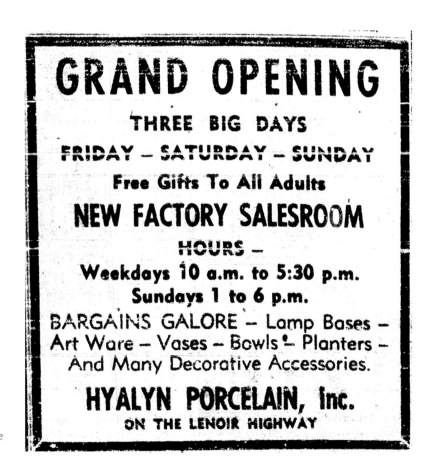

Fig 4.7 Many residents, along with travelers passing through Catawba County, enjoyed shopping for first and second quality Hyalyn Porcelain, Inc. items in its factory salesroom. Opened on September 7, 1956, the popular outlet sold lamp bases, artware, and decorative accessories. (*Newspapers.com*)

Fig. 4.8 and Fig. 4.9 Hyalyn designer Herbert Cohen created this clever promotional flyer to promote the company's new factory salesroom opening. In part, the piece reads: "A visit to the hyalyn factory salesroom is a must stop on your trip through western North Carolina ... Here in a new addition to the factory you can see and buy the many beautifully styled and colorful items manufactured in America's most modern porcelain plant." (*Historical Association of Catawba County*)

5

POST-HYALYN PORCELAIN, INC.
(1973–1997)

In 1962, Less Moody discovered that nothing would stop you in your tracks like a heart attack. He described the onset of his illness in a letter written to Russell Price:

> I judge that you have been made aware of the event of January that completely changed my activities pattern. After our wonderful visit in Atlantic City, I had the best of intentions of acknowledging that visit and reviewing the program in a letter. After the Atlantic City Show I had to prepare for my Annual Stockholders' Meeting on January 17. On the 18th I flew to Columbus for the American Ceramic Society program meeting on Saturday flew from there to Atlanta for the Atlanta Show. I returned to Hickory, N.C., late on Monday night and the heart attack caught me at about 7:30 P.M. Tuesday.[1]

On January 23, 1962, Less Moody's heart could no longer keep up with his labors' pace. While managing Hyalyn Porcelain, Inc.'s operation, representing the company at shows, and leading the American Ceramic Society's Design Division, Moody's heart said, "take a break." The information he gained while in Atlantic City that a Cleveland importer had copied almost all of Hyalyn Porcelain's product line undoubtedly compounded these pressures.[2] During his recuperation period, Frances Moody picked up some of Less's work-related responsibilities. David M. Latz of Linn Myers, Inc. acknowledged her excellent work:

> I am sure you know that the best information we have received in a long time was your bulletin of January 26th. We see that Les's [sic.] abilities to write outstanding sales bulletins has rubbed off a little bit on you.
> Everyone in our organization is rooting for Les and praying for his complete and speedy recovery.
> Frances, we know you are most capable of handling the situation, but with so much to do, if there is anything at all we can do to help Les or yourself, please let us know at once.[3]

Once adequately recovered from his heart attack, Moody again busied himself with Hyalyn Porcelain, Inc.'s business, but his heart attack was not the last of his health concerns. In 1973, Moody was diagnosed with lung cancer. With this fact revealed, and with his desire to retire made known, Moody and Hyalyn Porcelain, Inc.'s directors sought a company buyer. In 1973, Hamilton Cosco of Columbus, Indiana, offered to purchase Hyalyn Porcelain, Inc. Hyalyn's directors accepted the lamp base customer's offer. Unfortunately, just days after the company's sale, Moody entered the hospital for rest and rehabilitation, had a heart attack, and died on November 16, 1973.

Hyalyn Cosco, Inc.

On November 13, 1973, just days before Moody's hospitalization, a Columbia, Indiana, newspaper report announced Hamilton Cosco's acquisition of Hyalyn Porcelain, Inc. The company's owner, Clarence O. Hamilton, said that "the acquisition, when consummated, will assure our Tyndale subsidiary of a reliable source of high-quality lamp bases to enable it to meet the increasing demand for ceramic-based lamps."[4] At the time, Hyalyn Porcelain, Inc. mostly produced lamps for Tyndale, Rembrandt, and Stiffel. Hamilton Cosco gave the company the name Hyalyn Cosco, Inc. Hyalyn Cosco, Inc. operated as a separate company, producing lamp bases for Tyndale Cosco, Inc. and other buyers, artware, and kitchen and specialty items. The sale transferred all Hyalyn Porcelain, Inc. design rights and molds to the company's new owner.[5]

Hamilton's Hyalyn Cosco purchased Wilmar Company, Inc. and Morris Greenspan, Inc. in 1969. Greenspan established Wilmar Company, Inc. and registered the Tyndale trademark in 1946.[6] Later on, Greenspan opened a new lamp business named Morris Greenspan Lamp Manufacturing. Hyalyn Porcelain, Inc. made lamps for Greenspan's new company.

In December 1973, Colorado Springs, Colorado, native Robert E. Warmuth was named president and general manager of Hyalyn Cosco, Inc. His academic training from the University of Colorado included a degree in civil engineering and business. Warmuth lacked any ceramics industry experience. Before becoming Hyalyn Cosco, Inc.'s manager, Gallatin Aluminum Products, Inc., Cast-O-Matic, Samsonite Corporation, and Proctor and Gamble employed Warmuth.[7] While working in Gallatin, Tennessee, Warmuth became acquainted with Redman Industries' president. Redman Industries was a division of Hamilton Cosco. This relationship led to his employment by Hyalyn Cosco, Inc. Longtime Hyalyn Porcelain, Inc. employee Ben Crews was the plant manager, and Chet Maxwell was responsible for mixing the shop's glazes. A Clemson University-trained ceramics engineer named Alex Corpening followed Ben Crews as plant manager.[8]

Warmuth set about reassuring employees that the company would continue to operate as a lamp base and artware manufacturer. Warmuth faced immediate challenges. The 1973 oil crisis nearly cut off natural gas supplies to the factory. Hyalyn's fuel-hungry tunnel kilns required more fuel than the company's 5,000-gallon propane fuel tank could supply. Warmuth added a 30,000-gallon propane tank, and trucks delivered the fuel.[9]

During the company's four-year operation as Hyalyn Cosco, Inc., lamp base production increased, and the number of employees nearly doubled. Production changes led to the use of earthenware clays for lamp bases and the application of commercially mixed glazes. Hyalyn Porcelain, Inc.'s lower case hyalyn spelling became Hyalyn in promotional materials. Cataloged artware and decorative accessories sales continued. More retail stores opened in North Carolina cities, including Burlington, Cary, and Greensboro. Customers bought lamp bases and lamp parts and assembled lamps from them.[10] Store items sold were first and second quality.

The final Hyalyn Porcelain, Inc. catalog, issued in 1973, exhibited numerous undecorated and decalcomania-decorated canister sets, cookie jars, ashtrays, other smoking accessories, snack servers, salt and pepper shakers, hot plate tiles, a chinoiserie-decorated China Clipper group of decorative accessories, candle holders, planters, pots, and vases. Many items were old designs covered up with new glaze colors and decalcomania. No semblance of Less Moody's longstanding ambition for creative design remained. In fact, by the

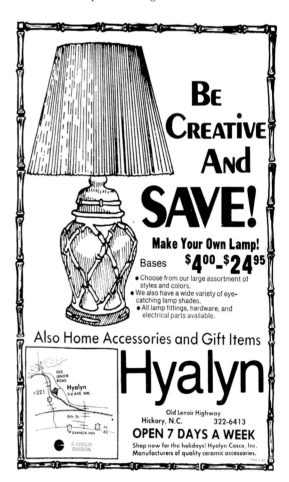

1970s, Hyalyn Porcelain, Inc. imported blank ceramic tiles for decorating. This circumstance is demonstrated in a letter from Less Moody to Charles R. Post of the H. P. and H. F. Hunt Company of Burlington, Massachusetts.

> We have delayed in bringing this up for daily we felt that the dock strike would be settled and that we would be able to get in our supply of tiles that are long overdue.
>
> It is a strange situation that no American tile manufacturer makes tile for hot plate tiles or decorating. All American manufacturers put side lugs on them for placing on bathroom walls or floor. Therefore all tile decorators are involved in using an English tile ... We're still hopeful that very shortly the dock strike will be settled but even then it will be two to three weeks before the boats are unloaded and we can get our shipment.[11]

Hyalyn Cosco, Inc.'s first catalog, issued in 1974, nearly matches Hyalyn Porcelain, Inc.'s last one. A couple of new cookie jars, a ball-shaped pencil holder, a sugar jar shaped like a vintage milk can, a pitcher, and a few additional items are barely noticeable additions. Besides Bamboo & Cane's design, little else changed about its non-lamp base offerings in subsequent years.

Mark Seacrest, Hyalyn Porcelain, Inc.'s marketing manager hired by Less Moody shortly before the change to Hamilton Cosco, Inc., created Bamboo & Cane for Hyalyn Cosco. Seacrest provided advice about new products and oversaw annual catalog production. After Hyalyn Porcelain, Inc.'s sale in 1973, no in-house designer was employed by Hyalyn Cosco, Inc., Hyalyn Ltd., or Vanguard Studios.[12]

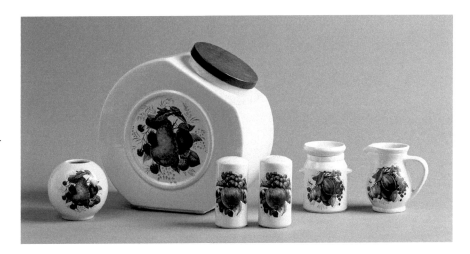

Previous page:
Fig. 5.1 In 1973, stockholders sold Hyalyn Porcelain, Inc., and the company name was changed to Hyalyn Cosco, Inc. Robert Warmuth became the plant's general manager. Besides home accessories and gift items, factory showroom customers could purchase parts and make lamps from Hyalyn Cosco lamp bases. From *The Charlotte Observer* (Charlotte, NC), November 24, 1977. (*Newspapers.com*)

▲ **Fig. 5.2** Hyalyn Cosco, Inc., abandoned many Hyalyn Porcelain, Inc., forms in favor of kitchen accessories like these made in 1974. (L–R) Nos. 910; 200D; 900; 907; and 906. (*Stephanie Turner Photography*)

▼ **Fig. 5.3** All of Hyalyn Porcelain, Inc.'s molds transferred to Hyalyn Cosco, Inc. These pieces, initially released by Hyalyn Porcelain, Inc., in 1964–1965 as part of its Decorator Collection, were offered by Hyalyn Cosco, Inc. under the name "Aztec." (*Stephanie Turner Photography*)

Fig. 5.4 First introduced in 1974, Hyalyn Cosco's Bamboo & Cane line proved to be one of the new company's best sellers. Each piece was available in Cane Yellow, Blue, Honey Brown, or White. (*Historical Association of Catawba County*)

Fig. 5.5 In 1977, Hyalyn Cosco, Inc., added a lidded ginger jar (No. 824, left) to Hyalyn Porcelain, Inc.'s previously popular China Clipper line. Bamboo & Cane, No. 304 (center). Multi-color planter, No. M221 (right). (*Stephanie Turner Photography*)

HYALYN, LTD.

In 1977, ownership of the company, first known as Hyalyn Porcelain, Inc., changed again. Cosco decided to sell subsidiaries Hyalyn Cosco, Inc. and Tyndale Cosco, Inc., and in July 1977, Arnold J. Karmatz of Melville, New York, agreed to purchase the company.[13] The planned purchase fell through, and by November 1977, Hyalyn Cosco, Inc.'s general manager, Robert E. Warmuth, acquired the business.[14] Warmuth changed the name to Hyalyn, Ltd., and the company's slogan became "Hyalyn: CRAFTSMEN OF FINE CERAMIC."

With Warmuth as the company's owner, the focus on lamp base production grew, and artware, giftware, and other product manufacture diminished in importance. From customers' drawings or prepared molds, Hyalyn, Ltd. made lamp bases for Chapman, Frederick Cooper, Ethan Allen, Paul Hanson, Nathan Lagin, Morris Greenspan, Lightolier, Westwood, Rembrandt, and Stiffel. Perhaps for the first time since the company's start, a Hyalyn-related company's own lamps, complete with shades, were shown in the late-1970s and early-1980s catalogs. Hyalyn, Ltd. manufactured ceramic picture frames for Burnes of Boston. According to Robert Warmuth, the arrangement with Burnes was a boon to business lost too soon to Taiwanese manufacturers.[15]

Hyalyn, Ltd.'s location, in the heart of North Carolina furniture-making country, made it a logical move for Warmuth to focus on the home decorating market. The company made many items for Levitz Furniture. In addition to ashtrays, Hyalyn, Ltd.'s Accent on Color line included vases and lidded ginger jars ranging from 6–24 inches tall, in colors like Mirage Blue, Black, Forest Green, Peach, Sage, Almond, Plum, Dusty Rose, Fawn, Terracotta, Mauve, Sky Blue, and Cinnamon.

In the 1980s, Hyalyn, Ltd. offered decorative collections, including some harvested from Hyalyn Porcelain, Inc.'s past, in various glazes. Groups like the Vintage, Crystal, Lace, Mosaic, Gemstone, Luster, and Silhouette collections were less about form and more about glaze color and texture. The Lace Collection, for example, achieved its finish by firing a unique decal into the ware at 1,950 °F. The Crystal Collection had a colored lower section, with a layer of crystalline glaze above it. With a matte black glaze covered over its top with a glossy, colored glaze, the Silhouette Collection looked remarkably like Less Moody's original "Two-color Matt Black Modern" glazing.

Fig. 5.6 Robert Warmuth, Hyalyn Cosco, Inc.'s general manager, purchased the company in 1977 and renamed it Hyalyn Ltd. These items represent some of the new company's products made in the 1970s and 1980s. (L–R) Nos. 441; 860; 866; 459; and 457. (*Stephanie Turner Photography*)

Fig. 5.7 Hyalyn Ltd. lamps. Although Robert Warmuth sold Hyalyn Ltd. long ago, a Greensboro, North Carolina business named Hyalyn Lamps (hyalyn Shades and Repairs), a Warmuth family enterprise, remains open, carrying on the Hyalyn name today. (*Stephanie Turner Photography*)

◄ **Fig. 5.8** Decorative items from Hyalyn Ltd., 1987. (*Historical Association of Catawba County*)

► **Fig. 5.9** Decorative items from Hyalyn Ltd., 1987. (*Historical Association of Catawba County*)

Fig. 5.10 Decorative items from Hyalyn Ltd., 1987. The company sold large animal figures and some sculpted figures made from molds designed by Frances Moody, like the three geisha figures named *Yako*, *Kiku*, and *Haru*. (*Historical Association of Catawba County*)

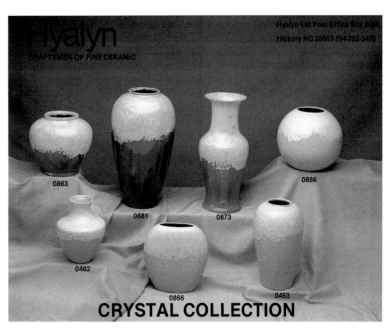

Fig. 5.11 "Crystal Collection" from Hyalyn Ltd., *c.* 1987–1989. (*Historical Association of Catawba County*)

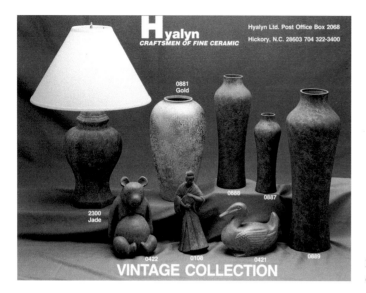

Fig. 5.12 "Vintage Collection" from Hyalyn Ltd.,
c. 1987–1989. (*Historical Association of Catawba County*)

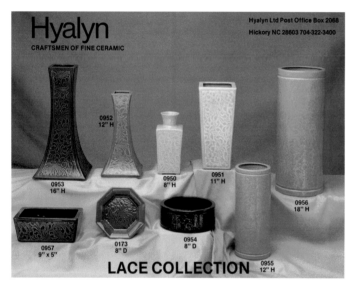

Fig. 5.13 "Lace Collection" from Hyalyn Ltd., c. 1987–
1989. (*Historical Association of Catawba County*)

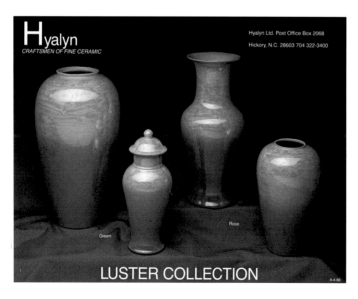

Fig. 5.14 "Luster Collection" from Hyalyn Ltd., c. 1987–1989.
(*Historical Association of Catawba County*)

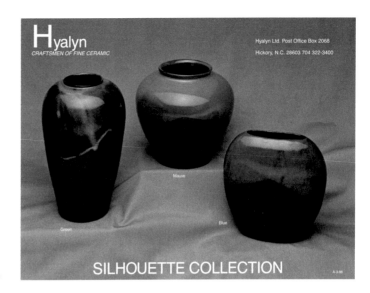

Fig. 5.15 "Silhouette Collection" from Hyalyn Ltd.,
c. 1987–1989. (*Historical Association of Catawba County*)

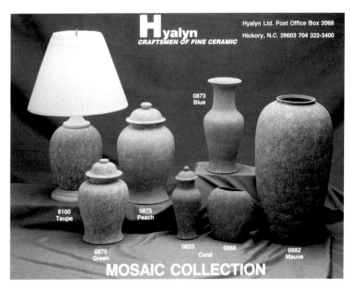

Fig. 5.16 "Mosaic Collection" from Hyalyn Ltd.,
c. 1987–1989. (*Historical Association of Catawba County*)

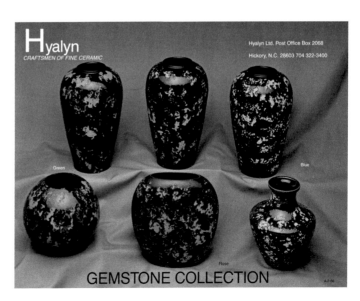

Fig. 5.17 "Gemstone Collection" from Hyalyn Ltd.,
c. 1987–1989. (*Historical Association of Catawba County*)

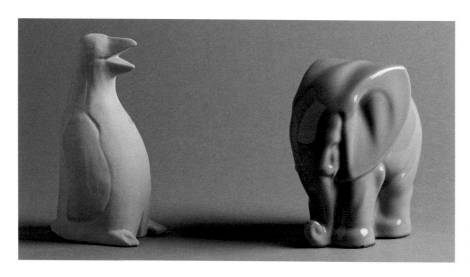

Fig. 5.18 Hyalyn Ltd. *Penguin* (No. 425) and *Elephant* (No. 423), *c.* 1987–1989. (*Stephanie Turner Photography*)

Warmuth's Hyalyn, Ltd. sold three of Frances Moody's sculpted figures called *Haru*, *Kiku*, and *Yako*. The company's figural collection included a bear, duck, penguin, elephant, cat, rabbit, and giraffe. According to Robert Warmuth, company representatives brought back interesting ideas from gift shows, which Hyalyn Cosco and Hyalyn, Ltd., in turn, made into new products.[16]

HYALYN CERAMICO/VANGUARD STUDIOS

Robert E. Warmuth's ownership of Hyalyn, Ltd. ended after a dozen years in late 1989, when Mike Greely's Vanguard Studios of Los Angeles, California, purchased the company. Warmuth stayed on as the general manager for Vanguard Studios until he left in 1993.[17] Hyalyn, Ltd.'s Raleigh and Burlington factory outlet stores closed. Robert and Beth Warmuth, and their daughter, Lynne, opened a retail lamp shop called Hyalyn Lamps in the company's former Greensboro, North Carolina, outlet location. Although in another Greensboro location today, the lamp shop remains open in 2021.

Vanguard manufactured lamps and home accessories, including framed art prints, tailored to sell to furniture market buyers. The company's products included large-scale wall decorations made at their California factory.

Vanguard received all of Hyalyn's designs and molds. Plant manager Alex Corpening moved the company away from its use of tunnel kilns—which required constant heating, high fuel use, and around-the-clock oversight—to use a periodic kiln.[18] Vanguard continued operation of Hickory's former Hyalyn Porcelain, Inc./Hyalyn, Ltd. retail outlet where customers could purchase art, paintings, lamps, statuary, and mirrors.

In November 1995, Lisa Tarlton O'Hair was named director of marketing for Vanguard Studio's Hickory facility. Her responsibilities included product development, working with the company's sales force, and instituting marketing programs for its Los Angeles office.[19] In 1997, Vanguard Studios of North Carolina, Inc. sold two tracts of land and the factory to Fiber and Yarn Products, Inc. The site sold for $420,000.[20] With the purchase made, the manufacture of ceramics ended where it began in 1946 when Hyalyn Porcelain, Inc.'s tunnel kiln turned out the first porcelain ware.

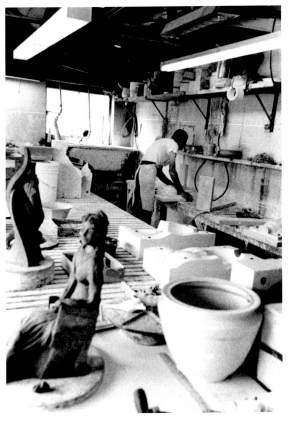

AFTER MARKET SALE

Vanguard Studios Factory Store
(formerly Hyalyn Porcelain)

Entire Store

30 to 50% OFF
ALL HOME ACCESSORIES

Showroom Samples ~ Discontinued and Slightly Imperfect Merchandise
Art ~ Paintings ~ Lamps ~ Statuary ~ Mirrors
The values will be outstanding!!!!

May 23ʳᵈ and May 24ᵗʰ

585 11th Street NW (old Lenoir Road) • Hickory, NC
10:00-5:00 Friday - 10:00-4:00 Saturday

(704) 322-6413

CASH, CHECK, VISA, MASTERCARD ACCEPTED

◄ **Fig. 5.19** Following the sale of Hyalyn Ltd. to Vanguard Studios in 1989, the new company made decorative items for home and commercial display. Seen in this 1993 image, a Vanguard Studios molder works in the same space utilized for decades by Hyalyn Porcelain, Inc., and Hyalyn Ltd. artisans. (*Sheri Dickson photo. Historical Association of Catawba County*)

► **Fig. 5.20** Like the two companies that preceded it, Vanguard Studios made sales through the factory store. As this 1997 advertisement indicates, Vanguard Studios offerings included art, paintings, lamps, statuary, and mirrors. Later in the year, Vanguard Studio's owner closed the company and sold the property to a textile-related business. From *The Charlotte Observer* (Charlotte, NC), May 23, 1997. (*Newspapers.com*)

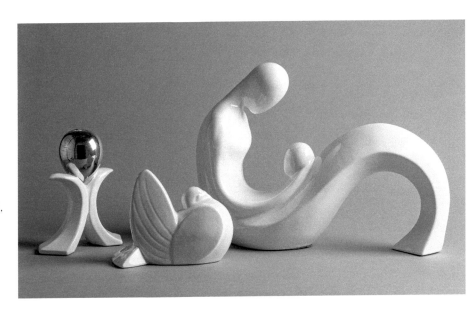

Fig. 5.21 Vanguard Studios products. The candleholder (left), No. 330646, and the mother and child figure (right), No. 330620, are marked Vanguard Studios. The bird (No. 101) is marked Vanguard Accents. (*Stephanie Turner Photography*)

Fig. 5.22 The Vanguard Studios *Seagull* (No. 105), seen here, is a Frances Moody design. *Bears* (No. 436) and *Giraffe* (No. 330642) are marked Vanguard Accents. (*Stephanie Turner Photography*)

Fig. 5.23 Vanguard Studios products. (L–R) *Duck*, No. 421; *Cat*, No. 424; and *Rabbit*, No. 420. (*Stephanie Turner Photography*)

Fig. 5.24 Vanguard Studios products. (L–R) Nos. 330696; 710; and 652. All marked Vanguard Accents. (*Stephanie Turner Photography*)

6

HYALYN'S PRODUCTS

Less Moody recognized that good design was essential to the successful sale of mass-produced ceramics. He believed that Hyalyn Porcelain, Inc. would "produce the best designed line on the market." This belief, impressed upon him by Ohio State University's Arthur Baggs, who was himself inspired by Charles Fergus Binns' ideals, guided Hyalyn Porcelain, Inc.'s product development.

When describing Ohio State University's fledgling ceramics department, Baggs said that "This course we are starting at Ohio State is merely carrying on the [Binns] torch with the special motive of furnishing more artistic fuel for the large industrial furnaces."[1] Baggs was aware of the challenges facing students who would become designers and engineers for making mass-produced ceramic ware. Of his training program, he said:

> We hope to inspire high artistic ideals but we intend to frankly accept the fact that to be an industrial designer one must adapt his artistic expression to the limitations of volume production and the general style trends which determine quantity distribution. I, for one, refuse to believe that a thing must be cheap art to sell cheaply and in volume. I think it is a most interesting challenge to the artist to prove that fine, tasteful products can be made and sold with equal or greater success than that attained by wares of mediocre or bad artistic conception.[2]

With his "good design" goal in mind, Moody introduced new items every year (sometimes twice each year) as he discontinued some old ones. The company's fresh ideas ensured that Hyalyn Porcelain, Inc.'s offerings were attentive to customers' changing interests. The challenge to regularly introduce new products in time for catalog production, advertisement, and national sales markets was daunting. The procedure, as described by Herb Cohen, was multi-faceted and time-consuming.

First, the designer made and modified three-dimensional "clay sketches" of a proposed product. This step might include wheel-turning and hand-modeling, using a clay body provided by the casting department for this purpose. Hyalyn Porcelain's slip-casting porcelain clay was not suited for wheel-turning. Each design required detailed, measured drawings. Using the model and measurements, plaster department workers made molds. Finally, casting department employees determined when workers could reliably produce a design.[3]

Moody had solutions for maintaining customer interest in Hyalyn Porcelain's products. Typically, an in-house designer created original models and modified shapes suggested by Moody or other employees. Early on, Less and Frances Moody contributed designs. Many of Hyalyn Porcelain, Inc.'s first products resembled shapes and decorations made by Abingdon and Rookwood potteries. By the late 1940s, both formerly successful operations were in decline. Changing post-war tastes leaned toward more modern design. To address this requirement, Moody sometimes purchased freelance designers' creations.

In addition to Less and Frances Moody, Edgar Littlefield and Wilhelmine Rehm provided some of Hyalyn Porcelain, Inc.'s first product designs. Moody engaged artists like Edwin Megargee and Dale Ulrey to create decalcomania for overglaze decoration. Moody attracted capable designers like Herbert Cohen, who were trained in some of the nation's finest university

ceramics departments. Sometimes, Moody teamed up with independent designers like Charles Leslie Fordyce. Fordyce created 1951's Golden Bar and Free Form lines. Lee Bernay designed Hyalyn Porcelain, Inc.'s Paisley line for release in 1966. That same year, it introduced its Rachel Carr Collection, named for the famed expert in floral arrangement. Hyalyn Porcelain, Inc. produced products for Raymor/Richards Morgenthau Co. created by contract designers like Michael Lax, Erwin Kalla, Eva Zeisel, and for M. Wille, Inc., distributor for Georges Briard's uniquely decorated Midas Gold and Silver line of ware. Placing these significant mid-twentieth-century product designers' names alongside Hyalyn Porcelain, Inc.'s name indisputably boosted the company's reputation and sales. The value of the company's relationship with Raymor/ Richards Morgenthau Co. and M. Wille, Inc. is incalculable.

Hyalyn Porcelain, Inc.'s 1953 annual and fall catalogs presented unattributed designs, including a pebble grain finish on some previously known forms and six new shapes; square pagoda plates and ashtrays; a TV lamp; four shapes making up the new Etruscan Group; a distinctively modern-looking Contour Group; a two-piece snack service; and nearly a dozen additions to the Garden Club Line. A yet-to-be-named in-house designer may have created these new items. A December 1954 news article announced Robert Sigmier's employment as Hyalyn's staff designer. By March 1956, Herbert Cohen took over Sigmier's role. Cohen remained at the job until 1958. Dean Russell Hokanson was the company's designer following Cohen's departure until around 1961 or 1962. After Hokanson, Robert D. Mitchell and James C. Pyron created most of the company's in-house designs.

Mitchell and Pyron first worked together before Pyron took on the task alone. Hyalyn Porcelain, Inc. offered few creatively envisioned designs between Pyron's departure around 1967 and Hyalyn Porcelain, Inc.'s sale of the company to Hamilton Cosco in 1973. This time was a rare period when Hyalyn Porcelain, Inc. employed no one as an in-house designer.

Hyalyn Porcelain, Inc. switched from porcelain to a semi-porcelain clay body in 1968. This clay required less fuel since it fired to a lower temperature than porcelain. Also, new glaze colors, not suitable for porcelain production, were used. Moody announced the release of an entirely new line of ware that year.[4] Despite his claim, the company's 1968 catalog included many former offerings. In early 1969, Less Moody employed Salisbury, North Carolina native, John Frank Frye, to lead its production. Trained as a ceramic engineer at North Carolina State University, Frye was a member of the American Ceramic Society, National Institute of Ceramic Engineers, and Keramos, an honorary ceramist organization.[5] It is not known if any new designs issued after 1969 were his.

Unfortunately, the skills and past achievements of talented Hyalyn designers and artists did not guarantee success. Some individual shapes, and sometimes entire lines of ware, proved to be of little interest to consumers—Moody called them "duds"—and were dropped from production.

The following brief biographies for identified in-house and contract designers, illustrators, and decorators demonstrate the measure of design expertise employed by Hyalyn Porcelain, Inc. Less and Frances Moody's contributions are discussed earlier in Chapter One. Unquestionably, others not identified here contributed to Hyalyn's design successes.

NOTEWORTHY DESIGNERS AND DESIGNS

Harvey Leslie Moody
(see Chapter One)

CATALOG No. 21

ABINGDON POTTERY
PRODUCT OF
ABINGDON SANITARY MANUFACTURING CO.
ABINGDON, ILLINOIS

Left:
Fig. DD.1 The front cover of Abingdon Pottery's first artware division catalog (1934) featured the company's No. 309 Neo-classic Vase. Described as "A modern adaptation of the ancient Greek Bell Crater urn," the object's design is attributed to Abingdon Pottery's first general manager, H. Leslie Moody. (*Historical Association of Catawba County*)

Below left:
Fig. DD.2 The similarity of Hyalyn Porcelain, Inc.'s No. 296 Classic Urn (1955), seen here, to Abingdon Pottery's No. 309 Neo-classic Vase is apparent. Hyalyn Porcelain, Inc., produced the form with and without the starburst design. (*Stephanie Turner Photography*)

Below right:
Fig. DD.3 A sketch resembling this shape found drawn in the margin of a Hyalyn Porcelain, Inc., document suggests that Less Moody created it. Called a Tall Classic Urn, the piece came with either a short (as seen here) or tall pedestal base. No. 379G, 1955. (*Stephanie Turner Photography*)

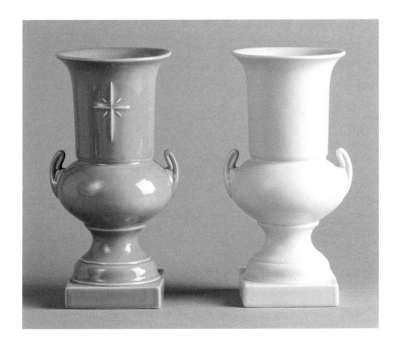

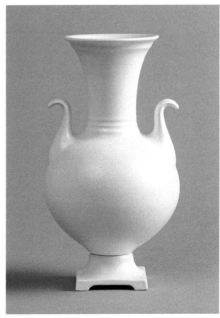

Fig. DD.4 Less Moody frequently sketched out new products in hotel rooms while attending gift and decorative accessories shows. This page of drawings reveals his concept for Hyalyn Porcelain, Inc.'s No. 277 console bowl, first offered for sale in the company's 1955 Garden Club Line catalog. (*Historical Association of Catawba County*)

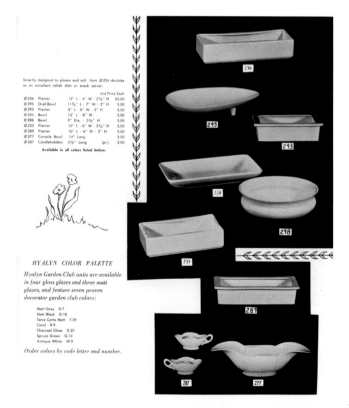

Fig. DD.5 A page from Hyalyn Porcelain, Inc.'s 1955 Garden Club Line catalog shows Less Moody's No. 277 console bowl (see Fig. DD.4). (*Historical Association of Catawba County*)

Frances Johnson Moody
(see Chapter One)

◄ **Fig. DD.6** Throughout her life, Frances Moody remained active as an artist and supporter of the arts. Here, she demonstrates her sculpting methods for a group of interested Hickory, North Carolina, residents. (*Hickory Landmarks Society*)

▶ **Fig. DD.7** Frances Moody's *Madonna and Child* (H10) and *Angel Candleholder* (H11), offered in Hyalyn Porcelain, Inc.'s 1951–1952 catalog, may be the first of her many sculpted designs produced by the company. (*Historical Association of Catawba County*)

Fig. DD.8 Often mistakenly referred to as a "pharaoh," this form, intended for use as a stand-alone sculpture, or in pairs as bookends, was to its creator, Frances Moody, the *Princess*, or *Egyptian Princess*. No. 101, 1959. (*Stephanie Turner Photography*)

From top to bottom:

Fig. DD.9 Along with her No. 101 *Egyptian Princess* figure, Frances Moody introduced her No. 100 *Horsehead* and No. 102 *Owl* figures in 1959. The No. 105 *Seagull* came later, in 1962. While Less Moody worked as Abingdon Pottery's general manager, Frances Moody supplied that company with many sculpted figures for sale, demonstrating her valuable contribution to Abingdon Pottery and Hyalyn Porcelain, Inc. (*Stephanie Turner Photography*)

Fig. DD.10 In addition to the No. 105 *Seagull*, Frances Moody introduced three more sculptures for sale by Hyalyn Porcelain, Inc., in 1962. These included (L–R) No. 106, *Polynesian*; No. 104, *Madonna* (later called *Peasant Girl*); and, No. 103, *African Head*. *Seagull* and *African Head* came mounted on black bases. (*Stephanie Turner Photography*)

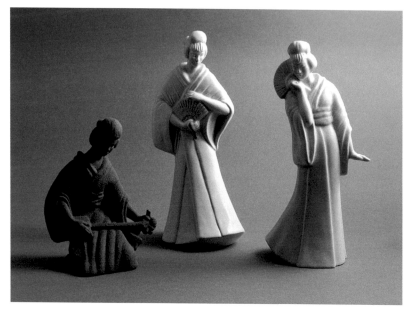

Fig. DD.11 In 1963, Frances Moody added four new sculpted figures, including these three (seen here in original glaze colors) described as "delicate Oriental figures ... perfect alone or charming with floral arrangements." (L–R) No. 109, *Kiku*, Textured Bronze Green; No. 108, *Haru*, Matte Gray with orange fan and blue sash and obi; and No. 110, *Yako*, Matte Sage with yellow fan and brown sash and obi. (*Compton photo*)

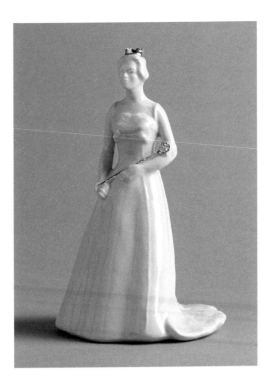

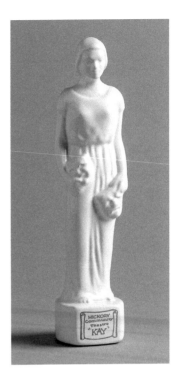

◀ **Fig. DD.12** Hyalyn Porcelain, Inc.'s 1963 catalog includes this foot-tall figurine, called *Beauty Queen* (No. 107). Designed by Frances Moody in 1962, each Miss America beauty pageant contestant received a *Beauty Queen* statuette. (*Stephanie Turner Photography*)

▶ **Fig. DD.13** Named for Moody's sister, Kay Johnson, Frances Moody's *Kay Award* recognizes outstanding performances and contributions made by participants in the Hickory Community Theatre (Hickory, NC). Kay Johnson helped organize the theatre group in 1949 while working for the city's recreation department. After Hyalyn Porcelain, Inc., ceased operation, Morganton, North Carolina's World of Ceramics made some *Kay Award* figurines. (*Stephanie Turner Photography*)

Edgar Littlefield

Tennessee-born Edgar Littlefield received a Bachelor of Science degree in ceramic engineering from Ohio State University in 1928. He graduated from a New Lexington, Ohio, high school in 1924.[6] Following his university graduation, Littlefield worked in Ohio State University's ceramics department as Arthur Baggs's research assistant. In 1931, he joined Baggs in a presentation to the American Ceramic Society regarding their discoveries for deriving blue, red, and purple glaze colors from copper.[7] Littlefield retired from his Ohio State University faculty position in 1967. He died in Ohio on June 20, 1970.

Littlefield and Less Moody worked together as Ohio State University ceramics department assistants before Moody's departure in 1932 to work for Love Field Pottery. In 1946 or 1947, Littlefield joined Moody at Hyalyn Porcelain, Inc. He worked as a designer, ceramics engineer, and production manager. In Moody's kiln start-up notes, Littlefield is named on February 21, 1947, and was instrumental in making the kiln operational. Bud Crumbaker, Hyalyn Porcelain, Inc.'s first employee and plant supervisor, who formerly worked for Moody at Abingdon Pottery, recalls spending time with Littlefield's family exploring North Carolina mountains when both families resided in Hickory.[8]

In May 1947, Charlotte, North Carolina's Mint Museum exhibited ceramics pieces fashioned by Hyalyn Porcelain, Inc. Littlefield designed most of the objects, among the company's first. Littlefield may have left his job at Hyalyn Porcelain, Inc. in 1947 or 1948 before resuming his research and teaching roles at the Ohio State University.

Wilhelmine Rehm

Cincinnati's Rookwood Pottery employed Wilhelmine "Willie" Rehm as a decorator and designer from about 1927–1937, and again from about 1943–1947.[9] In-between those times, Rehm taught art at Cincinnati's East Night High School, worked as a department store clothing designer, and designed etched glass for Cincinnati's Sterling Glass Company.[10] In late 1937, while teaching public high school art, Rehm attended evening sessions in ceramics offered by the University of Cincinnati College of Engineering and Commerce and School of Applied Arts.[11] In 1938, she worked as a sculptor in association with Cincinnati's Charlotte Haupt.[12]

On September 28, 1947, *The Cincinnati Enquirer* announced her acceptance of the position of designer for Hyalyn Porcelain, Inc.[13] Less Moody and Rehm became acquainted when Moody was Rookwood's manager.[14] Hyalyn Porcelain, Inc. had

released its first line of ware in May 1947. If Rehm left Cincinnati for Hickory, her stay in North Carolina was short-lived. In November 1948, accounts describing her ceramics and sculpture entries in Cincinnati shows and exhibits suggest that she was a resident there.[15] Following her Rookwood Pottery career, Rehm worked in Cincinnati's LaBlond Machine Tool Company's drafting department.[16] Newspaper accounts from the early 1950s show that Rehm designed and sold decorated glassware.[17] Her artistry in glass design is reported as early as 1932 when she exhibited her work in New York's Art Center.[18] She maintained a studio and home in a remodeled Cincinnati carriage house.[19]

Speaking to an Indiana Woman's Club group in 1936, while employed as a Rookwood Pottery artist, Rehm discussed industrial designers' importance. Her guidance closely matches Moody's outlook about mass-produced pottery.

Rehm stated that three principles that influence design, in addition to proportion and balance, are (1) the use, (2) the material, and (3) the tool of the manufacturer. She pointed out that machine-made things need not be ugly and are ugly when imitation handwork is machine-made. About machine-made articles, she urged that all realize that behind every design, whether produced by machine or hand, there is a person.[20]

A few of Hyalyn Porcelain, Inc.'s first products, both in glaze and form, reflect the 1930s–1940s Rookwood Pottery production ware. Rehm may have designed at least two lamps and four vases bearing carved designs for Hyalyn Porcelain, Inc. Wilhelmine Rehm died in Cincinnati, at age sixty-eight, on December 2, 1967.

Charles Leslie Fordyce

Product designer Charles Leslie Fordyce was born in Indiana in 1891 and died in Chicago, at age sixty-two, in 1954.[21] In 1920, Fordyce was an Indianapolis advertising industry artist.[22] He worked as a Chicago artist in 1930. Fordyce gained numerous patents for his 1940s glass designs. In 1945 alone, sixteen of his patents for glassware were approved and assigned to New York's Pitman-Dreitzer & Co., Inc. Fordyce's Top Hat cocktail glass, patented in 1942, and assigned to Koscherak Bros. Inc., New York, N.Y., is one of Fordyce's interesting creations.[23] Morgantown Glass Company produced the Top Hat glasses for Chicago's Knickerbocker Hotel.

Hyalyn Porcelain, Inc.'s 1951–1952 catalog introduced two new lines designed by Fordyce–Golden Bar and Free Form.[24] Each line contained eight forms, including vases, bowls, wall pockets, and ashtrays. Textured glazes called Oatmeal, Mossy Chartreuse, and Sahara Sand, and 22-k "golden bars" decorated the Golden Bar line. Hand-decorated, underglaze panels, and textured birch gray, forest green, and mink brown glazes highlighted Fordyce's Free Form line.[25]

Fig. DD.14 Before creating his Golden Bar and Free Form lines for Hyalyn Porcelain, Inc., product designer Charles Leslie Fordyce gained patents for glassware items like this Top Hat cocktail glass manufactured by Morgantown Glass Company exclusively for Chicago's Knickerbocker Hotel. (*Stephanie Turner Photography*)

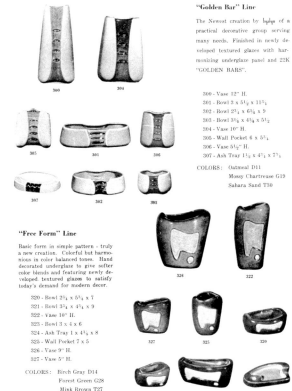

"Golden Bar" Line

The Newest creation by hyalyn of a practical decorative group serving many needs. Finished in newly developed textured glazes with harmonizing underglaze panel and 22K "GOLDEN BARS".

300 - Vase 12" H.
301 - Bowl 3 x 5½ x 11¾
302 - Bowl 2¾ x 6¼ x 9
303 - Bowl 3¼ x 4¼ x 5½
304 - Vase 10" H.
305 - Wall Pocket 6 x 5¾
306 - Vase 5½" H.
307 - Ash Tray 1½ x 4¾ x 7¾

COLORS: Oatmeal D11
 Mossy Chartreuse G19
 Sahara Sand T30

"Free Form" Line

Basic form in simple pattern - truly a new creation. Colorful but harmonious in color balanced tones. Hand decorated underglaze to give softer color blends and featuring newly developed textured glazes to satisfy today's demand for modern decor.

320 - Bowl 2¾ x 5¾ x 7
321 - Bowl 3¾ x 4¾ x 9
322 - Vase 10" H.
323 - Bowl 3 x 4 x 6
324 - Ash Tray 1 x 4¾ x 8
325 - Wall Pocket 7 x 5
326 - Vase 9" H.
327 - Vase 5" H.

COLORS: Birch Gray D14
 Forest Green G28
 Mink Brown T27

PAGE TWO

Clockwise from top left:

Fig. DD.15 An example of Fordyce's Free Form line, featured on Hyalyn Porcelain, Inc.'s 1951–1952 catalog cover, signaled a departure from the company's more traditional designs. (*Historical Association of Catawba County*)

Fig. DD.16 Eight items each made up Fordyce's Golden Bar and Free Form lines. Golden Bar was finished with textured glazes and 22-k "golden bars." Free Form—said by some to look like period radios—had textured glazes and hand-decorated underglaze panels. From Hyalyn Porcelain, Inc.'s 1951–1952 catalog. (*Historical Association of Catawba County*)

Fig. DD.17 Golden Bar. No. 300. Charles Leslie Fordyce, 1951. (*Stephanie Turner Photography*)

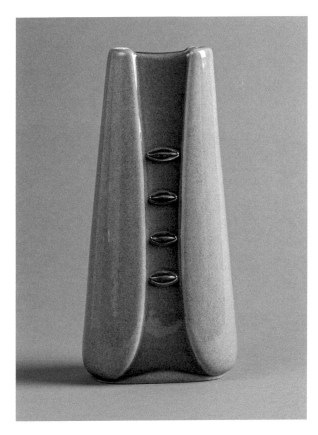

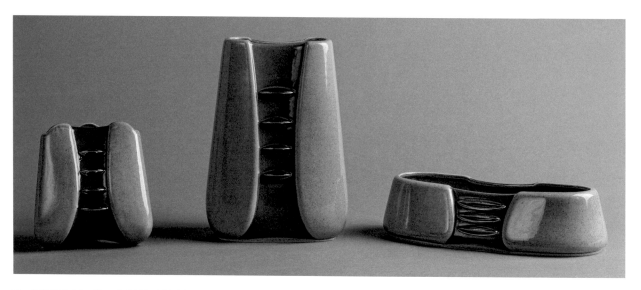

Fig. DD.18 Golden Bar. (L–R) No. 305; No. 304; and No. 301. Charles Leslie Fordyce, 1951. (*Stephanie Turner Photography*)

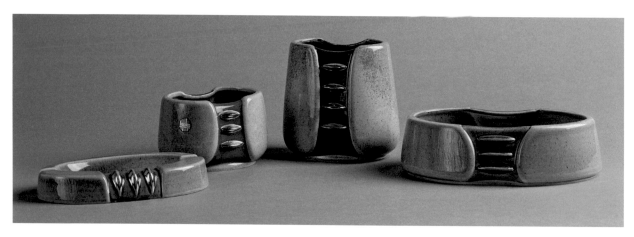

Fig. DD.19 Golden Bar. (L–R) No. 307; No. 303; No. 306; and No. 302. Charles Leslie Fordyce, 1951. (*Stephanie Turner Photography*)

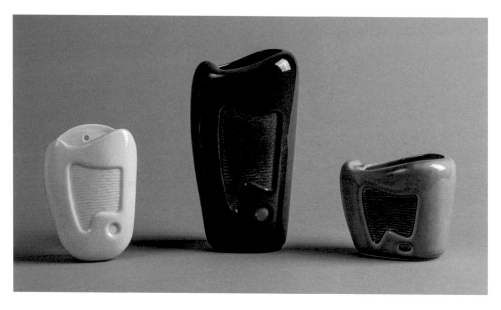

Fig. DD.20 Free Form. (L–R) No. 325; No. 322; and No. 327. Charles Leslie Fordyce, 1951. (*Stephanie Turner Photography*)

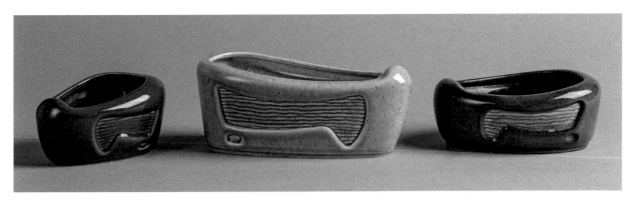

Fig. DD.21 Free Form. (L–R) No. 323; No. 321; and No. 320. Charles Leslie Fordyce, 1951. (*Stephanie Turner Photography*)

Michael Lax

Michael Lax is one of the most celebrated designers affiliated with Hyalyn Porcelain, Inc., who manufactured two Lax-designed ware lines—Raymor Capri (1953 and *c.* 1958) and Hi-Line by Hyalyn (1971 and 1972). Richards Morgenthau Co. distributed these lines.

Lax may have visited Hyalyn's plant since he preferred making his plaster models for his designs, and he often visited factories to oversee the manufacture of his products. "His feeling for form was based upon his feelings about craft and the hand-made object," said Copco's founder, Samuel Farber. "He always made his own plaster models," according to Farber. "He wanted to feel them as a craftsman would."[26]

Michael Lax grew up in New York City, where he was a boyhood friend of Hyalyn designer, Herb Cohen. Lax first attended and graduated from the New York School of Music and Art in 1951 before achieving a B.F.A. in 1951 from Alfred University's New York State College of Ceramics. A 1954 Fulbright Fellowship allowed him to study Danish Modern design in Finland. Following his return to the U.S., he designed dinnerware for Russel Wright.[27]

In the 1960s, Lax's work gained recognition for its modernist design. From around 1960, he created colorful enameled cast iron cookware for Copco, who sold a million of his 1962 enameled, teak-handled tea kettles. His *Lytegem* Lamp, made for Lightolier in 1965, with a cube base, ball reflector, and telescoping arm, found its way to the Museum of Modern Art's permanent collection, as did his later pyramid-shaped *Modulion 10 Ionizer* (1980).[28]

In 1977, Lax won the Rome Prize to study art at Rome's American Academy. He opened an Italian studio in 1984, where he focused on his work as a sculptor. Lax was born on November 8, 1929. He died, at age sixty-nine, on May 25, 1999.

First manufactured in white porcelain with walnut wood handles, covers, and bases, Raymor Capri's colors later included Blue Matte and Mustard Yellow. Every piece's simple shape has a silky, smooth surface devoid of any embellishment or decoration. When first offered, the line included nearly fifty items, including planters, teardrop-shaped and cylinder-shaped vases, candleholders, bowls, trays, pitchers, coffee servers, salt and pepper shakers, cruets, ashtrays, and more.

Michael Lax made the Hi-Line series (advertised as "white ceramic") in 1971 after Hyalyn departed from high-fired porcelain production to semi-porcelain ware in 1968. Hi-Line included a peppermill and salt shaker, lidded jars, orb-shaped flower frog vases, a lidded "super jar," a cocktail tray, bar bowl, and smoking accessories.

Rosemary Raymond Lax (Stoller)

Rosemary Raymond married Michael Lax in 1950.[29] The two met as students at Alfred University's New York State College of Ceramics, where she earned a B.F.A. Beforehand, in 1947, she received a BA from the University of Chicago. Rosemary Lax helped establish Michael's New York City design office and taught ceramics classes at the city's Young Men's and Women's Hebrew Association. Rosemary Lax designed a large bowl in the shape of a stylized bird for production by Hyalyn Porcelain, Inc.[30] With Michael Lax, she co-created the 1972–1973 Hi-Line items. Following her divorce from Michael Lax in 1978,

she married architect and University of California, Berkeley, professor, Claude Stoller.[31] Stoller first attended North Carolina's Black Mountain College before attending Harvard Graduate School of Design and the University of Florence in Italy.[32] Described at the end of her life as a prolific artist, Rosemary Stoller died, at age ninety, on February 26, 2019.

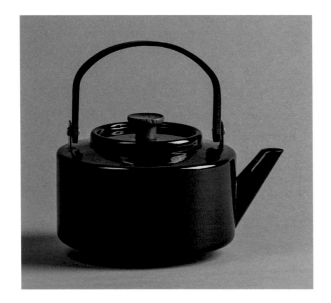

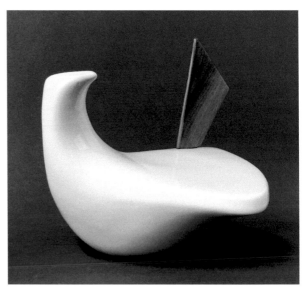

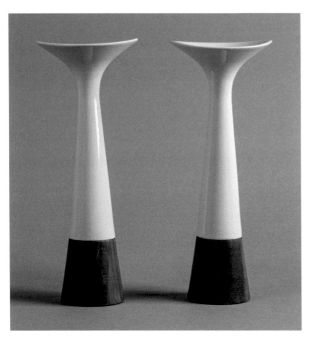

Clockwise from top left:

Fig. DD.22 Copco teakettle. Credited with introducing enamel to cast iron, Michael Lax created his iconic teakettle with a bent teak handle for Copco in the 1960s. Lax's ceramic Raymor Capri line, manufactured for Raymor by Hyalyn Porcelain, Inc. in 1953, is coveted by collectors today, nearly seven decades following its creation. (*Stephanie Turner Photography*)

Fig. DD.23 Raymor Capri. Bird figure. No. L152. Gloss-glazed white porcelain and walnut tail. Michael Lax, 1953. (*Photo courtesy of Chrissy Bailey, Bird's Vintage*)

Fig. DD.24 Raymor Capri. Tall candleholders. No. L159. Gloss-glazed white porcelain and walnut. Michael Lax, 1953. (*Stephanie Turner Photography*)

On the next page, from top to bottom:

Fig. DD.25 Raymor Capri. (L–R) No. L117, 1.5 qt. pitcher; No. L124, after-dinner coffee; and No. L153, coffee server. Michael Lax, 1953. (*Stephanie Turner Photography*)

Fig. DD.26 Raymor Capri. (L–R) No. L107SP, large salt and pepper shakers; No. L133, covered sugar bowl; and No. L134, creamer. Michael Lax, 1953. (*Stephanie Turner Photography*)

Fig. DD.27 Raymor Capri. (L–R) No. L111, tall tear-drop vase; No. L164, small long oval bowl; and No. L112, small tear-drop vase. Michael Lax, 1953. (*Stephanie Turner Photography*)

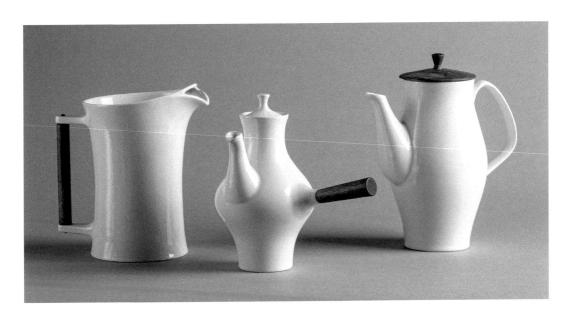

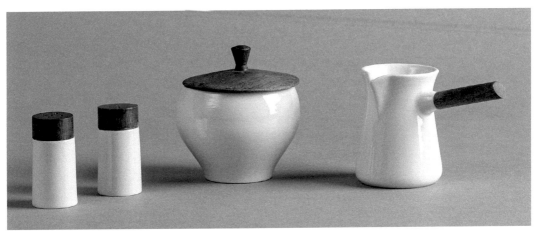

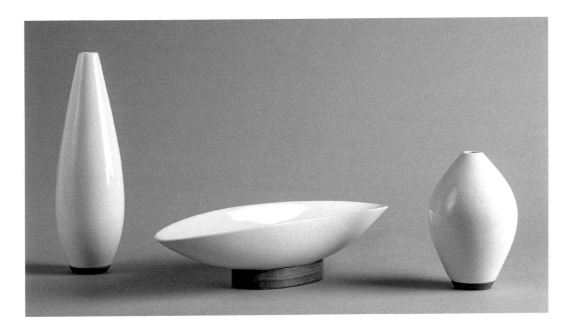

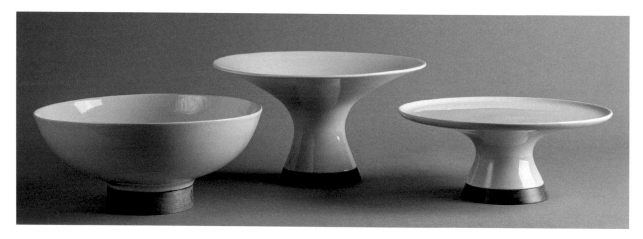

Fig. DD.28 Raymor Capri. (L–R) No. L125, round salad bowl; No. L103, pedestal bowl; and No. L102, cake server. Michael Lax, 1953. (*Stephanie Turner Photography*)

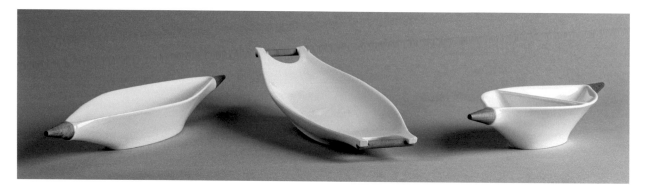

Fig. DD.29 Raymor Capri. (L–R) No. L115, long celery tray; No. L119, long tray; and No. L120, divided relish dish. Michael Lax, 1953. (*Stephanie Turner Photography*)

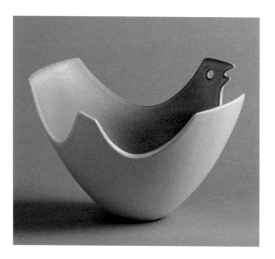 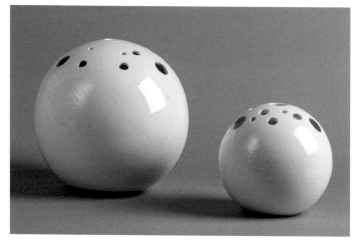

◄ **Fig. DD.30** Large bird bowl. Rosemary Lax. Although this bowl is not shown in the Raymor/Hyalyn 1953 or *c.* 1958 catalogs, Hyalyn designer and Michael Lax friend, Herbert Cohen, confirms its design by Rosemary Lax. Its cork base bears a Hyalyn trademark. (*Stephanie Turner Photography*)

▶ **Fig. DD.31** Hi-Line by Hyalyn. Flower frog vases. (L–R) No. JL26, large frog vase, and No. JL10, small frog vase. Michael Lax, 1971. White ceramic (not porcelain). Each one with seventeen holes of various sizes. Hyalyn Porcelain, Inc.'s 1972–1972 Hi-Line promotional flyer indicates that both Michael and Rosemary Lax designed some of the group's items. (*Stephanie Turner Photography*)

Robert Anthony Sigmier

Robert Anthony "Bob/Sig" Sigmier was a student attending the Kansas City Art Institute on September 14, 1942, when he enlisted for World War II service for the war's duration.[33] Born in Tulsa, Oklahoma, on March 1, 1921, Sigmier served in the Army Air Corps with General Claire Lee Chennault's Flying Tigers in China.[34] With the war over, Sigmier returned to the Kansas City Art Institute, where he graduated in 1948 with a B.F.A. in ceramics.[35] That year, he married classmate Patricia Claire Sweeney before moving to Broken Arrow, Oklahoma, where he opened a pottery studio and shop.[36] In the early 1950s, the couple moved to Newcastle, Pennsylvania, where Castleton China, Inc. employed Sigmier. In 1953, he designed a limited-edition Castleton China dinner plate commemorating Dwight David Eisenhower's first birthday in the White House.[37]

In 1954, Moody added Sigmier to Hyalyn Porcelain, Inc.'s staff as its new designer.[38] At the same time, George Vincent, a graduate of the New York State School of Ceramics at Alfred, New York, became the plant's new superintendent. According to general manager Less Moody, these two men's employment would lead to "new designs more efficiently produced."[39] Before their arrival, dismal sales in early 1954 led to Hyalyn Porcelain, Inc.'s first year without a profit. The plant was again profitable in 1955. Sigmier was not working for Hyalyn Porcelain, Inc. when Herb Cohen became the company's designer in March 1956.[40] By 1957, Sigmier moved to Los Angeles, where he worked as a draftsman and photo lab technician for Pafford and Associates, a surveying company specializing in the use of aerial photography.[41] As an Army Air Corps member, Sigmier learned how to interpret data from aerial photographs. While living in Los Angeles, he studied painting at the Otis Art Institute. In 1978, the Sigmiers moved to Poncha Springs, Colorado, where Sigmier mostly painted Farmington, New Mexico, scenes, and made stoneware. He is described by his son, Todd "Doc" Sigmier, as an excellent designer, fabricator, and mold maker. In 1998, and for a dozen years afterward, Sigmier assisted his son in designing and manufacturing extruded ceramic guitar slides.[42] Sigmier died in Farmington, New Mexico, on August 31, 2015.

Fig. DD.32 Hyalyn Porcelain, Inc. designer Robert Sigmier with his son Todd "Doc" Sigmier. In December 1954, Less Moody employed Sigmier, a Kansas City Art Institute graduate, to be Hyalyn's new designer. At the same time, George Vincent, a graduate of the New York State School of Ceramics at Alfred, New York, was named the plant's new superintendent. (*Photo courtesy of Todd Sigmier*)

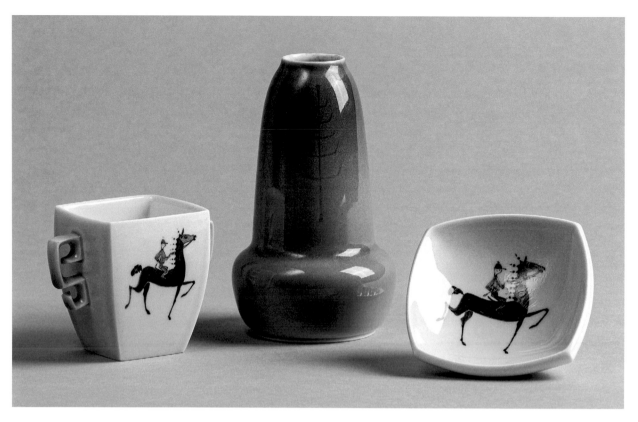

Fig. DD.33 Ceramic items created by Robert Sigmier before working for Hyalyn Porcelain, Inc. Each one is signed "Sigmier" on its base. (*Stephanie Turner Photography*)

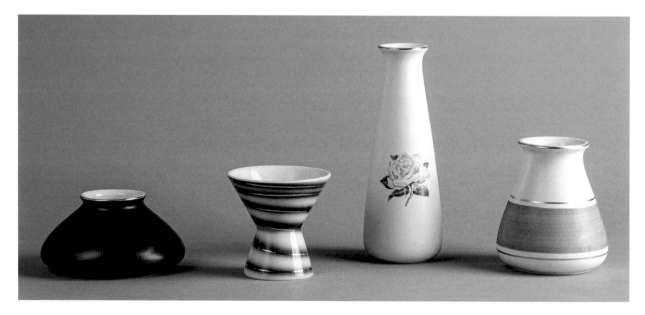

Fig. DD.34 Hyalyn Porcelain items first offered in the company's 1955-1956 catalog. Attributed to Robert Sigmier. (L–R) No. 652, vase; No. 642, nut dish; No. 650, vase; and No. 651, vase. (*Stephanie Turner Photography*)

Herbert Cohen

Herbert Cohen spent the earliest years of his life in New York City, where he was born on September 26, 1931. He made his first pottery at age six while a member of New York's Henry Street Settlement pottery club.[43] Cohen and designer Michael Lax attended New York's Music and Art High School together. During his sophomore and junior years in college, he and Lax were Alfred University roommates. Cohen earned a B.F.A. in 1952 and a M.F.A. degree in 1956 from Alfred University's New York State College of Ceramics.

From 1952–1954, Cohen fulfilled a full military duty tour in Korea during the Korean War. Afterward, he resumed his studies at Alfred University. Before completing the M.F.A., Cohen was lured to Hickory, North Carolina, in March 1956, to become Hyalyn Porcelain, Inc.'s chief designer. Charles Harder, head of Alfred's ceramics department, allowed Cohen to graduate when he agreed to write a plan for designing a line of pottery for commercial production. Once employed by Hyalyn Porcelain, Inc., Cohen immediately set about creating original designs. He modified some lamp bases designed by Gerald Thurston for Lightolier so that Hyalyn Porcelain, Inc. could accurately produce them.[44] In 1957, Cohen modified as many as ten new Michael Lax Raymor Capri items added about 1958 to his original 1953 line. According to Cohen, most designs submitted to Hyalyn Porcelain, Inc. from outside designers required some adjustment to match manufacturing requirements.

Hyalyn Porcelain, Inc.'s 1957 catalog introduced several new Garden Club Line items, including six Cohen-designed hanging planters. Hyalyn Porcelain, Inc. offered more than two dozen new Cohen shapes for the first time. Primarily intended for flower arrangement, these pieces included bowls, vases, and planters of various sizes. In 1958, Hyalyn Porcelain, Inc. added more Cohen shapes to the Garden Club collection, including a pair of wall planters.[45]

Cohen taught Hyalyn Porcelain, Inc. workers how to add slip-trailed decoration to glazed wares. Seen first in Hyalyn Porcelain, Inc.'s 1957 catalog, a dozen shapes—some old and some new—displayed patterns called sunburst, 4-block, thistle, leaf, scalloped, flame, block, 2-block, zig zag, and fish.

In the fall of 1957, Hyalyn Porcelain, Inc. introduced Cohen's Portfolio Collection without a name or any fanfare. The company's catalog described the line's first six entries (Nos. 681–686) as a "New and exciting decorator group." All six were bowls, defined as large and small round trays; fish bowl; butterfly bowl; and large and small oval bowls. By 1958, Portfolio, "Designed by Herbert Cohen, hyalyn staff designer," was touted as "truly the newest creation on the market – a complete group of smart decorator accessories." By 1959, Portfolio filled five pages of Hyalyn's twenty-four-page catalog. After Cohen's 1958 departure, Hyalyn Porcelain, Inc. presented some new Portfolio shapes and decorations.[46] These non-Cohen-designed Portfolio examples are seen in Hyalyn Porcelain, Inc.'s 1959–1961 catalogs and include item Nos. 687D-711. Herb Cohen designed a new company logotype made of an oval surrounding the words "hyalyn PORCELAIN." Hyalyn Porcelain, Inc. and succeeding companies used his mark and variants of it.

Cohen, still a young man and with a significant career as an artist ahead of him, left Hickory and Hyalyn Porcelain, Inc. in the fall of 1958 when he moved to Charlotte, North Carolina. There, he and his partner designed theatrical costumes for the Mint Museum's drama department. Cohen became the Mint Museum's exhibits director and twice served as the museum's acting director in the late 1960s. Charlotte's Queens College showed an exhibit of his work in April 1958.[47] More than five decades later, in 2013, a solo exhibition of Cohen's work, called "Sophisticated Surfaces: The Pottery of Herb Cohen," was shown at the Mint Museum Randolph. Of his work, Katherine Balcerek writes:

> As a potter Cohen is renowned for his ability to manipulate surface and form, blending each into a harmonious accord. Cohen's surfaces are often highly intricate and abstracted, suggesting a pre-calculated design, but he works freehand to develop a pattern based on the shape and function of the object. These patterns are created with glazes or slips using complicated techniques like mishima and sgraffito. Consequently, each piece is highly individualized even when the function is the same.[48]

In 1972, Cohen moved from Charlotte to Blowing Rock, North Carolina, where he built a home and studio. Thirty-eight years later, he and his partner, textile designer and artist, José Agustin Fumero, returned to live in Charlotte, North Carolina. After sixty years together, Fumero died in 2016 while the two were traveling together in Europe.

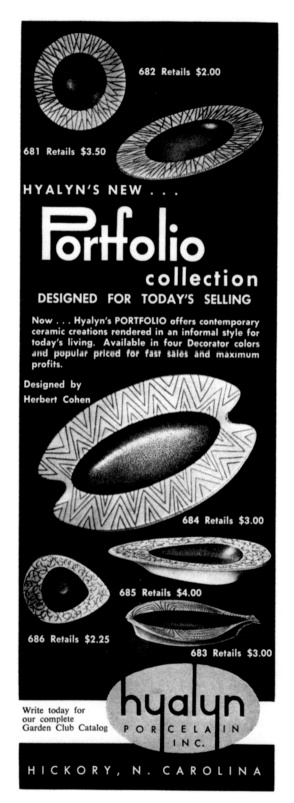

682 Retails $2.00

681 Retails $3.50

HYALYN'S NEW . . .

Portfolio

collection

DESIGNED FOR TODAY'S SELLING

Now . . . Hyalyn's PORTFOLIO offers contemporary ceramic creations rendered in an informal style for today's living. Available in four Decorator colors and popular priced for fast sales and maximum profits.

Designed by
Herbert Cohen

684 Retails $3.00

685 Retails $4.00

686 Retails $2.25

683 Retails $3.00

Write today for
our complete
Garden Club Catalog

hyalyn

PORCELAIN
INC.

HICKORY, N. CAROLINA

▶ **Fig. DD.35** Hyalyn Porcelain, Inc. designer, Herbert Cohen, at work in his office, *c.* 1956. A graduate of the New York State School of Ceramics at Alfred, New York, Cohen made many designs for Hyalyn Porcelain, Inc.'s Garden Club and Portfolio lines between the years 1956–1958. Later on, he had a stellar career as a professional studio ceramic artist. (*Historical Association of Catawba County*)

◀ **Fig. DD.36** Herbert Cohen is credited in this Portfolio Collection advertisement for its design. Offered in four colors, Hyalyn described the Portfolio Collection as "contemporary ceramic creations rendered in an informal style for today's living." (*Courtesy of Mark Bassett*)

On the next page, from top to bottom:

Fig. DD.37 Portfolio Collection. No. 684, *Butterfly Bowl*. Herbert Cohen, 1957. (*Stephanie Turner Photography*)

Fig. DD.38 Portfolio Collection. No. 683, *Fish Bowl*. Herbert Cohen, 1957. (*Stephanie Turner Photography*)

Fig. DD.39 Portfolio Collection. Nesting bowls. (L-R) No. 691, large bowl; No. 693, small bowl; and No. 692, medium bowl. Herbert Cohen, 1958. (*Stephanie Turner Photography*)

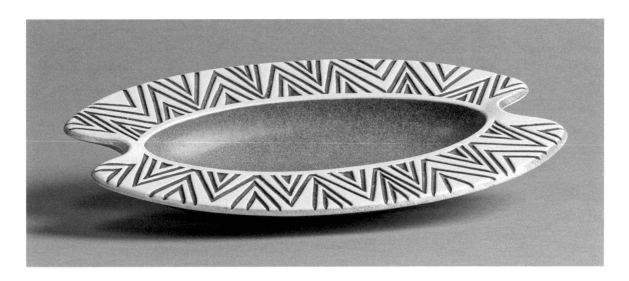

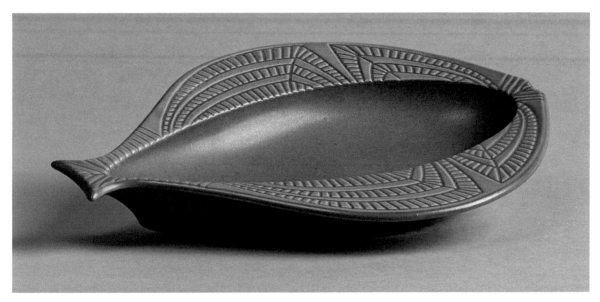

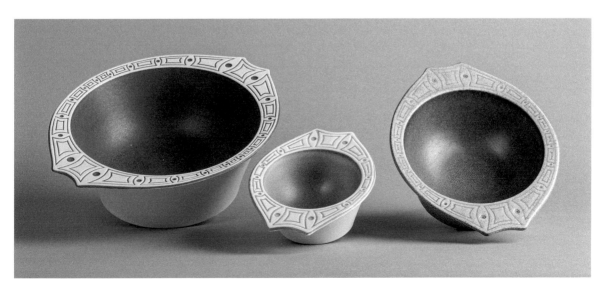

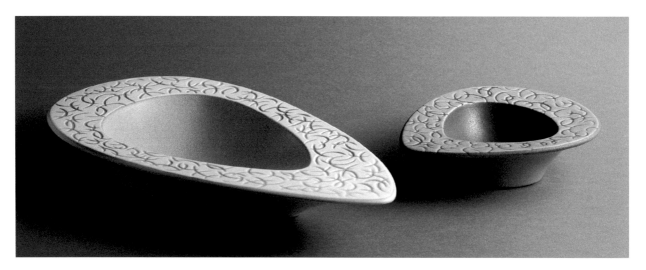

Fig. DD.40 Portfolio Collection. (L–R) No. 685, large oval bowl, and No. 686, small oval bowl. Herbert Cohen, 1957. (*Compton photo*)

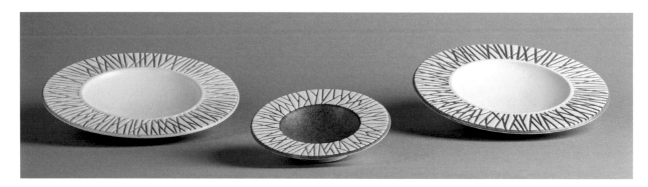

Fig. DD.41 Portfolio Collection. (L–R) No. 681, large round tray; No. 682, small round tray; and No. 681, large round tray. Herbert Cohen, 1957. (*Stephanie Turner Photography*)

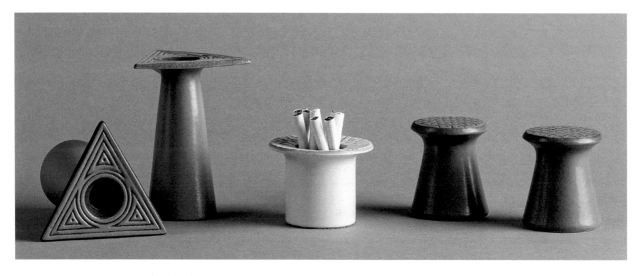

Fig. DD.42 Portfolio Collection. (L–R) No. 690, candlestick holders; No. 694C, cigarette cup; and No. 689, salt and pepper shakers. Herbert Cohen, 1958. (*Stephanie Turner Photography*)

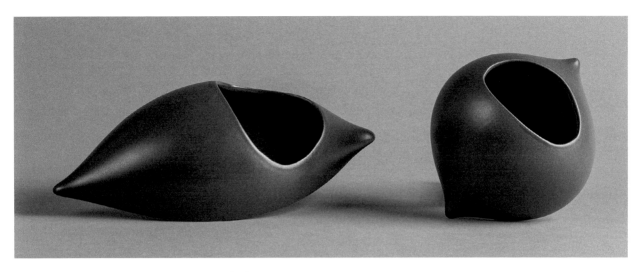

Fig. DD.43 Garden Club Line. Two wall planters. (L–R) No. 390, medium wall planter, and No. 389, small wall planter. Herbert Cohen, *c.* 1958. (*Stephanie Turner Photography*)

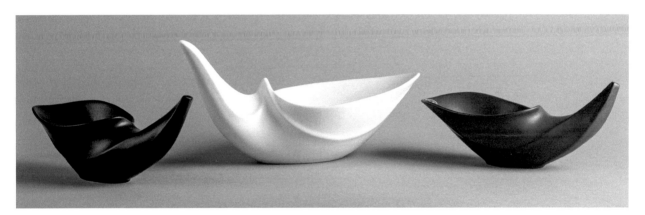

Fig. DD.44 Garden Club Line. Cornucopia planters. No. 326 (right and left, 1955) and No. 347 (center, 1956). Herbert Cohen. (*Stephanie Turner Photography*)

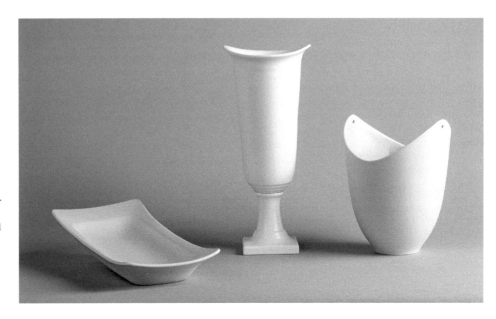

Fig. DD.45 Garden Club Line. (L–R) No. 343, rectangle flare bowl, 1956; No. 378, scalloped vase with high pedestal base, 1957; and No. 355, scalloped hanging planter, 1957. Herbert Cohen. (*Stephanie Turner Photography*)

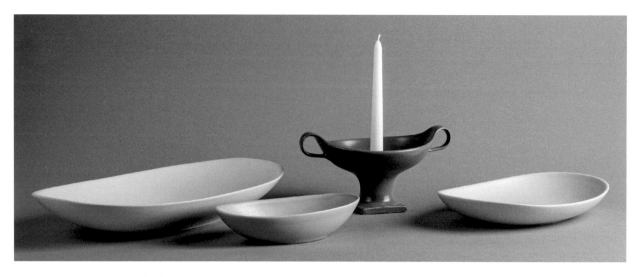

Fig. DD.46 Garden Club Line. (L–R) No. 346, large oval bowl, 1956; No. 345, small oval bowl, 1956; No. 382, candleholder bowl, 1957; and No. 344, medium oval bowl, 1956. Herbert Cohen. (*Stephanie Turner Photography*)

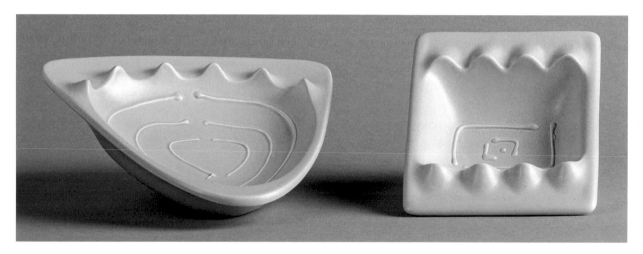

Fig. DD.47 Ashtrays. (L–R) No. 349, triangular ashtray, and No. 351, square ashtray. Herbert Cohen taught the slip-trailed decoration technique seen here on these ashtrays to Hyalyn Porcelain, Inc.'s decorators. Herbert Cohen, 1956 (shapes) and 1957 (slip-trailing). (*Stephanie Turner Photography*)

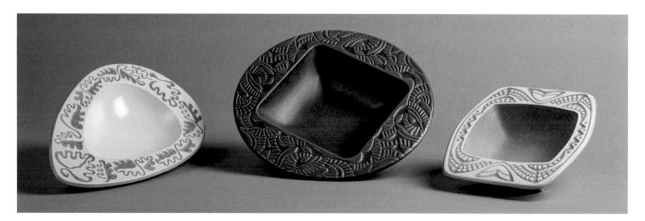

Fig. DD.48 Herbert Cohen gave up his role as Hyalyn Porcelain, Inc.'s designer in 1958. The company's 1959 catalog offered some Portfolio Collection designs with decorations like these, not made by Cohen. (L–R) No. 685, oval dish; No. 696, fruit dish; and No. 699, rectangular dish. (*Stephanie Turner Photography*)

Erwin Kalla

The son of a Hungarian father and a Czechoslovakian mother, Erwin Kalla was born in Donora, Pennsylvania, on Christmas Day, 1924. Kalla was an artist from a young age. He became a member of Pittsburg's Associated Artists when he was seventeen.[49] In his youth and throughout his adult life, Kalla received many awards for his paintings, sculptures, and imaginative product designs.

Following high school graduation, Kalla attended the Carnegie Institute of Technology on a full scholarship. Two years into his Carnegie term, Kalla received a fellowship to attend Bloomfield Hills, Michigan's Cranbrook Academy of Art, a unique educational community considered by some to be the "incubator of mid-century modernism."[50] There, he encountered Swedish sculptor Carl Milles and architect Eero Saarinen, who were Cranbrook instructors. Other former Cranbrook students include Charles and Ray Eames and Florence Knoll Bassett (née Schust).

Kalla gained national attention in 1957 when the first prize in the Sterling Today Hollowware Design Competition, sponsored by the Sterling Silversmiths Guild of America, went to him. His entry, a sterling silver coffee and tea set, lacked surface decoration. Kalla used white nylon, dyed black, to construct the set's handles (shaped downward on the pitcher and upward on the coffee and teapots). Of it, Kalla said: "I tried to eliminate all the elements which I consider undesirable in older designs of silver, principally the ornate carving and heaviness."[51]

Kalla reflected his ideas about dinnerware design in his silver project's outcome and Hyalyn Porcelain, Inc.'s Casual Craft line made around 1959–1960. He thought that cup handles should be large enough to be fully grasped by a human hand. "After all," he said, "who but humans drink from cups?" He wondered, "Why should dishes have to be round?" Kalla suggested that a triangular dinner plate, saucer, bread and butter, and salad plate could fit together to form a rectangle, the shape of most tables. And dish decoration? "There's no reason," claimed Kalla, "why a rose should appear when you push your food aside. If people like flowers so much, why don't they just drop them over the food and bring them to the table that way?"[52]

In the 1950s, Edwin M. Knowles China Co. employed Kalla as a freelance designer. Around 1958, Hyalyn Porcelain, Inc.'s Casual Craft line was created by him for Raymor to be sold exclusively by Richards Morgenthau Co. of New York City. Hyalyn's promotion for it called it an "out-door or buffet service, styled for tomorrows living." Some pieces featured bamboo handles; others had porcelain handles wrapped with rattan. Three colors were offered, including Textured Mottled Brown Matte, Mottled Medium Blue Matte, and Textured Orange Matte. Twenty-nine pieces, plus a two-piece set of birch salad bowl servers, made up the collection. The line contained casseroles, bowls, pitchers, salt and pepper shakers, a cake plate, a covered spice and jam jar, a mug, buffet plates, a teapot, a coffee server, vases, and six ashtrays.

In 1968, Hyalyn Porcelain, Inc. offered Kitchen Accessories by Kalla. 1968 was when Hyalyn Porcelain, Inc. shifted from vitreous porcelain to a lower temperature-fired semi-porcelain clay body. The collection included canisters, pitchers, mugs, and salt and pepper shakers. Each lidded canister featured bold, raised letters spelling out "flour," "tea," "sugar," "cookies," and "coffee." Offered about a decade after Kalla's acclaimed Casual Craft line, these wares in no way resemble the earlier series, bringing into question Erwin Kalla's hand in their creation.

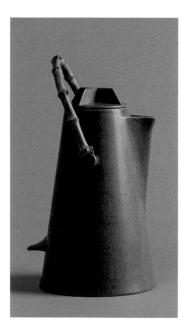
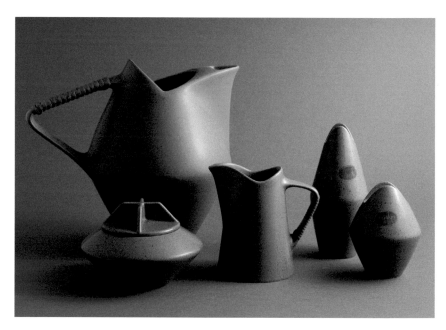

◀ **Fig. DD.49** Casual Craft. No. K-15, large coffee server. Erwin Kalla, for Raymor, *c.* 1958. (*Stephanie Turner Photography*)

▶ **Fig. DD.50** Casual Craft. (L–R) No. K-9, large pitcher with a rattan-wrapped handle; No. K-4, covered sugar bowl; No. K-5, creamer with rattan-wrapped handle; and No. K-21SP, large salt and pepper shakers. Erwin Kalla, for Raymor, *c.* 1958. (*Compton photo*)

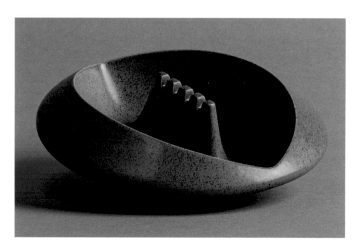

Fig. DD.51 Casual Craft. No. K-13, large ashtray. Erwin Kalla, for Raymor, *c.* 1958. (*Stephanie Turner Photography*)

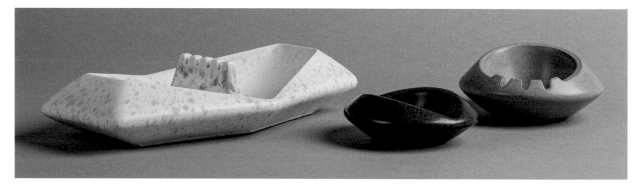

Fig. DD.52 Casual Craft. (L–R) No. K-23, hexagonal ashtray; No. K-14, small ashtray; and No. K-12, medium ashtray. Erwin Kalla, for Raymor, *c.* 1958. (*Stephanie Turner Photography*)

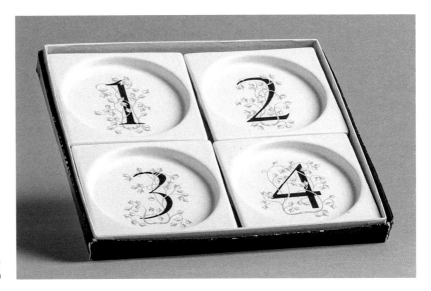

Fig. DD.53 A set of four coasters. Marked K-34 on a cork Hyalyn base. Attributed to Erwin Kalla. (*Stephanie Turner Photography*)

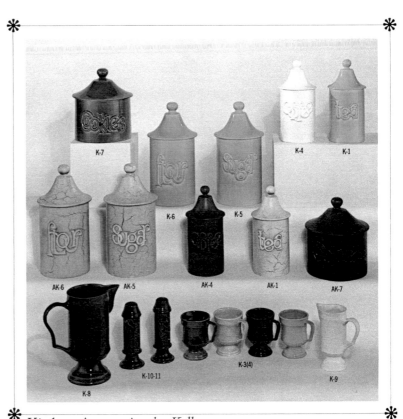

Kitchen Accessories *by Kalla*

A new look in decorative kitchen accessories — but completely utilitarian. Bold lettering, decorative in appearance, raised from the surface is a keynote feature of this new group. All items available in four of today's very popular colors reproduced in lovely gloss glazes.

	BLUE	WARM BROWN	PEPPER GREEN	YELLOW	
K-1	Tea, 5¼" D., 10¼" H.	$5.00	K-8	Large Pitcher, 3 pts. cap., 9½" H.	$5.00
K-3(4)	Set of 4 Mugs 8 oz. (G. B.)	6.00	K-9	Small Pitcher, 12 oz. cap., 6½" H.	3.00
K-4	Coffee, 5¼" D., 10¼" H.	5.00	K-10-11	Salt & Pepper (Gift Boxed)	5.00
K-5	Sugar, 7" D., 13" H.	6.00	K-1456	Set of 4 Canisters, Coffee, Tea, Flour,	
K-6	Flour, 7" D., 13" H.	6.00		Sugar (Packed)	20.00
K-7	Cookie, 8¼" D., 9" H. (Packed)	6.00	K-456	Set of 3 Canisters, Coffee, Flour, Sugar (Packed)	16.00

Canisters and Cookie Jar available in Hyalyn's unique ANTIQUE CRAQUEL finish.

	PERSIAN BLUE	PERNOD GREEN	OLD IVORY	POMPEIIAN RED	
AK-1	Tea, 5¼" D., 10¼" H.	$6.00	AK-7	Cookie, 8¼" D., 9". (Packed)	$ 7.00
AK-4	Coffee, 5¼" D., 10¼" H.	6.00	AK-1456	Set of 4 Canisters, Coffee, Tea, Flour,	
AK-5	Sugar, 7" D., 13" H.	8.00		Sugar (Packed)	25.00
AK-6	Flour, 7" D., 13" H.	8.00	AK-456	Set of 3 Canisters, Coffee, Flour, Sugar (Packed)	20.00

PAGE 4

ALL PRICES SHOWN ARE SUGGESTED RETAIL

Fig. DD.54 Kitchen Accessories by Kalla. This line of home accessories appears in Hyalyn Porcelain, Inc.'s 1968 catalog. (*Historical Association of Catawba County*)

Esta Greenspan Brodey (Huttner)

New York-born Esta Greenspan Brodey owned and operated Peerless Art Co., Inc. from 1946–1960.[53] She married Manual K. Brodey before marrying Pyramid Books co-founder and president Matthew Huttner in 1960.[54, 55] Her Brooklyn glass factory produced hand-painted lamps, vases, and table glassware.[56] Other decorations were silkscreen printed. Peerless Art Co. fashioned numerous decorated glassware objects for designer Georges Briard.[57]

Hyalyn's Basketry line, produced for Raymor/Richards Morgenthau Co. around 1959–1960, was designed by Esta Brodey in collaboration with artists employed by Peerless Art Co.[58] The wares' textured porcelain surfaces came in four color combinations: Cocoa on Black; Pumpkin on White; Blue on Black; and Mustard on White.

Brodey and her shop's artisans developed a silkscreen printing technique for applying raised gold decorations on glassware. Georges Briard's raised gold and silver decorations found on the Midas line (made for Georges Briard Designs and M. Wille, Inc.) employed Brodey's process. A Peerless Art Company process may have embellished Hyalyn's 1959 Decorators Collection.

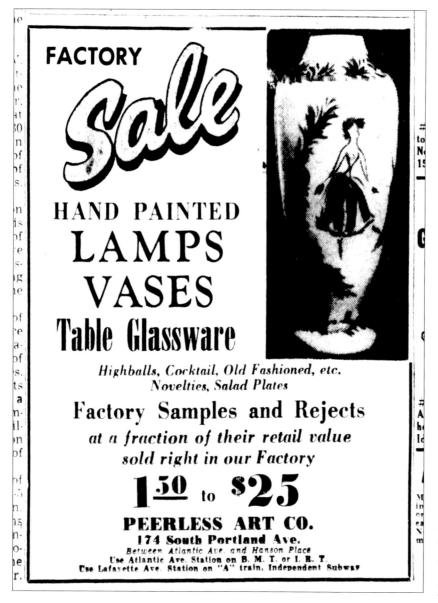

Fig. DD.55 Esta Brodey's Peerless Art Co. produced glassware items with silkscreen-printed decorations, including many designed by Georges Briard. Her Brooklyn, New York shop created the process for applying raised gold and silver patterns on Briard's Midas and Midas Gold and Silver lines. Brodey's Basketry line, made by Hyalyn for Raymor and distributed by Richards Morgenthau Co., utilized a unique Peerless Art process. From *The Brooklyn Daily Eagle* (Brooklyn, NY), January 11, 1948. (*Newspapers.com*)

▲ **Fig. DD.56** Basketry. (L–R) No. P10, small cylinder vase; No. P21, large vase, and No. P16, large round ashtray. Esta Brodey, Peerless Art Co., for Raymor, *c.* 1958. (*Stephanie Turner Photography*)

▼ **Fig. DD.57** Basketry. A pair of No. P14 short tear-drop vases. Esta Brodey, Peerless Art. Co., for Raymor, *c.* 1958. (*Stephanie Turner Photography*)

Dean Russell Hokanson

With a B.F.A. from Alfred University's New York State College of Ceramics completed, Dean Hokanson followed Herb Cohen as Hyalyn Porcelain, Inc.'s designer. Hokanson was born in Pennsylvania oil country on December 5, 1928. He died in Watkinsville, Georgia, on October 13, 2004. In 1968, Hokanson joined the faculty of Georgia College (Milledgeville) as an instructor in art.

Hyalyn Porcelain, Inc.'s 1959 catalog is a compendium of designs, including flower arrangement trays dating to its earliest years, Frances Moody's sculptures, and numerous Herb Cohen items designed between 1956–1958. The 1959 catalog most fully presents Cohen's Portfolio collection. Following Hokanson's arrival, the 1959 *Fall Additions* catalog introduced seven new shapes to the Garden Club Line, including Hyalyn Porcelain, Inc.'s distinctive candle boats and bowls and an entirely new Decorators Collection accented by Hyalyn Porcelain, Inc.'s new Hyalyn Glace colors. This collection, showing off bold colors cut-through by bands of wavy and cross-hatched sgraffito-like lines, is strikingly modern in appearance. The timing of Hokanson's employment when so many new designs appeared suggests his role in their design.

The new Decorators Collection was an immediate success—with a caveat. Hyalyn Porcelain, Inc. could not fill all orders for it in 1959 due to a strike limiting access to the required ceramic colors. For a while, Hyalyn Porcelain, Inc. discontinued the line's production. With the strike over in time for publication of the company's 1960 catalog, the collection was offered again, with an array of its wares making up the catalog's full-color front cover.

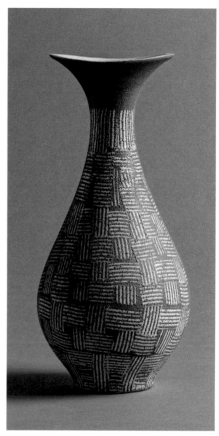

◀ **Fig. DD.58** By 1959, Alfred University graduate of the New York State College of Ceramics, Dean Russell Hokanson, was employed as Hyalyn Porcelain, Inc.'s designer. Hokanson may have created the company's new Decorators Collection and some new Garden Club Line items in 1959. Demand for the Decorators Collection items boosted the line to the cover of Hyalyn's 1960 catalog. (*Historical Association of Catawba County*)

▶ **Fig. DD.59** Decorators Collection. With a rim opening reminiscent of some Raymor Capri designs made by Michael Lax, this large bottle vase (No. 810) shows off the line's sgraffito-like glaze treatment, called Hyalyn Glace. Attributed to Dean Russell Hokanson. Said to have been developed exclusively for Hyalyn Porcelain, Inc., the decoration's raised, textured surface brings to mind Brodey's Basketry (*c.* 1958) and Georges Briard's Midas and Midas Gold and Silver lines (1961). Esta Brodey's Peerless Art Co. may have had a hand in creating all three glazing techniques. (*Stephanie Turner Photography*)

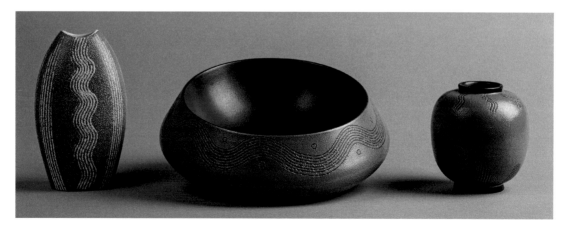

Fig. DD.60 Decorators Collection. (L–R) No. 801, oval vase, 1960; No. 824, large round bowl, 1959; and No. 821, small ball vase, 1960. Attributed to Dean Russell Hokanson. (*Stephanie Turner Photography*)

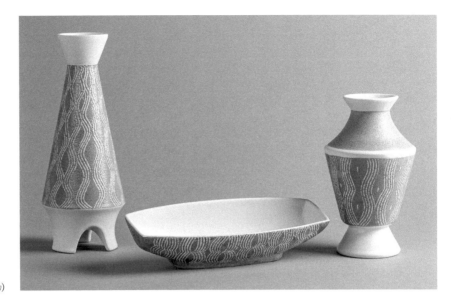

Fig. DD.61 Decorators Collection. (L–R) No. 814, footed bottle; No. 812, boat dish; and No. 813, shouldered bottle. All items, 1960. Attributed to Dean Russell Hokanson. (*Stephanie Turner Photography*)

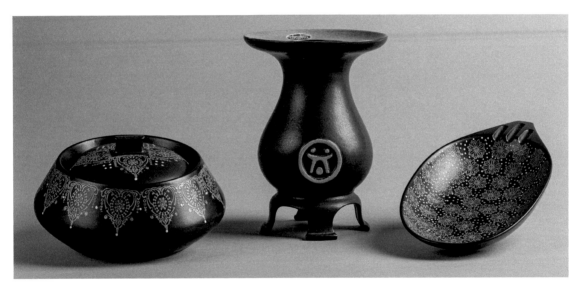

Fig. DD.62 Decorators Collection. Jewel-like patterns in Hyalyn Glace colors complement the collection's scratched, sgraffito-like decorations. (L–R) No. 825, covered bowl, 1959; No. 836 with "J" base, tall usubata on oriental base, 1960; and No. 804, round lug ashtray, 1959. Attributed to Dean Russell Hokanson. (*Stephanie Turner Photography*)

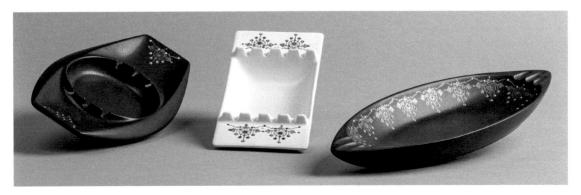

Fig. DD.63 Decorators Collection. (L–R) No. 837, safety ring ashtray; No. 803, rectangular ashtray; and No. 816, long oval ashtray. All items, 1960. Attributed to Dean Russell Hokanson. (*Stephanie Turner Photography*)

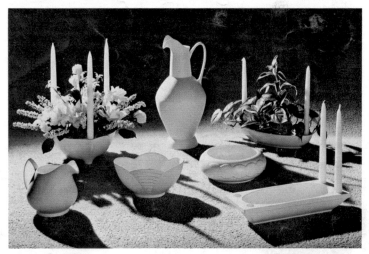

Fig. DD.64 Garden Club Line. Newly designed Garden Club Line items, like these, appeared in Hyalyn Porcelain, Inc.'s 1959 *Fall Additions* catalog. Attributed to Dean Russell Hokanson. (*Historical Association of Catawba County*)

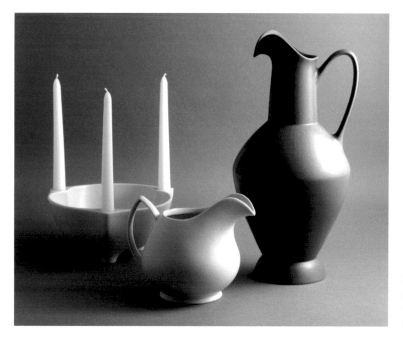

Fig. DD.65 Garden Club Line. (L–R) No. 436, three candle bowl; No. 439, ball pitcher; and No. 441, decorator pitcher. All items, 1959. Attributed to Dean Russell Hokanson. (*Compton photo*)

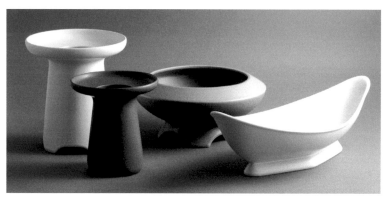

Fig. DD.66 Garden Club Line. (L–R) No. 450, medium footed reflector vase; No. 449, small, footed reflector vase; No. 452, footed coupe bowl; and No. 443, large deep oval bowl. All items, 1960. Attributed to Dean Russell Hokanson. (*Stephanie Turner Photography*)

Georges Briard

Hyalyn Porcelain, Inc. introduced the Georges Briard-designed Midas collection in 1961. Midas Gold and Silver may have preceded it around 1960. The lines included both undecorated and decorated ware. Decorated examples exhibited uniquely sculpted 22-k gold or silver designs applied to matte and gloss glazes. Glaze colors were White, Black, Olive Green, Terracotta, and Blue. Forms included coffee services, casseroles, hors d'oeuvres trays, ashtrays, cigarette cups and lighters, vases of various shapes and sizes, bowls, and cachepots.

Briard was born Jakub Brojdo in Ekaterinoslav, Ukraine, in 1917. After moving to the U.S. in 1937, he studied at the Art Institute of Chicago, where he earned a M.F.A. Max Wille, Briard's art school classmate, suggested the name Georges Briard to brand his commercial designs.[59] Hyalyn Porcelain, Inc. produced Midas for M. Wille, Inc. and Georges Briard Designs, of New York City.

Briard created decorated glassware (much of it overlaid with gold decoration), dinnerware, and other functional and decorative objects from the 1950s to the 1980s. Before his death, at age eighty-eight in 2005, Briard earned the Frank S. Child Lifetime Achievement Award from the Society of Glass and Ceramic Decorators.[60]

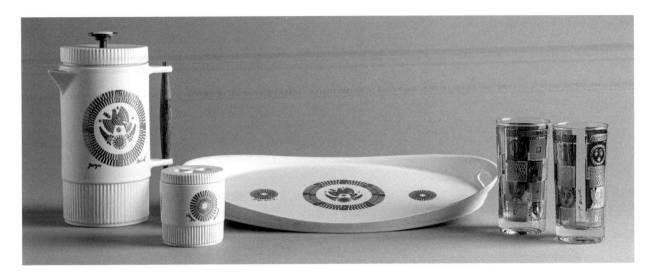

▲ **Fig. DD.67** Midas. Made by Hyalyn Porcelain, Inc. for M. Wille, Inc. and Georges Briard Designs. (L–R) No. B-48, 3-pt coffee pot; No. B-50, sugar with cover; and No. B-40, oval platter; complementary glassware by Georges Briard. All items, *c.* 1961. (*Stephanie Turner Photography*)

▼ **Fig. DD.68** Midas. No. B-10, tall tapered vase, 1961. Georges Briard. (*Stephanie Turner Photography*)

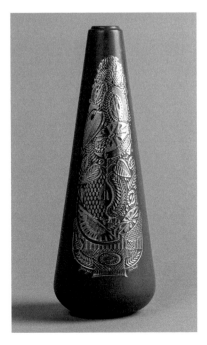

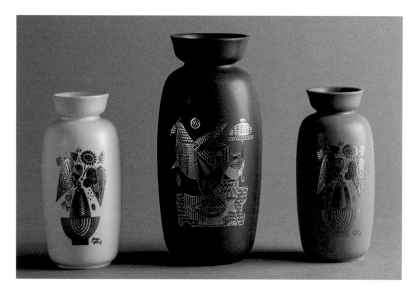

Fig. DD.69 Midas. (L–R) No. B-7, small continental vase; No. B-6, medium continental vase; and No. B-7, small continental vase. All items, 1961. Georges Briard. (*Stephanie Turner Photography*)

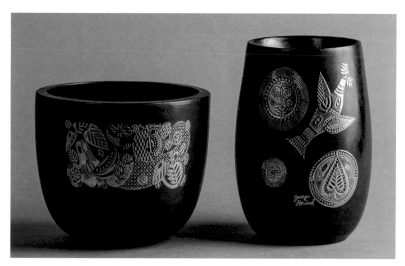

Fig. DD.70 Midas. (L–R) No. B-32, cachepot, and No. B-12, small tapered vase, 1961. Georges Briard. (*Stephanie Turner Photography*)

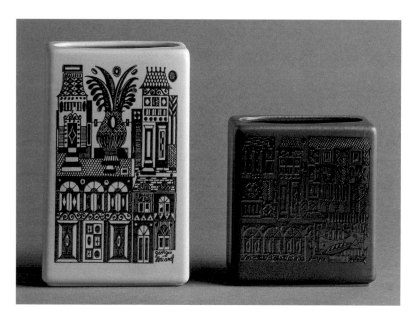

Fig. DD.71 Midas. (L–R) No. B-2, medium pillow vase, and No. B-3, small pillow vase, 1961. Georges Briard. (*Stephanie Turner Photography*)

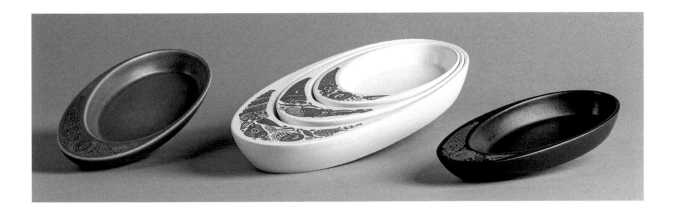

From top to bottom:

Fig. DD.72 Midas. (L–R) No. B-17, small oval relish; No. B-1789, relish set; and No. B-17, small oval relish. All items, 1961. Georges Briard. (*Stephanie Turner Photography*)

Fig. DD.73 Midas. (L–R) No. B-10, tall tapered vase, and No. B-11, medium tapered vase. All items, 1961. Georges Briard. (*Stephanie Turner Photography*)

Fig. DD.74 Midas. (L–R) No. B-30, long trapeziform ashtray; No. B-22, small boat ashtray; No. B-21, lighter; No. B-8, large cigarette box; No. B-20, cigarette cup; and No. B27, large square ashtray. All items, 1961. Georges Briard. (*Stephanie Turner Photography*)

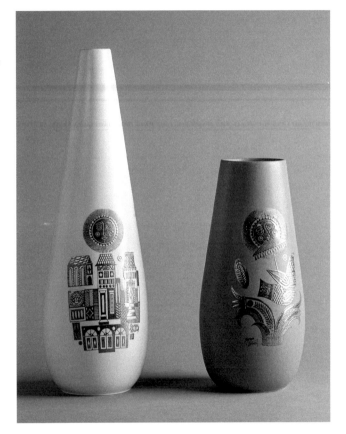

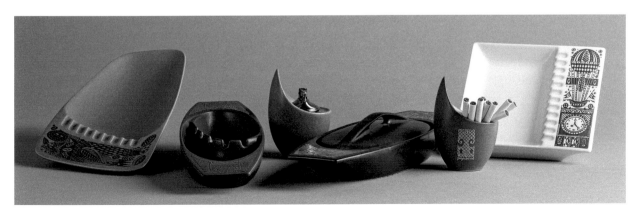

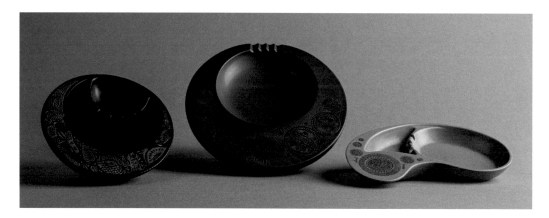

Fig. DD.75 Midas. (L–R) No. B-28, small round safety ashtray; No. B-13, large round ashtray; and No. B-16, small free form ashtray. All items, 1961. Georges Briard. (*Stephanie Turner Photography*)

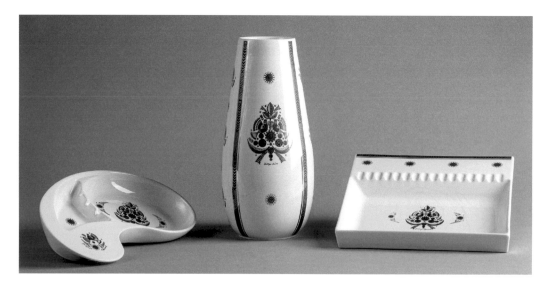

Fig. DD.76 Midas. (L–R) No. B-15, large free form ashtray; No. B-11, medium tapered vase; and No. B-27, large square ashtray. These items are distinct from typical Midas items since they have gloss glaze and flat decalcomania decorations in bright gold. Georges Briard. (*Stephanie Turner Photography*)

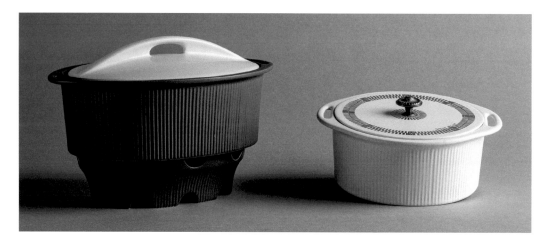

Fig. DD.77 Midas. (L–R) No. PB-43W, 3-qt casserole with warmer, and B-47, 3-qt casserole, 1961. Georges Briard. (*Stephanie Turner Photography*)

Robert Dixon Mitchell and James C. Pyron

Robert Dixon Mitchell was born in Florence, Alabama, on March 18, 1930. Following his death in Hickory, North Carolina, on February 9, 1995, his obituary described him as a graphic artist and industrial engineer. In the early 1960s, Less Moody claimed that a commercial firm named Mitchell and Pyron was responsible for Hyalyn Porcelain, Inc.'s designs.[61] In 1962, Mitchell and Pyron Industrial Design Company was formed in Hickory, North Carolina, by Mitchell and James C. Pyron. Mitchell formerly worked as an associate for Cushing and Nevell, a New York City industrial design firm.[62]

Charlotte, North Carolina, native James Clifford Pyron was born on August 6, 1932. He first studied architecture at North Carolina State University, where he was a member of Army R.O.T.C. After commissioning as a second lieutenant in the U.S. Army Quartermaster Corps, Pyron served as a training officer at Fort Lee, Virginia, and a company commander in Perique, France. Pyron then attended Alabama Polytechnic Institute (which became Auburn University), where he graduated in 1959 with a degree in industrial design.[63]

The Joe L. Williams architectural firm in Corpus Christi, Texas, employed Pyron as a designer following graduation.[64] In early 1962, Pyron joined Robert Mitchell to start up the commercial firm, Mitchell & Pyron Industrial Design Company. In 1966, Pyron was Hyalyn's "staff designer and assistant working very closely with Moody."[65] A 1966 newspaper account calls him the assistant general manager and design director.[66] Pyron probably designed numerous items for Hyalyn Porcelain, Inc. from around 1961 until around 1967 (as a contract designer and an employee). These may include Shibui; Fiesta; Fantasia; La Elegante; Fascination; Decorator Collection; Gold 'N Color; Impresión; Colonial Accessories; and dozens of Garden Club Line items.

In 1968, Pyron opened the Approach Gift Shop in Auburn, Alabama, a retail business operated by him until 1985 when he started Pyron Design and Marketing.[67] Pyron died in Loachapoka, Alabama, on September 3, 2015.

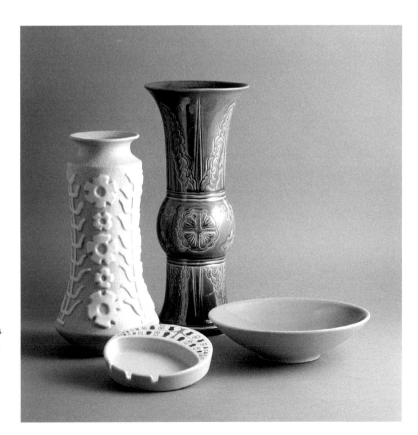

Fig. DD.78 Beginning in 1962, Mitchell and Pyron Industrial Design Company, established by Robert D. Mitchell and James C. Pyron, created many of Hyalyn Porcelain, Inc.'s new products. By 1966, James C. Pyron was named Hyalyn Porcelain, Inc.'s design director. These examples represent some of the lines and glazes first offered during their term as the company's designers. (L–R) Impresión, No. 618, medium vase, 1965; Fiesta, No. 847, small round safety ashtray, 1962; Decorator Collection, No. 580, beaker vase, 1964; and Shibui, No. T537, bowl, 1964. (*Compton photo*)

Eva Striker Zeisel

In 1964, Hyalyn Porcelain, Inc. produced Eva Zeisel's High Fashion line for Raymor, to be distributed nationally by Richards Morgenthau Co. As originally cataloged, the line contained twenty-four items (counting a cup and saucer as one item), which were available in four colors: Olive, Oxblood, Gold, and Mottled Taupe.[68] Simply marked with the letter "Z" and an item number (e.g., Z-1), Hyalyn's *High Fashion* line is popularly known as "Z-Ware." Catalog entries included three dinnerware items with numbers preceded by the letters SZ. These are a 10.5-inch dinner plate, an 8-inch salad plate, and a 6-ounce cup and saucer combination. Four- and five-piece place settings were available for purchase (the five-piece set included a soup bowl). As many as eight additional items may have supplemented High Fashion catalog pieces.[69]

Hungarian-born Éva Amália Striker (Zeisel) was born on November 13, 1906, and died on December 30, 2011.[70] After first pursuing a career as a painter at Budapest's Hungarian Royal Academy of Fine Arts, she turned toward ceramics and studied the craft with Jakob Karpancsik. Upon completion of her training, Striker worked at Hamburg's Hansa-Kust-Keramik workshop.[71]

Striker's career led her from Germany to Russia, where she became the Russian China and Glass Trust's artistic director.[72] Falsely accused in 1936 of plotting Joseph Stalin's assassination, she spent sixteen months in prison (twelve of them in solitary confinement) before deportation to Austria. When Nazis invaded Austria, she and her future husband, Hans Zeisel, fled Europe for the United States.[73]

Fig. DD.79 Eva Striker Zeisel (1906–2011), from the 1970s. Zeisel, an internationally renowned dinnerware designer, created the High Fashion Line, produced by Hyalyn Porcelain, Inc., in 1964 for distribution by Richards Morgenthau and Co. (*Brigitte Lacombe photo. ©Brigitte Lacombe*)

Once in the U.S., Eva Zeisel taught ceramics as industrial design at New York's Pratt Institute. In 1942, New York City's Museum of Modern Art honored her by putting on its first-ever one-woman exhibition. "New Shapes in Modern China Designed by Eva Zeisel" displayed a china line commissioned by the Museum of Modern Art and Pennsylvania's Castleton China Company.[74] Today, numerous museums, including the British Museum, hold Zeisel's work in their permanent collections. In 2005, she received the Lifetime Achievement Award issued by the Cooper-Hewitt Smithsonian National Design Museum.

Zeisel exhibits her philosophy of design in the High Fashion line. The items are non-angular, fluid in form, and useful. Their simplicity in form belies Zeisel's deep thoughtfulness that pervades her designs. The Museum of Modern Art's curator of architecture and design at the time of Zeisel's death, Paola Antonelli, says, "She brought form to the organicism and elegance and fluidity that we expect of ceramics today."[75]

In the 1990s, two of Zeisel's "Z-Ware" shapes were re-created by Brett Bortner for New York's Orange Chicken gallery (Z-2B and Z-6). The pieces were slightly modified in size from Zeisel's originals and came in all black or black with red or white interiors.[76] Vanguard Studios (successor of Hyalyn, Ltd.) showed no interest when approached by Zeisel about reproducing these High Fashion shapes. A company mold-maker put Eva Zeisel in touch with World of Ceramics owner Lynn Causby (Allen), initiating a business relationship lasting from 1996–1999. From 1999–2001, World of Ceramics worked directly with the Orange Chicken when reproducing Zeisel's shapes. North Carolina's World of Ceramics made the two former Z-Ware shapes in three glaze colors—Black, Blue, and White. Zeisel's World of Ceramics pieces are marked "EZ" (plus a two-digit numeral for the year; e.g., EZ_{97}). For several years, Eva Zeisel worked directly with World of Ceramics to reproduce her shapes from Red Wing Pottery's Town and Country dinnerware line. World of Ceramics shipped Zeisel's ware throughout the U.S., including to New York City's Museum of Modern Art and San Francisco's Museum of Modern Art gift shops.[77]

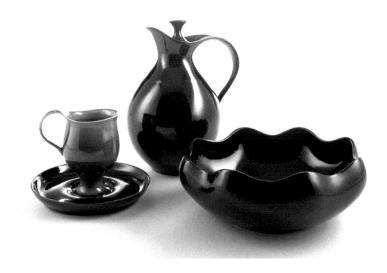

Fig. DD.80 High Fashion. (L–R) No. Z-31-2, cup and saucer; No. Z-13, coffee server; and No. Z-6, salad bowl. All items, 1964. Eva Zeisel. (*Photo © Brent C. Brolin, all rights reserved*)

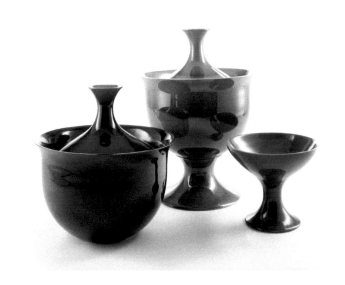

Fig. DD.81 High Fashion. (L–R) No. Z-2, small tureen; No. Z-2B, small, footed tureen; and No. Z-5, footed candy dish. All items, 1964. Eva Zeisel. (*Photo © Brent C. Brolin, all rights reserved*)

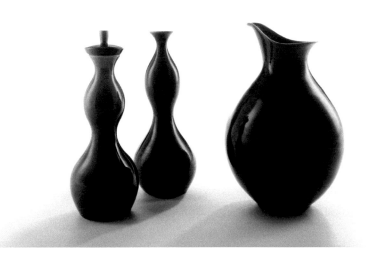

Fig. DD.82 High Fashion. (L–R) No. Z-26, pepper mill; No. Z-25, large salt; and No. Z-14 creamer. All items, 1964. Eva Zeisel. (*Photo © Brent C. Brolin, all rights reserved*)

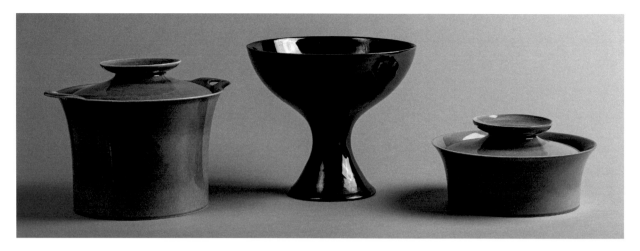

Fig. DD.83 High Fashion. (L–R) No. Z-18, ice bucket; No. Z-4, footed bowl; and No. Z-16, 2-qt casserole. All items, 1964. Eva Zeisel. (*Stephanie Turner Photography*)

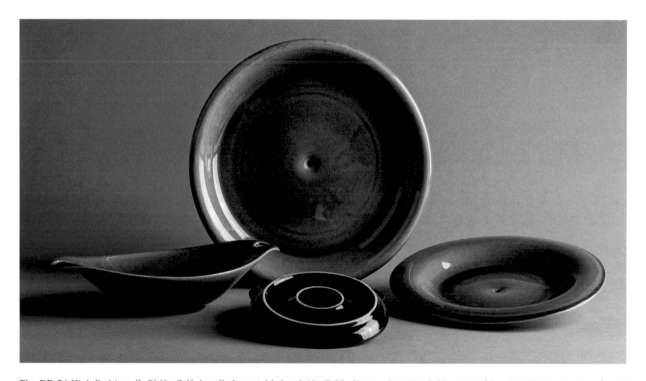

Fig. DD.84 High Fashion. (L–R) No. Z-11, handled vegetable bowl; No. Z-28, dinner plate; No. Z-32, saucer (showing "Z" mark on base); and No. Z-29, salad plate. All items, 1964. Eva Zeisel. (*Stephanie Turner Photography*)

On the next page:

◄ **Fig. DD.85** In 1966, Rachel Elizabeth Carr (Kimball), best known for her books about floral arrangement, designed nine floral containers for Hyalyn Porcelain, Inc. These containers, filled with plants and flowers, are illustrated in one of her popular books, *Creative Ways With Flowers: The Best of Two Worlds East and West.*

▶ **Fig. DD.86** Rachel Carr Collection, showing nine containers suitable for Ikebana floral arrangements or western styles. 1966. (*Historical Association of Catawba County*)

Rachel Schwarz Carr (Kimball)

In 1966, Hyalyn Porcelain, Inc. introduced its Rachel Carr Collection, made up of nine flower arranging containers. To enhance sales, Hyalyn Porcelain, Inc. offered a forty-five-minute slide program for presentation at garden club meetings consisting of seventy 35-mm slides showing tools and techniques for flower arranging and a corresponding program guide. When purchased, each container came with a sixteen-page booklet called *Simple Steps On Flower Designing*, written by Mary Jo Napier, showing five possible flower arrangements.[78] In 1968, Hyalyn Porcelain, Inc. combined the group of containers into The Floweranger Collection. Hyalyn Porcelain, Inc. numbered the shapes RC-1 through RC-9.

Born and educated in China, Rachel Elizabeth Carr (*née* Schwarz) later lived in Japan, where she became accomplished in *Ikebana*, the Japanese art of flower arrangement. In 1956, she received a Master's Degree from Japan's Koryu School for three Japanese flower arrangement styles—*Seika* (classical style), *Moribana* (shallow container style), and *Nageire* (vase style). Carr was the first person from the West to receive the degree.[79] In addition to numerous articles on the subject, Carr authored *A Year of Flowers: Japanese Flower Arrangement Engagement Calendar* (1955), *Stepping Stones to Japanese Floral Art* (1955), *Japanese Floral Art: Symbolism, Cult, and Practice* (1961), and *Creative Ways With Flowers: The Best of Two Worlds: East and West* (1964, 1965, and 1970). This last book shows some flower arrangements made up in Hyalyn Porcelain, Inc.'s Rachel Carr Collection containers. In 1949, she married Olympic track star William A. Carr in Shanghai, China. Following his death in Japan in 1966, Carr married photographer and illustrator, Edward N. Kimball Jr., in New York, in 1970.

Carr was a prolific writer, and in addition to her books about flower arrangement design, she authored books about yoga. Tragically, in December 1981, Rachel Carr lost sight in her right eye after being shot by an intruder who entered her New York apartment.[80]

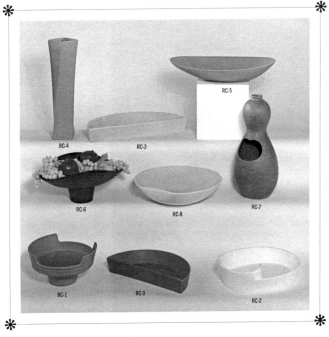

The Floweranger Collection....

Pages 5 - 9 show the best balanced collection of containers for fruit and floral arrangements on today's market. Each available in your choice of five luxurious matte glazes designed to enhance the final product.

Colors Available: BLACK WHITE YELLOW FERN GREEN ZINNIA ORANGE

The above group comprises one special section . . . THE RACHEL CARR COLLECTION . . . Containers equally ideal for Oriental or Western floral designs.

RC-1	Footed Bowl, 9¼" D., 4¾" H.		$4.00	RC-6 Footed Oval Compote, 12½" x 10" Oval, 5½" H.	$4.00
RC-2	Swirl Low Bowl, 12" x 9" Oval, 3" H.		5.00	RC-7 Gourd-Bottle Vase, 6" D., 14½" H.	5.00
RC-3	Half Circle Large Bowl, 17" D., 2¼" H.		5.00	RC-8 Large Round Bowl, 13" D., 3" H.	5.00
RC-4	Twisted Pillow Vase, 3½" Sq., 15" H.		4.50	RC-9 Half Circle Small Bowl, 12¾" D., 2" H.	3.50
RC-5	Large Oval Bowl, 17" x 12¼" Oval, 3" H.		5.00		

PLEASE NOTE: The Matte Glazes BLACK - WHITE - YELLOW - FERN GREEN - ZINNIA ORANGE are available on all Hyalyn FLOWERANGER CONTAINERS and all Hyalyn MATTE SMOKING ACCESSORIES.

ALL PRICES SHOWN ARE SUGGESTED RETAIL

PAGE 5

Hyalyn offers a 45 minute slide program which consists of 70 35mm slides showing tools and techniques of arranging and finished arrangements. The 8 photos shown on this page are typical of the many shown in the program. With the program comes a commentary describing the materials, etc. used.

We suggest that you contact your local garden club presidents, tell them of this offer, and work with them so that you may order the containers for them. Write directly to us for additional information.

PAGE 12

Fig. DD.87 Hyalyn Porcelain, Inc. offered a forty-five-minute, seventy-slide program for use by garden clubs to promote the sale of the Rachel Carr Collection. The program included these eight photographs. (*Historical Association of Catawba County*)

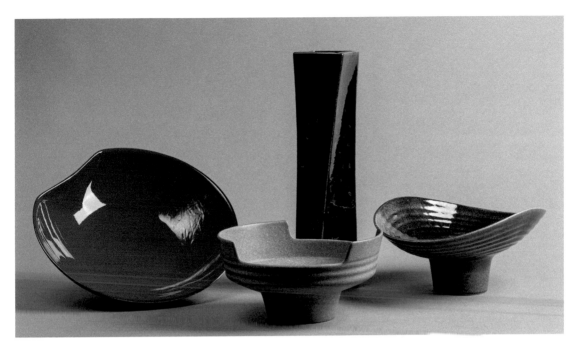

Fig. DD.88 Rachel Carr Collection. (L–R) No. RC-8, large round bowl; No. RC-1 (front center), footed bowl; No. RC-4, twisted pillow vase; and No. RC-6, footed oval compote. All items, 1966. Rachel Carr. (*Stephanie Turner Photography*)

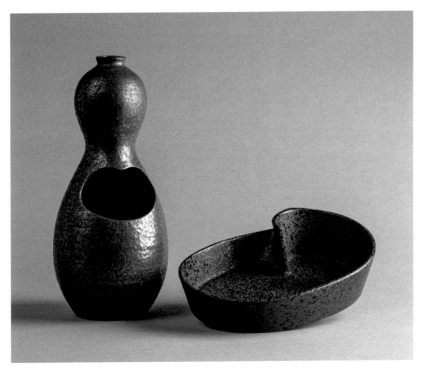

Fig. DD.89 Rachel Carr Collection. (L–R) No. RC-7, gourd-bottle vase, and No. RC-2, swirl low bowl. All items, 1966. Rachel Carr. (*Stephanie Turner Photography*)

Lee Bernay

Mostly known for lamp designs, Lee Bernay created Hyalyn Porcelain, Inc.'s Paisley line of porcelain decorative and serving accessories. The series, first introduced by Hyalyn Porcelain, Inc. in the fall of 1966, included ashtrays, cigarette boxes and lighters, lidded jars and canisters, cachepots, candleholders, vases, party trays, and bath accessories. Initially, Paisley patterns came in three colors: Blue, Brown, and Green. Later, Hyalyn Porcelain, Inc., offered matte-glazed pieces in four color combinations, including Blue on Turquoise, Green on Fern Green, Orange on Zinnia Orange, and Brown on Yellow. Gloss glazes came in colors named Kumquat, Goldfinch, and Parrot Green. Hyalyn Porcelain, Inc. last offered Paisley for sale in 1970. The letters "LB" go before Bernay-designed Hyalyn Paisley ware numbers. In the 1950s, Lee Bernay Associates had offices at 129 W. 22nd Street, New York, NY. In the 1960s, Lee Bernay Designs, India, produced decorative objects, jewelry, and clothing accessories.

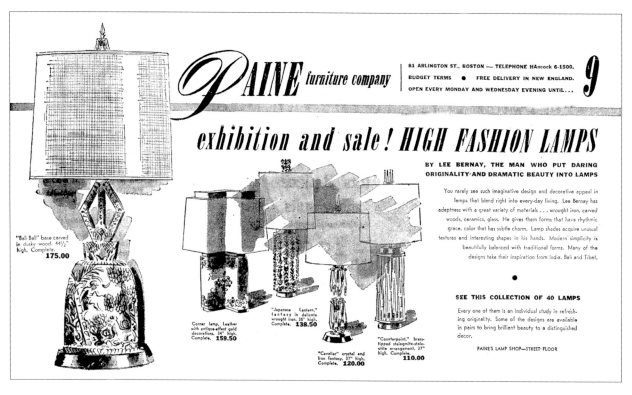

Fig. DD.90 Designer Lee Bernay created lamps for Hargri Studios, Lamp-Craft Studios, his own Lee Bernay and Associates, and perhaps others. His work as a lamp designer likely led him to know Less Moody and to the creation of the Paisley collection of hostess service and accessories for Hyalyn Porcelain, Inc., in 1966. From the *Boston Traveler* (Boston, MA), October 27, 1953. (*genealogybank.com*)

On the next page:

▲ **Fig. DD.91** A sample of Paisley items offered by Hyalyn Porcelain, Inc. Promoted as, "The bold look that is today's fashion … serving and smoking accessories for those who are IN," Paisley came in three colors—blue, brown, and green. (*Historical Association of Catawba County*)

▼ **Fig. DD.92** Paisley. (L–R) No. LB-103, candle holder, 1967; No. LB-101, soap dish, 1966; No. LB-118, small canister, 1967; No. LB-111, tall vase, 1967; and No. LB-103, candle holder, 1967. (*Stephanie Turner Photography*)

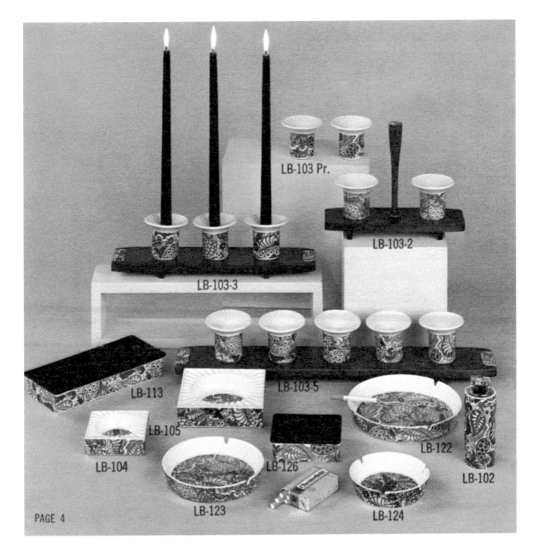

PAGE 4

LB-103 Pr.

LB-103-2

LB-103-3

LB-103-5

LB-113

LB-105

LB-104

LB-126

LB-123

LB-124

LB-122

LB-102

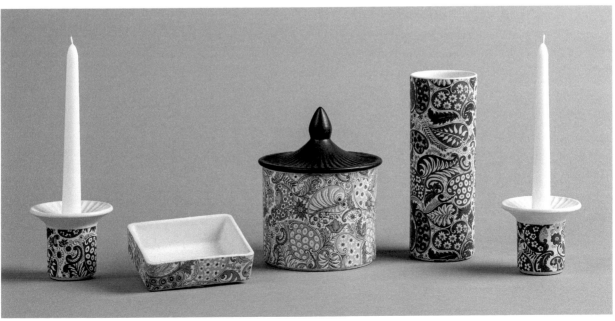

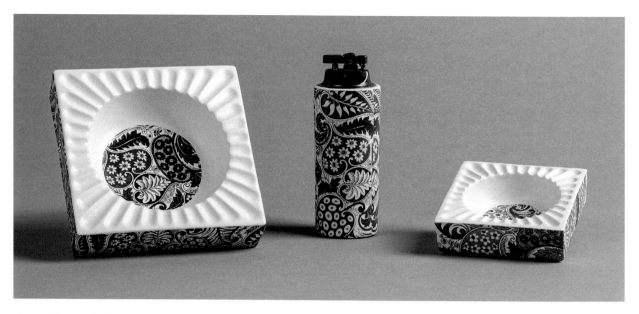

Fig. DD.93 Paisley. (L–R) No. LB-105, medium ashtray; No. LB-102, lighter; and No. LB-104, small ashtray. All items, 1967. (*Stephanie Turner Photography*)

Illustrators

Decalcomania decorated many Hyalyn Porcelain, Inc. ashtrays, tiles, mugs, coasters, plates, and plaques. Early coupe-shaped picture plates carried images of fruit and floral arrangements and copies of classical paintings, like several illustrating French couples by Jean-Antoine Watteau (1684–1721).

Some decalcomania was original art generated exclusively for Hyalyn Porcelain, Inc. In 1960, the Hyalyn Porcelain, Inc. catalog defined decalcomania:

> They are picture transfers printed by lithography or silk screen process in ceramic (metal oxide) colors. When applied to HYALYN porcelain ware the colors from the decalcomanias are fused into the glaze at 1325˚F. The colorful decoration is then permanent and a part of the glazed surface. The brilliant colors are maintained forever.

Most of Hyalyn Porcelain, Inc.'s decalcomania artists remain unnamed. One example, like the hand-colored drawing on an ashtray, bears the artist's name. The artist W[illiam?] Soles probably created the clever design exclusively for Setauket, Long Island, New York's Delano Studios in 1958. The ashtray, perhaps designed by Robert Sigmier, was produced by Hyalyn Porcelain, Inc. Stuart Bruce's name appears on decalcomania depicting horses, dogs, and birds. Edwin Megargee, Dale Ulrey, and Lynn Moody made original decalcomania art for Hyalyn Porcelain, Inc.

Edwin Megargee

Although he capably painted other animals, Edwin Megargee is best known for his paintings of dogs. Hyalyn Porcelain, Inc. employed decalcomania derived from his pictures of hunting dogs, puppies, and probably horses and game birds.

Philadelphia born, he first attended Georgetown University before studying art at Drexel University. Later, he attended classes at the Art Students League, where he studied with Kenyon Cox, Vincent du Mond, and Walter A. Clarke.[81] His paintings found their way into publications like *Field and Stream* and *Country Life* and books by Derrydale Press. His illustrated dog dictionaries are well-known, and the running greyhound logo for the Greyhound Bus Company was his design.[82] Edwin Megargee's designs decorate items sold by Syracuse China, Delano Studios, Italy's Verbano Porcelain, and others.

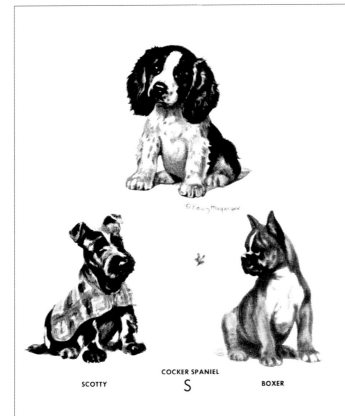

Puppies

....lovable, adorable, salable

Dog specialist or everyday dog lover—both will acclaim the excellent reproduction of these six well known breeds. All reproductions are in full color, permanently fired and signed by their creator, these pups make every item a fine conversation piece.

Available singly on 638, 676, 679, 679-N, 680 ash trays and 677 coaster set.

Available in B or S group (be sure to specify which) on 505 and 507 tiles, 510 and 512 plaques, 615 ash tray, and 641 mug.

SCOTTY

COCKER SPANIEL

S

BOXER

PUPPIES

by Mr. Edwin Megargee, the famous illustrator of domestic animals, who painted the originals for reproduction on our accessory group of porcelain items. Mr. Megargee has had his work reproduced in such well known magazines as Country Gentlemen, Country Life, Field and Stream, Spur, and many others. He is the illustrator of the new book, "World Book of Dogs", by Julie Campbell Thatum.

Besides being a gifted delineator of dogs, he is a qualified judge of several breeds; and his own experience as a breeder has helped to stamp his illustrations with an authority difficult, otherwise, to be recognized. In addition to holding office in several breed clubs and appearing in "Who's Who," Mr. Megargee is chairman of a library committee of the American Kennel Club.

These Puppy illustrations speak with authority and are perfect in every detail.

DACHSHUND

B

BEAGLE

BOSTON BULL

Page 15

Fig. DD.94 Noted for his depictions of purebred dogs, Edwin Megargee (1883–1958) provided original decalcomania art to decorate Hyalyn Porcelain, Inc. accessories, including tiles, plaques, ashtrays, and mugs. The company introduced its "Puppies by Hyalyn Porcelain" series in 1957. (*Historical Association of Catawba County*)

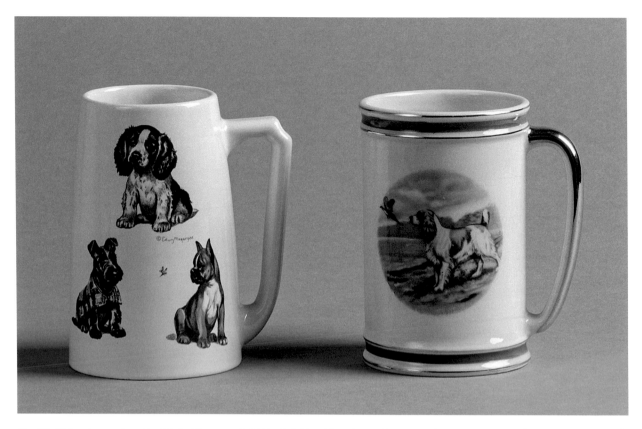

Fig. DD.95 Decalcomania art by Edwin Megargee. (L–R) No. 641, 1955 (shape); 1957 (decoration); and No. 620, 1951 (shape and decoration). (*Stephanie Turner Photography*)

Dale Conner Ulrey

Hyalyn Porcelain, Inc. had good fortune when the prominent professional illustrator, Dale Ulrey, moved to Hickory, North Carolina, in 1952. Less Moody engaged Ulrey to design exclusive decorations for Hyalyn Porcelain, Inc. Hyalyn Porcelain, Inc.'s catalogs prominently featured tiles, plaques, coasters, and ashtrays bearing original Ulrey designs.

Mildred Dale Conner was born near Sulphur Springs, Texas, in 1904. She began her art training at Texas University, where she studied theater art. For twelve years, Ulrey worked as an artist for New York's Hadley Studios. She then worked in Chicago before moving with her husband, Herb, to Hickory, where he opened the F. H. M. Ulrey advertising agency. She was the agency's art director.[83]

Ulrey illustrated several syndicated comic strips, including *Mary Worth's Family* (formerly *Apple Mary*), *Ayer Lane*, and *Hugh Striver* (written by her husband). In addition to *Jaglon and the Tiger Fairies* (1953) and *The Tin Woodman of Oz* (1955), she illustrated a 1956 edition of *The Wonderful Wizard of Oz*.[84]

On the next page:

▲ **Fig. DD.96** Following her move to Hickory in 1952, Less Moody engaged professional illustrator, Dale Ulrey, to design exclusive decalcomania decorations for Hyalyn Porcelain, Inc. The six original designs, seen here on No. 631 pagoda plates, were made in pairs for a decorative line called American Provincial. (*Compton photo*)

▼ **Fig. DD.97** Dale Ulrey likely designed the art for Hyalyn Porcelain, Inc.'s 1953 line called Courtin' Daz. Two examples (top), seen here on No. 631 pagoda plates, are from this series. The coasters display Ulrey's floral design made for the American Provincial series. (*Compton photo*)

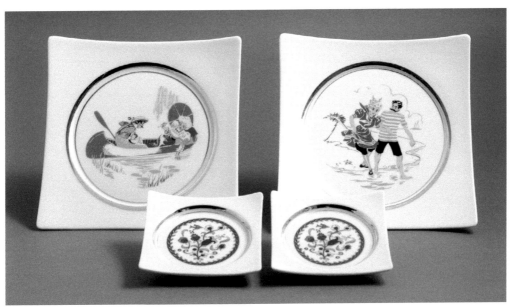

INTRODUCING

hyalyn for FALL 1969

AMERICA'S FINEST
HICKORY. NORTH CAROLINA

"MERRIE MODS"
FOR YOUNG MODERNS

Fig. DD.98 Suggesting that it be called the Hippy Line, Less and Frances Moody's daughter, Lynn, created the decalcomania art for what became Hyalyn Porcelain, Inc.'s Merrie Mods for Young Moderns group of smoking accessories, in 1969. (*Hickory Landmarks Society*)

Lynn Moody (Igoe)

Born in Galesburg, Illinois, in 1937, Lynn Moody Igoe was the daughter of H. Leslie and Frances Johnson Moody. An artist, art historian, and author, she chaired North Carolina Central University's art department and directed its art gallery. With her husband, James Igoe, Lynn Moody Igoe published *250 Years of Afro-American Art: An Annotated Bibliography* (Bowker, 1981). She held degrees in English and contemporary art from the University of North Carolina at Chapel Hill. Moody spent her growing-up years in Hickory, North Carolina, before moving to Chapel Hill, where she died from cancer in 2006. Hyalyn introduced her Merry Mods decalcomania designs in its Fall 1969 catalog.

DECORATORS

At first, Hyalyn Porcelain, Inc. created hand-painted underglaze ware and overglaze decorated ware. Overglaze ware decorators applied decalcomania, 22-k gold, and colored glazes on rims, handles, and plate fronts. Hyalyn Porcelain, Inc. soon eliminated underglaze hand-painted decoration in favor of decalcomania and gold embellishments. Later, gold and silver designs applied to Georges Briard's Midas lines, and patterns used on other lines, were silkscreen printed onto surfaces. Herb Cohen taught slip-trailed decoration to workers.

Most of the hand-painted underglaze decoration may have been applied to ware by Hickory artist Emma Louisa Cilley. Born in North Carolina in 1902, Cilley died from cancer in 1961. Cilley most likely worked for Hyalyn Porcelain, Inc. from 1947–1948. Edgar Littlefield probably created the stylized, brushed-on line patterns she painted. Though time-consuming, the simple brush-stroke designs added a "handmade" quality to some of Hyalyn Porcelain's mass-produced products.

Benjamin F. Crews, Jr., led Hyalyn's decorating department from 1947 to 1973. Before taking on his Hyalyn Porcelain, Inc. role as a decorator and the department superintendent, Cambridge, Ohio's Universal Potteries Company, employed Crews.[85] He was born August 20, 1917, in Coshocton, Ohio. His father, Benjamin Crews, Sr., was an Ohio potter.[86] In 1940, Ben Crews, Jr., was an apprentice gilder engaged in the production of table and cooking pottery ware.[87] He was married to Hyalyn decorator, Gwendolyn Mary Crews (*née* Weiger). Gwen Crews died on January 14, 1980.

Undoubtedly, there were many more Hyalyn Porcelain, Inc. decorators. Others known to have worked in the decorating department include Susan Kirby, Verna Reid, and Jimmie Teague. Company records call Reid and Teague "stipplers."

ADDITIONAL LINES

Lamps

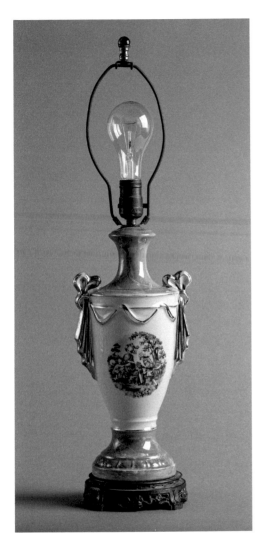 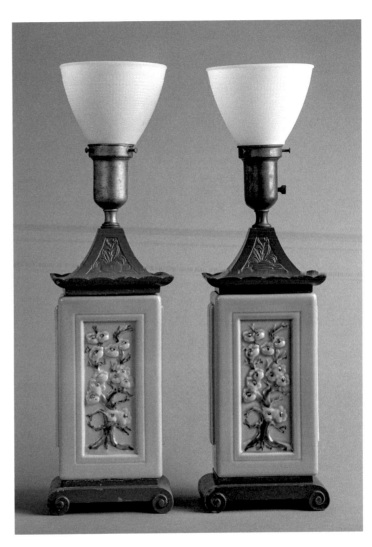

◄ **Fig. LL.1** A traditionally-styled lamp, attributed to Hyalyn Porcelain, Inc., featuring a cast metal base, an Antoine Watteau decalcomania decoration found on No. 801 picture plates, and gold trim. Marked W-77 on its base. Possibly produced for Westwood, *c.* 1948. (*Stephanie Turner Photography*)

► **Fig. LL.2** Two lamps made by Hyalyn Porcelain, Inc. for Rembrandt Lamps, *c.* 1947–1948. The lamps' carved panels reflect the design found on Hyalyn's No. 203 pillow vases. Design attributed to Rookwood Pottery's Wilhelmine Rehm. Base and cap are cast metal. Each lamp's lightbulb socket is marked Rembrandt Lamps. (*Stephanie Turner Photography*)

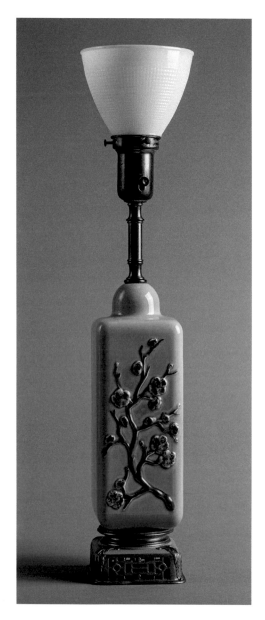

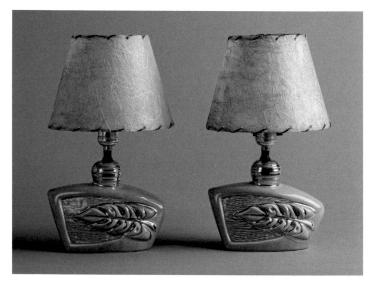

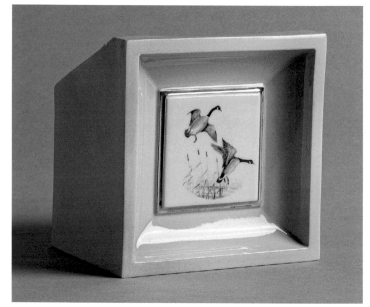

◄ **Fig. LL.3** A lamp made by Hyalyn Porcelain Inc. for Rembrandt Lamps. Design attributed to Wilhelmine Rehm. The base is cast metal. The lamp's lightbulb socket is marked Rembrandt Lamps. (*Stephanie Turner Photography*)

▶ **Fig. LL.4** Lamps attributed to designer Charles Leslie Fordyce and Hyalyn Porcelain, Inc. Textured panels, front and back, with leaf motif on front side only, *c.* 1951. This lamp's shape and the textured panel is reminiscent of Fordyce's Free Form line made for Hyalyn in 1951. Original shades replaced. (*Stephanie Turner Photography*)

▶ **Fig. LL.5** Television lamp. No. 627. Hyalyn Porcelain, Inc., 1953. (*Stephanie Turner Photography*)

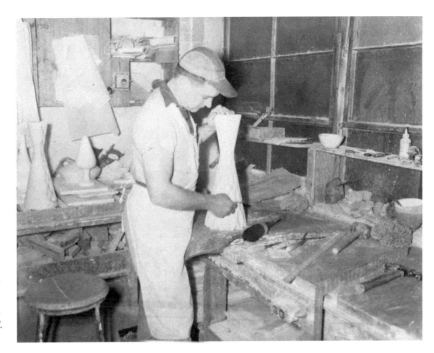

Fig. LL.6 A Hyalyn worker prepares a lamp base model for mold-casting. The lamp's design is by Gerald Thurston for Lightolier, c. 1953. For finished examples, see Fig. LL.7. (*Hickory Landmarks Society*)

Fig. LL.7 Gerald Thurston-designed lamps made for Lightolier. See Fig. LL.6. Ceramic components by Hyalyn Porcelain, Inc., c. 1953. (*Photo courtesy of Judy Engel*)

Fig. LL.8 Lamps attributed to Hyalyn Porcelain, Inc. for an undetermined company. Each one is marked S-26 on its base. Hickory, NC, provenance, *c.* 1946–1956. (*Stephanie Turner Photography*)

Fig. LL.9 Lamp bases collected and contributed to the Historical Association of Catawba County by Hyalyn, Ltd.'s former owner, Robert Warmuth. Attributed to Hyalyn Porcelain, Inc. T.V. lamp (center) is marked P-380. (*Stephanie Turner Photography*)

 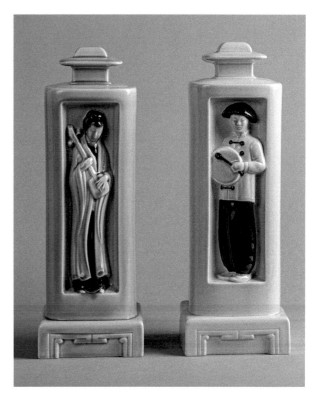

◄ **Fig. LL.10** Lamps attributed to Hyalyn Porcelain, Inc. The Asian-themed, floral decorated example's glaze matches the company's 1940s glaze called Dawn-Mist Gray. (*Stephanie Turner Photography*)

► **Fig. LL.11** Two lamps featuring Asian musicians. Designs attributed to Frances Johnson Moody for Hyalyn Porcelain, Inc. Bases marked (L–R) NS-13 and NS-12. Dawn-Mist Gray glaze with hand-decorated highlights. (*Stephanie Turner Photography*)

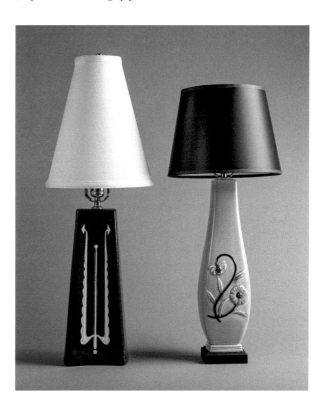

Fig. LL.12 Two lamp bases collected and contributed to the Historical Association of Catawba County by Hyalyn, Ltd.'s former owner, Robert Warmuth. Attributed to Hyalyn Porcelain, Inc. The black wooden base is added, and the lamps' original shades are replaced. (*Stephanie Turner Photography*)

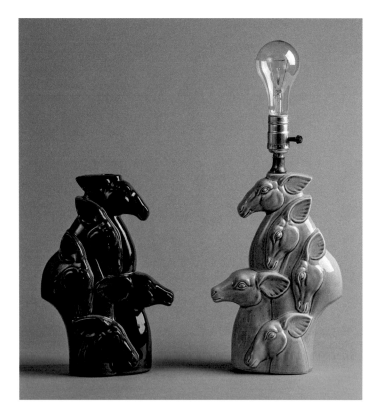

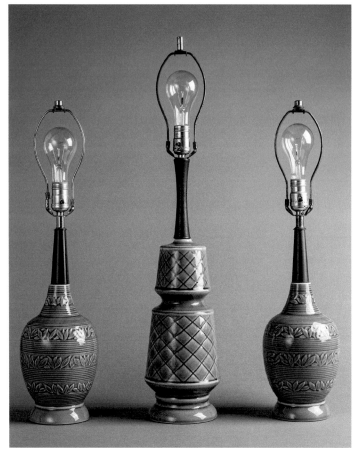

◄ **Fig. LL.13** Deer lamps. Design attributed to Frances Johnson Moody for Hyalyn Porcelain, Inc. Bases are marked M-167. (*Stephanie Turner Photography*)

◄ **Fig. LL.14** Lamps attributed to Hyalyn Porcelain, Inc. The lamps' footed bases match in size and shape the base for Hyalyn's No. 441 decorator pitcher, which may have been created by Dean Russell Hokanson, *c*. 1959. Their carved designs and soft brown translucent glaze color harken back to Wilhelmine Rehm's and Less Moody's collaborative design and glaze work in the 1940s. (*Stephanie Turner Photography*)

► **Fig. LL.15** A lamp base representing Claremont High School's yearbook called the *Hickory Log* (Hickory, NC). Design attributed to Frances Johnson Moody for Hyalyn Porcelain, Inc. (*Stephanie Turner Photography*)

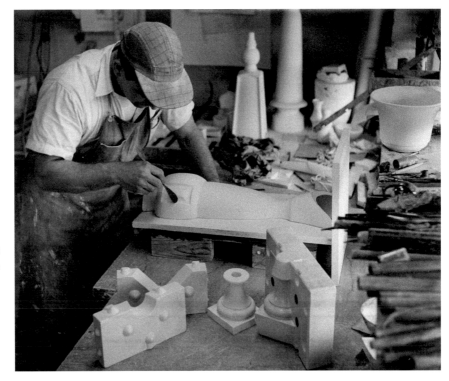

Fig. LL.16 Lamp base modeling. From its beginning, Hyalyn Porcelain, Inc., manufactured lamp bases for many companies, including Lightolier, Morris Greenspan, Westwood, and Rembrandt. Designers' plans sometimes required modification to conform to production methods. (MaDan Studios, 1957. *Photographs of Hyalyn Porcelain Company, MC 00337, Special Collections Research Center, North Carolina State University Libraries, Raleigh, NC*)

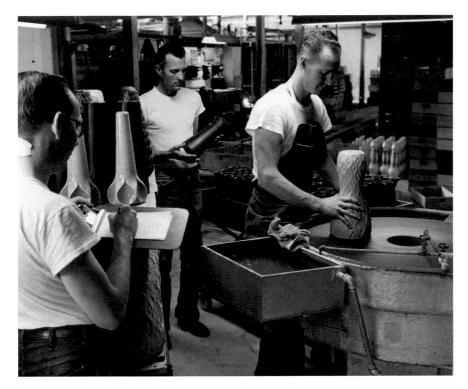

◄ **Fig. LL.17** Hyalyn Porcelain, Inc.'s finishing process included grinding each lamp's base. (MaDan Studios, 1957. *Photographs of Hyalyn Porcelain Company, MC 00337, Special Collections Research Center, North Carolina State University Libraries, Raleigh, NC*)

► **Fig. LL.18** The porcelain section of this lamp base, made by Hyalyn Porcelain, Inc., is like the one being ground smooth in Fig. LL.17. Rare photographs made inside the factory make it possible to confirm the company's production of otherwise unmarked lamp bases. (*Photo courtesy of Barbarella Home*)

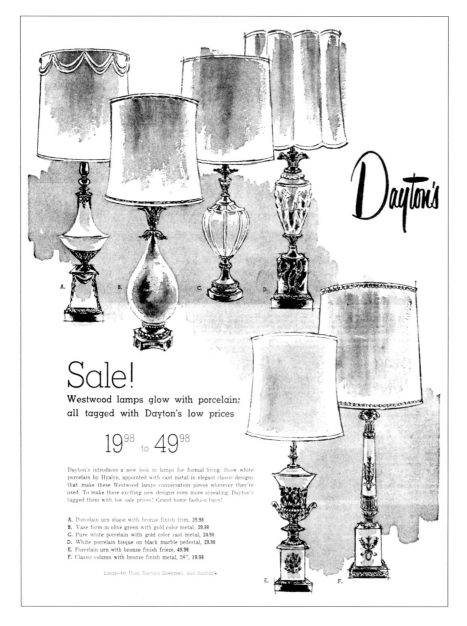

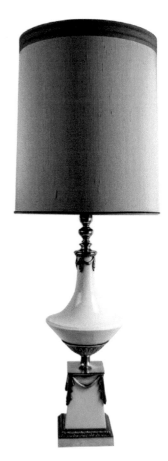

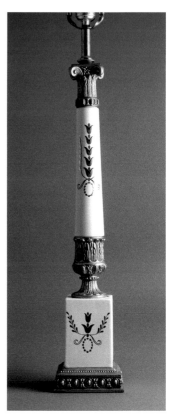

Clockwise from top left:

Fig. LL.19 Advertisements like the one seen here, showing a group of Hyalyn-made lamps for Westwood, help when identifying unmarked Hyalyn Porcelain, Inc. examples. From *The Minneapolis Star* (Minneapolis, MN), May 16, 1963, p. 14. (*Newspapers.com*)

Fig. LL.20 A lamp base manufactured for Westwood by Hyalyn Porcelain, Inc., *c.* 1963. The advertisement found in Fig. LL.19 offers this lamp for sale. (*Photo courtesy of Barbarella Home*)

Fig. LL.21 A lamp base manufactured for Westwood by Hyalyn Porcelain, Inc., *c.* 1963. The advertisement found in Fig. LL.19 offers this lamp for sale. (*Photo courtesy of Barbarella Home*)

9, 10 LIGHTOLIER: Interlocking hourglass shapes, in beige striated porcelain, are topped with gold foil shade. White glazed porcelain is fashioned into curvaceous base, has pleated white vinyl-over-fiber-glass shade. Both are designed by Gerald Thurston and retail for about $30. In New York at 11 East 36th Street.

9 10

Counterclockwise from top left:

Fig. LL.22 Hyalyn Porcelain, Inc. contributed to the manufacture of this Gerald Thurston-designed Lightolier lamp. (See Fig. LL.24) Buyers praised the company for its porcelain lamp components' consistently high quality. (*Photo courtesy of Stamford Modern*)

Fig. LL.23 Like the lamp seen in Fig. LL.22, this example is made up of Gerald Thurston-designed porcelain components manufactured by Hyalyn Porcelain, Inc. (See Fig. LL.24). Unfortunately for collectors, few Hyalyn Porcelain-made lamps bear the company's trademark. (*Photo courtesy of Michelle Sommerlath, Galerie Sommerlath*)

Fig. LL.24 The lamps seen in Figures LL.22 and LL.23 are shown here in a trade magazine advertisement encouraging Lightolier's buyers to visit the company's New York showroom. (*Historical Association of Catawba County*)

The Garden Club Line

Attention
Garden Club Members

Just arrived in time for you to use in all your prize winning spring flower arrangements - - - HYALYN PORCELAIN'S GARDEN CLUB line of bowls, pillow vases, and urns ... in matt black, chartreuse, spruce green, dawn mist gray, and antique white.

Hyalyn Porcelain's graceful proportions, simple design and rich glaze will accent the beauty of your flower arrangements ... Make Hyalyn Porcelain your choice for the Strolling Flower Show March 31st.

SAM FRANK & MOORE

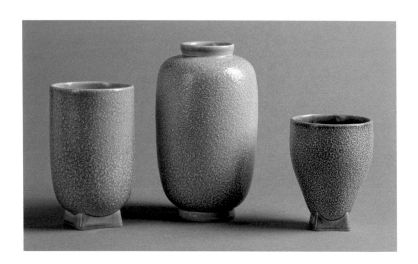

Top left:
Fig. GC.1 Hyalyn Porcelain, Inc. and retail sellers promoted the usefulness of the company's Garden Club Line of bowls, trays, and vases for floral arrangement. This 1955 Alabama newspaper advertisement encourages buyers to select Hyalyn Porcelain to make arrangements for an upcoming spring flower show. From *The Decatur Daily* (Decatur, AL), March 6, 1955. (*Newspapers.com*)

Top right:
Fig. GC.2 Pebble Grain Finish. When introduced in 1953, Hyalyn offered Pebble Grain Finish in four colors (Swedish White, Oatmeal, Warm Gray, and Forest Green). No. S-255, rose vase, 1953. (*Stephanie Turner Photography*)

Middle left:
Fig. GC.3 No. 235, planter bowl (center), and No. 247, candleholder (left and right). All items, 1951. The Garden Club Line was initially called the Floral Arrangement Line. (*Stephanie Turner Photography*)

Left:
Fig. GC.4 Pebble Grain Finish. (L–R) No. S-257, square footed vase; No. S-256, tall vase; and No. S-258, square footed vase. All items, 1953. (*Stephanie Turner Photography*)

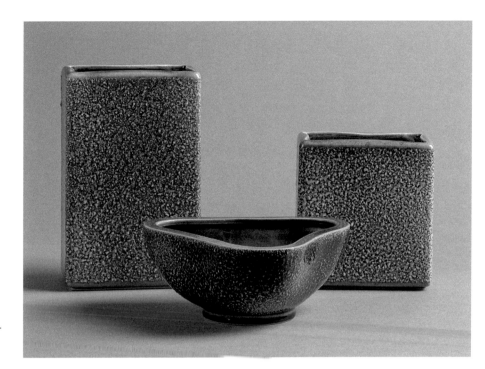

Fig. GC.5 Pebble Grain Finish. (L–R) No. S-228, large pillow vase; No. S-260, tri-form bowl; and No. S-229, small pillow vase. All items, 1953. (*Stephanie Turner Photography*)

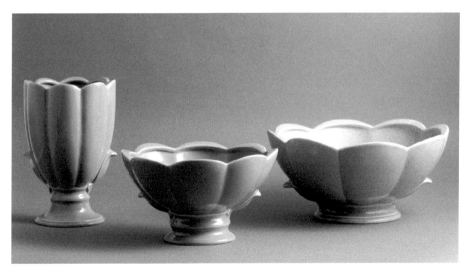

Fig. GC.6 The Etruscan Group. "At the request of the Garden Clubs," Hyalyn Porcelain, Inc. created The Etruscan Group of footed pieces that included two bowls, a vase, and candleholders. Hyalyn first offered the group in five colors (New Matt Black, New Chartreuse, Spruce Green, Dawn Mist Gray, and Antique White). (L-R) No. 253, vase; No. 252, bowl; and No. 251, bowl. All items, 1953. (*Compton photo*)

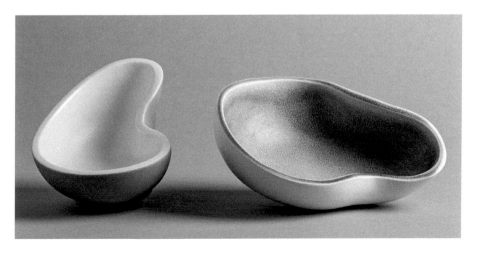

Fig. GC.7 Describing it as "excellent for flower arrangements, fruit and nut bowls," Hyalyn added the Contour Group in the fall of 1953. The group included five shapes. Matte glaze combinations included Dark Terracotta, Green and Black—all with Ivory inside— and Ivory with Brown Blush inside. (L–R) No. 265, long bowl, and No. 273, long bowl. All items, 1953. (*Stephanie Turner Photography*)

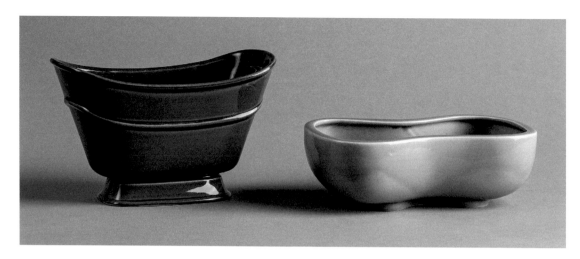

Fig. GC.8 New Garden Club Line items, first offered in the fall of 1953, included these No. 263 (left) and No. 271 (right) floral containers. All items, 1953. Color choices included Dawn Mist Gray, Spruce Green, Chartreuse, Matt Black, Antique White, and Terracotta Matt. (*Stephanie Turner Photography*)

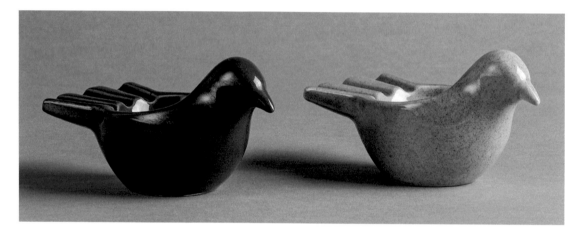

Fig. GC.9 Hyalyn Porcelain, Inc.'s 1953 fall offerings included two small bird-shaped planters. Both examples shown here are the line's No. 270 bird planter, 1953. (*Stephanie Turner Photography*)

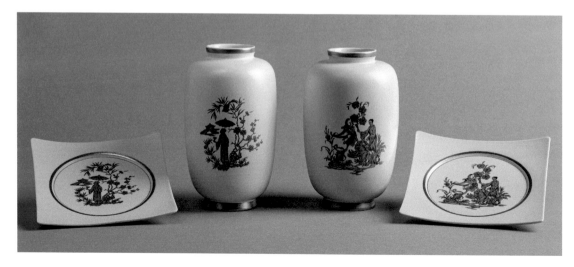

Fig. GC.10 Available in White Semi-Matt or Black Matt, Hyalyn Porcelain, Inc.'s Chinese Motif–Gold Decor group came in the two patterns seen here. No. 631, pagoda plate and No. 256, vase. All items, 1953. (*Stephanie Turner Photography*)

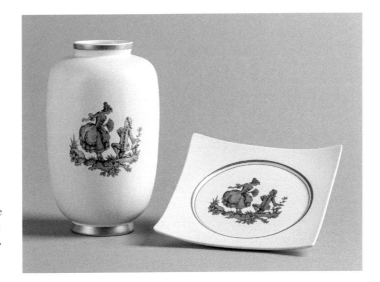

Fig. GC.11 Following its 1953 introduction, the Chinese Motif–Gold Decor group came decorated with new designs, including the colonial couple scene shown here. No. 256, vase and No. 631, pagoda plate. All items, *c.* 1954. (*Stephanie Turner Photography*)

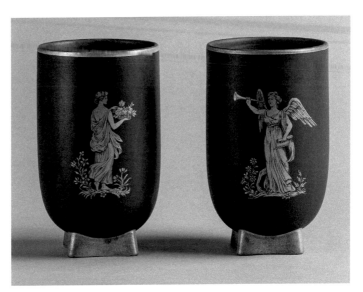

Fig. GC.12 The Chinese Motif–Gold Decor group. No. 257, square footed vase, *c.* 1954. (*Stephanie Turner Photography*)

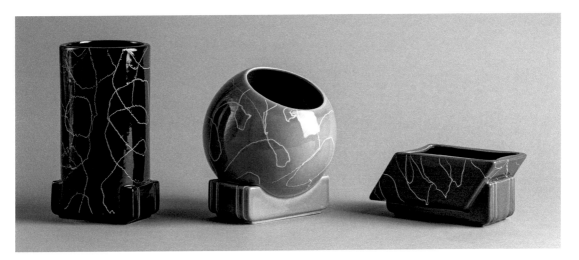

Fig. GC.13 These "atomic age-looking" planters, perhaps offered only in 1954, show Less Moody's growing awareness of some buyers' preference for modern designs. (L–R) No. 282; No. 285; and No. 283. All items, *c.* 1954. (*Stephanie Turner Photography*)

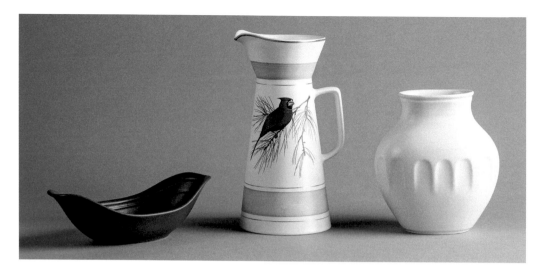

Fig. GC.14 Garden Club Line. Three distinctive shapes, all claimed to be useful for flower arrangement. North Carolina's state bird, the cardinal, decorates the pitcher. Its base bears a mark indicating that Hyalyn created it for the Order of the Eastern Star. (L–R) No. 304, bowl; No. 645, pitcher, and No. 311, vase. All items, *c.* 1955. These items were introduced during Robert Sigmier's term as Hyalyn Porcelain, Inc.'s designer. (*Stephanie Turner Photography*)

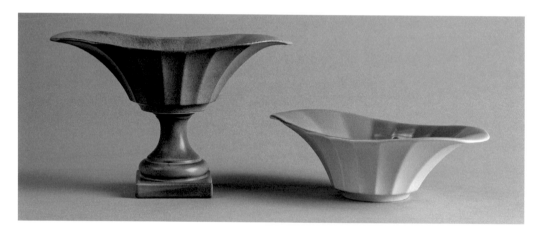

Fig. GC.15 Garden Club Line. (L-R) No. 308 with base, oval bowl, and No. 308, no base. All items, 1955. (*Stephanie Turner Photography*)

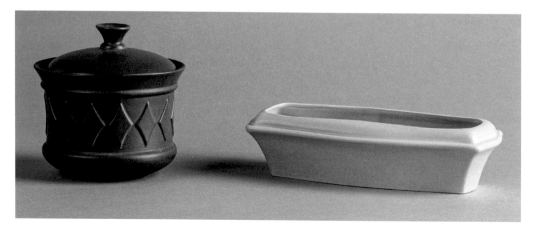

Fig. GC.16 Garden Club Line. (L–R) No. L301C, cachepot with cover, and No. 313, medium planter. All items, 1955. (*Stephanie Turner Photography*)

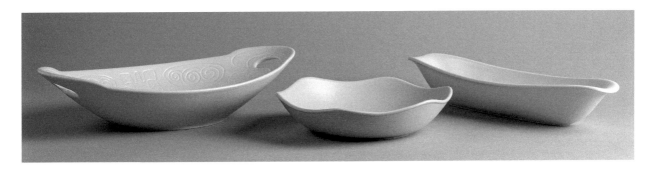

From top to bottom:

Fig. GC.17 Garden Club Line. Three bowls for floral arrangement. (L–R) No. 342, large oval bowl; No. 334, low scalloped bowl; and No. 348, long boat. All items, 1956. (*Stephanie Turner Photography*)

Fig. GC.18 Garden Club Line. No. 299A, bowl with medium base, 1955. In 1961, this shape, with the base shown, was included in Hyalyn Porcelain, Inc.'s new logotype. (*Stephanie Turner Photography*)

Fig. GC.19 Harkening back to designs like those he produced at Abingdon Pottery years before, Less Moody introduced this group of three classic vases in 1956. This Lansing, Illinois, hardware store advertisement hails them as a "jewel-like trio ... to make your loveliest flowers even lovelier still!" From *The Times* (Munster, IN), August 2, 1956. (*Newspapers.com*)

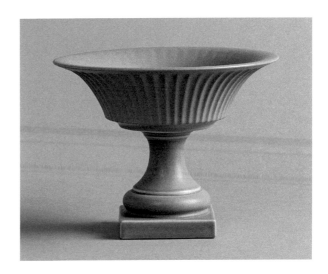

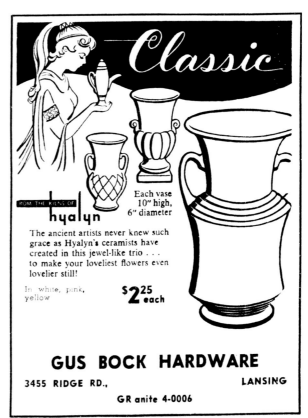

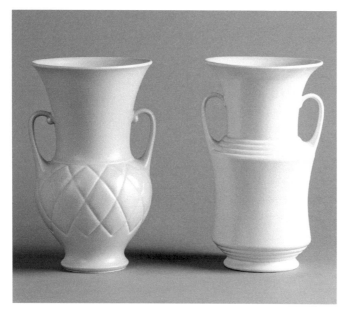

From top to bottom:

Fig. GC.20 Garden Club Line. Two of three classic vases advertised for sale in the Gus Bock Hardware advertisement seen in Fig. GC.19. (L–R) No. 338 and No. 339. All items, 1956. (*Stephanie Turner Photography*)

Fig. GC.21 Garden Club Line. (L–R) No. 354C, bowl with low base, 1956; No. 395D, ribbed bowl with footed base, 1958; and No. 336, flare vase, 1957. (*Stephanie Turner Photography*)

Fig. GC.22 Garden Club Line. (L–R) No. 315, medium cylinder vase, 1957; No. 363, rectangular footed bowl, 1957; and No. H324, medium vase, 1956, attributed to Frances Moody. (*Stephanie Turner Photography*)

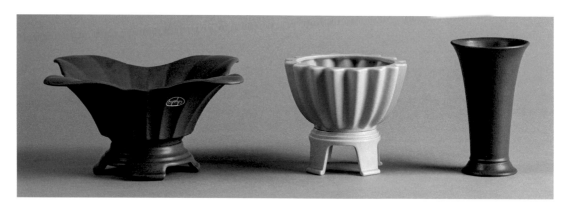

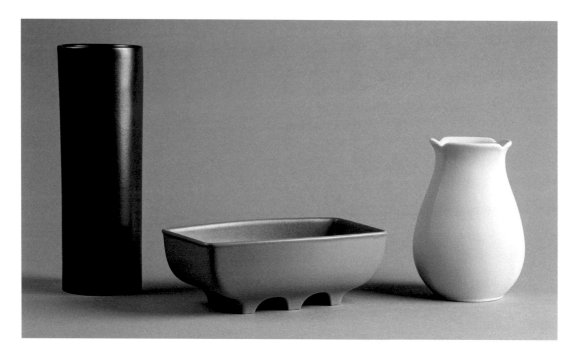

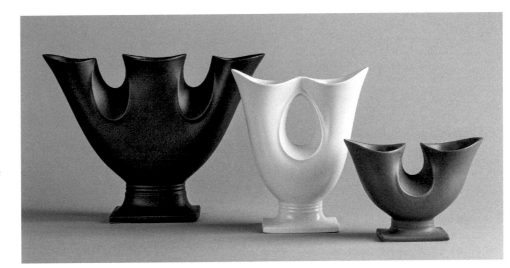

Fig. GC.23 Garden Club Line. (L–R) No. 383, large gladiola vase; No. 387, double, tall cornucopia; and No. 388, double, low cornucopia. All items, 1958. (*Stephanie Turner Photography*)

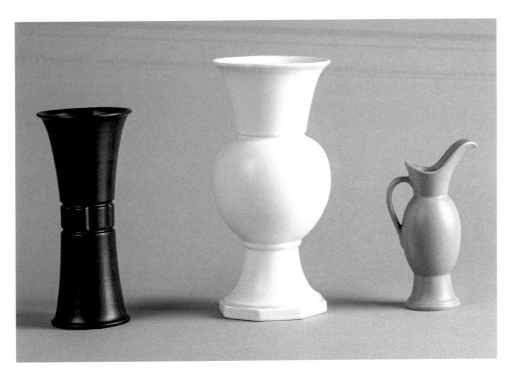

Fig. GC.24 Garden Club Line. (L–R) No. 386, tall collared vase; No. 407, large classic vase; and No. 406, small pitcher. All items, 1958. (*Stephanie Turner Photography*)

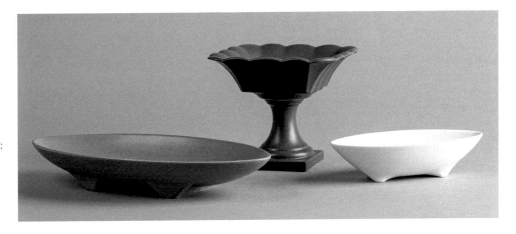

Fig. GC.25 Garden Club Line. (L–R) No. 435, medium footed bowl, 1959; No. 429E, rectangular bowl with base, 1959; and No. 400, footed oval bowl, 1958. (*Stephanie Turner Photography*)

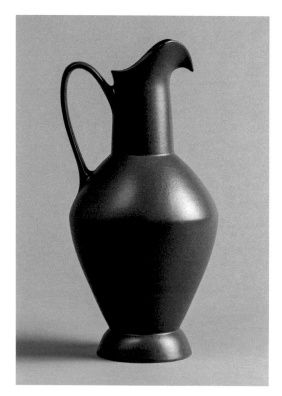

Fig. GC.26 Garden Club Line. No. 441, decorator pitcher, 1959. Attributed to Dean Russell Hokanson. (*Stephanie Turner Photography*)

Fig. GC.27 Promotional flyer. Raymor/Richards Morgenthau Co. planters, manufactured by Hyalyn Porcelain, Inc. before 1963. (*Historical Association of Catawba County*)

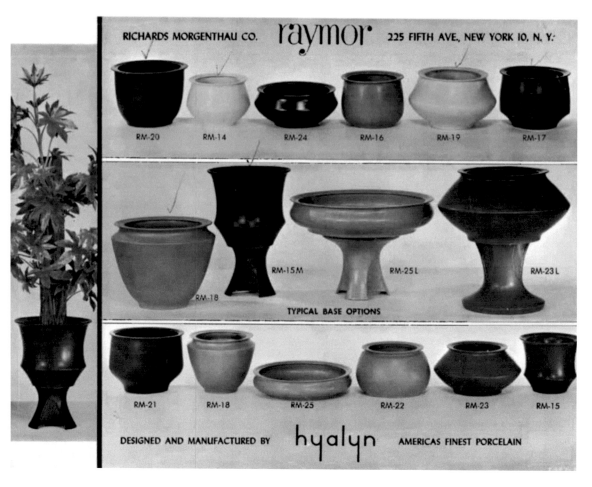

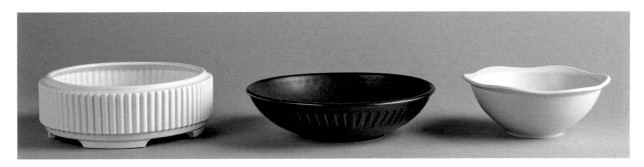

Fig. GC.28 Garden Club Line. No. 445, round reeded bowl; No. 411, round deep bowl; and No. 454, small round bowl. All items, 1960. (*Stephanie Turner Photography*)

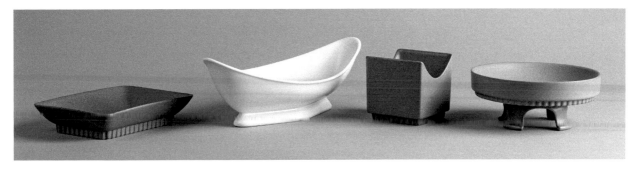

Fig. GC.29 Garden Club Line. No. 459, rectangular bowl with a reeded foot; No. 443, large deep oval bowl; No. 460, square planter with a reeded foot; and No. 458J, shallow bowl on an oriental base. All items, 1960. (*Stephanie Turner Photography*)

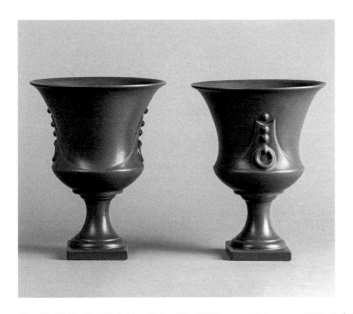

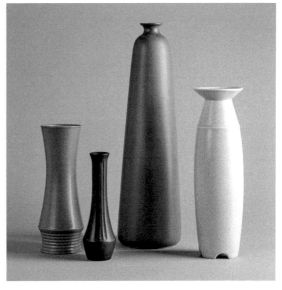

◀ **Fig. GC.30** Garden Club Line. Pair of No. 478E urns with bases, *c.* 1960–61. (*Stephanie Turner Photography*)

▶ **Fig. GC.31** Garden Club Line. No. 448, flared vase; No. 475, candleholder bud vase; No. 823, tall bottle vase; and No. 809, tall footed vase. All items, 1961. (*Stephanie Turner Photography*)

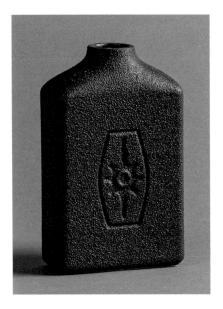

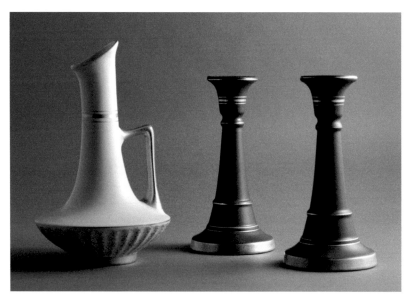

◀ **Fig. GC.32** Pebblecraft by Hyalyn. No. 905, bottle vase. 1961. (*Stephanie Turner Photography*)

▶ **Fig. GC.33** La Eleganté. No. G472, classic bud vase, 1961; No. G494, tall classic candleholder, 1962. (*Stephanie Turner Photography*)

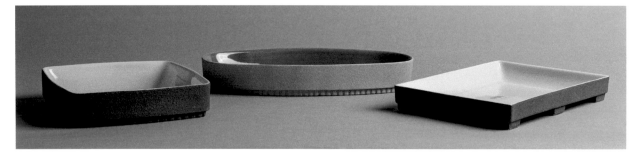

Fig. GC.34 Shibui. According to the line's first catalog description, "The beauty of SHIBUI can only be produced from organic honesty coupled with artistic superlativeness." (L–R) No. T483, square bowl, 1962; No. 489, large oval bowl with a reeded foot, 1962; and No. T532, large footed rectangular bowl, 1963. (*Stephanie Turner Photography*)

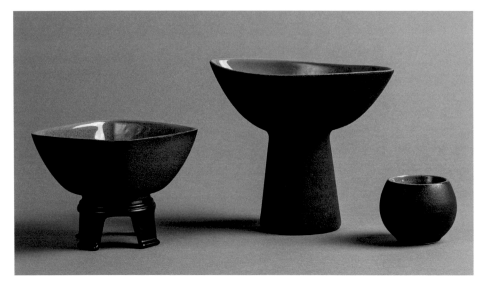

Fig. GC.35 Shibui. (L–R) No. T401D, deep bowl on classic foot; No. T817, tall oval compote, 1963; and No. 762, ball cigarette cup, 1961. (*Stephanie Turner Photography*)

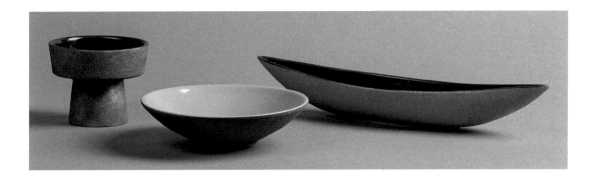

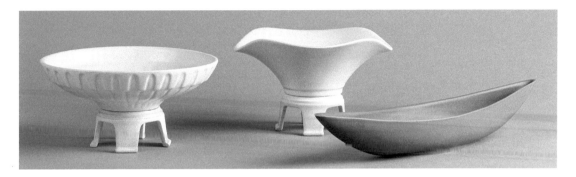

From top to bottom:

Fig. GC.36 Shibui. (L–R) No. T516, small round compote, 1963; No. T537, round bowl, 1964; and No. T530, large crescent bowl, 1963. (*Stephanie Turner Photography*)

Fig. GC.37 Garden Club Line. (L–R) No. 503D, sculptured bowl on classic foot, 1963; No. 432D, flared bowl on classic foot, 1962; and No. 530, large crescent bowl, 1963. (*Stephanie Turner Photography*)

Fig. GC.38 Flower Creations from Hyalyn. Hyalyn sold floral containers with "permanent" flower arrangements, including the ones illustrated here in its 1963 catalog. That same year, *Simple Steps of Flower Designing*, a book by Mary Jo Napier, was offered for sale to encourage garden club business. (*Historical Association of Catawba County*)

PROUDLY PRESENTS FOR TODAY'S MARKET

Fruit Creations

The beauty of fruit artfully arranged in colorful complementing porcelain containers is "FRUIT CREATIONS". This permanent fruit is the finest of polyethylene, and the containers are recognized as America's Finest Porcelain — **hyalyn.**

A national advertising program in trade and consumer magazines will aid you in increasing your sales. The national prestige of "Fruit Creations" will be recognized by your customers.

There is a decorative need in every home for fruit arrangements to add color and charm to the dining or patio area. The fruit is so natural looking, colorful and permanent.

These elegant arrangements are compatible in traditional or modern decor. The styling is both unique and classic. Show Hyalyn fruit creations for increased sales.

Another fine gift item from —

HYALYN PORCELAIN, INC. HICKORY, NORTH CAROLINA

◀ **Fig. GC.39** Fruit Creations from Hyalyn. Introduced in 1963, Fruit Creations offered Hyalyn Porcelain, Inc.'s containers filled with "permanent fruit" constructed of "the finest polyethylene." (*Historical Association of Catawba County*)

▶ **Fig. GC.40** Fruit Creations from Hyalyn. No. 503E, sculptured bowl on medium base, with polyethylene fruit, 1963. (*Stephanie Turner Photography*)

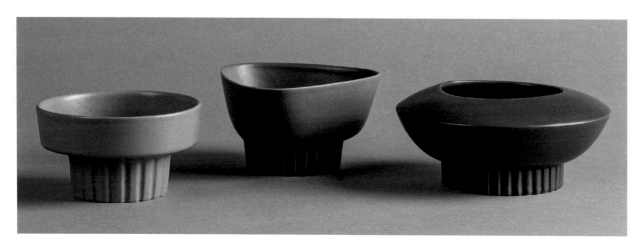

Fig. GC.41 Garden Club Line. Junior bowls. (L–R) No. J23, small compote, 1963; No. J22, tri-shaped bowl, 1963; and No. J11, low round bowl, 1961. (*Stephanie Turner Photography*)

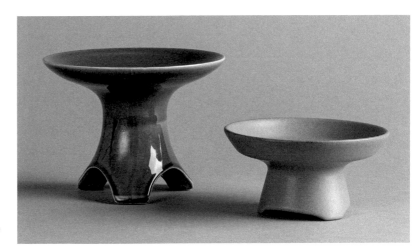

Fig. GC.42 Garden Club Line. No. 548, footed usubata, and No. 519, reflector bowl. All items, 1964. (*Stephanie Turner Photography*)

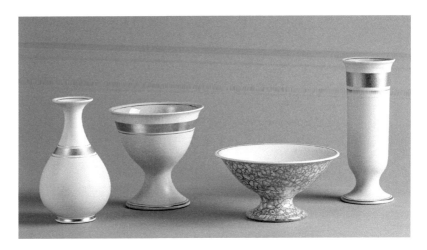

Fig. GC.43 Gold 'N Color. (L–R) No. 563, bud vase; No. 565, tall candy dish; No. 549, small compote; and No. 562, footed vase. All items, 1964. (*Stephanie Turner Photography*)

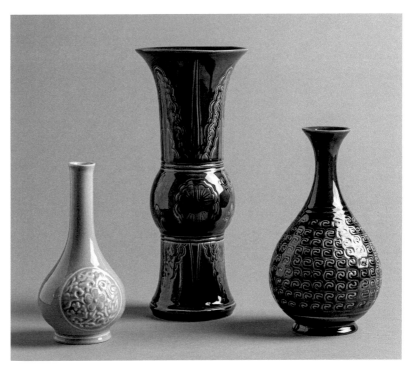

Fig. GC.44 Decorator Collection. (L–R) No. 582, bottle bud vase; No. 580, beaker vase; and No. 575, flask vase. All items, 1964. (*Stephanie Turner Photography*)

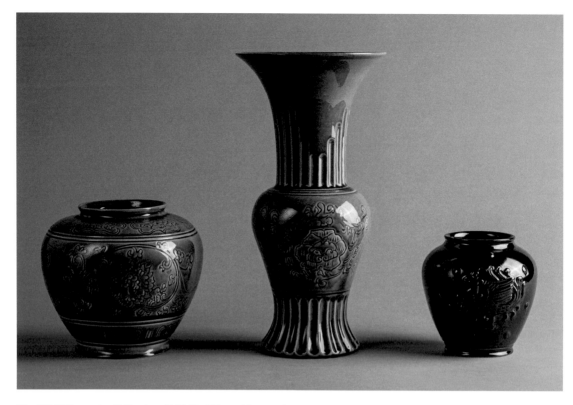

Fig. GC.45 Decorator Collection. (L–R) No. 581, potiche jar, 1964; No. 571, Yen Yen vase, 1964; and No. 589, dragon jar, 1965. (*Stephanie Turner Photography*)

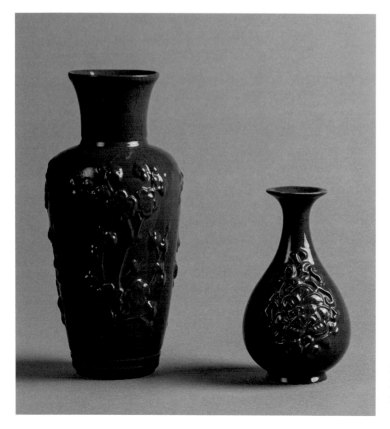

Fig. GC.46 Decorator Collection. (L–R) No. 574, Rouleau vase, 1964, and No. 577, flask bud vase, 1964. Red glaze version, 1966. (*Stephanie Turner Photography*)

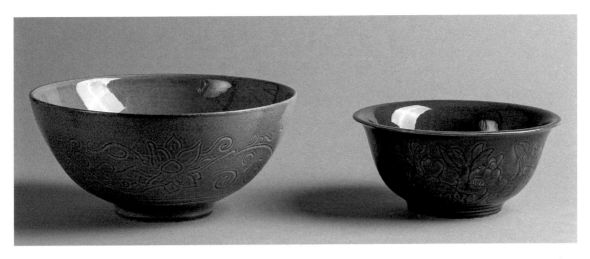

Fig. GC.47 Decorator Collection. (L–R) No. 573, large bowl, and No. 579, flare bowl. All items, 1964. (*Stephanie Turner Photography*)

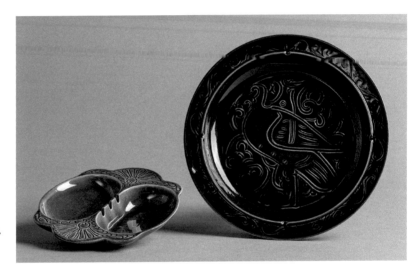

Fig. GC.48 Decorator Collection. (L–R) No. 654, double safety ashtray, 1965, and No. 576, large bird tray, 1964. (*Stephanie Turner Photography*)

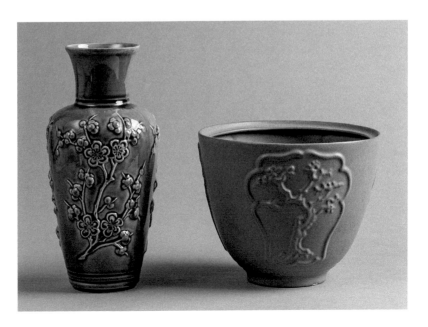

Fig. GC.49 Decorator Collection. (L–R) No. 574, Rouleau vase, 1964, and No. 602, Ming Tree jardinière, 1966. (*Stephanie Turner Photography*)

Fig. GC.50 Hyalyn introduced the Impresión Collection in its Fall 1962 catalog. Described as a "spirited new collection of accessories," its quirky raised floral motif was well-suited to 1960s "Mod" tastes. (*Historical Association of Catawba County*)

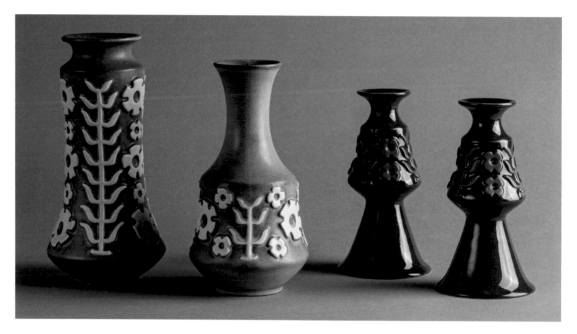

Fig. GC.51 Impresión Collection. (L–R) No. 618, medium vase; No. 619, bottle vase; and No. 625, bud vase candle holders. All items, 1965. (*Stephanie Turner Photography*)

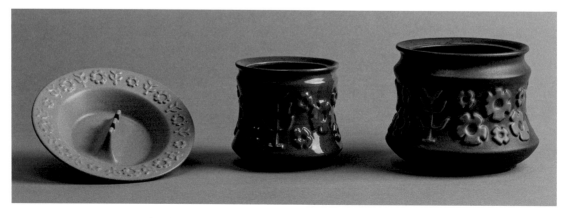

Fig. GC.52 Impresión *Collection.* (L–R) No. 639, center rest ashtray, 1965; No. 630, candy bowl; and No. 620, cachepot. All items, 1965. No. 630, red glaze version, 1966. (*Stephanie Turner Photography*)

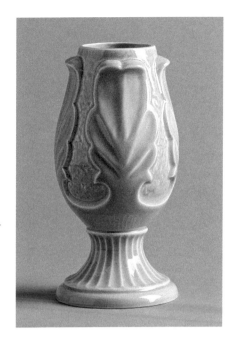

From top to bottom:

Fig. GC.53 Garden Club Line. No. 665, acanthus vase, 1966. (*Stephanie Turner Photography*)

Fig. GC.54 Garden Club Line. (L–R) No. G673, Gold 'N Bronze, shell bowl, 1966; No. 737, swirl bowl, 1967; No. 592, classic vase, 1965; and No. 613, rectangular bowl, 1966. (*Stephanie Turner Photography*)

Fig. GC.55 Garden Club Line. (L–R) No. F-14, pedestal vase; No. F-11, rose vase; and No. F-18, small pedestal bowl. All items, 1968. (*Stephanie Turner Photography*)

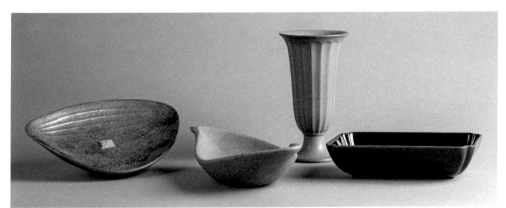

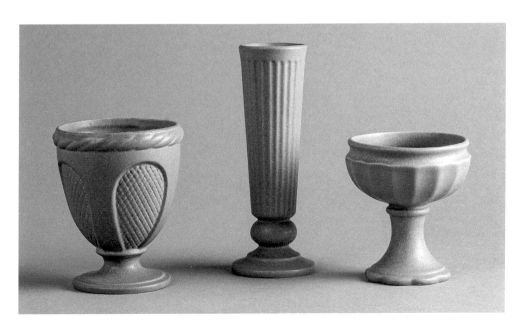

Smoking Accessories

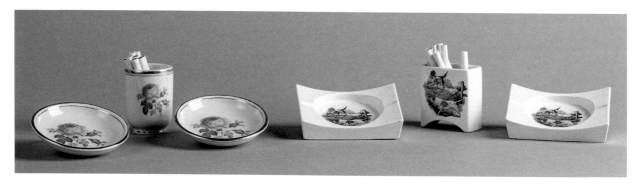

Fig. SA.1 Cigarette cup and ashtray sets. (L–R) Unmarked set with No. 603 ashtrays, Natural Rose decalcomania, *c.* 1950, and No. 680CS, 1957, "Our new smart cigarette set consisting of two oblong ashtrays and a new style cigarette cup for king size or regular cigarettes." Each set came packaged in a gift box. (*Stephanie Turner Photography*)

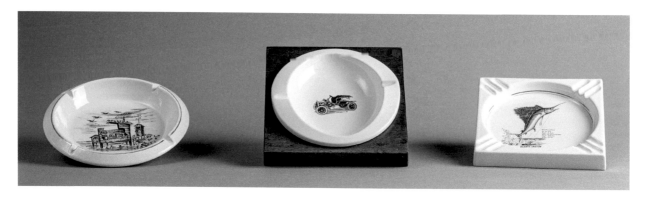

Fig. SA.2 Large ashtrays. (L–R) No. 647. Custom decalcomania by W. Soles. Made for Delano Studios, Setauket, Long Island, New York, 1958; No. 679, The Porcelain Prince, 1957; No. 615, He-Man ashtray. Shape, 1951; and Game Fish pattern, 1958. (*Stephanie Turner Photography*)

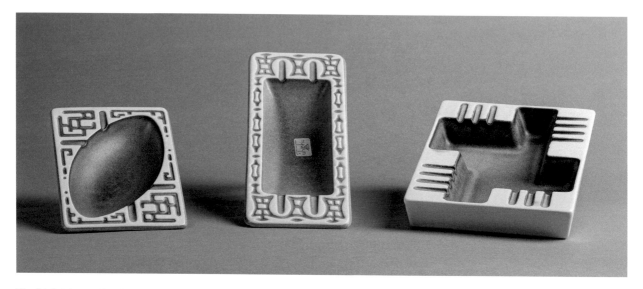

Fig. SA.3 Ashtrays. Portfolio Collection. Hyalyn added these designs after Herbert Cohen's 1958 departure from Hyalyn Porcelain, Inc. (L–R) No. 703; No. 701, rectangular ashtray and No. 704, deep ashtray. All items, 1959. (*Stephanie Turner Photography*)

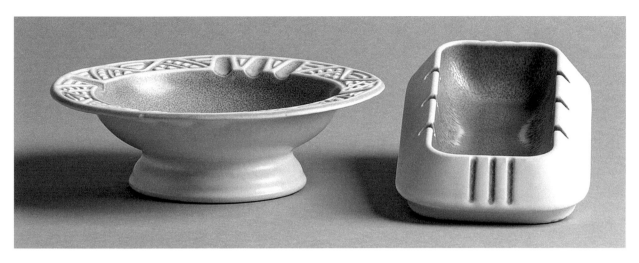

Fig. SA.4 Ashtrays. Portfolio Collection. Hyalyn added these designs after Herbert Cohen's 1958 departure from Hyalyn Porcelain, Inc. (L–R) No. 698, footed ashtray, 1959, and No. 711, boat ashtray, 1961. (*Stephanie Turner Photography*)

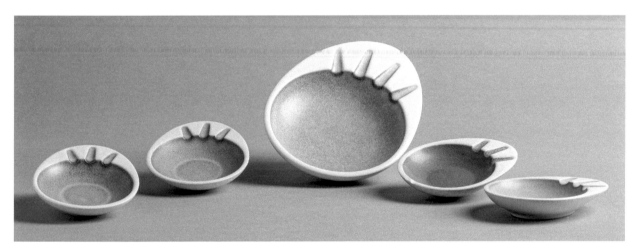

Fig. SA.5 Ashtrays. Portfolio Collection. Hyalyn added these designs after Herbert Cohen's 1958 departure from Hyalyn Porcelain, Inc. No. 709, small ashtray-coaster and No. 708, medium oval ashtray. All items, 1960. (*Stephanie Turner Photography*)

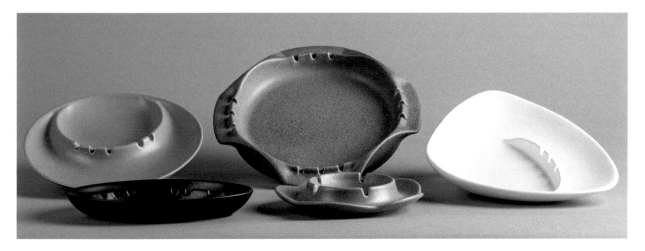

Fig. SA.6 Ashtrays. (Front row, L–R) No. 808, oval ashtray, 1961; No. 41, 1968; (Back row, L-R): No. 807, large round center rest ashtray, 1962; No. 759, large safety ashtray, 1960; and No. 672, large tri-form safety center ashtray, 1966. (*Stephanie Turner Photography*)

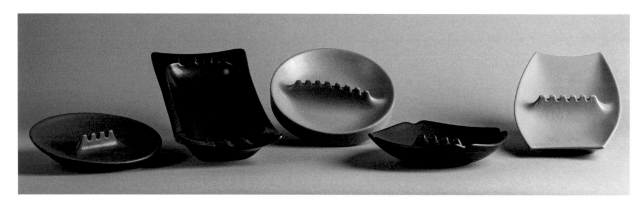

Fig. SA.7 Ashtrays. (L–R) No. 770, large round center rest ashtray, 1963; No. 671, rectangular ashtray, 1957; No. 765, center rest ashtray, 1962; No. 651, center rest ashtray, 1966; and No. 755, large rectangular center rest ashtray, 1960. (*Stephanie Turner Photography*)

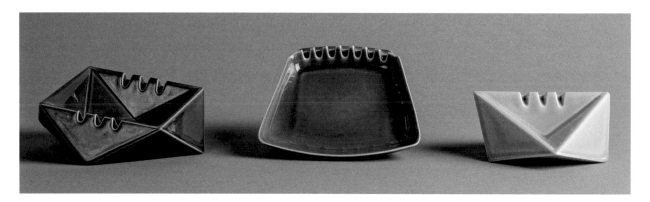

Fig. SA.8 Ashtrays. (L–R) No. 781, quadrangular safety ashtray; No. 785, trapezoid ashtray; and No. 782, triangular safety ashtray. All items, 1962. (*Stephanie Turner Photography*)

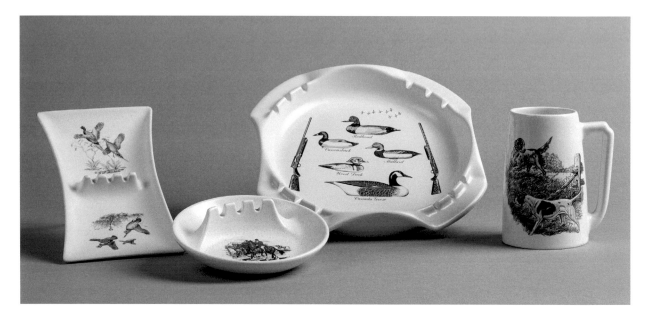

Fig. SA.9 The Sportsman Line. The Sportsman Line of decorations first appeared in Hyalyn Porcelain, Inc.'s 1962 catalog. (L–R) No. 756, medium rectangular center rest ashtray; No. 44, small round center rest ashtray; No. 759, large round safety ashtray; and No. 641, mug. All items, 1962. (*Stephanie Turner Photography*)

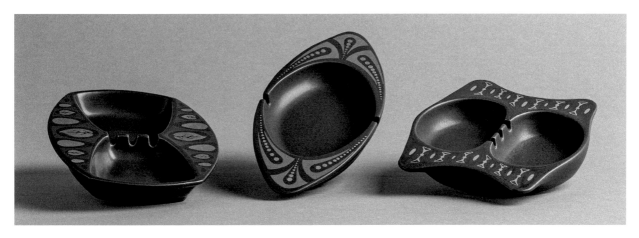

Fig. SA.10 Fiesta Smokers Accessories. Fiesta Smokers Accessories first appeared in Hyalyn Porcelain, Inc.'s Fall 1962 catalog. Eggshell Matte glaze decoration colors included Red and Antique Gold, Green and 22-k Gold, and Purple and Turquoise. Pistachio Green Matte decoration colors included Purple and Antique Gold, Brown and Orange, and Turquoise and 22-k Gold. In 1963, Espresso Brown glaze was added, with Orange and 22-k Gold or Green and 22-k Gold decorations. (L–R) No. 843, 2-compartment safety ashtray; No. 842, oval safety ashtray; and No. 841, 2-compartment safety ashtray. (*Stephanie Turner Photography*)

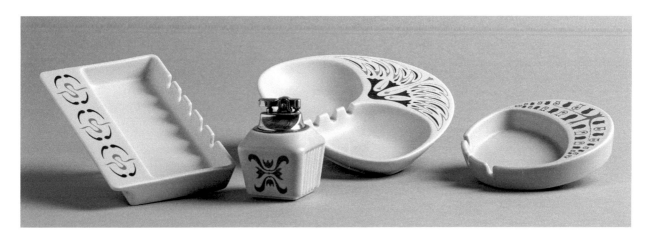

Fig. SA.11 Fiesta Smokers Accessories. (L–R) No. 846, shelf pattern safety ashtray; No. 789L, lighter; No. 840, double-tri ashtray; and No. 847, small round safety ashtray. All items, 1962. (*Stephanie Turner Photography*)

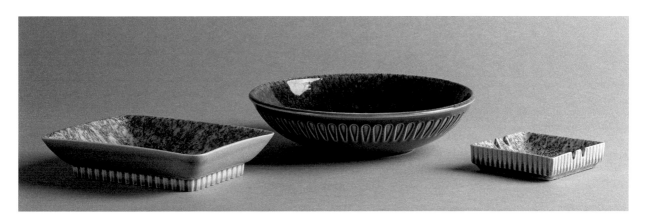

Fig. SA.12 Fantasia Smoking Accessories and Gifts. Hyalyn introduced Fantasia in its Fall 1962 catalog. The line's catalog entry described the glaze treatment as being like flowing patterns of multi-colored Italian marble. (L–R) No. F459, small rectangular bowl with a reeded foot; No. F411, deep round bowl; and No. 787, small square reeded ashtray. All items, 1962. (*Stephanie Turner Photography*)

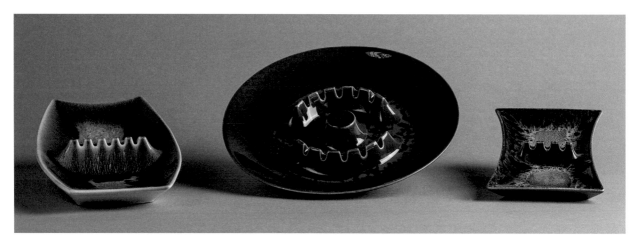

Fig. SA.13 Mosaico ashtray line. Hyalyn Porcelain, Inc. introduced Mosaico in its Fall 1963 catalog, describing it as a mingling of Mediterranean colors. The line came in three color combinations: Sahara Brown, Mediterranean Blue, and Lava Dust Black. (L–R) M755, medium-size center rest ashtray; No. M863, combination pipe smoker; and No. M756, bow-shaped ashtray. All items, 1963. (*Stephanie Turner Photography*)

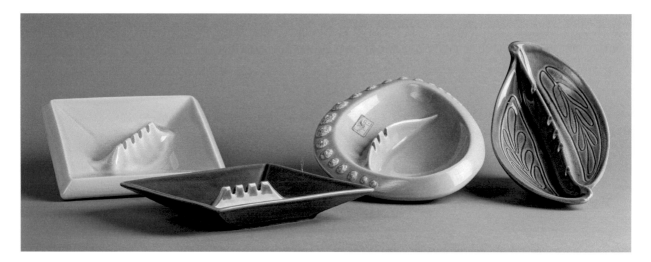

Fig. SA.14 Ashtrays. (L–R) No. 31, square ashtray, 1964; No 652, square ashtray, 1965; No. 680, large free-form safety ashtray, 1968; and No. 674, large swirl safety ashtray, 1966. (*Stephanie Turner Photography*)

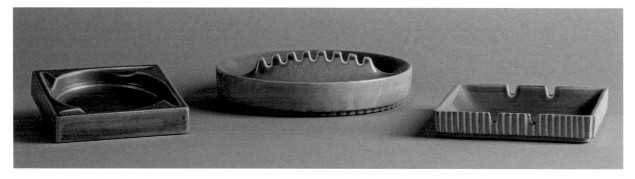

Fig. SA.15 Ashtrays. (L–R) No. G616, small square ashtray (shape: Herbert Cohen, 1958), hand-decorated with 22-k gold, 1962; No. 765, round center rest ashtray, Matte and Gloss, 1966; and No. 775, square reeded ashtray, Matte and Gloss, 1966. (*Stephanie Turner Photography*)

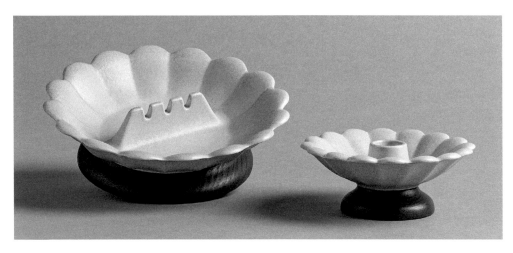

Fig. SA.16 Colonial Accessories by Hyalyn. (L–R) No. 711, large safety ashtray and No. 695, low candle holder. All items, 1966. (*Stephanie Turner Photography*)

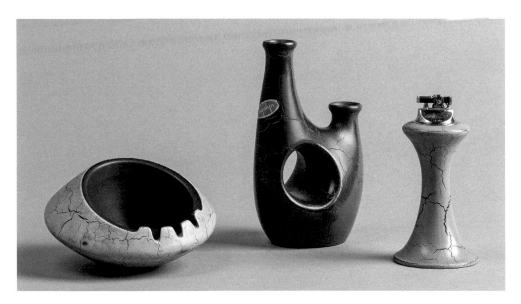

Fig. SA.17 Antique Craquel-glazed smoking accessories. Hyalyn introduced Antique Craquel in its 1968 catalog. (L–R) No. A-12, ashtray (Erwin Kalla design, K12, *c.* 1958); No. A-62, double bottle vase; and No. A-555, lighter. All items, *c.* 1968. (*Stephanie Turner Photography*)

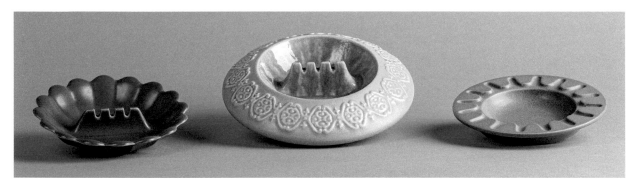

Fig. SA.18 Ashtrays. (L–R) No. 711, scalloped center rest ashtray, 1968; No. 77, round center rest ashtray, Multi-Color, 1968; and No. 710, cog ashtray, 1963. (*Stephanie Turner Photography*)

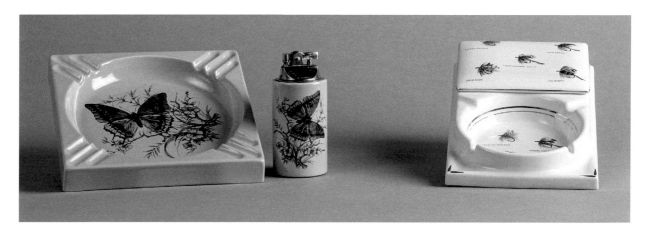

Fig. SA.19 Smoking accessories. (L–R) No. 615, He-Man ashtray, 1951 (shape); No. 763, lighter, 1968; and No. 639, cigarette box-ashtray combination, 1955. (*Stephanie Turner Photography*)

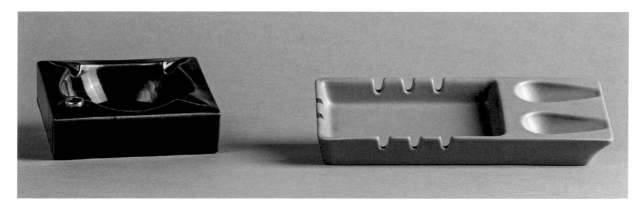

Fig. SA.20 Ashtrays. (L–R) No. 676X, safety cigarette extinguisher ashtray, 1965, and No. 851, pipe ashtray, 1963. (*Stephanie Turner Photography*)

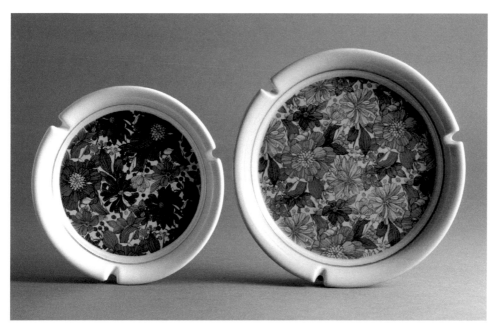

Fig. SA.21 La Femme Boutique. Ashtrays. (L–R) No. 118, round ashtray and No. 117, round ashtray. All items, 1970. (*Stephanie Turner Photography*)

Decorative Accessories

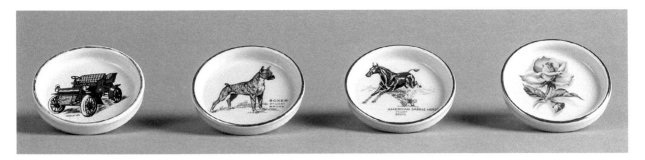

Fig. DA.1 No. 601 coasters with decalcomania. Though bearing a low item number (item Nos. 600, 602, and 603 were made in 1947–48), the No. 601 coaster's production may have begun later. The shape does not appear in the company's 1948-49 catalog. (*Stephanie Turner Photography*)

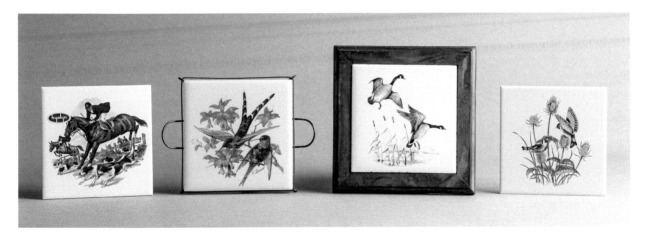

Fig. DA.2 No. 505 square tiles with decalcomania. Hyalyn Porcelain, Inc., first offered the No. 505 tile, *c.* 1950–51. In 1953, buyers could purchase a tile with a black metal trivet (second from the left). The tile shown here (with trivet) bears a Hyalyn Porcelain sticker on its back. Curiously, the tile is embossed "Mosaic." Less Moody first worked for Zanesville, Ohio's, Mosaic Tile Company. Moody correspondence suggests that Hyalyn Porcelain, Inc. may have purchased its No. 505 and No. 507 blank tiles elsewhere before decorating them with decalcomania. (*Stephanie Turner Photography*)

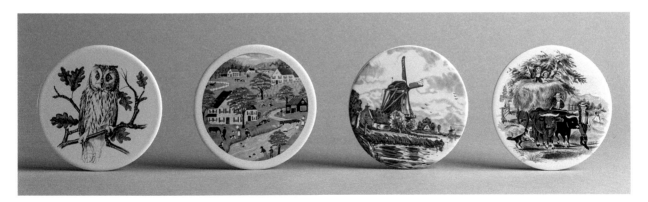

Fig. DA.3 Round tiles with decalcomania. All items, No. 507. Hyalyn Porcelain, Inc., first offered the No. 507 tile, *c.* 1955. (*Stephanie Turner Photography*)

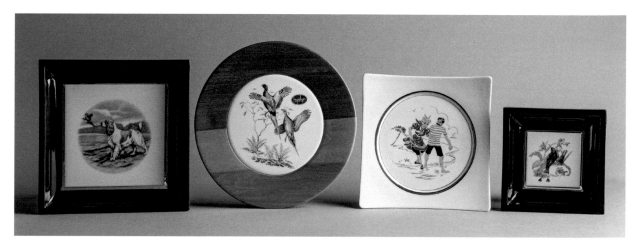

Fig. DA.4 Plaques and plates. (L–R) No. 624, large framed plaque or tray, *c.* 1953–54; No. 507 plaque or cheese plate, 1956; No. 631, pagoda plate with Courtin' Daz decalcomania, 1953; and No. 630, small plaque or tray, *c.* 1953–54. (*Stephanie Turner Photography*)

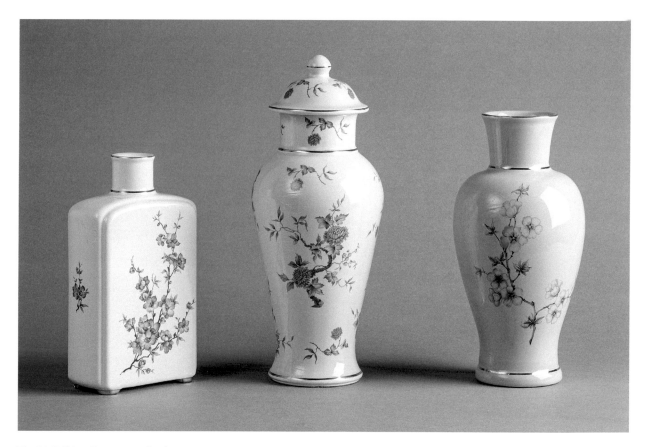

Fig. DA.5 China Clipper Line. (L–R) No. 174, bottle vase, peach decoration, 1972; No. 823, Ming vase, mum decoration, 1973; and No. 175, narrow neck vase, cherry decoration, 1972. (*Stephanie Turner Photography*)

Kitchen Accessories

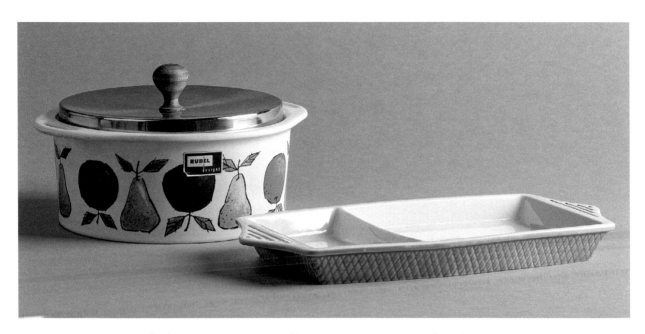

Fig. KA.1 Kitchen accessories. (L–R) Lidded casserole. No. R-38(?). Rubel Designs. Decorative art by Fred Press. Date unknown; and No. HL-108, Impromptu oven-to-table ware, *c.* 1961–62. (*Stephanie Turner Photography*)

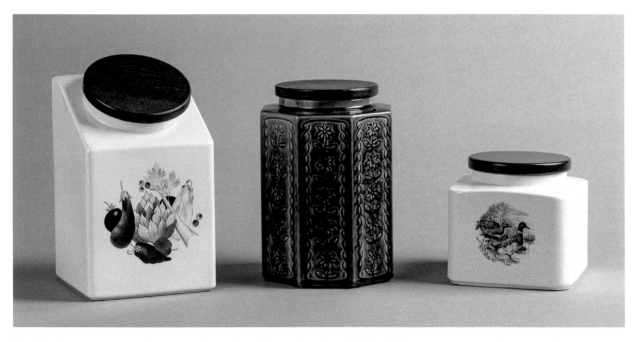

Fig. KA.2 Kitchen accessories. (L–R) No. W199L-D, large decorated canister, 1972; No. W194, octagon canister with patterned decoration, 1971; and No. 181, small decorated canister, 1970. (*Stephanie Turner Photography*)

Business Gift and Promotional Products

 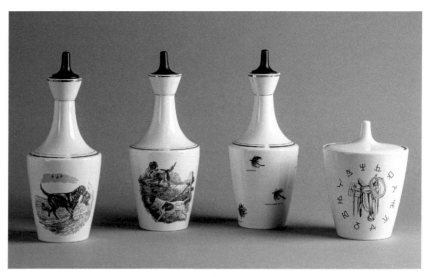

◀ **Fig. PP.1** In 1956, Hyalyn Porcelain, Inc. issued a promotional gift catalog titled *Your Goodwill Ambassador by Hyalyn*. With commercial customers in mind, the catalog promoted a limited group of items for use as business gifts. Hyalyn could imprint most things with a business's name or other preferred information. Single items numbering more than 1,000 pieces could have custom decalcomania applied.

▶ **Fig. PP.2** Hyalyn Porcelain, Inc.'s *Your Goodwill Ambassador* catalog included business gift suggestions like these No. 663 decanters and the No. 662 humidor. Hyalyn introduced the Boots and Saddles decoration in 1953. James Pugh managed the Goodwill Ambassador division. (*Stephanie Turner Photography*)

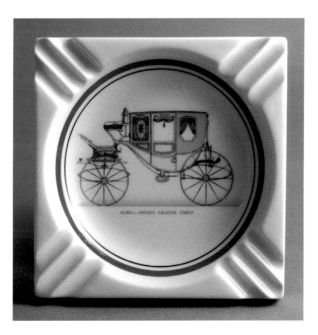

◀ **Fig. PP.3** Slightly smaller versions of Hyalyn Porcelain, Inc.'s No. 615 He-Man ashtrays, like this one, were given out as holiday gifts by Seaver and Son, of Marion, Virginia. *c.* 1951–1953. (*Compton photo*)

▶ **Fig. PP.4** Reverse of the ashtray seen in Fig. PP.3. The foil label reads "AN EXECUTIVE LINE PRODUCT." Attributed to Hyalyn Porcelain, Inc. (*Compton photo*)

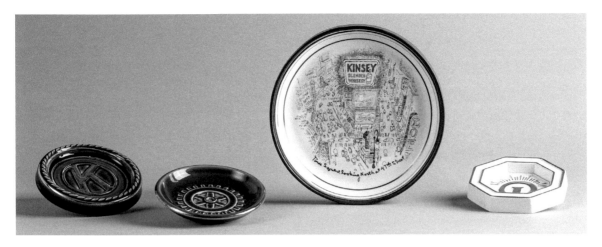

Fig. PP.5 Gift items. (L–R) No. 702, paperweight or ashtray, Kiwanis logotype; No. 801 coupe picture plate with custom decalcomania for Kinsey Blended Whiskey. The coupe plate is seated within a red leather or "leatherette" holder; and No. 704, paperweight or ashtray, Optimist International logotype. (*Stephanie Turner Photography*)

Fig. PP.6 Hyalyn Porcelain, Inc., created some ashtrays, or trinket dishes, shaped like states for a company named Emrich's. Each one is marked with "Emrich's," the state's name, and "State of the Union by hyalyn." Two states—Maine (left) and North Carolina (right)—are among those produced. The footprint-shaped tray represents North Carolina's "Tarheel" nickname. (*Stephanie Turner Photography*)

Fig. PP.7 Hyalyn Porcelain, Inc.'s *Your Goodwill Ambassador* catalog offered custom decalcomania art added to large orders of single items like these. (L–R) No. 617, extra-large ashtray, made for the 1963 Grand National horse race, Aintree Racecourse, near Liverpool, England; No. 615, He-Man ashtray, made for Hickory, North Carolina's centennial celebration, 1970; Nos. 119; 117; and 118, nesting ashtrays, made for the World Safety Institute, Inc., for presentation to representatives of the Union Railroad Company, 1970. (*Stephanie Turner Photography*)

Appendix I

IDENTIFYING MARKS

Hyalyn Porcelain, Inc., Hyalyn Cosco, Inc., Hyalyn, Ltd., and Vanguard Studios applied identification marks to their various products with few exceptions. Marks include those embossed by molds into clay, some stamped on ceramic or cork bases, and adhered labels.

Lamp bases typically, but not always, have impressed base marks made up of letters and numbers only (e.g., P-380). Some Raymor products lack the Hyalyn name but include identification letters and numbers. Eva Zeisel's High Fashion "Z-ware" items are marked this way (e.g., Z-32). Raymor Capri items with walnut bases are not noticeably marked. Ware lines attributed to particular designers, like Rachel Carr, show their initials and a number (e.g., RC-7).

The range of marks used by Hyalyn Porcelain, Inc., and successor companies is shown below. Others likely remain to be identified. All dates are approximate. In some instances, items with embossed or stamped marks also had adhered labels.

Fig. MM.1 Hyalyn Porcelain, Inc., *c.* 1947–53. **Fig. MM.2** Hyalyn Porcelain, Inc., *c.* 1947–53. **Fig. MM.3** Hyalyn Porcelain, Inc., *c.* 1947–53.

Fig. MM.4 Hyalyn Porcelain, Inc., *c.* 1947–?.

Fig. MM.5 Hyalyn Porcelain, Inc., *c.* 1947–53.

Fig. MM.6 Hyalyn Porcelain, Inc., *c.* 1953–56(7).

Fig. MM.7 Hyalyn Porcelain, Inc., *c.* 1953–56(7).

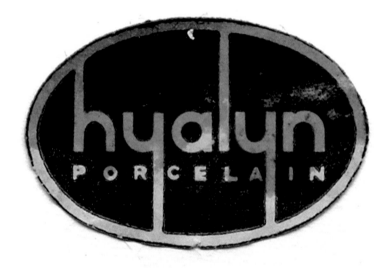

Fig. MM.8 Hyalyn Porcelain, Inc., *c.* 1956(7)–62.

Fig. MM.9 Hyalyn Porcelain, Inc., *c.* 1956(7)–62.

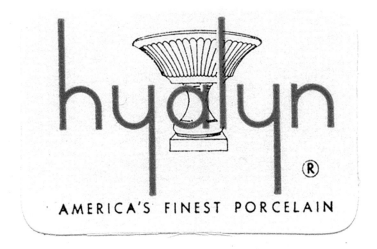

Fig. MM.10 Hyalyn Porcelain, Inc., *c.* 1962–73.

Fig. MM.11 Hyalyn Porcelain, Inc., *c.* 1962–73.

Fig. MM.12 Hyalyn Cosco, *c.* 1973–77.

Fig. MM.13 Hyalyn Cosco, *c.* 1973–77.

Fig. MM.14 Hyalyn, Ltd., *c.* 1077 89

Fig. MM.15 Hyalyn, Ltd., *c.* 1977–89.

Fig. MM.16 Vanguard Studios, *c.* 1989–97.

Fig. MM.17 Vanguard Studios, *c.* 1989–97.

Fig. MM.18 High Fashion, Eva Zeisel, "Z Ware," *c.* 1964.

Fig. MM.19 Casual Craft, Erwin Kalla, *c.* 1958.

Fig. MM.20 Hi-Line, Michael Lax, *c.* 1971–73.

Fig. MM.21 Basketry, Esta Brodey/Peerless Art Co., *c.* 1958.

Fig. MM.22 Rachel Carr Line, Rachel Carr, *c.* 1966.

Fig. MM.23 Paisley, Lee Bernay, *c.* 1966.

Fig. MM.24 Frances Johnson Moody, *c.* 1963.

Fig. MM.25 Midas, Georges Briard, *c.* 1991.

Fig. MM.26 Frances Johnson Moody (attrib.), *c.* 1955.

Fig. MM.27 Junior Bowl line, *c.* 1961.

Fig. MM.29 Footed floral containers, *c.* 1968.

Fig. MM.28 Junior Bowl line, *c.* 1961.

Fig. MM.30 Variety of Herb Cohen-designed mark, *c.* 1956(7)–62. **Fig. MM.31** Lamp base mark, with cast metal base, *c.* 1947–50.

Fig. MM.32 Paper (foil) label,
Westwood lamp, *c.* 1963.

Appendix II

Selected Catalogs

Hyalyn Porcelain, Inc., published catalogs to promote wholesale purchases from 1948 (perhaps 1947) to 1973, when the company was sold to Hamilton Cosco. Typically, an annual issue was offered along with a smaller fall "New Additions" version. After Hyalyn Porcelain, Inc.'s sale, Hyalyn Cosco, Inc. and Hyalyn, Ltd. issued catalogs. Surviving copies of these companies' catalogs are scarce. Fortunately, most of them are preserved by the Historical Association of Catawba County (Newton, NC) and Hickory Landmarks Society (Hickory, NC).

Facsimiles of some Hyalyn-related catalogs are shown here. The first one (issued 1948–1949) displays most of Hyalyn Porcelain, Inc.'s first products. A few of the firm's products produced in 1947 are missing from this catalog. It is included here as a benchmark against which to measure the company's subsequent designs.

The others are catalogs created to promote items made for Raymor/Richards Morgenthau Co., Georges Briard Designs/ M. Wille, Inc., and World of Ceramics. These issues encompass designs completed by Michael and Rosemary Lax, Erwin Kalla, Esta Brodey/Peerless Art Co., Eva Zeisel, and Georges Briard.

Reproduction of these catalogs is courtesy of the Historical Association of Catawba County and Hickory Landmarks Society.

I. Hyalyn Porcelain, Inc. (1948–1949)

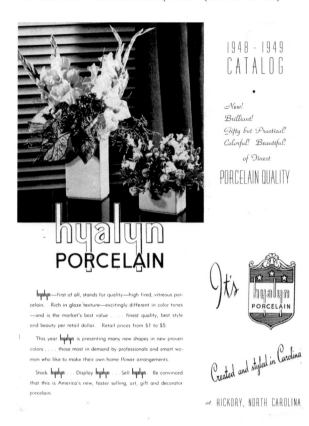

Fig. CT.1 Hyalyn Porcelain, Inc., p. 1.

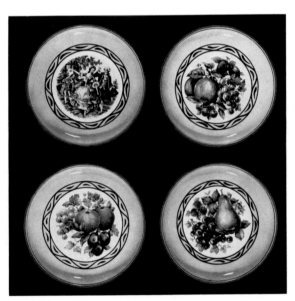

Fig. CT.2 Hyalyn Porcelain, Inc., p. 2.

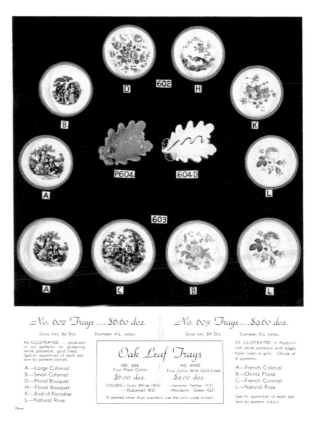

No. 602 Trays $6.60 doz. *No. 603 Trays....$9.60 doz.*

Gross lots, $6 Doz. Diameter 4¼ inches Gross lots, $9 Doz. Diameter 5¼ inches

AS ILLUSTRATED produced in six patterns on glistening white porcelain, gold lined. Specify quantities of each pat- tern by pattern initials.

A—Large Colonial. B—Small Colonial. D—Floral Bouquet. H—Floral Bouquet. K—Bird of Paradise L—Natural Rose.

Oak Leaf Trays

NO. 604 NO. 604D Four Plain Colors Four Colors With Gold Lines *$6.00 doz.* *$9.00 doz.*

COLORS—Ivory White (W3) —Jasmine Yellow (Y3) —Dubonnet (R2) —Mandarin Green (G2)

If wanted other than assorted, use the color code initials.

AS ILLUSTRATED in Hyalyn's rich white porcelain with edges hand lined in gold. Choice of 4 patterns.

A—French Colonial B—Chintz Floral C—French Colonial L—Natural Rose

Specify quantities of each pat- tern by pattern initials

Three

Fig. CT.3 Hyalyn Porcelain, Inc., p. 3.

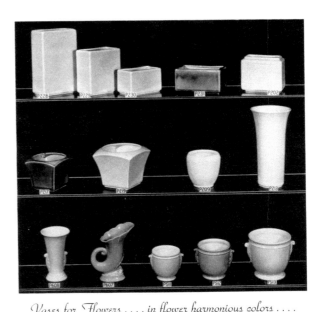

Vases for Flowers in flower harmonious colors

Each available in all five pastel colors.

Dawn-Mist Gray D-1 Lime Chartreuse G-6 New Aqua Green G-12 Jasmine Yellow Y-3 Matt White W-2

P202—Pillow (4½ x 5 x 3)	1.00		P230—Pillow (3 x 6 x 3)	.75
P209—Cashe Pot (4½" High)	.75		P231—Pillow (3 x 6 x 4)	1.00
P213—Vase (9¾" High)	1.50		P511—Cashe Pot (3¾" Dia.)	.75
P217—Sq. Pot (5" Square)	1.00		P512—Cashe Pot (4½" Dia.)	1.00
P219—Sq. Pot (6" Square)	1.25		P513—Cashe Pot (5¾" Dia.)	1.25
P228—Pillow (8 x 5 x 3)	1.25		P607—Cornucopia (7" High)	1.25
P229—Pillow (5½ x 5 x 3)	1.00		P608—Flare Vase (6½" High)	1.00

Four

Fig. CT.4 Hyalyn Porcelain, Inc., p. 4.

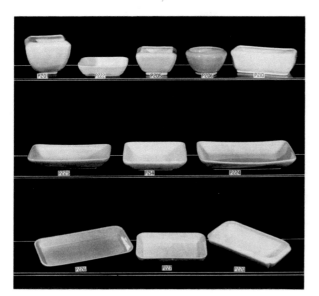

Bowls and Planters . . in 5 proven colors

Use code number as aid in specifying shape and color.

P201—Sq. Bowl (5½" Square)	1.25
P205—Sq. Bowl (5" Square)	.75
P206—Rnd. Bowl (5" Dia.)	.75
P210—Window Bowl (8" Long)	1.00
P214—Sq. Bowl (8" Square)	1.25
P220—Long Bowl (6" x 11")	1.25
P222—Sq. Tray (6" Square)	.75
P224—Long Bowl (8" x 12")	1.75

Down Mist Gray D-1　　　Lime Chartreuse G-6

New Aqua Green G-12　　　Jasmine Yellow Y-3

New Matt White W-2

P225—Long Bowl (6" x 10")	1.25
P226—Long Bowl (6" x 12")	1.50
P227—Long Bowl (6" x 9")	1.00

hyalyn planters and bowls meet every requirement for dish gardens and floral arrangements . . . and many of the bowls are equally as important for food service (fruits, candy, salads, sandwiches, etc.)

Five

Fig. CT.5 Hyalyn Porcelain, Inc., p. 5.

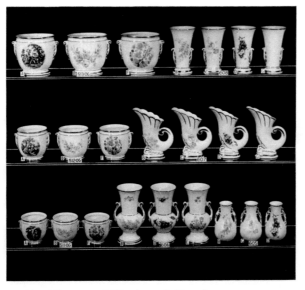

Hand Decorated Traditional Porcelains

AVAILABLE IN TWO BASE COLORS—brilliant white and rich sea-island coral. Hand decorated in 22K coin gold and popular decal patterns. Order color and pattern by code initials.

511 OG—Cashe Pot—3¾" Diameter	1.50
WHITE—WA—WB—WF	
CORAL—RA—RB—RF	
512 OG—Cashe Pot—4½" Diameter	1.75
WHITE—WA—WB—WF	
CORAL—RA—RB—RF	
513 OG—Cashe Pot—5¾" Diameter	2.00
WHITE—WA—WB—WF	
CORAL—RA—RB—RF	

The code initials refer to the patterns after W for white and R for coral.

605 OG—Sml. Vase—5½" high	1.25
WHITE—WB—WC—WD	
CORAL—RB—RC—RD	
606 OG—Urn Vase—7¾" High	2.00
WHITE—WB—WD—WE	
CORAL—RB—RD—RE	
607 OG—Cornucopia—7" High	2.00
WHITE—WB—WC—WD—WG	
CORAL—RB—RC—RD—RG	
608 OG—Flare Vase—6½" High	1.50
WHITE—WB—WC—WD—WG	
CORAL—RB—RC—RD—RG	

Six

Fig. CT.6 Hyalyn Porcelain, Inc., p. 6.

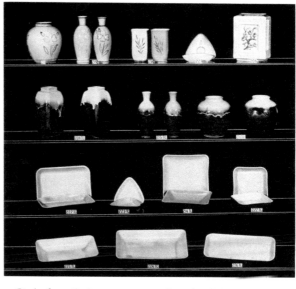

Underglaze Hand Decorated Ware

Shown on top row of photograph. Decorated underglaze in free-hand designs in contrasting colors.

COLORS:—Dawn-Mist Gray D-1 —New Matt White W-2
—Chartreuse G-6 —Jasmine Yellow Y-3
—New Aqua Green G-12 (Order by code)

No. 203—Pillow (7½" high)
No. 211—Ball Vase (6½" high) 2.50
No. 215—Bud Vase (6½" high) 2.00
No. 218—Sq. Vase (5" high) 1.00
No. 223—Ash Tray (5" triangle) 1.00
.75

A new and sparkling treatment—perfect for the modern home. Matt black is in vogue and will be a top sales color. These color combinations to . . . ny modern decor.

Two-Color Black Matt Modern

Shown on three bottom rows of photograph.

COLORS:—Gray on Black D-5
—Green on Black G-13 —Tan on Black T-9

No. 204TC—7⅝" Sq. Vase 1.25
No. 211TC—6½" Ball Vase 1.50
No. 214TC—8" Sq. Bowl 1.50
No. 215TC—6½" Bud Vase75
No. 222TC—6" Sq. Tray 1.00
No. 223TC—5" Tri. Tray75
No. 224TC—12" x 8" Bowl 2.00
No. 225TC—10" x 6" Bowl 1.50
No. 226TC—12" x 6" Bowl 1.75
No. 227TC—9" x 6" Bowl 1.25

Seven

Fig. CT.7 Hyalyn Porcelain, Inc., p. 7.

Wall Pocket Planters

Kitchen and breakfast nook planters in white porcelain hand decorated in red, blue, green, and yellow fired colors with decals.

No. 500 Tea Pot	No. 501 Sauce Pan	No. 502 Jar	No. 510 Rolling Pin
$15.00 Doz.	$18.00 Doz.	$9.00 Doz.	$12.00 Doz.
R—red with fruit	R—red with fruit	R—red with daisy	R—red with daisy
B—blue willow	B—blue with fruit	B—blue with daisy	B—blue with daisy
G—green with fruit	G—green with fruit	G—green with daisy	G—green with daisy
Y—yellow with fruit	Y—yellow with fruit	Y—yellow with daisy	Y—yellow with daisy

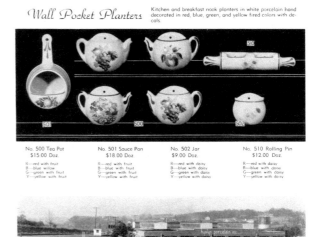

AMERICAS FINEST CERAMIC PLANT — HICKORY, NORTH CAROLINA

General Information

PRICES shown are NET—wholesale.

TERMS—2% 10 days, net 30 days.

SHIPMENTS are F. O. B. Hickory, N. C.

Our responsibility ceases when shipment is accepted by the carrier.

PACKING CHARGE—no packing charge on orders of $25.00 or more net. Minimum charge—50 cents.

Be sure to specify shape number and decoration letter and color code letters to insure corre.. filling of or...

Representatives

EAST WALTER CROWELL, 225 Fifth Ave., New York.
MIDDLE WEST HARRY NEVILLE, Mdse. Mart, Chicago.
SOUTH WEST CARY PRODUCTS CO., 934 No. Lancaster Ave.,
Dallas, Texas.
SOUTH CENTRAL ROBERT VINZ, Mississippi City, Miss.
SOUTH EAST STANLEY CRAFT, Box 460, Hickory, N. C.
MOUNTAIN STATES . MONETA CO., 1639 Blake St., Denver, Colo.

hyalyn porcelain, inc.
...WER 460,
...AL—P..............
HIC ℃9Y, NORTH CAROLINA

Fig. CT.8 Hyalyn Porcelain, Inc., p. 8.

II. RAYMOR CAPRI BY MICHAEL LAX (1953)

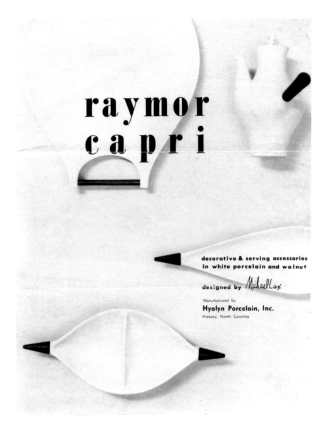

Fig. **CT.9** Raymor Capri by Michael Lax, p. 1.

RAYMOR CAPRI IS SUPERIOR WARE OF INHERENT ELEGANCE.

Superbly styled, it is made of the finest vitreous white porcelain, combined and highlighted with natural finished walnut accents. The shapes are so classically simple, so universally appealing as to combine readily with almost every dinnerware service or accessory theme—contemporary or traditional. At the same time, the decisive contrast of the two materials, both neutral in tone, contributes high textural interest to each unit and offers versatility of use in any interior color planning. From the bird centerpiece and the pedestaled cake server to the single candlesticks and the ashtray, the line incorporates a full complement of serving and decorative pieces to fulfill a diversity of functional and accessorizing requirements. Raymor Capri was designed by Michael Lax, talented young American whose creativeness is coupled with a thorough knowledge of his materials and the technical aspects of ceramic manufacture. It is manufactured by Hyalyn Porcelain, Inc., of Hickory, North Carolina, known throughout the United States as a principal producer of true porcelain. To Raymor Capri, Hyalyn has applied its unusual facility for turning out by commercial means and at mass-market prices porcelain ware that adheres in every sense to the high standards generally associated only with the work of the hand potter. Interestingly enough, Hyalyn derives its name from the dictionary word "hyaline" meaning "Glossy, translucent" — apt adjectives for the purity and beauty of Raymor Capri. Here, then, are accessories of value — to own or to give with pleasure, with the awareness that they are always in good taste.

THE PLANT
BEHIND THE PRODUCT

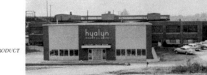

National Distributor: Richards Morgenthau, Inc., 225 Fifth Avenue, N. Y. C.; 1215 The Merchandise Mart, Chicago 34, Illinois

Fig. **CT.10** Raymor Capri by Michael Lax, p. 2.

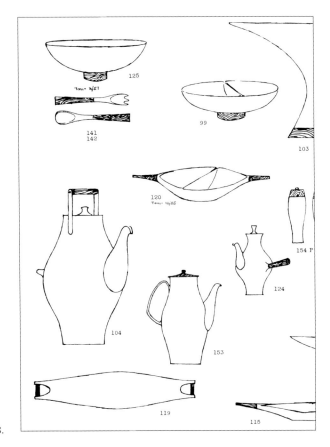

Fig. CT.11 Raymor Capri by Michael Lax, p. 3.

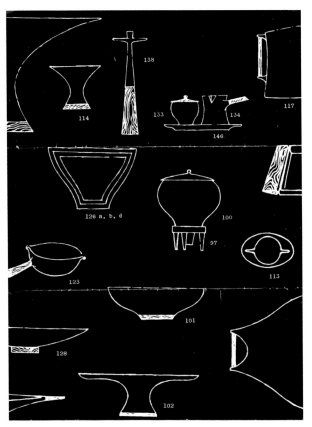

Fig. CT.12 Raymor Capri by Michael Lax, p. 4.

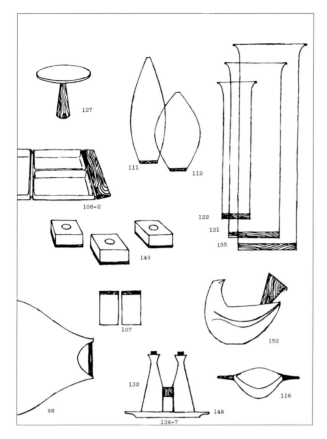

Fig. CT.13 Raymor Capri by Michael Lax, p. 5.

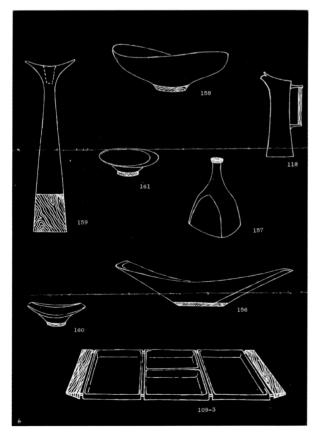

Fig. CT.14 Raymor Capri by Michael Lax, p. 6.

III. HI-LINE by HYALYN by Michael Lax (1971–1972)

HI-LINE by HYALYN
1971 - 1972
DESIGNED BY MICHAEL LAX

A correlated grouping of ceramic accessories, handcrafted in white ceramic - many combined with walnut accents. The collection runs the gamut of ceramic, decorative ideas with snack items, storage or cookie jars, flower holders and arranging pieces, smoking accessories as well as condiment sets.

JL11 - Flower candle arranger, 3¼" H. - creates many arrangement combinations. $8.00 pr.

Other items illustrated to the right appear elsewhere.

All prices shown are suggested retail - may be slightly higher west of the Mississippi.

FOR SERVING
JL234 - Peppermill and salt in gift box. $16.00.
JL23 - Peppermill only, 8¾" H. - $10.00.
JL12345 - Set; four jars - condiment set with wood covers in gift box. - $13.50.
Covered jars available separately.
JL13 - Medium jar, 4¼" H. - $3.50.
JL12 - Large jar, 5½" H. - $4.00.
JL14 - Small jar, 3" H. - $3.00.
JL28OV set - Oil and Vinegar with wood covers in gift box, 7¼" H. - $9.00.

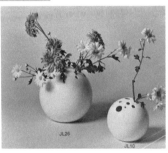

FLOWER FROG VASES
With seventeen varied holes.
JL26 - Large frog vase, 9" H. - 9½" D. - $12.50
JL10 - Small frog vase - 6" H. - 6½" D. - $8.00

Nationally distributed by
Raymor/Richards, Morgenthau, Inc.
734 Grand Avenue
Ridgefield, New Jersey 07657
Showrooms:
225 Fifth Avenue, New York 10010
520 West 7th Street, Los Angeles, Calif. 90010
1567 Merchandise Mart, Chicago, Ill. 60654
278 So. Furn. Expo., High Point, N. C. 27261

Fig. CT.15 HI-LINE by HYALYN (1971–1972), p. 1.

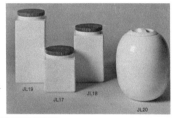

STORAGE JARS
3 with sealing wood covers.
JL19 - Tall storage jar, 10¾" H. - $9.50.
JL17 - Small storage jar, 6" H. - $7.50.
JL18 - Medium storage jar, 8½" H. - $8.50.
All above 4¾" square.
JL20 - Super jar with ceramic cover,
9¾" H. - 8" D. - $10.00.

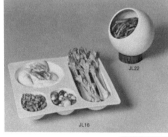

FOR SNACKS
JL16 - Cocktail Tray, 12" sq. - $7.00.
JL22 - Bar Bowl - Rolls on wood base,
6½" D. - 7¼" H. - $6.00

HI-LINE by HYALYN
is manufactured and shipped by:
Hyalyn Porcelain, Inc. -
Hickory, North Carolina 28601
Terms: 1% 15 - Net 30.
Handling Charge - Under $50 net add 5% —
minimum $1.50.

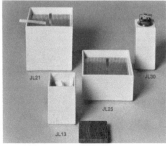

FOR THE SMOKER
JL21 - 5" cube ash tray with chrome,
removable grid - $6.50
JL25 - 5" sq. ash tray with chrome grid,
3" H. - $6.00.
JL13 - Cigarette cup with wood cover,
4¼" H. - $3.50.
JL30 - Chrome lighter; gas, 6" H. - $5.00.
Lighter unit is guaranteed by replacement.

Printed in Hickory, N. C. - U.S.A.

Fig. CT.16 HI-LINE by HYALYN (1971–1972), p. 2.

IV. HI-LINE BY HYALYN BY MICHAEL & ROSEMARY LAX (1972–1973)

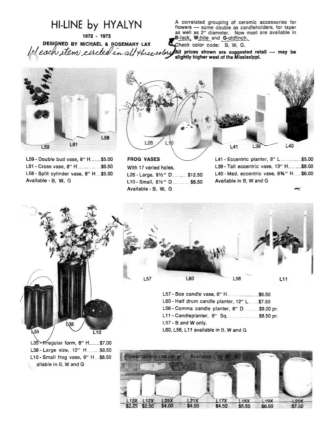

Fig. **CT.17** HI-LINE by HYALYN (1972–1973), p. 1.

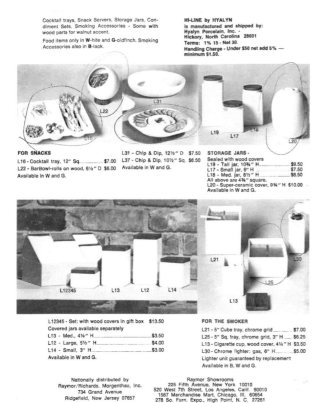

Fig. **CT.18** HI-LINE by HYALYN (1972–1973), p. 2.

V. CASUAL CRAFT, BASKETRY, RAYMOR CAPRI BY ERWIN KALLA, ESTA BRODEY/PEERLESS ART CO., MICHAEL LAX (*c.* 1958)

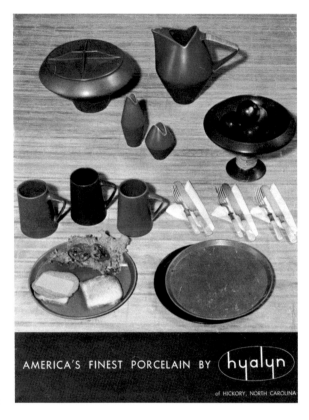

Fig. CT.19 Casual Craft, Basketry, Raymor Capri, p. 1.

Fig. CT.20 Casual Craft, Basketry, Raymor Capri, p. 2.

Casual Craft designed by
ERWIN KALLA

Casual Craft — for out-door or buffet service, styled for tomorrows living by Erwin Kalla.

Erwin Kalla, a young ceramic designer from Pittsburgh has proven in his several successes that he can anticipate the trends of the market. He has styled this line for today's requirements. It is being produced by Hyalyn in it's high temperature, quality porcelain body in earthy textured matt glazes. The beauty of shape and color is enhanced by the bamboo handles and rattan wrapping.

Illustrated in color on the front cover to show the line's true beauty, we illustrate in the following pages in black and white the complete line for your selections. The line includes several excellent ash trays in good form and color.

We offer for your choice, three proven colors:

Textured mottled Brown Mat
Mottled medium Blue Mat
Textured Orange Matt

Stock CASUAL CRAFT complete to serve your customer's needs.

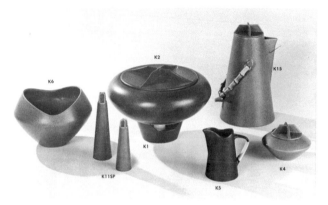

DEEP BOWL, SALT & PEPPERS, LARGE CASSEROLE WITH WARMER, LARGE COFFEE SERVER, CREAMER AND SUGAR BOWL.

K1—Warmer base w/candle, 3" H.	$ 2.00	K6—Deep Bowl, 9¼" D. x 6" H.	$
K2—Lg. Casserole (4½ Qt.), 12½" D. x 5¼" H.	$10.00	K11SP—Salt & Pepper, 7" H. — 5½" H.	$
K4—Sugar Bowl, Covered 5½" D. x 3¾" H.	$ 3.50	K15—Lg. Coffee Server (3 Qt.) 7" D. x 11½" H.	$10.00
K5—Creamer—Rattan wrapped handle, 3½" D. x 5" H.	$	K2B—Combination of K1 and K2, 8¼" H.	$12.00

ALL PRICES ARE SUGGESTED RETAIL

Page 3

Fig. CT.21 Casual Craft, Basketry, Raymor Capri, p. 3.

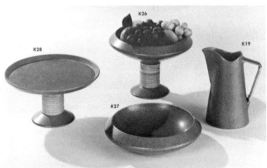

FOOTED CAKE PLATE, TALL FOOTED BOWL, MILK PITCHER AND SMALL BOWL.

K19—Milk Pitcher, (1 Qt.), 4¾" D. x 7½" H.	$5.00	K27—Small low bowl, 10" D. x 2½" H.	
K26—Bowl, Rattan wrapped foot, 10" D. x 6¾" H.	$6.50	K28—Cake Plate, Rattan wrapped foot, 10¼" D. x 5" H.	$6.00

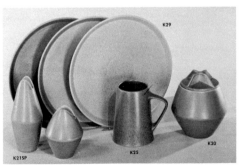

BUFFET PLATES, LARGE MUG, SPICE - JAM JAR AND LARGE SALT AND PEPPER SHAKERS

K20—Spice and Jam Jar, Covered — 5" D. x 5½" H. $3.75
K21SP—Large Salt and Peppers, 6¼" H. - 4¼" H.
K25—Large Mug (16 oz.) 3¾" D. x 4¾" H.
K29—Buffet Plate, 10¼" D.

Page 4

Fig. CT.22 Casual Craft, Basketry, Raymor Capri, p. 4.

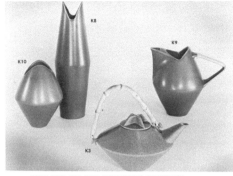

SMALL VASE, TALL VASE, LARGE PITCHER AND TEA POT

K3—Tea Pot w/bamboo handle (approx. 1½ Qt.) 8¾" D. x 5½" H. $6.50
K9—Larger Pitcher (3 Qt.) Rattan wrapped handle, 7¼" D. x 9" H. $7.00
K8—Tall Vase, 5" D. x 15½" H. $4.50
K10—Small Vase, 6¼" D. x 8¼" H. $3.50

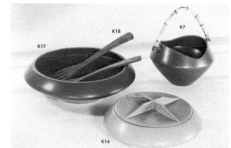

LARGE SALAD BOWL, BIRCH SERVERS, BOWL WITH HANDLE AND SMALL COVERED CASSEROLE

K7—Deep bowl w/bamboo handle, 9¼" D. x 6" H. $6.50 **K17**—Lg. Salad Bowl, 15¼" D. x 4¼" H. $7.00
K16—Covered Casserole (2½ Qt.), 11¾" D. x 4½" H. $8.00 **K18**—Birch Servers $4.00 Pr.
K16X—Sm. Salad Bowl (K16 open) 11¾" D. x 3¼" H. $5.00

ALL PRICES ARE SUGGESTED RETAIL Page 5

Fig. CT.23 Casual Craft, Basketry, Raymor Capri, p. 5.

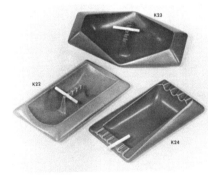

LARGE ASH TRAYS FOR MODERN LIVING

K22—Rect. Ash Tray, w/center rest, 12" L. x 7¼" W. $4.00
K23—Hexagonal Ash tray, 14¼" L. x 8¼" W. $5.00
K24—Deep Rect. Ash tray 12" L. x 6½" W. x 2½" H. $4.50
All have cork pad on bottom.

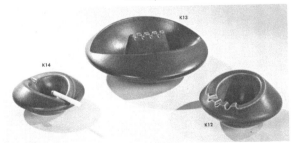

ROUND ASH TRAYS — SMALL TO LARGE

K12—Med. Ash Tray, 6¼" D. x 3" H. $2.25
K13—Lg. Ash Tray, 10½" D. x 3" H. $4.00
K14—Sm. Ash Tray, 5½" D. x 2" H. $1.75
All have cork pad on bottom.

Fig. CT.24 Casual Craft, Basketry, Raymor Capri, p. 6. Page 6

Basketry... A new decorative technique developed by Peerless Arts that enables Hyalyn to produce a wide range of colorful accessory and service items. The color charm of the Basketry texture is offered in a choice of 4 distinctive color combinations.

Cocoa on Black — Pumpkin on White Blue on Black — Mustard on White

For your color choice see illustration below — for item selection, review the following illustrations in Black and White.

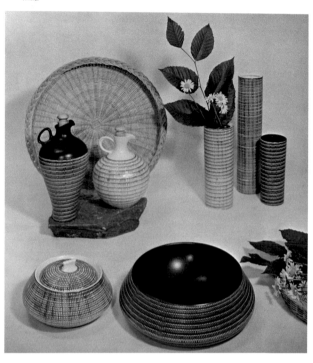

Fig. **CT.25** Casual Craft, Basketry, Raymor Capri, p. 7.

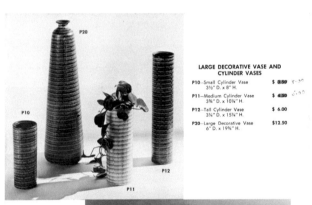

LARGE DECORATIVE VASE AND CYLINDER VASES

P10—Small Cylinder Vase 3½" D. x 8" H.	$ 3.50
P11—Medium Cylinder Vase 3¾" D. x 10¼" H.	$ 4.50
P12—Tall Cylinder Vase 3¼" D. x 15¼" H.	$ 6.00
P20—Large Decorative Vase 6" D. x 19¾" H.	$12.50

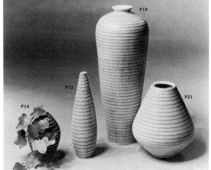

LARGE DECORATIVE VASE, LARGE FLORAL VASE, TALL AND SHORT TEAR-DROP VASES

P13—Tall tear-drop vase, 3¾" D. x 11¾" H.	$5.00	**P19**—Lg. Decorative Vase, 8" D. x 19½" H.	$15.00
P14—Short tear-drop vase, 4¾" D. x 6¼" H.	$4.50	**P21**—Lg. Vase, 9" D. x 9¼" H.	$ 7.50

Page 8 ALL PRICES ARE SUGGESTED RETAIL

Fig. **CT.26** Casual Craft, Basketry, Raymor Capri, p. 8.

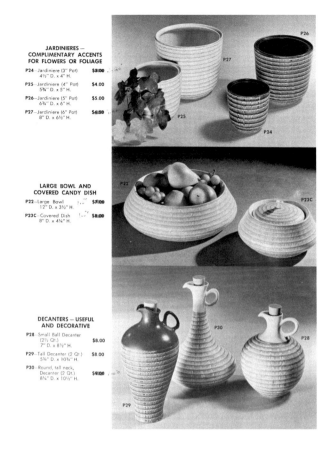

JARDINIERES —
COMPLIMENTARY ACCENTS
FOR FLOWERS OR FOLIAGE

P24—Jardiniere (3" Pot) $3.00
 4½" D. x 4" H.

P25—Jardiniere (4" Pot) $4.00
 5¾" D. x 5" H.

P26—Jardiniere (5" Pot) $5.00
 6¾" D. x 6" H.

P27—Jardiniere (6" Pot) $6.50
 8" D. x 6½" H.

LARGE BOWL AND
COVERED CANDY DISH

P22—Large Bowl $7.00
 12" D. x 3½" H.

P23C—Covered Dish $8.00
 8" D. x 4¼" H.

DECANTERS — USEFUL
AND DECORATIVE

P28—Small Ball Decanter $8.00
 (2½ Qt.)
 7" D. x 8½" H.

P29—Tall Decanter (2 Qt.) $8.00
 5¾" D. x 10¾" H.

P30—Round, tall neck, $9.00
 Decanter (2 Qt.)
 8¼" D. x 10½" H.

Fig. CT.27 Casual Craft, Basketry, Raymor Capri, p. 9.

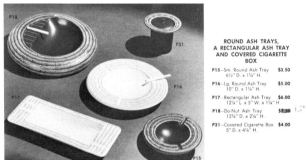

ROUND ASH TRAYS,
A RECTANGULAR ASH TRAY
AND COVERED CIGARETTE
BOX

P15—Sm. Round Ash Tray $3.50
 6½" D. x 1¼" H.

P16—Lg. Round Ash Tray $5.00
 10" D. x 1¼" H.

P17—Rectangular Ash Tray $6.00
 12¼" L x 5" W. x 1¼" H.

P18—Do-Nut Ash Tray $7.50
 12¼" D. x 2¼" H.

P31—Covered Cigarette Box $4.00
 5" D. x 4¼" H.

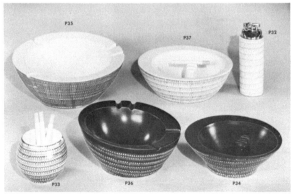

ASH TRAYS, CIGARETTE CUP AND LIGHTER

P32—Cylindrical lighter, 2" D. x 5¾" H. $4.00
P33—Ball Cigarette cup, 3½" D. x 2¾" H. $2.00
P34—Small Rnd. ash tray w/center rest, 6¾" D. x 2" H. $4.00
P35—Lg. Round Ash tray, 9¼" D. x 3½" H. $6.00
P36—Med. Round Ash tray, 7" D. x 3" H. $5.00
P37—Lg. Rnd. Ash tray, w/center rest, 8" D. x 2½" H. $6.00

Page 10 ALL PRICES ARE SUGGESTED RETAIL

Fig. CT.28 Casual Craft, Basketry, Raymor Capri, p. 10.

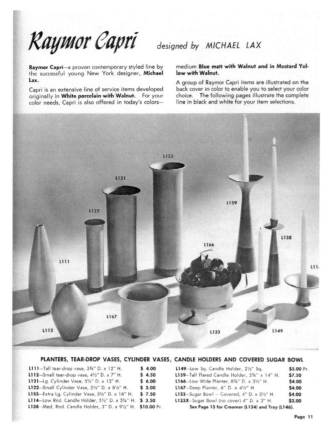

Raymor Capri designed by MICHAEL LAX

Raymor Capri—a proven contemporary styled line by the successful young New York designer, **Michael Lax.**

Capri is an extensive line of service items developed originally in **White porcelain with Walnut.** For your color needs, Capri is also offered in today's colors—medium **Blue matt with Walnut** and in **Mustard Yellow with Walnut.**

A group of Raymor Capri items are illustrated on the back cover in color to enable you to select your color choice. The following pages illustrate the complete line in black and white for your item selections.

PLANTERS, TEAR-DROP VASES, CYLINDER VASES, CANDLE HOLDERS AND COVERED SUGAR BOWL

L111—Tall tear-drop vase, 3¾" D. x 12" H.	$ 4.00	
L112—Small tear-drop vase, 4½" D. x 7" H.	$ 4.50	
L121—Lg. Cylinder Vase, 5½" D. x 13" H.	$ 6.00	
L122—Small Cylinder Vase, 2½" D. x 8½" H.	$ 3.00	
L155—Extra Lg. Cylinder Vase, 5½" D. x 16" H.	$ 7.50	
L114—Low Rnd. Candle Holder, 5½" D. x 3¼" H.	$ 3.50	
L138—Med. Rnd. Candle Holder, 3" D. x 9½" H.	$10.00 Pr.	
L149—Low Sq. Candle Holder, 2½" Sq.	$5.00 Pr.	
L159—Tall Flared Candle Holder, 5¾" x 14" H.	$7.50	
L166—Low Wide Planter, 8¾" D. x 3½" H.	$4.00	
L167—Deep Planter, 6" D. x 4½" H.	$4.00	
L133—Sugar Bowl — Covered, 4" D. x 3½" H.	$4.00	
L133X—Sugar Bowl (no cover) 4" D. x 3" H.	$2.00	

See Page 13 for Creamer (L134) and Tray (L146).

Page 11

Fig. CT.29 Casual Craft, Basketry, Raymor Capri, p. 11.

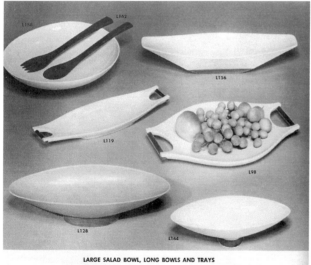

LARGE SALAD BOWL, LONG BOWLS AND TRAYS

L 98—Large Tray, 16¼" x 12"	$10.00
L119—Long Tray, 16¼" x 6"	$ 5.00
L128—Lg. Long Oval Bowl, 11¾" x 4¾" x 2¾" H.	$ 7.50
L156—Lg. Rect. Bowl, 19½" x 6¾" x 3¾" H.	$ 8.50
L164—Sm. Long Oval Bowl, 10¾" x 7¾" x 4½" H.	$ 3.50
L158—Lg. Round Salad Bowl, 14½" D. x 3¾" H.	$10.00
L162—Walnut Servers, 13¼" L.	$ 4.00 Pr.

Choose Raymor Capri for the extra - special service items. Capri adds to the formality of the table setting yet is so contemporary in styling.

Porcelain and Walnut — Truly a beautiful material combination.

Fig. CT.30 Casual Craft, Basketry, Raymor Capri, p. 12.

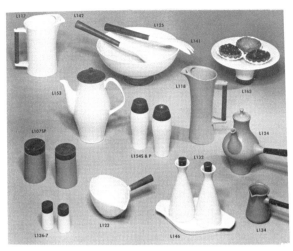

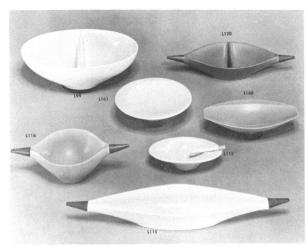

PITCHERS, COFFEE SERVERS, CREAMER, BOWLS, COMPOTE, SALT & PEPPER SHAKERS, PEPPER MILL, TRAY, CRUETS AND SERVERS

L107SP--Large Salt, Pepper Shakers, 4¼" H. $5.00 Pr.
L136-7--Small Salt, Pepper Shakers, 2¾" H. $3.50 Pr.
L154S--Tall Salt Shaker, 6" H. $3.50
L154P--Tall Pepper Mill, 6" H. $6.00
L117--Pitcher, (1½ Qt.) 5" D. x 8" H. $6.50
L118--Martini Pitcher, 3¾" D. x 9½" H. $6.00
L124--After Dinner Coffee, 4¾" D. x 8" H. $6.50
L153--Coffee Server, 4¾" D. x 9" H. $7.50
L123--Gravy Boat, 6¾" x 4½" x 2¾" H. $3.50
L163--Compote, Cake Plate, 10" D. x 4" H. $5.00
L125--Round Salad Bowl, 11¾" D. x 5" H. $9.00
L141--Fork (porcelain), 14" L. $3.50
L142--Spoon (porcelain) 14" L. $3.50
L132--Cruet, 3" D. x 6½" H. $3.00 Ea.
L146--Small Tray, 9" x 6" $2.50
L134--Creamer, 2¾" D. x 3½" H. $3.00
See Page 11 for Sugar Bowl (L133)

ALL PRICES ARE SUGGESTED RETAIL Page 13

BOWLS AND ASH TRAYS

L 99--Divided Vegetable, 12" x 8" x 4" H. $6.50
L115--Long Celery Tray, 18½" x 4½" x 2" H. $5.00
L116--Nut, Mint, Garni Dish, 10½" x 5½" x 3" H. $3.50
L120--Divided Relish Dish, 13¾" x 5½" x 2¼" H. $4.00
L113--Sm. Oval Ash Tray, 3¾" x 6½" x 1¾" H. $5.00
L160--Med. Ash Tray, 9" x 5" x 2¼" H. $3.00
L161--Med. Round Ash Tray, 7½" D. x 2½" H. $3.00
See Color Illustration of Capri on Back Cover

IMPORTANT — GENERAL INFORMATION

Prices shown are suggested selling prices subject to the usual trade discount. TERMS 2% 10 days, net 30 days.

All shipments are F. O. B. HICKORY, NORTH CAROLINA. We ship by insured carriers — whether parcel post, express, truck or rail and at the lowest rate in consideration of the size of shipment, or, as requested or specified by the customer.

NOTE -- On truck or rail shipments you pay the minimum freight rate on 100 pounds or less. Some areas have a 200 pound minimum. The average 100 pound shipment of HYALYN is approximately $150.00 list. Plan your order to

be sure of the best truck or rail rate.
HANDLING CHARGE. No handling charge is added to orders amounting to $35.00 net or more. If the order amounts to less than $35.00 net, a charge of 5% of the net amount of the order is added with a minimum charge of 75 cents.

CREDIT: If you have not established an account with HYALYN PORCELAIN, INC., please furnish three or more trade references with your order.

ORDERS -- Send all orders to Richards Morgenthau Company 225 Fifth Avenue, New York 10, New York.

Page 14

Clockwise from top left:

Fig. CT.31 Casual Craft, Basketry, Raymor Capri, p. 13.

Fig. CT.32 Casual Craft, Basketry, Raymor Capri, p. 14.

Fig. CT.33 Casual Craft, Basketry, Raymor Capri, p. 15.

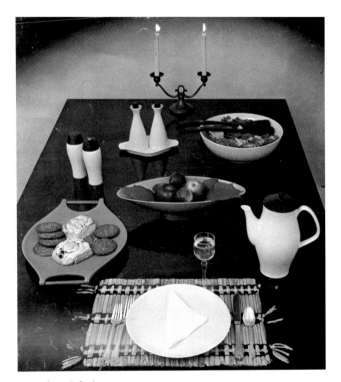

Casual Craft...
Basketry........
Raymor Capri.

Sold Exclusively By

RICHARDS MORGENTHAU CO.

225 FIFTH AVE. - NEW YORK CITY

VI. Casual Craft, Basketry, Raymor Capri Smoking Accessories (*c.* 1958–60)

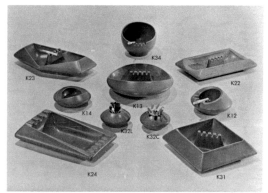

Casual Craft

3 Matte Colors - Black, White, Orange
3 Gloss Colors - Green, Coral, Gold

For service with safety you can recommend Casual Craft by Hyalyn. All ash trays in this group have the safety feature of cigarette snuffer rests. The entire line available in six distinctive textured matte colors to add color accent or contrast in decorating. All items have cork bottoms for the protection of table tops. Casual Craft means smoking accessories for office or den.

Coral Gold

QTY.	STYLE	DESCRIPTION	Alabaster	Black	Blue	Brown	Orange	White	LIST PRICE EACH	AMOUNT
	K12	Medium Ash Tray — 6½" D. x 3" H.							10.00	2.65
	K13	Large Ash Tray — 10½" D. x 3" H.							4.00	
	K14	Small Ash Tray — 5⅜" D. x 2" H.							2.00	
	K22	Center Rest Ash Tray — 12" L. x 7½" W.							4.00	
	K23	Hex. Ash Tray — 14½" L. x 8½" W.							3.00	
	K24	Rect. Deep Ash Tray — 12" L. x 6½" W. x 2½" H.							4.00	
	K31	Square Ash Tray — 9" Sq. x 2½" H.							4.00	4.50
	K32L	Cigarette Lighter — 4½" Dia. 3" H.							4.00	3.50
	K32C	Cigarette Cup — 4½" Dia. 2" H.							1.50	
	K34	Ball Ash Tray — 6½" D. 4½" H.							3.00	3.25
									TOTAL AMOUNT	

USE THIS CATALOG SHEET FOR YOUR ORDER SELECTION. ANOTHER COPY FOR RE-ORDER USE WILL BE SENT TO YOU UPON RECEIPT OF YOUR ORDER.

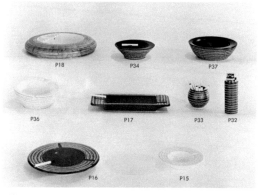

Basketry

For unique decorative treatment and color harmony, Basketry by Hyalyn offers four popular color combinations. All are hand decorated in raised enamel to add that plus value for decorative accent. For those who want the smoking accessory that's different you can recommend Basketry.

QTY.	STYLE	DESCRIPTION	COCOA	PUMKIN	BLUE	MUSTARD	LIST PRICE EACH	AMOUNT
	P15	Sm. Round Ash Tray — 6½" D. x 1½" H.					$3.00	
	P16	Lg. Round Ash Tray — 10" D. x 1¾" H.					5.00	
	P17	Rect. Ash Tray — 12½" L. x 5" W. x 1½" H.					5.00	
	P18	Dbl-Nut Ash Tray					8.00	
	P32	Lighter — 2" D. 5½" H.					4.50	
	P33	Cigarette Cup — 3½" D. 2¾" H.					2.00	
	P34	Sm. Round Ash Tray — 6½" D. 2" H.					3.00	
	P36	Medium Ash Tray — 7" D. x 3" H.					4.00	
	P37	Large Ash Tray — 8" D. x 2½" H.					5.00	
							TOTAL AMOUNT	

SEND ALL ORDERS TO

RICHARDS MORGENTHAU CO.
225 FIFTH AVENUE — NEW YORK 10, N. Y.

Clockwise from top left:

Fig. CT.34 Casual Craft, Raymor Smoking Accessories, p. 1.

Fig. CT.35 Basketry, Raymor Smoking Accessories, p. 2.

Fig. CT.36 Raymor Capri Smoking Accessories, p. 3.

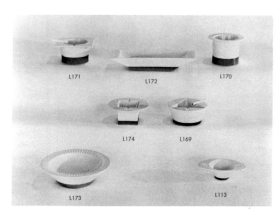

Capri

Raymor Capri Accessories combining lustrous white porcelain with natural walnut makes that perfect quality tone combination. Easy to care for, classic in form, but contemporary in concept — offer Capri by Hyalyn for that elegant look. A wide choice of sizes and designs all in white with walnut.

QUANTITY	STYLE	DESCRIPTION	LIST PRICE EACH	AMOUNT
	L113	Ash Tray — 3¾" x 6½" x 1½" H.	$2.50	
	L169	Triangle Ash Tray — 6" Dia. 2½" H.	3.50	
	L170	Deep Round Ash Tray — 6" Dia. 4" H.	4.00	
	L171	Medium Square Ash Tray — 6" Sq. 3" H.	4.00	
	L172	Long Rect. Ash Tray — 14" L. x 5" W.	6.00	
	L173	Round Ash Tray — 9" Dia. 2½" H.	3.00	
	L174	Deep Square Base Ash Tray — 6" Dia. 2½" H.	3.00	
			TOTAL AMOUNT	

SEND ALL ORDERS TO

RICHARDS MORGENTHAU CO.
225 FIFTH AVENUE — NEW YORK 10, N. Y.

VII. MIDAS GOLD AND SILVER BY GEORGES BRIARD (*c.* 1960)

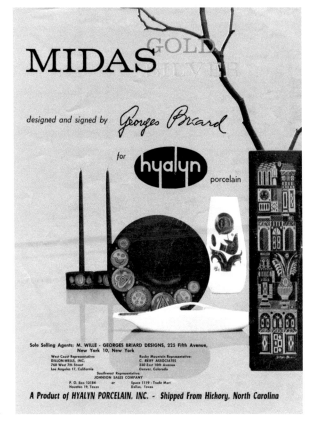

Fig. CT.37 Midas Gold and Silver, p. 1.

World Premier of a Brilliant Design Innovation

A prestige group of accessories in genuine porcelain that is the finest expression of the potter's art . . . dramatized by a brilliant, exclusive, patented new technique of sculptured ornamentation in either 22-karat gold or sterling silver. You can literally **feel** the deep-dimension elegance! Choose from a variety of pieces imaginatively styled for decor, floral setting, serving and smoking . . . remarkably priced from 3.50 to 15.00 retail. **MIDAS**—sculptured beauty in precious gold and silver—is designed and signed by Georges Briard, and manufactured by HYALYN PORCELAIN, INC., producers of America's Finest Porcelain. Shipping and billing is from Hickory, North Carolina.

PLEASE NOTE: All Accessories are available in either satin white or black porcelain, with either **gold** or **silver** motifs. Please specify the combinations you desire.

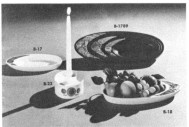

THREE NESTED TRAYS FOR SERVING OR SMOKING WITH A CANDLEHOLDER

B-17—Small Oval Tray $ 4.00
 4½" W x 9¾" L x 1" H

B-18—Medium Oval Tray 6.00
 5" W x 12½" L x 1¼" H

B-19—Large Oval Tray 8.00
 6" W x 15½" L x 1½" H

B-1789—Nest of Three Trays 18.00

B-23—Candleholder 5.00
 4½" D x 2¼" H each

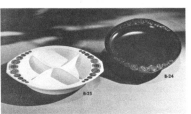

ELEGANT SERVICE PIECES — TWO BUFFET SERVERS, ONE DIVIDED FOR HORS D'OUEVRES

B-24—Large Tray $12.50
 16" x 13½" Oval x 1¾" H

B-25—Four Compartment Tray 12.50
 16" x 13½" Oval x 1¾" H

Fig. CT.38 Midas Gold and Silver, p. 2.

DISTINCTIVELY DIFFERENT DESIGNS ON TWO FREE FORM ASH TRAYS WITH CIGARETTE CUP AND LIGHTER

B-15—Large Free Form Ash Tray **$7.50**
5⅜" W x 12¼" L x 1¼" H

B-16—Small Free Form Ash Tray **6.00**
5" W x 10¼" L x 1¼" H

B-20—Cigarett Cup **3.50**
3¼" D x 4½" H

B-21—Cigarett Lighter **6.50**
3¼" D x 4½" H

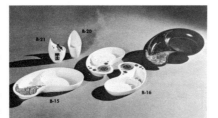

CIGARETTE OR CANDY BOX WITH TWO CENTER-REST ASH TRAYS

B-8—Cigarett Box **$10.00**
4¾" W x 14½" L x 2¾" H

B-9—Large Boat Ash Tray **8.50**
5¼" W x 16½" L x 1½" H

B-22—Small Boat Ash Tray **6.50**
4" W x 12¼" L x 1½" H

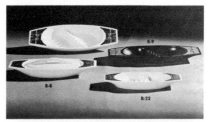

SMOKING ELEGANCE WITH TWO ROUND ASH TRAYS AND CIGARETTE CUP AND LIGHTER

B-13—Large Round Ash Tray **$7.00**
10¼" D x 1½" H

B-14—Small Round Ash Tray **4.50**
6¾" D x 1¼" H

B-20—Cigarett Cup **3.50**
3¼" D x 4½" H

B-21—Cigarett Lighter **6.50**
3¼" D x 4½" H

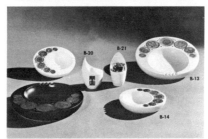

Fig. CT.39 Midas Gold and Silver, p. 3.

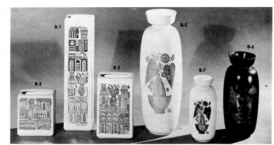

GOLD AND SILVER ON PORCELAIN HIGHLIGHT THE MIDAS COLLECTION OF VASES

B-1—Tall Pillow Vase **$11.00**
3" x 4" x 15¼" H

B-2—Medium Pillow Vase **8.50**
3" x 5" x 8" H

B-3—Small Pillow Vase **$ 7.00**
3" x 5" x 5½" H

B-5—Tall Continental Vase **15.00**
6" D x 16¼" H

B-6—Med. Continental Vase **$9.00**
5" D x 10¾" H

B-7—Small Continental Vase **6.50**
4" D x 8¼" H

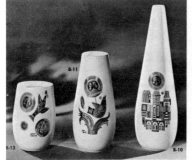

PRECIOUS METALS GLOW ON THE CONTEMPORARY ELEGANCE OF THREE TAPPERED VASES

B-10—Tall Tapered Vase **$12.50**
6" D x 18¼" H

B-11—Medium Tapered Vase **10.00**
6" D x 10¾" H

B-12—Small Tapered Vase **7.50**
6" D x 7" H

GENERAL INFORMATION

PRICES shown are suggested selling prices subject to the usual trade discount. Terms — 2% 10 days, net 30 days.

SHIPMENTS are F. O. B. Hickory, **North Carolina.** We ship by insured carriers — whether parcel post, express, truck or rail and at the lowest rate in consideration of the size of shipment, or, as requested or specified by the customer.

NOTE—On truck or rail shipments you pay the minimum freight rate on 100 pounds or less. Some areas have a 200 pound minimum. The average 100 pound shipment of HYALYN is approximately $150.00 list. Plan your order to be sure of the best truck or rail rate.

HANDLING CHARGE: No handling charge is added to orders amounting to $35.00 net or more. If the order amounts to less than $35.00

net, a charge of 5% of the net amount of the order is added with a minimum charge of 75 cents.

CREDIT: If you have not established an account with HYALYN PORCELAIN, INC., please furnish three or more trade references with your order.

PACKING: ALL HYALYN ware is vacuum packed to reduce shipping charges, prevent breakage and protect, with polyethylene film, each piece ordered from our factory.

ORDERS: Send all order to Georges Briard Designs, 225 Fifth Avenue, New York 10, New York or to your nearest Briard Regional Representative.

Fig. CT.40 Midas Gold and Silver, p. 4.

VIII. MIDAS BY GEORGES BRIARD (1961)

Fig. CT.41 Midas, p. 1.

Fig. CT.42 Midas, p. 2.

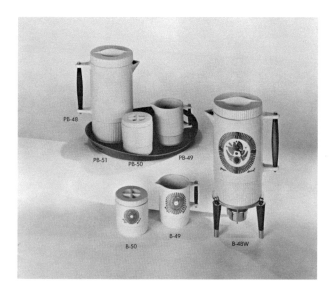

COFFEE SERVICE WITH BRASS AND WALNUT WARMER CLASSIC SIMPLICITY — CONTEMPORARY ELEGANCE		
B-48	3-pt Coffee Pot decorated	$12.50
B-48W	3-pt Coffee Pot w/warmer and candle, 11½" H	16.00
B-49	Creamer — 4" High	6.00
B-50	Sugar with cover — 3½" High	5.50
PB-48	Coffee Pot — Plain	9.00
PB-48W	Plain Coffee Pot w/warmer	12.00
PB-49	Creamer — Plain	4.00
PB-50	Sugar — covered — Plain	3.00
PB-51	Round Tray — Plain	5.00
Letter "P" indicates — Plain — Not Decorated		
All except Tray available in White only.		

Fig. CT.43 Midas, p. 3.

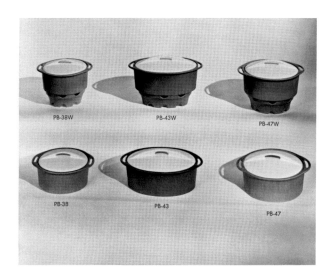

COLORFUL — SERVICEABLE — SALABLE		
PB-38	2-qt. Casserole Dish — 8¼" Dia.	$ 7.50
PB-38W	2-qt. Casserole w/warmer and candle	10.00
PB-43	3-qt. Casserole Dish — Plain, 11½" x 7¾" Oval	10.00
PB-43W	3-qt. Casserole w/warmer and candle	15.00
PB-47	3-qt. Casserole — Plain — 10" Dia.	9.50
PB-47W	3-qt. Casserole w/warmer and candle	14.00

Casseroles with all porcelain covers with or without warmer.

Fig. CT.44 Midas, p. 4.

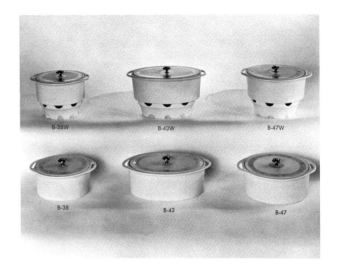

DECORATED CASSEROLES —
WITH PORCELAIN WARMER

Black or White Matte, with White Gloss
inside. 24k Gold metal lacquered
knob on cover.

B-38	2-qt. Casserole Dish Decorated, 8¼" Dia.	$10.00
B 38W	2-qt. Casserole Decorated, w/warmer and candle 8¼" Dia.	12.50
B-43	3-qt. Casserole Dish—Decorated, 11½" x 7¾" Oval	12.50
B-43W	3-qt. Casserole Decorated, w/warmer and candle, 11½" x 7¾" Oval	18.50
B-47	3-qt. Casserole Decorated, 10" Dia.	12.00
B-47W	3-qt. Round Casserole Decorated, w/warmer and candle, 10" Dia.	17.50

All above individually packaged in corrugated mailers.

Fig. CT.45 Midas, p. 5.

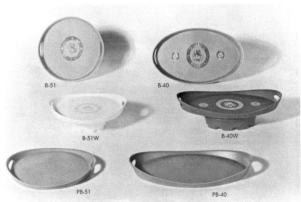

HOT HORS D'OUEVRES SERVERS
DECORATIVE TRAYS —

Large Oval or Round Tray — Decorated
or Plain.

B-40	Oval Platter, 17¼" Long	$10.00
PB-40	Oval Platter — Plain	6.50
B-40W	Hors d'ouevres Platter w/warmer and candle	13.00
PB-40W	Hors d'ouevres Platter w/warmer and candle — Plain	9.00
B-51	Round Tray — 12¾" Dia.	8.00
PB-51	Round Tray — Plain	5.00
B-51W	Round Tray w/warmer and candle	11.00
PB-51W	Round Tray w/warmer and candle — Plain	8.00

Your choice of White, Black, Olive or Terra Cotta, matte colors.

GENERAL INFORMATION

PRICES shown are suggested selling prices subject to the usual trade discount. Terms — 2% 10 days, net 30 days.

SHIPMENTS are F. O. B. Hickory, North Carolina. We ship by insured carriers — whether parcel post, express, truck or rail and at the lowest rate in consideration of the size of shipment, or, as requested or specified by the customer.

NOTE—On truck or rail shipments you pay the minimum freight rate on 100 pounds or less. Some areas have a 200 pound minimum. The average 100 pound shipment of HYALYN is approximately $150.00 list. Plan your order to be sure of the best truck or rail rate.

HANDLING CHARGE: No handling charge is added to orders amounting to $35.00 net or more. If the order amounts to less than $35.00

net, a charge of 5% of the net amount of the order is added with a minimum charge of 75 cents.

CREDIT: If you have not established an account with HYALYN PORCELAIN, INC., please furnish three or more trade references with your order.

PACKING: ALL HYALYN ware is vacuum packed to reduce shipping charges, prevent breakage and protect, with polyethylene film, each piece ordered from our factory.

ORDERS: Send all orders to Georges Briard Designs, 225 Fifth Avenue, New York 10, New York or to your nearest Briard Regional Representative.

Show Rooms — 225 Fifth Avenue, New York 10, New York
1119 Trade Mart, Dallas, Texas

Fig. CT.46 Midas, p. 6.

**LIGHTER SETS —
GIFT PACKAGED**

B-36 Cigarette Cup—2¾" H. **$ 3.50**

B-37 Small Reeded Lighter,
2" Dia. 4.00

B-36-7 Cup and Lighter
(Gift Boxed) 7.50

B-45 Cigarette Cup — 3" Dia.,
2¾" High 4.00

B-46 Tall Cigarette Lighter,
2" Dia., 5¾" High 6.50

B-45-6 Lighter and Cigarette
Cup (Gift Boxed) 10.00

Available in Black, White, Blue,
Olive Green or Terra Cotta Matte
glazes, with sculptured gold deco-
ration.

**CIGARETTE BOX
DESK SET
SMALL HAND ASH TRAYS**

B-41 Cigarette Box—4½" L. **$ 5.00**

B-42 Desk Set in Gift Box,
7¾" L., 6½" W. 10.00

B-52-2 Small Ash Tray (Gift
Boxed) Set of Two 5.00

Your choice of Black, White, Blue,
Olive or Terra Cotta, decorated in
sculptured gold.

Fig. CT.47 Midas, p. 7.

**ASH TRAYS —
SMOKERS ACCESSORIES —
DECORATED SCULPTURED GOLD**

B-8 Lg. Cigarette Box, 4¾" W. x 14½" L. x 2¾" H. **$ 8.50**
B-9 Lg. Boat Ash Tray, 5¼" W. x 16½" L. x 1½" H. 7.50
B-15 Lg. Free Form Ash Tray, 5¾" W. x 12¼" L. x 1¼" H. 6.50
B-16 Sm. Free Form Ash Tray, 5" W. x 10¼" L. x 1¼" H. 5.00
B-20 Cigarette Cup, 3¼" D. x 4½" H. 3.50
B-21 Lighter, 3¼" D. x 4½" H. 6.50
B-20-1 Set — Cigarette Cup and Lighter — gift packed 10.00
B-22 Sm. Boat Ash Tray, 4" W. x 12¼" L. x 1½" H. 6.00
Your choice of colors—Black, White, Blue, Olive or Terra Cotta with
22k Gold Decoration.

**ASH TRAYS — WITH ELEGANT
RAISED GOLD DECORATIONS**

B-13 Lg. Round Ash Tray, 10¼" D. x 1½" H. **$7.00**
B-14 Sm. Round Ash Tray, 6¾" D. x 1¼" H. 4.00
B-28 Sm. Round Safety Tray — 8" Dia. x 2¼" H. 6.00
B-29 Lg. Round Safety Tray, 10" Dia. x 2¾" H. 7.50
Specify your color choice—Black, White, Blue, Olive, or Terra Cotta.

Fig. CT.48 Midas, p. 8.

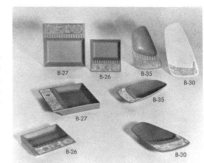

TRAPEZIFORM OR SQUARE ASH TRAYS LARGE AND SMALL

B-26 Sm. Square Ash Tray,
7¼" Sq. $6.00
B-27 Lg. Square Ash Tray,
10" Sq. 8.50
B-30 Lg. Trapeziform, Tray
12" L. x 6½" W. 6.50
B-35 Sm. Trapeziform Ash
Tray, 10½" L. x 6½" W. 5.00

Available in Black, White, Blue,
Olive or Terra Cotta Matte.

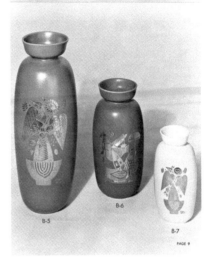

CONTINENTAL STYLED VASES
in
CONTEMPORARY ELEGANCE

B-5 Tall Continental Vase
16¼" H. x 6" D. $12.50
B-6 Med. Continental Vase
10¾" H. x 5" D. 8.50
B-7 Small Continental Vase
8¼" H. x 4" D. 6.00

Your color choice — Black, White,
Blue, Olive or Terra Cotta. All de-
corated with 22k sculptured gold.

Fig. CT.49 Midas, p. 9.

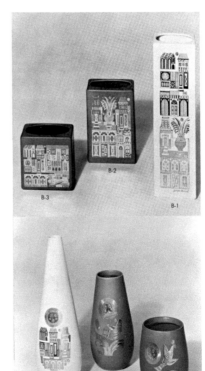

PILLOW VASES FACADE DECORATION

B-1 Tall Pillow Vase,
3" x 4" x 15¼" H. $10.00
B-2 Md. Pillow Vase,
3" x 5" x 8" H. 7.50
B-3 Small Pillow Vase,
3" x 5" x 5½" H. 6.00

Specify your color choice — Black,
White, Blue, Olive or Terra Cotta
Matte.

CONTEMPORARY ELEGANCE TAPERED VASES

B-10 Tall Tapered Vase,
6" Dia. x 18¼" H. $12.50
B-11 Med. Tapered Vase,
6" Dia. x 10¾" H. 10.00
B-12 Small Tapered Vase,
6" Dia. x 7" H. 7.50

Available in Black, White, Blue,
Olive or Terra Cotta Matte.

Fig. CT.50 Midas, p. 10.

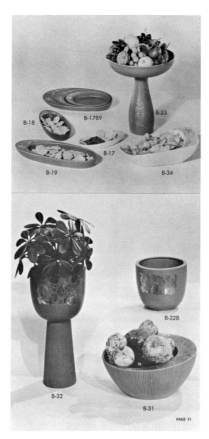

RELISH SERVERS
FRUIT BOWL and
PEDESTAL BOWL

B-17 Sm. Oval Relish,
　　4½" W. x 9¾" L. x 1" H. **$ 3.50**
B-18 Med. Oval Relish,
　　5" W. x 12½" L. x 1¼" H. **5.00**
B-19 Lg. Oval Relish,
　　6" W. x 15½" L. x 1½" H. **6.50**
B-1789 Relish Set (3) **15.00**

B-33 Lg. Pedestal Bowl,
　　14¾" H. x 13" Dia. **12.50**
B-34 Trapeziform Bowl,
　　14½" L. x 7½" W. x 3½" H. **7.50**

Your choice of colors—Black, White,
Blue, Olive and Terra Cotta Matte
Glazes.

FRUIT BOWL
TALL COMPOTE
CACHE POT

B-31 Lg. Fruit Bowl,
　　12" Dia. x 5" H. **$12.00**
B-32 Tall Compote,
　　14" H. x 7¼" D. **10.00**
B-32B Cache Pot,
　　6¼" H. x 7½" Dia. **7.00**

Specify your color choice—Black,
White, Blue, Olive Green or Terra
Cotta.

Fig. CT.51 Midas, p. 11.

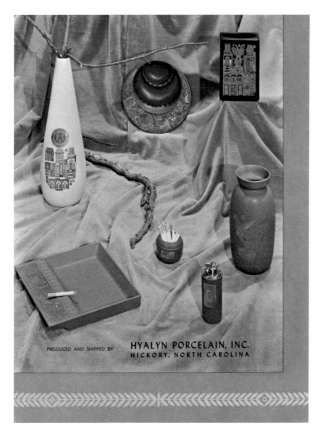

Fig. CT.52 Midas, p. 12.

IX. HIGH FASHION BY EVA ZEISEL (1964)

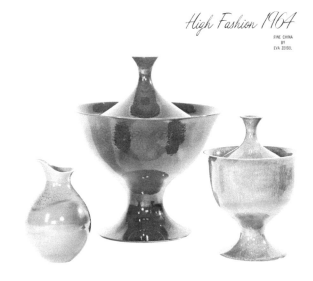

High Fashion 1964

FINE CHINA
BY
EVA ZEISEL

A QUALITY PRODUCT FROM

hyalyn ®

AMERICA'S FINEST PORCELAIN

NATIONALLY DISTRIBUTED BY RAYMOR

RICHARDS MORGENTHAU AND COMPANY
225 FIFTH AVENUE, NEW YORK 10, N. Y.

SHOWROOMS: 225 FIFTH AVENUE, NEW YORK
1567 MERCHANDISE MART, CHICAGO

Fig. CT.53 High Fashion, p. 1.

High Fashiondesigned by *Eva Zeisel*

Reminiscent of the best in ancient oriental ceramics is the glowing look of Raymor's new buffet service, tureens and bowls, casseroles and pitchers, plates and cups, all share graceful curves and sensitive, playful forms, yet individually each is a self-container design of classic perfection, creatively devised.

Ovenproof, "High Fashion" lends itself beautifully to buffet or patio service, and the hardness of the high-fired china and its high-fired glaze is exceptionally resistant to chipping. The glazes vary on each piece, providing a fascinating effect of contrast, which may be furthered by choosing a service that mixes the four colors, or by introducing a new color with each course, a new fashion in table setting now in vogue with sophisticates.

Many of the pieces, so lovely in proportion and coloration, tempt their display as purely decorative objects when they are not serving their planned function: the shapely bottle or pitcher may serve as a vase; a footed tureen could adorn a console.

Eva Zeisel, educated at the Royal Academy of Art, Budapest; Ecole des Beaux Arts, Paris; Journeyman's Degree in the Hungarian Guild of Potters. Taught ceramics at Pratt Institute and Rhode Island School of Design. Has exhibited at all World's Fairs, from Philadelphia Sesqui-Centennial International Exhibit 1926, Paris World's Fair 1937, New York World's Fair 1938, Brussels Fair.

Museum exhibits include: Museum of Modern Art many times, but especially the first one-man show for any industrial designer introducing the now famous "Museum Shape" in 1946; Brooklyn Museum, Museum of Contemporary Crafts; Walker Art Center; Akron Art Institute.

Eva Zeisel has designed in metal, wood, plaster, as well as china and glass, for firms all over the world, including Mexico, Germany, Japan as well as the United States.

Z-1	Large Tureen, 15" D., 6¾" H., 2 gals.	$16.00		Z-8	Individual Bowl, 6½" Dia.	$ 3.00
Z-1B	Large Footed Tureen, 15" D., 16½" H., 2 gals	$20.00		Z-9	Large Oval Platter, 20" x 12½" Oval	$ 7.50
Z-2B	Small Footed Tureen, 8½" D., 8¾" H., 2 qts.	$10.00		Z-11	Handled Vegetable Bowl, 12" x 6¾" Oval	$ 3.50
Z-4	Footed Bowl, 10½" D., 9" H.	$ 8.00		Z-18	Ice Bucket, 9" H. 1 Gal.	$12.50
Z-5	Footed Candy Bowl, 5¾" D., 5" H.	$ 3.00		Z-22	Pitcher, 8½" H., 3 pt.	$ 4.00

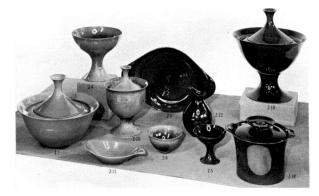

Fig. CT.54 High Fashion, p. 2.

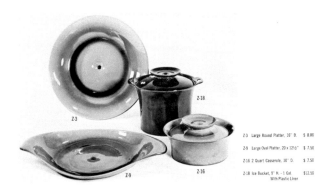

Z-3　Large Round Platter, 16" D.　$ 8.00

Z-9　Large Oval Platter, 20 x 12½"　$ 7.50

Z-16　2 Quart Casserole, 10" D.　$ 7.50

Z-18　Ice Bucket, 9" H. - 1 Gal.　$12.50
　　　With Plastic Liner

High Fashion is OVENPROOF CHINA . . . perfect for buffet and patio service. Each piece is available in all 4 distinctive art glazes —

OLIVE, OXBLOOD, GOLD, MOTTLED TAUPE
ALL PRICES SHOWN ARE LIST

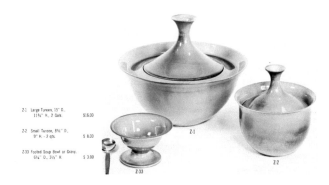

Z-1　Large Tureen, 15" D.,
　　　11¾" H., 2 Gals.　$16.00

Z-2　Small Tureen, 8¾" D,
　　　9" H. - 2 qts.　$ 8.00

Z-33　Footed Soup Bowl or Gravy,
　　　6¼" D., 3½" H.　$ 3.00

Fig. CT.55 High Fashion, p. 3.

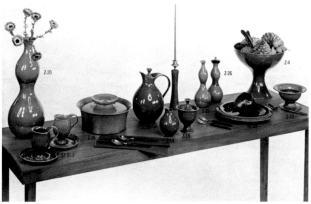

Z-4　Footed Bowl, 10½" D., 9" H.　$8.00
Z-13　Coffee Server, 8½" H., 3 pts.　$7.00
Z-14　Creamer, 4¾" H., 8 oz.　$2.50
Z-15　Covered Sugar, 4" D., 5" H.　$4.00
Z-16　2 Qt. Casserole, 10" D.　$7.50
Z-20　Wine Bottle/Vase, 17" H., 5 pts.　$7.50

Z-25　Large Salt, 8" H.　$ 3.00
Z-26　Pepper Mill, 8" H.　$10.00
SZ-28　Dinner Plate, 10½" D.　$ 2.75
SZ-31-2　Cup & Saucer - 6 oz.　$ 2.75
Z-33　Footed Soup Bowl, 6¾" D., 3½" H.　$ 3.00

1 — Chip Resistant — High fired art glaze in high fired body.
2 — Each piece is ovenproof.
3 — Each piece has dual purpose. e. g. Wine Bottle/Decorator Vase — Flower Arranger.
4 — Colors are co-ordinated for mix-match settings.

All prices shown are suggested retail, subject to the usual trade discounts. Prices may be slightly higher west of the Mississippi.

TERMS — 1% 15 Days, Net 30 Days, on approved credit.

HANDLING CHARGE. No handling charge is added to orders amounting to $50.00 net or more. If the net order amounts to less than $50.00, a Handling Charge of 5% of the net amount of the order is added with a minimum charge of $1.00.

SHIPMENTS. All shipments are **F. O. B. HICKORY, NORTH CAROLINA.** We ship by insured carriers — whether parcel post, express, truck, or rail and at the lowest rate in consideration of the size of the shipment or as requested by the customer.

If you have not established an account with Hyalyn Porcelain, Inc., please furnish three or more trade references with your order.

SEND ALL ORDERS TO — RICHARDS MORGENTHAU COMPANY
225 Fifth Avenue
New York 10, New York

Fig. CT.56 High Fashion, p. 4.

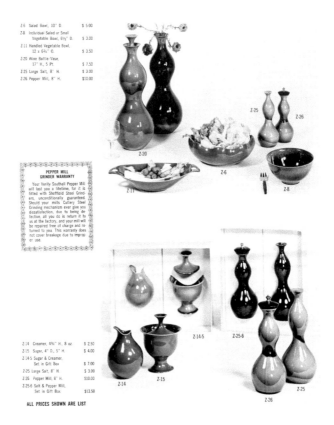

Z-6　Salad Bowl, 10" D.　　　　$ 5.00
Z-8　Individual Salad or Small
　　Vegetable Bowl, 6½" D.　$ 3.00
Z-11 Handled Vegetable Bowl,
　　12 x 6¾" D.　　　　$ 3.50
Z-20 Wine Bottle-Vase,
　　17" H., 5 Pt.　　　　$ 7.50
Z-25 Large Salt, 8" H.　　　$ 3.00
Z-26 Pepper Mill, 8" H.　　　$10.00

PEPPER MILL
GRINDER WARRANTY

Your Verity Southall Pepper Mill
will last you a lifetime, for it is
fitted with Sheffield Steel Grind-
ers, unconditionally guaranteed.
Should your mills Cutlery Steel
Grinding mechanism ever give you
dissatisfaction, due to being de-
fective, all you do is return it to
us at the factory, and your mill will
be repaired free of charge and re-
turned to you. This warranty does
not cover breakage due to improp-
er use.

Z-14　Creamer, 4¾" H., 8 oz.　　$ 2.50
Z-15　Sugar, 4" D., 5" H.　　　$ 4.00
Z-14-5 Sugar & Creamer,
　　　Set in Gift Box　　　$ 7.00
Z-25　Large Salt, 8" H.　　　$ 3.00
Z-26　Pepper Mill, 8" H.　　　$10.00
Z-25-6 Salt & Pepper Mill,
　　　Set in Gift Box　　　$13.50

ALL PRICES SHOWN ARE LIST

Fig. CT.57 High Fashion, p. 5.

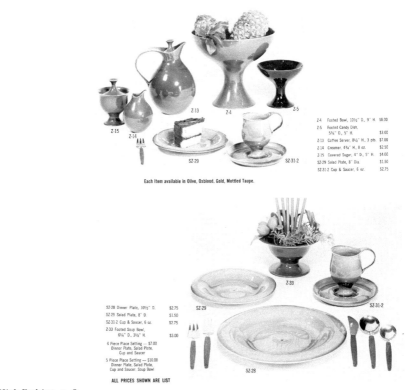

Z-4　Footed Bowl, 10½" D., 9" H.　$8.00
Z-5　Footed Candy Dish,
　　5¾" D., 5" H.　　　　$3.00
Z-13　Coffee Server, 8½" H., 3 pts.　$7.00
Z-14　Creamer, 4¾" H., 8 oz.　　$2.50
Z-15　Covered Sugar, 4" D., 5" H.　$4.00
SZ-29　Salad Plate, 8" Dia.　　　$1.50
SZ-31-2 Cup & Saucer, 6 oz.　　$2.75

Each Item available in Olive, Oxblood, Gold, Mottled Taupe.

SZ-28 Dinner Plate, 10½" D.　$2.75
SZ-29 Salad Plate, 8" D.　　$1.50
SZ-31-2 Cup & Saucer, 6 oz.　$2.75
Z-33 Footed Soup Bowl,
　　6¼" D., 3½" H.　　　$3.00

4 Piece Place Setting — $7.00
　Dinner Plate, Salad Plate,
　Cup and Saucer
5 Piece Place Setting — $10.00
　Dinner Plate, Salad Plate,
　Cup and Saucer, Soup Bowl

ALL PRICES SHOWN ARE LIST

Fig. CT.58 High Fashion, p. 6.

X. EVA ZEISEL DESIGNS MANUFACTURED BY WORLD OF CERAMICS (*c.* 1996)

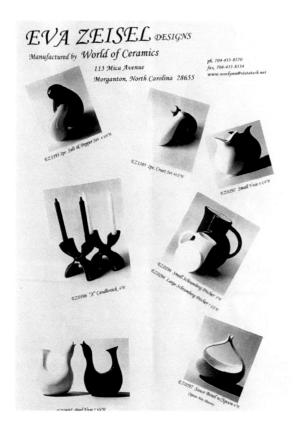

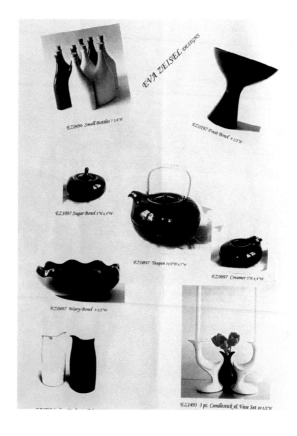

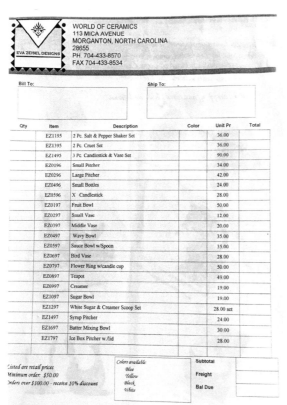

WORLD OF CERAMICS
113 MICA AVENUE
MORGANTON, NORTH CAROLINA
28655
PH. 704-433-8570
FAX 704-433-8534

Bill To:

Ship To:

Qty	Item	Description	Color	Unit Pr	Total
	EZ1195	2 Pc. Salt & Pepper Shaker Set		36.00	
	EZ1395	2 Pc. Cruet Set		36.00	
	EZ1495	3 Pc. Candlestick & Vase Set		90.00	
	EZ0196	Small Pitcher		34.00	
	EZ0296	Large Pitcher		42.00	
	EZ0496	Small Bottles		24.00	
	EZ0596	X Candlestick		28.00	
	EZ0197	Fruit Bowl		50.00	
	EZ0297	Small Vase		12.00	
	EZ0397	Middle Vase		20.00	
	EZ0497	Wavy Bowl		35.00	
	EZ0597	Sauce Bowl w/Spoon		35.00	
	EZ0697	Bird Vase		28.00	
	EZ0797	Flower Ring w/candle cup		50.00	
	EZ0897	Teapot		49.00	
	EZ0997	Creamer		19.00	
	EZ1097	Sugar Bowl		19.00	
	EZ1297	White Sugar & Creamer Scoop Set		28.00 set	
	EZ1497	Syrup Pitcher		24.00	
	EZ1697	Batter Mixing Bowl		30.00	
	EZ1797	Ice Box Pitcher w./lid		28.00	

Listed are retail prices
Minimum order: $50.00
Orders over $100.00 - receive 10% discount

Colors available:
Blue
Yellow
Black
White

Subtotal

Freight

Bal Due

Clockwise from top left:

Fig. CT.59 Eva Zeisel Designs, p. 1.

Fig. CT.60 Eva Zeisel Designs, p. 2.

Fig. CT.61 Eva Zeisel Designs, p. 3.

ENDNOTES

CHAPTER 1

1 Igoe, L. M., typewritten biography. I am indebted to the late Lynn Moody Igoe for her typewritten account of her parents' lives, Leslie and Frances Moody. Additional biographical information about Less Moody comes from his 1942 "Proposal [for a] White Ware Industry for North Carolina."

2 Henzke, L., *American Art Pottery* (New York: Thomas Nelson Inc., 1970), pp. 313–314.

3 Igoe, L. M., *op. cit.*

4 *Makio* (Columbus, OH: The Ohio State University, 1931), p. 267.

5 "Arthur Eugene Baggs," marbleheadpottery.net/Marblehead_pottery_site/A_E_Baggs.html.

6 Moody, H. L., "Proposal: White Ware Industry for North Carolina" (1942), p. 10.

7 Igoe, L. M., *op. cit.*

8 *Ohio, County Marriage Records, 1774–1993* [database on-line]. Lehi, UT, U.S.A.: Ancestry.com Operations, Inc., 2016.

9 Moody, H. L., *op. cit.*, p. 10.

10 Igoe, L. M., *op. cit.*

11 Paradis, J., *Abingdon Pottery Artware: 1934–1950: Stepchild of the Great Depression* (Atglen, PA: Schiffer Publishing, Ltd., 1997), p. 14.

12 *Ibid.*, p. 13.

13 Moody, H. L., *op. cit.*, p. 11.

14 Abingdon Pottery's artware division closed in 1950.

15 Letter to H. Leslie Moody from E. M. Underwood of The Patterson Foundry and Machine Co., East Liverpool, OH (December 15, 1941).

16 Letter to H. Leslie Moody from J. T. Robson, Ferro Enamel Corporation, Allied Engineering Division, Cleveland, OH (December 22, 1941).

17 Letter to J. T. Robson, Ferro Enamel Corporation, from H. Leslie Moody, Abingdon, IL (December 16, 1941).

18 Moody, H. L., *op. cit.*, p. 1.

19 Keiser Jr., A., typewritten history of Hyalyn Porcelain, Inc.'s business organization (no date).

20 Frost, S. T., *Colors on Clay: The San Jose Tile Workshops of San Antonio* (San Antonio, TX: Trinity University Press, 2009), p. 108.

21 Igoe, L. M., *op. cit.*

22 Cummins, V. R., Leonard, C., and Coleman, D. (eds.), *Rookwood Pottery Potpourri* (Silver Spring, MD: 1980), p. 119.

23 Leslie Moody to Mrs. H. Leslie Moody, telegram from Cincinnati, OH to San Antonio, TX (July 12, 1943).

24 Letter to Mr. H. Leslie Moody from Charles B. Hoffmann, Sperti, Inc., Cincinnati, OH (July 3, 1943).

25 Sperti invented an ultraviolet lamp that added vitamin D to milk, Aspercreme, and Preparation H.

26 Rago, D., *American Art Pottery* (New York: Knickerbocker Press, 2001), p. 12.

27 Igoe, L. M., *op. cit.*

28 Cummins, Leonard, and Coleman, *op. cit.*, p. 119.

29 Riley Humler to the author, personal email correspondence (April 2, 2020).

30 Waltman, C. E., & Associates, "Ceramic Research for Rookwood Pottery," (November 1943).

31 "Basic Plan For 1945 for Rookwood Pottery: A Division of SPERTI, Inc.," (1945).

32 "Wilhelmine Rehm," *The Cincinnati Enquirer* (Cincinnati, OH: September 28, 1947), p. 4.

33 Nance, D. C., "Men of Hickory, Pleased With Idea, Begin Manufacture," *Journal and Sentinel* (Winston-Salem, NC: January 4, 1948), Section IV, p. 1.

34 "Ceramic Society Names Hickory Man," *The Charlotte Observer* (Charlotte, NC: April 7, 1961), p. 1.

35 American Ceramic Society, customer service reply to an email inquiry (March 16, 2020).

36 Letter from F. J. VonTury to Mr. H. Leslie Moody (April 21, 1963).

37 Less Moody's cause of death was acute myocardial infarction. He suffered from congestive heart failure and carcinoma of the lung. He suffered a heart attack in January 1961. *N.C., Death Certificates, 1909–1976* [database on-line]. Provo, UT, USA: Ancestry.com Operations Inc., 2007.

38 U.S. Federal Census, 1930, Bexley Village, Franklin County, OH, Ancestry.com.

39 webapp1.dlib.indiana.edu/archivesphotos/results/item.do?itemId=P0025142.

40 Moody, F. J., "An Explanation of the Production of a Sculpture Group 'Diana' Together with a Brief Historical Survey of Sculpture,"library. ohio-state.edu/search/o61502868.

41 Igoe, L. M., *op. cit.*

42 *Columbus Art League History: 1923–1935* (Columbus, OH: Columbus Art League, 1985), play.google.com/store/books/details?id=sj_53I aTyfkC&rdid=book-sj_53IaTyfkC&rdot=1.

43 Paradis, J. *op. cit.*, pp. 13; 34.

44 Igoe, L. M., *op. cit.*

45 Frost, S. T., *op. cit.*, pp. 110-111.

46 Letter from Less Moody to Morris Greenspan (August 28, 1972).

47 Illustrated brochure, "American Art Pottery from the Moody Collection at the Hickory Museum of Art" (no date), Hickory Museum of Art, HickoryMuseumofArt.org.

CHAPTER 2

1 Paradis, J., *Abingdon Pottery Artware: 1934–1950: Stepchild of the Great Depression* (Atglen, PA: Schiffer Publishing, Ltd., 1997), p. 14.

2 Moody, H. L., "Proposal: White Ware Industry in North Carolina," (1942), p. 2.

3 Cummins, V. R., Leonard, C., and Coleman, D. (eds.), *Rookwood Pottery Potpourri* (Silver Spring, MD: 1980), p. 119.

4 Unknown author, typewritten history of Hyalyn Porcelain, Inc. (*c.* 1962).

5 Keiser Jr., A., typewritten history of Hyalyn Porcelain, Inc.'s organization as a business.

6 "Men and Machines Spell Success for Hyalyn," *Ceramic Industry*, Volume 76, No. 2 (Chicago, IL), February 1961, p. 50.

7 Paradis, J., *op. cit.*, p. 15.

8 Nance, D. C., "Men of Hickory, Pleased With Idea, Begin Manufacture," *Journal and Sentinel* (Winston-Salem, NC: January 4, 1948), Section IV, p. 1D.

9 "Pottery Plant Site Acquired," *Hickory Daily Record* (Hickory, NC: October 30, 1945), p. 1.

10 "Pottery Plant Lets Contract," *Hickory Daily Record* (Hickory, NC: November 10, 1945), p. 6.

11 "'America's Finest Porcelain' Made By Hyalyn – In Hickory," *Hickory Daily Record*, Historical Edition (Hickory, NC: September 1962), p. 83.

12 "Porcelain Plant Begins Production," *The Charlotte News* (Charlotte, NC: December 30, 1946), p. 3.

13 "Hyalyn Porcelain Large Modern Plant for Art Pottery," *The E.S.C. Quarterly* (Spring-Summer 1947), p. 56.

14 Journal including hand-written entries outlining propane purchases and initial tunnel kiln firing issues, Hyalyn Porcelain, Inc., 1946-1956. H. Leslie Moody or Edgar Littlefield most likely made the entries.

15 Paradis, J., *op. cit.*, p. 31.

16 "Hyalyn Expansion Nears Completion," *Retailing Daily* (June 6, 1950).

17 *Ibid.*

18 "Hyalyn Plant Outlook Good," *Hickory Daily Record* (Hickory, NC: January 15, 1948).

19 *Ibid.*

20 *Ibid.*

21 *Ibid.*

22 A pencil-written note accompanying the type-written list says to file it "with mortgage note."

23 "Men and Machines Spell Success for Hyalyn," *Ceramic Industry*, Volume 76, No. 2 (Chicago, IL: February 1961), p. 50.

24 "Art Display At Mint," *The Charlotte News* (Charlotte, NC: May 17, 1947), p. 6.

25 "Experienced Pottery Mould Maker-Modeler," *The Times Recorder* (Zanesville, OH: August 21, 1946), p. 10.

26 "Experienced casters needed," *The Times Recorder* (Zanesville, OH: July 14, 1948), p. 1; *The Evening Review* (East Liverpool, OH: July 19, 1948), p. 1.

27 *The E.S.C. Quarterly, op. cit.*, p. 55.

28 Catalog, Hyalyn Porcelain, Inc. (1953), p. 3.

29 *Ibid.*, pp. 4–11.

30 Baggs, A., letter to Wallace S. Baldinger, Lawrence College, Appleton, Wisconsin, about a pottery collection to be exhibited in Appleton. In Roberta Stokes Persick, "Arthur Eugene Baggs, American Potter," a dissertation presented in partial fulfillment of the requirements for the degree Doctor of Philosophy in the Graduate School of The Ohio State University (1963) p. 46. etd.ohiolink.edu/!etd.send_file?accession=Ohio State University1486554418658984&disposition=inline.

31 *Ibid.*, p. 82.

CHAPTER 3

1 Keiser Jr., A., typewritten history of Hyalyn Porcelain, Inc.'s business organization (no date).

2 *Ibid.*

3 Letter from H. Leslie Moody to Lawrence H. Brown (December 5, 1969).

4 Paradis, J., *Abingdon Pottery Artware: 1934–1950: Stepchild of the Great Depression* (Atglen, PA, Schiffer Publishing, Ltd., 1997), p. 165.

5 *Ibid.*, pp. 165–168.

6 Abingdon Pottery Catalog No. 21 (Abingdon, IL: Abingdon Pottery, a division of Abingdon Sanitary Manufacturing Co., 1934).

7 Peck, H., *The Second Book of Rookwood Pottery* (Tucson, AZ: Herbert Peck, 1985), p. 164.

8 *Ibid.*, p. 169.

9 Cummins, V. R., Leonard, C., and Coleman, D. (eds.), *Rookwood Pottery Potpourri* (Silver Spring, MD: 1980), p. 58.

10 Gaps in the sequence of numbered lines are unexplained. Form No. 601 is a small, round coaster found in later catalogs. Unnumbered examples of it are known.

11 Letter from Barney Parsons to Mr. H. Leslie Moody (February 14, 1949) with attached Atlas China Company advertisement.

12 This date is surmised from Moody's notes written on typewritten plans for a new sales year. The plan's contents suggest a 1948 date of origin. Moody sketched a two-color decorated vase at the top of one of the plan's pages.

13 Letter from Harry A. Neville to Less Moody (June 16, 1948).

14 These two ware lines were created by Charles Leslie Fordyce.

15 Hill, M., "Who & What Was Raymor," markhillpublishing.com/who-what-was-raymor/.

16 Kaplan, M., *Raymor: Modern in the Tradition of Good Taste* (Knoxville, TN: Image Enterprises, 2018), p. 7.

17 Hill, M., *op. cit.*, p. 17.

18 Kaplan, M., *op. cit.*, p. 4.

19 *Ibid.*, p. 16.

20 *Ibid.*, p. 13.

21 *Ibid.*, p. 5.

22 *Ibid.*, p. 8.

23 Vejnoska, J., "Garden Clubs: A Serious Force in Georgia and Throughout Nation," *The Atlanta Journal-Constitution* (Atlanta, GA: March 28, 2018), ajc.com/lifestyles/garden-clubs-serious-force-georgia-and-throughout-nation/TfbnlqcWtWWPmkpt4wwt/9L/.

24 Less Moody insisted upon adding classically-shaped bases to some of Cohen's bowls, planters, and vases.

25 "Moody, Hyalyn Porcelain G.M. Explains Designing Problems," *Hickory Daily Record* (Hickory, NC: April 28, 1958).

26 *Ibid.*

27 *Ibid.*

28 *Ibid.*

CHAPTER 4

1 Letter from Less Moody to Joe VonTury (March 5, 1962).

2 Letter from Less Moody to Lawrence H. Brown (April 10, 1970).

3 "Good Going, Hyalyn," *Hickory Daily Record* (Hickory, NC: July 5, 1957).

4 Letter from Less Moody to Chester Heppberger (May 29, 1947).

5 Moody, H. L., "HOW TO BE A SUCCESSFUL HYALYN SALESMAN" (no date).

6 Sales meeting booklet, Hyalyn Porcelain, Inc. (c. 1962/1963), p. 23.

7 Telephone interview with Lynn Allen, Morganton, NC (May 7, 2020).

CHAPTER 5

1 Letter from H. Leslie Moody to Mr. J. Russell Price (March 5, 1962).

2 Letter from H. Leslie Moody to Mr. Joe VonTury (March 5, 1962).

3 Letter from David M. Latz to Mrs. H. L. Moody (January 31, 1962).

4 "Cosco Acquires Hyalyn Porcelain," *The Republic* (Columbus, IN: November 13, 1973), p. 10.

5 Telephone interview, Robert E. Warmuth (June 10, 2020).

6 "Cosco Acquiring Three New Firms," *The Columbus Herald* (Columbus, IN: January 10, 1969).

7 "Springs Man To Head Hyalyn Porcelain," *Colorado Springs Gazette-Telegraph* (Colorado Springs, CO: December 23, 1973), p. 54.

8 Telephone interview, Warmuth, *op. cit.*

9 *Ibid.*

10 *Ibid.*

11 Letter from H. Leslie Moody to Charles R. Post (November 3, 1971).

12 Telephone interview, Warmuth, *op. cit.*

13 "Subsidiaries Sold By Cosco, Inc.," *The Republic* (Columbus, IN: July 8, 1977), p. 12.

14 "Cosco, Inc., Sells Hyalyn Subsidiary," *The Republic* (Columbus, IN: November 23, 1977), p. 14.

15 Telephone interview, Warmuth, *op. cit.*

16 *Ibid.*

17 "Manager has stepped down at Hyalyn," *The Charlotte Observer* (Charlotte, NC: January 20, 1993), p. 7.

18 Telephone interview, Warmuth, *op. cit.*

19 "New Marketing Director," *The Charlotte Observer* (Charlotte, NC: November 12, 1995), p. 24.

20 "Land Transactions," *The Charlotte Observer* (Charlotte, NC: December 21, 1997), p. 22.

CHAPTER 6

1 Persick, R. S., "Arthur Eugene Baggs, American Potter," a dissertation presented in partial fulfillment of the requirements for the degree Doctor of Philosophy in the Graduate School of The Ohio State University (1963), etd.ohiolink.edu/!etd.send_file?accession=Ohio State University1486554418658984&disposition=inlinePersick, p. 95.

2 *Ibid.*, p. 96.

3 Herbert Cohen, telephone interview (April 19, 2020).

4 "Hyalyn Porcelain Presents Completely New 1968 Line," *Hickory Daily Record* (Hickory, NC: December 22, 1967), pp. 1; 18.

5 "Salisbury Native Joins Hyalyn Staff," *Hickory Daily Record* (Hickory, NC: February 6, 1969), p. 25.

6 "Edgar Littlefield," *The Newark Advocate* (Newark, OH: June 22, 1970), p. 2.

7 "Finds Secret Of Old Ceramic Art," *Lancaster Eagle-Gazette* (Lancaster, OH: March 4, 1931), p. 1.

8 Paradis, J., *Abingdon Pottery Artware: 1934–1950: Stepchild of the Great Depression* (Atglen, PA: Schiffer Publishing, Ltd., 1997), p. 17.

9 These dates are estimates based upon information gleaned from city directories, the U.S. Federal Census, newspaper accounts, and school yearbook records. Other sources claim her Rookwood Pottery employment dates to be 1927–1935 and 1943–1948.

10 "Wilhelmina [*sic*] Rehm, Art," *U.S., School Yearbooks, 1900–1999 for Wilhelmina Rehm*, Ancestry.com.

11 "Sculptures Win Awards," *The Cincinnati Enquirer* (Cincinnati, OH: December 4, 1937), p. 3.

12 "Wilhelmine Rehm, sculptor," *Williams' Cincinnati City Directory 1939* (Cincinnati, OH: The Williams Directory Company, 1938), p. 926.

13 "Wilhemina [*sic*.] Rehm," *The Cincinnati Enquirer* (Cincinnati, OH: September 28, 1947), p. 4.

14 The 1944 *Cincinnati City Directory* calls Moody "Manager, Rookwood Pattern Division." In 1945, he was named Rookwood Pottery's "Manager."

15 Alexander, M. L., "Best In Late Years, Is Rating Of Women's Art Club Exhibit," *The Cincinnati Enquirer* (Cincinnati, OH), November 15, 1948, p. 1; "The Week in Art Circles," *The Cincinnati Enquirer* (Cincinnati, OH), November 28, 1948, p. 10.

16 Cummins, V. R., Leonard, C., and Coleman, D., eds., *Rookwood Pottery Potpourri* (Silver Spring, MD: 1980), p. 69.

17 Alexander, M. L., "Week In Art Circles," *The Cincinnati Enquirer* (Cincinnati, OH: April 16, 1950), p. 15.

18 *The Smith Alumnae Quarterly 1932–33*, Smith College, Northampton, MA, p. 330.

19 Cummins, V. R., *op. cit.*, p. 69.

20 "'Design Personalities,' Is Discussed Before Local Group," *The Richmond Item* (Richmond, IN: December 9, 1936), p. 4.

21 "Charles L. Fordyce," obituary. *Chicago Tribune* (Chicago, IL: December 9, 1954), p. 7.

22 U.S. Federal Census, 1920, Indianapolis Ward 15, Marion, IN, Ancestry.com.

23 United States Patent Office, Des. 133,776. Design for a cocktail glass or similar article, Charles L. Fordyce, New York, N.Y., assignor to Koscherak Bros. Inc., New York, N.Y., a corporation of New York.

24 Fordyce's great-granddaughter, Nicole Neuner, identifies him as Hyalyn's Golden Bars line designer. Modish.net.

25 Charles Leslie Fordyce designed the Free Form Line.

26 Iovine, J. V., "Michael Lax, Designer, Dies at 69; Sculptor of 60's Icons," *The New York Times* (New York, NY: June 5, 1999), Section C, p. 15, nytimes.com/1999/06/05/arts/Michael-lax-designer-dies-at-69-sculptor-of-60-s-icons.html, 1999, Section C, p. 15.

27 *Ibid.*

28 "Michael Lax: American, 1929–1999," moma.org/artists/3421.

29 "Miss Rosemary Raymond Bride Of Michael S. Lax at Alfred," *The Evening Tribune* (Hornell, NY: November 22, 1950), p. 8.

30 "Herb Cohen," email conversation with Barry Gurley Huffman (April 16, 2020).

31 "Rosemary (Raymond) Stoller," *San Francisco Chronicle* (San Francisco, CA: March 24, 2019), pressreader.com/usa/san-francisco-chronicle-Sunday/20190324/282595969256115.

32 "Claude Stoller: Professor Emeritus of Architecture," ced.berkeley.edu/ced/faculty-staff/claude-stoller.

33 "Robert A Sigmier," *U.S., World War II Army Enlistment Records, 1938-1946* [database on-line]. Provo, UT, USA: Ancestry.com Operations, Inc., 2005.

34 Todd Sigmier, personal email correspondence (April 13, 2020).

35 Cruz DeSimeo, A., Alumni Relations Manager, Kansas City Art Institute, Kansas City, Missouri, email correspondence (April 14, 2020).

36 "Robert Anthony Sigmier and Patricia Claire Sweeney," *Application for License to Marry, Missouri, Marriage Records, 1805-2002 for Robert Anthony Sigmier*, Ancestry.com.

37 Todd Sigmier, phone interview (April 13, 2020).

38 Sigmier remained in New Castle, Pennsylvania, as late as July 1954, when his son, Todd, was born.

39 "Hyalyn Porcelain Head Optimistic About 1955," *Hickory Daily Record* (Hickory, NC: December 31, 1954), p. 4.

40 Herbert Cohen, telephone interview (April 19, 2020).

41 Sigmier's daughter, Leigh, was born in California on February 10, 1957.

42 Sigmier, phone interview, *op. cit.*

43 Cohen, telephone interview, *op. cit.*

44 *Ibid.*

45 Herb Cohen refutes an erroneous claim that Eva Zeisel designed these wall pockets.

46 Cohen, *op. cit.*

47 "Ceramics Display," *The Charlotte News* (Charlotte, NC: April 12, 1958), p. 1.

48 Balcerek, K. "Sophisticated Surfaces at the Mint Museum Randolph," hpps://knightfoundation.org/articles/sophisticated-surfaces-at-the-mint-museum-randolph/.

49 "Prize Silver Set Shown Here," *The Pittsburgh Press* (Pittsburgh, PA: February 21, 1958), p. 1.

50 Johnson, L. A., "Obituary: Erwin Kalla/Shadyside sculptor, product designer," *Pittsburgh Post-Gazette* (Pittsburg, PA: July 28, 2005), post-gazette.com/news/obituaries/2005/07/28/Obituary-Erwin-Kalla-Shadyside-sculptor-product-designer/stories/200507280294.

51 "Prize Silver Set Shown Here," *op. cit.*

52 Elson, L., "Customary Ideas In Dinnerware Are Challenged," *The Journal Times* (Racine, WI: August 4, 1957), p. 2.

53 "Therapy Advocate Dies at 83," *News and Record* (Greensboro, NC: September 30, 1992), greensboro.com/therapy-advocate-dies-at/article_1f80dab8-6a23-57c9-94c4-80ab733d4225.html.

54 "Matthew Huttner," obituary, *Daily News* (New York, NY: July 14, 1975), p. 4.

55 "Esta Brodey," *New York, New York, Marriage License Indexes, 1907–2018* [database on-line]. Lehi, UT, USA: Ancestry.com Operations, Inc., 2017.

56 Peerless Art Co. advertisement, *The Brooklyn Daily Eagle* (Brooklyn, NY: January 11, 1948), p. 1.

57 Dr. James F. Brodey, telephone interview (May 14, 2020).

58 *Ibid.*

59 en.wikipedia.org/w/index.php?title=Georges_Briard&oldid=932587182.

60 *Ibid.*

61 Moody, H. L., Hyalyn Porcelain, Inc. sales department notebook (1962).

62 "New Type Business To Start," *Greensboro Daily News* (Greensboro, NC: January 29, 1962), p. 10.

63 "James "Jim" C. Pyron," obituary, oanow.com/obituaries/c-pyron-james-jim/article_bdf1427c-b6bb-56ce866e-2621e6e245fc.html.

64 *Ibid.*

65 Moody, Hyalyn Porcelain, Inc. sales department notebook (1966).

66 "Hyalyn Porcelain, Inc. Sees Best Year In 1966," *Hickory Daily Record* (Hickory, NC: January 13, 1966), p. 1.

67 "James "Jim" C. Pyron," obituary, *op. cit.*

68 *High Fashion 1964: Fine China by Eva Zeisel*, a catalog produced by Hyalyn Porcelain, Inc., Raymor, and Richards Morgenthau and Company (1964).

69 Email message from Pat Moore to Lynn Allen (February 6, 2006), Eva Zeisel Forum files.

70 Hamilton, W. L., "Eva Zeisel, Ceramic Artist and Designer, Dies at 105," *The New York Times* (New York, NY: December 30, 2011), nytimes.com/2011/12/31/arts/design/eva-zeisel-ceramic-artist-and-designer-dies-at-105.html?_r=1. A version of this article appears in print on December 31, 2011, Section B, p. 7 of the New York edition of *The New York Times*.

71 "Eva Zeisel," en.wikipedia.org/wiki/Eva_Zeisel.

72 *Ibid.*

73 Hamilton, W. L., *op. cit.*

74 "Eva Zeisel," *op. cit.*

75 Hamilton, W. L., *op. cit.*

76 Townley, D. D., "Hyalyn Porcelain Company: High Fashion," *Eva Zeisel: Life, Design, and Beauty*, Pat Kirkham, ed. (San Francisco: Chronicle Books, 2013), p. 125.

77 Phone interview with Lynn Causby Allen (May 7, 2020).

78 Moody, H. L., Hyalyn Porcelain, Inc. sales department notebook (1963).

79 Enomoto, Grand Master of the Koryu and Shogen Schools, May 1956, in Rachel Carr, *Stepping Stones to Japanese Floral Art*, Sixth Revised Edition (1959), xi.

80 Kerber, F., "Burglar's shot takes her eye," *Daily News* (New York, NY), December 5, 1981, p. 17.

81 "Edwin Megargee (American, 1883–1958)," William Secord Gallery, dogpainting.com/info_detail.cfm?type=artist&rts_id=EM.

82 "Edwin Megargee (American, 1883–1958)," artnet.com/artists/Edwin-megargee/biography.

83 "Produces Artistic Ceramic Designs For Hyalyn Pottery," *Hickory Daily Record* (Hickory, NC: April 30, 1953), p. 5.

84 "Dale Ulrey," oz.fandom.com/wiki/Dale_Ulrey.

85 "Benjamin Franklin Crews Jr.," *U.S. WWII Draft Cards Young Men, 1940–1947*, Ancestry.com.

86 U.S. Federal Census, 1930, Byersville Village, Guernsey County, OH.

87 U.S. Federal Census, 1940, Cambridge, Guernsey County, OH.

BIBLIOGRAPHY

Abingdon Pottery Catalog No. 21 (Abingdon, IL: Abingdon Pottery, a division of Abingdon Sanitary Manufacturing Co., 1934), Historical Association of Catawba County, Newton, NC

Alexander, M. L., "Best In Late Years, Is Rating Of Women's Art Club Exhibit," *The Cincinnati Enquirer* (Cincinnati, OH: November 15, 1948), Newspapers.com; "The Week in Art Circles," *The Cincinnati Enquirer* (Cincinnati, OH: November 28, 1948), Newspapers.com; "The Week In Art Circles," *The Cincinnati Enquirer* (Cincinnati, OH: April 16, 1950), Newspapers.com

"American Art Pottery from the Moody Collection at the Hickory Museum of Art," illustrated brochure, Historical Association of Catawba County, Newton, NC

"'America's Finest Porcelain' Made By Hyalyn—In Hickory," *Hickory Daily Record*, Historical Edition (Hickory, NC: September 1962), photocopy, Historical Association of Catawba County, Newton, NC

"Art Display At Mint," *The Charlotte News* (Charlotte, NC: May 17, 1947), Newspapers.com

Balcerek, K., "Sophisticated Surfaces at the Mint Museum Randolph," hpps://knightfoundation.org/articles/sophisticated-surfaces-at-the-mint-museum-randolph/

"Benjamin Franklin Crews Jr.," *U.S. WWII Draft Cards Young Men, 1940-1947*, Ancestry.com

"Ceramics Display," *The Charlotte News* (Charlotte, NC: April 12, 1958), Newspapers.com

"Ceramic Society Names Hickory Man," *The Charlotte Observer* (Charlotte, NC: April 7, 1961), Newspapers.com

"Charles L. Fordyce" obituary, *Chicago Tribune* (Chicago, IL: December 9, 1954), Newspapers.com

"Claude Stoller: Professor Emeritus of Architecture," ced.berkeley.edu/ced/faculty-staff/claude-stoller

Columbus Art League History: 1923-1935 (Columbus, OH: Columbus Art League, 1985), play.google.com/store/books/details?id=sj_53IaTyfkC&rdid=book-sj_53IaTyfkC&rdot=1

"Cosco Acquires Hyalyn Porcelain," *The Republic* (Columbus, IN: November 13, 1973), Newpapers.com

"Cosco, Inc., Sells Hyalyn Subsidiary," *The Republic* (Columbus, IN: November 23, 1977), Newspapers.com

Cummins, V. R., Leonard, C., and Coleman, D. (eds.), *Rookwood Pottery Potpourri* (Silver Spring, MD: 1980)

"Dale Ulrey," oz.fandom.com/wiki/Dale_Ulrey

"'Design Personalities,' Is Discussed Before Local Group," *The Richmond Item* (Richmond, IN: December 9, 1936), Newspapers.com

"Edgar Littlefield," *The Newark Advocate* (Newark, OH: June 22, 1970), Newspapers.com

"Edwin Megargee (American, 1883-1958)," William Secord Gallery, dogpainting.com/info_detail.cfm?type=artist&rts_id=EM

"Edwin Megargee (American, 1883-1958)," artnet.com/artists/Edwin-megargee/biography

Elson, L., "Customary Ideas In Dinnerware Are Challenged," *The Journal Times* (Racine, WI: August 4, 1957), Newspapers.com

Enomoto, R., Grand Master of the Koryu and Shogen Schools, May 1956, in Rachel Carr, *Stepping Stones to Japanese Floral Art*, Sixth Revised Edition (Tokyo: Tokyo News Service, Ltd., 1959)

"Esta Brodey," *New York, New York, Marriage License Indexes, 1907–2018* [database on-line]. Lehi, UT, USA: Ancestry.com Operations, Inc., 2017

"Eva Zeisel," en.wikipedia.org/wiki/Eva_Zeisel

"Experienced casters needed," *The Evening Review* (East Liverpool, OH: July 19, 1948), Newspapers.com

"Experienced casters needed," *The Times Recorder* (Zanesville, OH: July 14, 1948), Newspapers.com

"Experienced Pottery Mould Maker-Modeler," *The Times Recorder* (Zanesville, OH: August 21, 1946), Newspapers.com

"Finds Secret Of Old Ceramic Art," *Lancaster Eagle-Gazette* (Lancaster, OH: March 4, 1931), Newspapers.com

Frost, S. T., *Colors on Clay: The San Jose Tile Workshops of San Antonio* (San Antonio, TX: Trinity University Press, 2009)

"Georges Briard," en.wikipedia.org/w/index.php?title=Georges_Briard&oldid=932587182

"Good Going, Hyalyn," *Hickory Daily Record* (Hickory, NC: July 5, 1957)

Hamilton, W. L., "Eva Zeisel, Ceramic Artist and Designer, Dies at 105," *The New York Times* (New York, NY: December 30, 2011), nytimes. com/2011/12/31/arts/design/eva-zeisel-ceramic-artist-and-designer-dies-at-105.html?_r=1. A version of this article appears in print on December 31, 2011, Section B, p. 7 of the New York edition of *The New York Times*

Henzke, L., *American Art Pottery* (New York: Thomas Nelson Inc., 1970)

High Fashion 1964: Fine China by Eva Zeisel, a catalog produced by Hyalyn Porcelain, Inc., Raymor, and Richards Morgenthau and Company (1964), Historical Association of Catawba County, Newton, NC

Hill, M., "Who & What Was Raymor," markhillpublishing.com/who-what-was-raymor/

"H. Leslie Moody," *N.C., Death Certificates, 1909–1976* [database on-line]. Provo, UT, USA: Ancestry.com Operations Inc., 2007

Hoffmann, C. B., letter to Mr. H. Leslie Moody, Cincinnati, OH (July 3, 1943), Hickory Landmarks Society, Hickory, NC

"HOW TO BE A SUCCESSFUL HYALYN SALESMAN," attributed to H. Leslie Moody, Historical Association of Catawba County, Newton, NC

"Hyalyn Expansion Nears Completion," *Retailing Daily* (June 6, 1950), Historical Association of Catawba County, Newton, NC

"Hyalyn Plant Outlook Good," *Hickory Daily Record* (Hickory, NC: January 15, 1948), photocopy, Historical Association of Catawba County, Newton, NC

"Hyalyn Porcelain Head Optimistic About 1955," *Hickory Daily Record* (Hickory, NC: December 31, 1954), photocopy, Historical Association of Catawba County, Newton, NC

Hyalyn Porcelain, Inc., journal including hand-written entries outlining propane purchases and initial tunnel kiln firing issues, 1946-1956, Historical Association of Catawba County, Newton, NC

Hyalyn Porcelain, Inc., sales department notebook (1962), Historical Association of Catawba County, Newton, NC

Hyalyn Porcelain, Inc. sales department notebook (1963), Historical Association of Catawba County, Newton, NC

Hyalyn Porcelain, Inc., sales department notebook (1966), Historical Association of Catawba County, Newton, NC

Hyalyn Porcelain, Inc., sales meeting booklet (*c.* 1962/1963), Historical Association of Catawba County, Newton, NC

"Hyalyn Porcelain, Inc. Sees Best Year In 1966," *Hickory Daily Record* (Hickory, NC: January 13, 1966), photocopy, Historical Association of Catawba County, Newton, NC

"Hyalyn Porcelain Large Modern Plant for Art Pottery," *The E.S.C. Quarterly* (Spring-Summer 1947), Historical Association of Catawba County, Newton, NC

"Hyalyn Porcelain Presents Completely New 1968 Line," *Hickory Daily Record* (Hickory, NC: December 22, 1967), photocopy, Historical Association of Catawba County, Newton, NC

Iovine, J. V., "Michael Lax, Designer, Dies at 69; Sculptor of 60's Icons," *The New York Times* (New York, NY: June 5, 1999), Section C, nytimes. com/1999/06/05/arts/Michael-lax-designer-dies-at-69-sculptor-of-60-s-icons.html

"James 'Jim' C. Pyron" obituary, oanow.com/obituaries/c-pyron-james-jim/article_bdf1427c-b6bb-56ce866e-2621e6e245fc.html

Johnson, L. A., "Obituary: Erwin Kalla/Shadyside sculptor, product designer," *Pittsburgh Post-Gazette* (Pittsburg, PA: July 28, 2005), post-gazette.com/news/obituaries/2005/07/28/Obituary-Erwin-Kalla-Shadyside-sculptor-product-designer/stories/200507280294

Kaplan, M., *Raymor: Modern in the Tradition of Good Taste* (Knoxville, TN: Image Enterprises, 2018)

Keiser Jr., A., typewritten history of Hyalyn Porcelain, Inc.'s business organization, Historical Association of Catawba County, Newton, NC

Kerber, F., "Burglar's shot takes her eye," *Daily News* (New York, NY: December 5, 1981), Newspapers.com

"Land Transactions," *The Charlotte Observer* (Charlotte, NC: December 21, 1997), Newspapers.com

Makio (Columbus, OH: The Ohio State University, 1931), edu.arcasearch.com/usohosy/

"Manager has stepped down at Hyalyn," *The Charlotte Observer* (Charlotte, NC: January 20, 1993), Newspapers.com

"Matthew Huttner" obituary, *Daily News* (New York, NY: July 14, 1975), Newspapers.com

"Men and Machines Spell Success for Hyalyn," *Ceramic Industry*, Volume 76, No. 2 (Chicago, IL: February 1961), Historical Association of Catawba County, Newton, NC

"Michael Lax: American, 1929-1999," moma.org/artists/3421

"Miss Rosemary Raymond Bride Of Michael S. Lax at Alfred," *The Evening Tribune* (Hornell, NY: November 22, 1950), Newspapers.com

Moody, H. L., letter to Chester Heppberger (May 29, 1947), Historical Association of Catawba County, Newton, NC; letter to J. T. Robson (December 16, 1941), Historical Association of Catawba County, Newton, NC; letter to Lawrence H. Brown (December 5, 1969), Historical Association of Catawba County, Newton, NC; letter to Mr. J. Russell Price (March 5, 1962), Historical Association of Catawba County, Newton, NC; letter to Mr. Joe VonTury (March 5, 1962), Historical Association of Catawba County, Newton, NC; "Proposal: White Ware Industry for North Carolina" (1942). Typewritten copy, Hickory Landmarks Society, Hickory, NC; telegram to Mrs. H. Leslie Moody from Cincinnati, OH to San Antonio, TX (July 12, 1943). Photocopy, Historical Association of Catawba County, Newton, NC

"Moody, Hyalyn Porcelain G.M. Explains Designing Problems," *Hickory Daily Record* (Hickory, NC: April 28, 1958), Historical Association of Catawba County, Newton, NC

Moore, P., email message to Lynn Allen (February 6, 2006). Eva Zeisel Forum files

Nance, D. C., "Men of Hickory, Pleased With Idea, Begin Manufacture," *Journal and Sentinel* (Winston-Salem, NC: January 4, 1948), Historical Association of Catawba County, Newton, NC

Neville, H. A., letter to Less Moody (June 16, 1948), Historical Association of Catawba County, Newton, NC

"New Marketing Director," *The Charlotte Observer* (Charlotte, NC: November 12, 1995), Newspapers.com

"New Type Business To Start," *Greensboro Daily News* (Greensboro, NC: January 29, 1962), Genealogybank.com

Paradis, J., *Abingdon Pottery Artware: 1934-1950: Stepchild of the Great Depression* (Atglen, PA: Schiffer Publishing, Ltd., 1997)

Parsons, B., letter to Mr. H. Leslie Moody (February 14, 1949) with attached Atlas China Company advertisement, Historical Association of Catawba County, Newton, NC

Peck, H., *The Second Book of Rookwood Pottery* (Tucson, AZ: Herbert Peck, 1985)

Peerless Art Co. advertisement, *The Brooklyn Daily Eagle* (Brooklyn, NY: January 11, 1948), Newspapers.com

Persick, R. S., "Arthur Eugene Baggs, American Potter," a dissertation presented in partial fulfillment of the requirements for the degree Doctor of Philosophy in the Graduate School of The Ohio State University (1963), etd.ohiolink.edu/!etd.send_file?accession=Ohio State University1486554418658984&disposition=inline

"Porcelain Plant Begins Production," *The Charlotte News* (Charlotte, NC: December 30, 1946), Newspapers.com

"Pottery Plant Lets Contract," *Hickory Daily Record* (Hickory, NC: November 10, 1945), photocopy, Historical Association of Catawba County, Newton, NC

"Pottery Plant Site Acquired," *Hickory Daily Record* (Hickory, NC: October 30, 1945), photocopy, Historical Association of Catawba County, Newton, NC

"Prize Silver Set Shown Here," *The Pittsburgh Press* (Pittsburgh, PA: February 21, 1958), Newspapers.com

"Produces Artistic Ceramic Designs For Hyalyn Pottery," *Hickory Daily Record* (Hickory, NC: April 30, 1953), photocopy, Historical Association of Catawba County, Newton, NC

Rago, D., *American Art Pottery* (New York: Knickerbocker Press, 2001)

"Robert A Sigmier," *U.S., World War II Army Enlistment Records, 1938-1946* [database on-line]. Provo, UT, USA: Ancestry.com Operations, Inc., 2005

"Robert Anthony Sigmier and Patricia Claire Sweeney," *Application for License to Marry, Missouri, Marriage Records, 1805-2002 for Robert Anthony Sigmier*, Ancestry.com

Robson, J. T., letter to H. Leslie Moody (December 22, 1941), Historical Association of Catawba County, Newton, NC

"Rosemary (Raymond) Stoller," *San Francisco Chronicle* (San Francisco, CA: March 24, 2019). pressreader.com/usa/san-francisco-chronicle-Sunday/20190324/282595969256115

"Salisbury Native Joins Hyalyn Staff," *Hickory Daily Record* (Hickory, NC: February 6, 1969), photocopy, Historical Association of Catawba County, Newton, NC

"Sculptures Win Awards," *The Cincinnati Enquirer* (Cincinnati, OH: December 4, 1937), Newspapers.com

"Springs Man To Head Hyalyn Porcelain," *Colorado Springs Gazette-Telegraph* (Colorado Springs, CO: December 23, 1973), Newspapers.com

Stockton West Burkhart, Inc., "Basic Plan for 1945 for Rookwood Pottery," (1945), Hickory Landmarks Society, Hickory, NC

"Subsidiaries Sold By Cosco, Inc.," *The Republic* (Columbus, IN: July 8, 1977), Newspapers.com

"Therapy Advocate Dies at 83," *News and Record* (Greensboro, NC: September 30, 1992), greensboro.com/therapy-advocate-dies-at/article_1f80dab8-6a23-57c9-94c4-80ab733d4225.html

The Smith Alumnae Quarterly 1932-33, Smith College, Northampton, MA, MyHeritage.com

Townley, D. D., "Hyalyn Porcelain Company: High Fashion," *Eva Zeisel: Life, Design, and Beauty*, Pat Kirkham (ed.) (San Francisco: Chronicle Books, 2013)

Underwood, E. M., letter to H. Leslie Moody (December 15, 1941), Historical Association of Catawba County, Newton, NC

United States Patent Office, Des. 133,776. Design for a cocktail glass or similar article, Charles L. Fordyce, New York, N.Y., assignor to Koscherak Bros. Inc., New York, N.Y., a corporation of New York, patents.google.com/patent/USD133776S/en

Unknown author, Typewritten history of Hyalyn Porcelain, Inc. (*c.* 1962) Historical Association of Catawba County, Newton, NC

U.S. Federal Census, 1920, Indianapolis Ward 15, Marion, IN, Ancestry.com

U.S. Federal Census, 1930, Bexley Village, Franklin County, OH, Ancestry.com

U.S. Federal Census, 1930, Byersville Village, Guernsey County, OH, Ancestry.com

U.S. Federal Census, 1940, Cambridge, Guernsey County, OH, Ancestry.com

U.S. Federal Census, 1940, Cincinnati, Hamilton, OH, Ancestry.com

Vejnoska, J., "Garden Clubs: A Serious Force in Georgia and Throughout Nation," *The Atlanta Journal-Constitution* (Atlanta, GA: March 28, 2018), ajc.com/lifestyles/garden-clubs-serious-force-georgia-and-throughout-nation/TfbnlqcWtWWPmkpt4wwt/9L/

VonTury, F. J., letter to Mr. H. Leslie Moody (April 21, 1963), Historical Association of Catawba County, Newton, NC

Waltman, C. E., & Associates, "Ceramic Research for Rookwood Pottery," (November 1945), Hickory Landmarks Society, Hickory, NC

"Wilhelmina [*sic*] Rehm," *The Cincinnati Enquirer* (Cincinnati, OH: September 28, 1947), Newspapers.com

"Wilhelmina [*sic*] Rehm, Art," *U.S., School Yearbooks, 1900–1999*, Ancestry.com

"Wilhelmine Rehm, sculptor," *Williams' Cincinnati City Directory 1939* (Cincinnati, OH: The Williams Directory Company, 1938), MyHeritage.com

"Wilhelmine Rehm," *The Cincinnati Enquirer* (Cincinnati, OH: September 28, 1947), Newspapers.com

INDEX

Abingdon Pottery 10-11, 15-18, 20, 25-26, 34, 38-40, 62, 81, 84-85, 141

Abingdon Sanitary Manufacturing Company 10-11

Aimcee Wholesale Corporation 64

Alfred University (See *New York State College of Ceramics*)

American Ceramic Society 15, 44, 67, 80, 85

Appalachian Mountains 6, 21

Art Linkletter's *House Party* radio and television show 59-60

Art Students' League 16, 122

Atlas China Company 40

Baggs, A. E. 6, 8-9, 13, 19, 21, 30, 33, 44, 79, 85

Baker's Dozen sales plan 63

Beauty Queen (Miss America Pageant) 18, 65, 85

Bernay, L. (designer, Hyalyn Porcelain, Inc.) 62, 80, 120, 172

Bidwell, R. 10

Binns, C. F. 8-9, 30, 33, 79

Blue Ridge Mountains 65

Briard, G. (designs produced by Hyalyn Porcelain, Inc.) 5, 19, 62, 80, 104, 106, 109-112, 126, 172, 175, 193-200

Bristol glaze 9

Brittain, L. W. (foreman, shipping dept., Hyalyn Porcelain, Inc.) 26

Brown, L. H. 37

Broyhill Furniture Company 5, 59

Bruce, S. 122

Brush, G. D. 22

Burnes of Boston (ceramic picture frames) 71

C. E. Waltman & Associates 14

Carnegie Institute of Technology 8, 101

Carolina and North Western Railway 22

Carolina China Company 26-27

Carr (Kimball), R. E. S. (designer, Hyalyn Porcelain, Inc.) 64, 80, 116-119, 166, 172

Castleton China, Inc. 93, 114

Catalina Pottery 19

Caughlin, J. 22

Cilley, E. L. (decorator, Hyalyn Porcelain, Inc.) 26, 32, 34, 48, 126

Claremont High School 132

Clarke, W. A. 122

Cleveland (OH) importer (copied most of Hyalyn's product line) 58, 67

Coalport Bone China 38

Cohen, H. (designer, Hyalyn Porcelain, Inc.) 4-5, 19, 29, 43, 58-59, 65-66, 79-80, 89, 92-93, 95-96, 98-100, 105, 126, 154-155, 158, 174

Conant, A. P. 36, 39

Contract orders and specialty items 58, 65

Copco teakettle (M. Lax) 90

Corpening, A. 68, 76

Cowan Pottery (Cleveland, OH) 8

Cox, K. 122

Crews, B. F. (mgr., decorating department, Hyalyn Porcelain, Inc.) 25, 30, 68, 126

Crews, B., Sr. 126

Crews, G. M. W. (decorator, Hyalyn Porcelain, Inc.) 26, 126

Crockery and Glass Journal 59

Crumbaker, M. L. "Bud" 25, 34, 85

Dallas Technical High School 8

Danish Modern design in Finland 89

Decalcomania (defined) 30

Delano Studios (Setauket, Long Island, NY) 122, 154

Department stores (selling Hyalyn Porcelain) 14-15, 42, 60-61, 64

Derrydale Press 122

Dock strike (glaze chemical shortage) 69

Drexel University 122

du Mond, Vincent 122

Duke Power Company 21

Eames, Ray and Charles 41, 101

East Night High School (Cincinnati, OH) 85

Eisenhower, D. D. 93

Elliott Building Company 22

Emrich's *State of the Union* (ashtrays, trinket dishes) 65, 165

Enameled cast iron for Copco 89

Encaustic Tiling Company 8

Ever-thine Flowers (Los Angeles, CA) 60, 62

Ferro Enamel Corporation (Allied Engineering Division) 12

Fiber and Yarn Products (Hickory, NC) 76

Ford, B. 37

Fordyce, C. L. 19, 41, 43, 60, 80, 86-88, 128

Fox, C. (supt., mold shop, Hyalyn Porcelain, Inc.) 25-26

Fox, J. W. 21

Frans, L. P. 21

Frederick Wholesale Corporation 64

Frey, E. F. 9, 16, 19

Frye, J. F. 80

Fulbright Fellowship 89

Fulbright, E. (mold maker, Hyalyn Porcelain, Inc.) 26, 28

Garden Club Movement 42

George Armstrong Custer monument 9

Georges Briard Designs, Inc. 62, 104, 109, 175

Georgetown University 122

Gifford, L. C. 21
Gift and Art Center (New York City) 40
Goodwill Ambassador Division (Hyalyn Porcelain, Inc.) 59, 164-165
Great Depression 8, 42
Greely, M. 76
Greenspan, M. 18, 58, 68, 71, 104, 133
Greyhound Bus Company (running greyhound logo) 122
Grueby Pottery 19
Gus Bock Hardware 141-142

H. P. & H. F. Hunt Company (Burlington, MA) 69
Hadley Studios (New York City) 124
Haeger Potteries, Inc. (Dundee, IL) 7, 12, 20, 58
Hargri Studios 120
Hall, Dr. H. J. 8
Hamilton Cosco (Columbus, IN) 16, 27, 59, 67-69, 80, 175
Hamilton, C. O. 68
Harrop Ceramic Service Company (Columbus, OH) 22
Harrop, C. B. 22
Harvard Graduate School of Design 90
Haupt, C. 85
Hedrick Sr., D. (glazer, Hyalyn Porcelain, Inc.) 26
Heppberger, C. 63
Hertslet, E. 10, 17
Hickory Chamber of Commerce (Hickory, NC) 21
Hickory History Center (Lyerly House) 5
Hickory Landmarks Society (Hickory, NC) 4, 175
Hickory Log 132
Hickory Museum of Art (Hickory, NC) 19
Hickory, North Carolina 4-8, 15-16, 21-22, 25, 58, 60, 65, 67, 76, 83, 85-86, 95, 113 124, 126
Historic Preservation Commission (City of Hickory, NC) 4
Historical Association of Catawba County (Newton, NC) 4-5, 175
Hodges, G. (glazer, Hyalyn Porcelain, Inc.) 26
Hoffman, C. B. 13
Hokanson, D. R. (designer, assist. mgr., Hyalyn Porcelain, Inc.) 80, 105-108, 132, 144
Huffman, B. G. 2, 4-5
Huffman, F. (foreman, Hyalyn Porcelain, Inc.) 26

Humler, R. 4, 14
Hurley, E. T. 19
Huttner, E. B. (designer, Raymor/ Richards Morgenthau Co.; owner, Peerless Art Co.) 41, 44, 104-106, 171, 175, 185, 188-189
Hyalyn (derivation of name from hyaline) 21
Hyalyn Cosco, Inc. (Hickory, NC) 4, 16, 59, 68-71, 76, 166, 169, 175
Hyalyn Lamps (Greensboro, NC) 72, 76
Hyalyn Ltd. and Vanguard Studios retail stores 65, 68, 76-77
Hyalyn Porcelain, Inc. factory salesroom (outlet) 23, 65-66
Hyalyn Porcelain, Inc. manufacturer representatives 24, 63
Hyalyn Porcelain, Inc. permanent product displays 24, 63
Hyalyn Porcelain, Inc. product distributors 63
Hyalyn, Ltd. 4, 71, 76, 114, 130-131, 166, 170, 175
Hyalyn, Ltd. lamp base customers 71
Hy-lan Furniture Co. (Hickory, NC) 21

Igoe, L. M. (decalcomania designer, Hyalyn Porcelain, Inc.) 4, 12, 14, 122, 126
Indiana University 16
Institutum Divi Thomae 13

Japanese manufacturers 58
Johnson, F. (See Moody, F. J.)
Johnson, H. M. 16
Johnson, K. 85
Johnson, L. G. 16

Kalla, E. (designer, Raymor/Richards Morgenthau Co.) 5, 19, 41, 43-44, 62, 80, 101-103, 159, 171, 175, 185-187
Kansas City Art Institute 93
Kaplan, M. 4, 41-42
Karmatz, A. J. 71
Kay Award 65, 85
Kenton Hills Pottery (Erlanger, KY) 39
Keramos 80
Kilns 12, 14, 20, 22-25, 30-31, 34, 68, 76
Kirby, S. (decorator, Hyalyn Porcelain, Inc.) 126
Knickerbocker Hotel (Chicago, IL) 86

LaBlond Machine Tool Company (Cincinnati, OH) 86
Lamp base manufacture 10, 12, 18, 20, 22-24, 34, 36, 58, 65, 67-68, 71, 95
Lamp companies 34

Lamp-Craft Studios 120
Langerbeck, K. 8
Latz, D. M. 63, 67
Lax (Stoller), R. R. (designer, Raymor/ Richards Morgenthau Co.) 41, 62, 89, 92, 175, 184
Lax, M. (designer, Raymor/Richards Morgenthau Co.) 5, 19, 30, 41-43, 60, 62, 80, 89, 90-92, 95, 106, 171, 175, 180-184 190-191
Lenoir Highway (Hickory, NC) 65
Levitz Furniture 71
Limoges, France 38
Linn Myers Inc. 63, 67
Littlefield, E. (designer, ceramics engineer, Hyalyn Porcelain, Inc.) 23-25, 32, 34, 79, 85, 126
Live High on a Low Budget 5, 42, 59-60
Lostro, R. 12, 14
Love Field Pottery (Dallas, TX) 8-9, 12, 15, 85
Lumpkin, Mrs. E. K. 42
Lyerly Sr., W. 21
Lytegem lamp (Lightolier, 1965) 89

M. Wille Inc. 62, 80, 104, 109, 175
Magazines (featuring Hyalyn Porcelain, Inc.) 5, 59-61, 135
Marblehead Pottery (Marblehead, MA) 8-9, 19
Mason's Patent Ironstone 38
Max, P. 41
Maxwell, C. 68
McCartan, E. 16, 19
Megargee, E. (decalcomania designer, Hyalyn Porcelain, Inc.) 79, 122-124
Menzel, R. E. 36, 39
Menzies, K. C. 21
Michaelian and Kohlberg Company of New York 12-13
Mingus, F. (glazer, Hyalyn Porcelain, Inc.) 26, 29
Mint Museum (Charlotte, NC) 25, 85, 95
Miss America Pageant (See Beauty Queen) 18, 65, 85
Mitchell, R. D. (designer, Hyalyn Porcelain, Inc.) 80, 113
Modulion 10 Ionizer 89
Moody, D. I. B. 8
Moody, F. J. (designer, Hyalyn Porcelain, Inc.) 4-5, 7-10, 12, 16-21, 34, 41, 65, 67, 73, 76, 78-80, 83-85, 105, 126, 131-132, 142, 172
Moody, H. L. (manager, designer, Hyalyn Porcelain, Inc.) 5-24, 26-27, 34-40, 42-43,

46, 48, 58-59, 61-63, 67-68, 71, 79-82, 84-85, 93, 113, 120, 124, 126, 132, 139, 141, 161
Moody, J. H. 8
Morgantown Glass Company (Morgantown, WV) 86
Morgenthau, E. 41
Morris Greenspan, Inc. 18, 58, 68, 71, 133
Mosaic Tile Company 8, 15, 37
Mueller, H. 8
Museum of Modern Art 89, 114

Napier, M. J. 64, 117, 147
National Garden Clubs, Inc. 42
National Industrial Recovery Act 8
National Institute of Ceramic Engineers 80
National Recovery Administration (See *National Industrial Recovery Act*)
Nelson, G. 41
Neville, H. A. 40, 63
New York Art Center 86
Nifty Gifties 6
North Carolina (*The Good Roads State*) 21
New York School of Music and Art 89
New York State College of Ceramics (Alfred University) 8-9, 33, 89, 95, 105-106
North Carolina Central University (art department and gallery) 126
North Carolina State University School of Design (College of Design), Raleigh, NC 6

O'Hair, L. T. 76
Ohio State University 6, 8-10, 13, 15-16, 21-22, 24, 34, 37, 79, 85
Order of the Eastern Star 140

Paradis, J. 39, 43
Parsons, Barney 40
Patterson Foundry & Machine Co. (East Liverpool, OH) 10
Pearl Harbor, HI (bombing of) 10
Peerless Art Co. 41, 44, 62, 104-106, 171, 175, 185, 188-189
Persick, R. S. 33
Piedmont Gas Company 22
Piedmont Region (North Carolina) 21
Pitman-Dreitzer & Co., Inc. (NY) 86
Porcelain (*v.* pottery) 27-28
Porcelain replaced by semi-porcelain clay body 59, 80, 89, 101
Porcelain-making materials: ball clay, feldspar, flint (quartz), kaolin 12, 20
Post, C. R. 69
Press, F. 163

Price, R. 67
Pugh, J. 59, 164
Purcell, C. M. 4
Pyrometric equipment 12
Pyron, J. C. (designer, Hyalyn Porcelain, Inc.) 80, 113

Rago, D. 14
Raymor Mfg. Division, Inc. 41
Raymor/Richards Morgenthau Co. 41-42, 62, 80, 89, 101, 104, 114, 144, 175
Rehm, W. "Willie" (designer, Hyalyn Porcelain, Inc.) 15, 24, 34-35, 40, 44-45, 47-48, 79, 85-86, 127-128, 132
Reid, V. (decorator/stippler, Hyalyn Porcelain, Inc.) 126
Richards (Rappaport), I. 41-42
Robson, J. T. 12
Rookwood Pottery 12-16, 18-19, 21, 24, 34-36, 39-40, 79, 85-86, 127
Roseville Pottery 7, 19
Rubel Designs 163
Ruge, A. "Andy" 41
Rutgers University (NJ) 16

San Jose Mission 12
San Jose Potteries (San Antonio, TX) 12-13, 15, 18
Saville, B. 16, 19
Seacrest, M. 69
Shelter magazine 59, 61
Shirayamadani, K. 19, 36, 39
Seibel, B. 41
Sigmier, R. A. (designer, Hyalyn Porcelain, Inc.) 80, 93-94, 122, 140
Sigmier, T. "Doc" 93
Silkscreen printing process 104, 126
Skin packing shipping process 32-33
Soles, W. 122, 154
Sperti, Inc. 12-14
Spruce Pine (NC) mineral district 20
Sterling Glass Company (Cincinnati, OH) 85
Stern Brothers 41
Stockdale, V. B. 10
Stockton West Burkhart, Inc. (Cincinnati, OH) 14
Stoller, C. 90
Sweeney, P. C. 93

Tau Sigma Delta fraternity 8
Teague, J. (decorator/stippler, Hyalyn Porcelain, Inc.) 126
Teco Pottery 19
Texas University 124

The Economy Equipment Company 10
The Haeger Pottery Exhibit (New York World's Fair, 1934) 12
Thurston, G. 95, 129, 135
Tiffany Pottery 19
Tile-making process 37
Todd, M. (worker, Hyalyn Porcelain, Inc.) 26
Top Hat cocktail glass 86
Tyndale Cosco, Inc. 68, 71

Ulrey, M. D. C. (decalcomania designer, Hyalyn Porcelain, Inc.) 79, 122, 124
Underwood, E. M. 10
Universal Potteries Company (Cambridge, OH) 126
University of California, Berkeley 90
University of Cincinnati College of Engineering and Commerce and School of Applied Arts 85

Van Briggle Pottery 19
Vanguard Studios of Los Angeles, California 76
Vanguard Studios of North Carolina, Inc. 76
Vincent, George 93
VonTury, F. J. 15, 58
Vontury, Inc. (Perth Amboy, NJ) 15

Walter Crowell Co. 40, 63
Wareham, J. D. 36, 39
Warmuth, B. 76
Warmuth, L. 4
Warmuth, R. E. 4, 68-69, 71-72, 76, 130-131
Weller Pottery 19
Whiteware industry 12, 15
Wilmar Company, Inc. 68
Wilson, J. H. (accountant, Hyalyn Porcelain, Inc.) 26
Wilson, Z. (stenographer, Hyalyn Porcelain, Inc.) 26
World of Ceramics 65, 85, 114, 175, 204
World War II 7, 10, 14-15, 20-21, 38, 43, 58, 93
Wright, F. L. 44
Wright, R. 41, 89

Young Men's and Women's Hebrew Association 89

Zeisel, E. A. S. (designer, Raymor/Richards Morgenthau) 5, 19, 41-42, 44, 62, 80, 114-116, 166, 171, 175, 201-204